Identity Design Sourcebook

Successful IDs Deconstructed and Revealed

Clay Andres

Catharine Fishel

Pat Matson Knapp

ROCKPORT

© 2004 by Rockport Publishers, Inc.

First published in the United States of America by
Rockport Publishers, Inc.
33 Commercial Street
Gloucester, Massachusetts 01930-5089
Telephone: (978) 282-9590
Fax: (978) 283-2742
www.rockpub.com

Library of Congress Cataloging-in-Publication data available

ISBN 1-59253-029-X

10 9 8 7 6 5 4 3 2 1

Cover Design: Jerrod Janakus

Printed in China

Contents

Corporate Identity

"…Clarity in expressing the brand—whether it be for a manufactured product or for a business-to-business corporation—may be the final [business] frontier."

—Peter Lawrence, Corporate Design Foundation

At the starting gate of a new century, a volatile economy fueled by the Internet and new technology has created a business landscape that changes at warp speed.

Mergers and acquisitions in industries such as financial services, telecommunications, and energy have produced huge new corporations that must find ways to humanize themselves to appeal to local as well as global audiences. Companies rooted in traditional technologies are searching for inroads to the high-tech world. And at the same time, Internet startups struggle to find footholds in the constantly shifting economic terrain.

For companies trying to survive and thrive in the New Economy, carving out strong and memorable identities is crucial. "Brand awareness" has become a corporate mantra, and many companies recognize design as among their most effective business tools. Executed well and applied consistently, strong corporate identities strengthen the bonds between businesses and their customers, and ultimately improve the bottom line.

"Design is an essential competitive element," notes Peter Lawrence, founder and chairman of the Corporate Design Foundation, established in 1985 to promote the integration of design and business. "We've covered price. Manufactured quality and technology are now essentially commodities, so they're no longer the determining factors in what to buy or which services company to use. Now, clarity in expressing the brand—whether it is for a manufactured product or for a business-to-business corporation—may be the final frontier."

This section follows companies through recent identity launches, exploring the challenges, processes, and solutions behind them. Each of the case studies—from large international corporations such as BP and TNT to dot-com startups such as Plural and BuildNet—show how companies use design to connect with their audiences.

Their reasons for embarking on new identities are as diverse as the businesses themselves, but regardless of the reason for the change, effective corporate identities share some common elements, says Kris Larsen, managing director of Interbrand's Chicago office. "A strong brand should do four things: it should be relevant to customers; it should be credible (and by that I mean truthfully represent the brand); it should differentiate itself from the competition; and it should have the ability to stretch as the market stretches."

Good brands also share another key characteristic, says Ken Carbone, Carbone Smolan Agency (New York). "They are a way for companies to forge an emotional bond with their audiences. If you can touch their emotions in some way, the brand becomes a living, memorable thing."

—*Pat Matson Knapp*

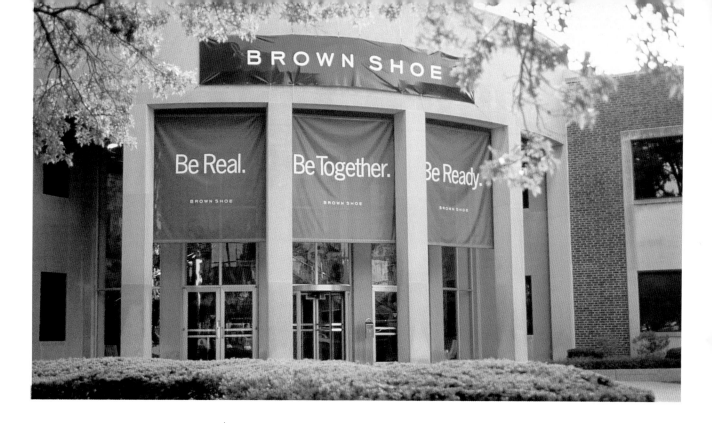

Brown Shoe Company

A venerable shoe company finds a fitting identity.

With more than forty popular shoe brands and 1,400 retail stores in its portfolio, Brown Shoe is one of the world's largest footwear companies. But its image as a stolid, conservative manufacturing operation in its hometown of St. Louis, Missouri—famous for "shoes and booze"—meant it got little respect as the fashion leader it had become.

Founded in 1878 as Bryan, Brown and Company, Brown Shoe had grown over the years into a manufacturer, wholesaler, and retailer of brands such as Naturalizer, Buster Brown, and LifeStride, as well as the designer/marketer of licensed footwear brands like Dr. Scholl's and Barbie. The company also owns more than 900 Famous Footwear and close to 500 Naturalizer shoe stores. Annual sales for the company reached $1.6 billion in 1999.

In the 1970s, the company had diversified into other businesses and changed its name to Brown Group. But by the late 1990s (under the leadership of new CEO Ron Fromm), Brown was again focused solely on shoes. Management recognized that the company name, and a corporate image that had become outdated and fragmented, should reflect the new focus. So in addition to reverting to its old name, Brown Shoe Company, management turned to Kiku Obata & Company (St. Louis) to polish its corporate image.

[above] *Signage was an important element of the program. Kiku Obata replaced the old, 1970s-era signage on Brown Shoe's corporate headquarters with temporary banners that promoted the new identity and taglines.*

Brown Group, Inc.

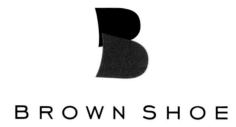

BROWN SHOE

Client: **Brown Shoe Company, St. Louis**

Ron Fromm	chairman
Jo Jasper Dean	director, events marketing and special projects
Carol Wiley	manager, creative services, public relations

Design Team: **Kiku Obata & Company, St. Louis**

Kiku Obata	Scott Gericke
Amy Knopf	Joe Floresca
Jennifer Baldwin	and Carole Jerome

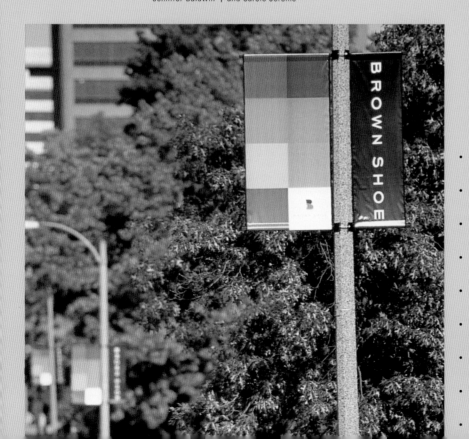

[above—left] *(Before)* In the 1970s, Brown Shoe had diversified into other non-shoe-related businesses. Its identity reflected the era and the diversification.

[above—right] Brown Shoe loved the visual pun referenced in the final solution. The "B" is formed by two overlapping heels, one in brown and one in black. Designers chose a modified version of Engraver's Gothic for the typeface and spaced the letters generously to give the logotype a stylish yet classic feel unique to Brown Shoe.

[left] To signal the community that change was afoot, Kiku Obata designed street banners in the same earthy color palette as the launch kit and brochures.

[above & opposite page—far right] *Early logo explorations focused on making the "B" its prominent feature. Designers also explored literal interpretations of shoes and other, more conceptual illustrative approaches. The team generated more than fifty initial logo sketches.*

Sizing Up the Brand

Kiku Obata started the process with an exhaustive research effort. First, the design team interviewed Brown Shoe employees across a wide range of positions and three management tiers. Then came reviews of existing market research, internal reports, and competitors' materials. Finally, the team evaluated Brown Shoe's marketing strengths and weaknesses.

The research was enlightening, not only for the design team, but for the company's employees. "I don't think many people in the company had ever seen a complete list of all the brands they were involved in," notes Kiku Obata. "It really helped us, and them, articulate who the Brown Shoe Company is."

Carol Wiley, Brown Shoe's manager of creative services, public relations, agrees. "It became very evident that we had not been focusing on the identity we were presenting to the outside world. People in different divisions were using different business cards, and some divisions had even been making up their own letterhead. This process became an opportunity for us to get a clear vision of Brown Shoe, and to pay attention to how we were presenting ourselves visually."

A New Self-Image

After four weeks of intensive research, Kiku Obata developed a presentation book and a series of boards to illustrate their findings. The team's strategic recommendations were dramatic: "Most of all, they needed to move away from the mindset of still being a manufacturer, and see themselves as what they are: a fashion company," notes Obata.

Brown Shoe's new identity needed to be "solid but smart," conveying the current, market-driven nature of the footwear business, but also communicating the trustworthiness and dependability of a 125-year-old company. It needed to position them well against competitors such as Nine West, but also convey that Brown Shoe is about fashion and comfort. With those attributes in mind, the Kiku Obata team presented three visual concepts as well as a series of identifiers, including a phrase ultimately adopted as its tagline, "The Leader in Footwear."

Although designers generated close to fifty variations of logos, explorations turned quickly toward treatment of the letter "B" as a visual pun. The final solution incorporates a stylized "B" shaped by two overlapping heels, one in black and one in brown. Beneath the symbol, Brown Shoe is presented in a clean, classic typeface based on Engraver's Gothic. Generous letter spacing and plenty of white space around the mark make it stylish and unique to Brown Shoe. "It's very simple, easy to read, and also fairly elegant," notes Obata. "It was intended to be solid but stylish, and something that has a sense of history behind it."

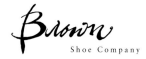

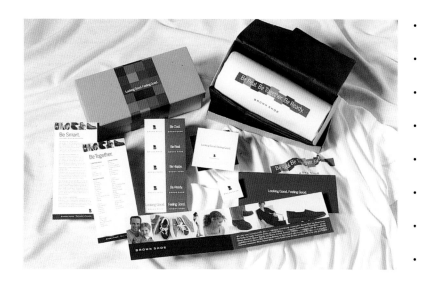

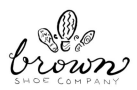

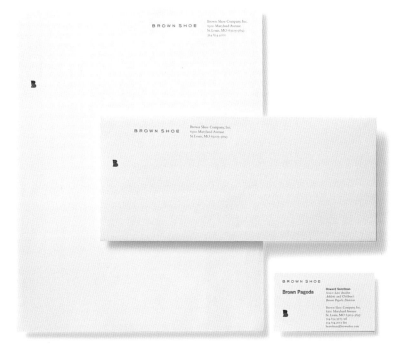

[top—left] *Brown Shoe needed a launch kit to introduce the new identity to its shareholders. Cleverly packaged in a shoebox, the kit included a t-shirt; footcare products; a "Be Smart" card summarizing the logic behind the name change; a "Be Together" card listing all of Brown Shoe's brands; and a series of "Be" stickers incorporating upbeat photo images.*

[middle & bottom] *Corporate collateral included stationery and business cards, as well as a graphic standards manual. To help ensure the identity is applied consistently throughout the company, the wirebound standards manual includes disks that provide electronic versions of the logo and document templates.*

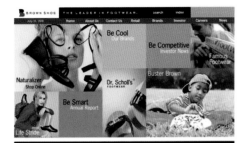

Putting the Best Foot Forward

Kiku Obata was also assigned to develop a launch kit for the annual share-holders' meeting, where the new name and identity were up for approval. To complement the logo and further the fashion-forward message, designers commissioned a series of upbeat, fashion-oriented photographs that are accompanied by taglines playing on the "B" theme: ("Be Real. Be Cool. Be Happy. Be Together. Be Ready."). The images form the core of the launch promotion, print ads, brochures, Web site design, and other materials developed around the new identity.

The photos, says Obata, add depth to the new image. "Corporate identity is not just about a logo. It's a whole look and feel, as well as a brand voice and attitude. All these elements must work together to communicate the brand image."

Obata's team applied the logo to stationery, signage, and a graphic standards manual that includes electronic versions of the logo, letterhead, fax and memo sheets, and other applications. They also created tradeshow booth and point-of-purchase concepts for the company's newly renamed children's' division, Buster Brown & Co.

Wiley says the new identity has helped the company sharpen its focus, both internally and externally: "It has given us a clear vision of who we are, and how to present ourselves to the world. It brands us as stylish, but timeless." ∎

[above] *The Brown Shoe Web site borrows the look and feel of the new identity, promoting a lifestyle-based image and emphasizing the company's many popular brands.*

[right] *Promotional materials for a national footwear convention emphasized the kid-focused identity developed for the Buster Brown division. The "Bucket of Worms" kit, complete with gummy worms, was designed to entice recipients to the Buster Brown tradeshow booth.*

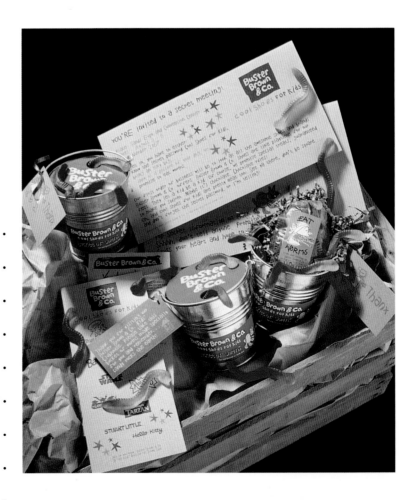

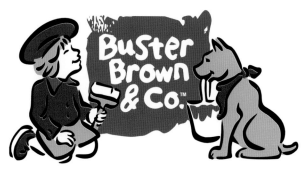

The Kids' Division of Brown Shoe

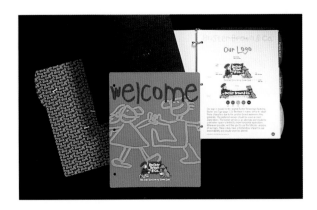

Brown Shoe Company

B

BROWN SHOE CO

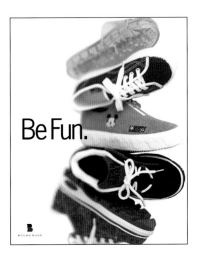

Be Fun.

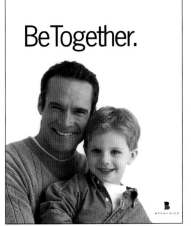

Be Together.

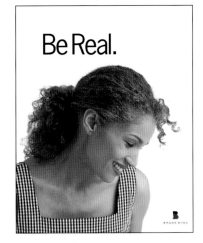

Be Real.

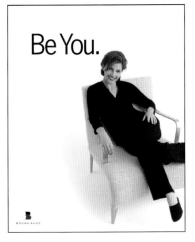

Be You.

[above] *The final three, more refined concepts included three distinct approaches: type only (top), with a symbol (middle), and with the "B" prominent (bottom).*

[above—left] *Kiku Obata also developed the logo for the newly renamed children's division, Buster Brown & Co. A separate graphic standards guide (second from top) addresses the colorful palette and whimsical images used for the kids' brands.*

[bottom—left] *Ads placed in footwear industry magazines position Brown Shoe as not just a footwear company, but a fashion and lifestyle leader.*

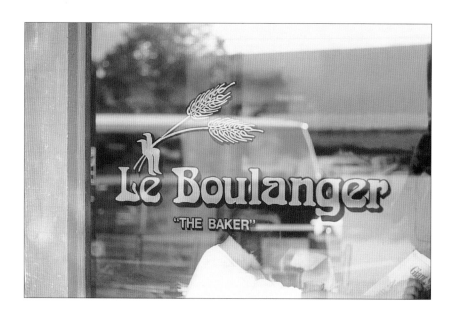

LeBoulanger

A Bay Area bakery chain keeps its identity fresh to encourage growth.

When LeBoulanger, a Sunnyvale, California-based chain of bakery cafes, began work-ing with Tharp Did It in 1991, its owners had already found a recipe for business success. But they knew their small chain needed a strong visual identity to position it for future growth. So Tharp Did It (Los Gatos, California) created an award-winning logotype, packaging design, and signage solutions that helped LeBoulanger expand from seven to twenty-one stores by 2000.

[right] *(Before) The original LeBoulanger logotype and packaging, circa 1981, was designed by the owner. By 1991, the chain had grown to seven stores, but needed a strong visual identity to keep it growing.*

[opposite page] *(After) Seven years after Tharp created the first identity, LeBoulanger needed a fresh look. Tharp Did It designed a grid system inspired by Dutch painter Piet Mondrian and set text blocks and new pen-and-ink product illustrations within it. The new design also features "The Baker" more prominently.*

Seven years after Tharp created the identity, LeBoulanger's owners decided it needed updating, and turned to Tharp Did It again to help guide the evolution of the brand. "This identity had been phenomenally successful for us, and we didn't want to lose any of the equity we had established with it," notes Ray Montalvo, LeBoulanger's director of marketing and retail operations. "But to keep growing, we knew we needed to look fresh and modern to our customers."

A Smooth Transition

With new competitors arriving in the bakery cafe market, LeBoulanger needed a visual identity that would keep it ahead of the pack. While the bakery chain's executives were rethinking store interiors with an eye toward tweaking the existing color palette, the stores' menuboards also came under scrutiny. LeBoulanger asked Tharp Did It to redesign them, and soon realized that pack-aging and print communications should follow suit.

Client: LeBoulanger Bakery Cafes, Sunnyvale, California

Ray Montalvo | director of marketing and retail operations

Design Team: Tharp Did It, Los Gatos, California

Rick Tharp	principal, designer, writer, illustrator
Jana Heer	designer
Jean Mogannam	designer
Gina Kim-Mageras	designer
Nicole Coleman	designer
Cheryl Laton	designer
Kasumi Ito	designer
Ken Eklund	writer
Ray Montalvo	writer
Jim Barnes	writer
Don Weller	illustrator

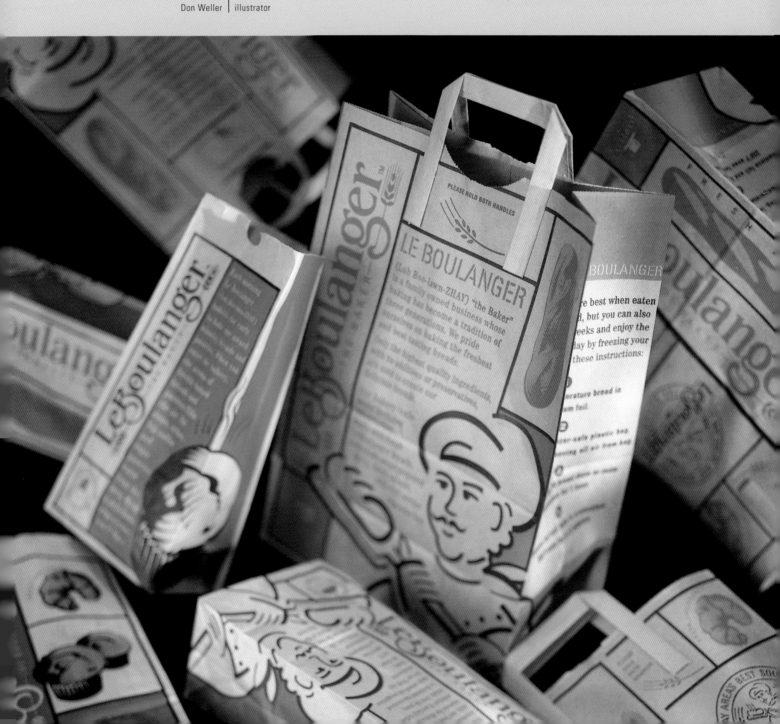

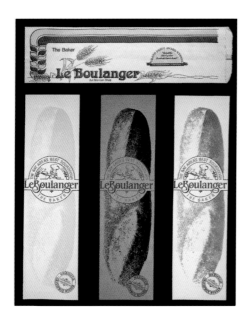

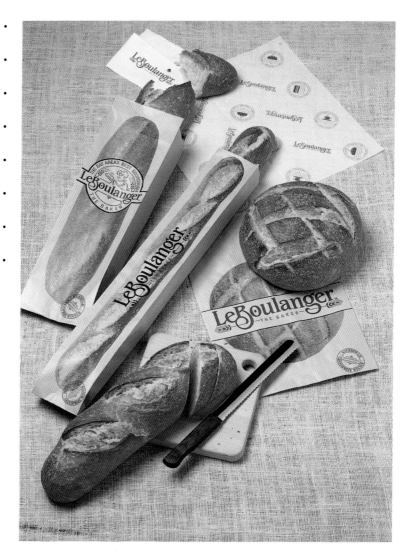

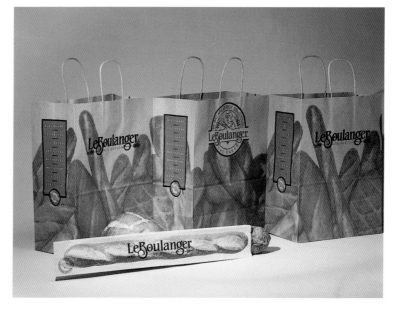

[above] *The original LeBoulanger packaging (top) used the owner's design. Tharp Did It's 1992 designs (above right) put more emphasis on the bread itself.*

[right] *For the 1992 identity, Tharp Did It designed custom-sized bread bags to fit LeBoulanger's varying products, as well as business cards and other marketing collateral. Mouth-watering mezzotint illustrations encouraged customers to buy.*

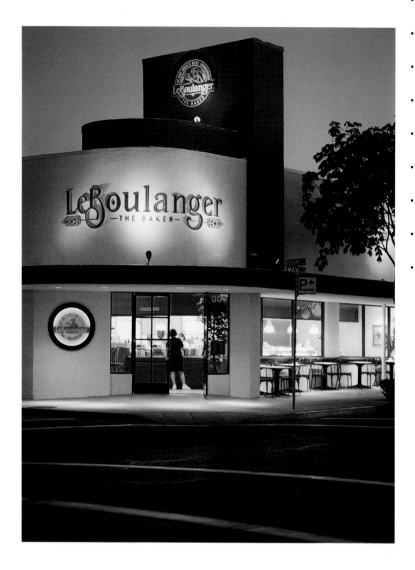

To keep costs down, LeBoulanger planned to roll out the new identity over a period of a few years, replacing packaging and promotional materials as supplies of the old ones ran out. So the new identity needed to blend harmoniously with the old one. Ideally, it would add a new dimension to LeBoulanger's brand message, but still complement the original graphic elements in place at the twenty-one stores.

"We also didn't want to alienate our existing customers with radical changes," notes Montalvo. "Sometimes when people see a new logo, they assume there's been a change in ownership, or even worse, that the product has changed in some way. We didn't want to send that message."

In With the Old (and New)

Tharp's team began by focusing on promotional, non-permanent elements of the program, such as shopping bags and other packaging, print ads, brochures, and take-out menus. LeBoulanger's existing hand-drawn emblem, which features the LeBoulanger "baker man" and the tagline "The Bay Area's Best Sourdough" in a custom typeface, was one element that needed to stay, says Rick Tharp, design firm principal. "So much equity had been gained over the

[above—left] *Suburban stores (top right) sported dimensional versions of the bread bag and loaf, while Tharp Did It designed a more subdued signage and lighting scheme for this store in historic Los Altos, California (top left).*

[above—right] *The LeBoulanger logotype, created in 1992, is still in use, but designers freshened its appeal by applying it on packaging vertically instead of horizontally.*

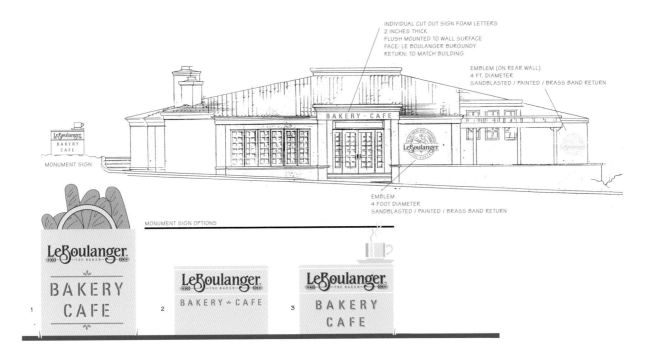

INDIVIDUAL CUT OUT SIGN FOAM LETTERS
2 INCHES THICK
FLUSH MOUNTED TO WALL SURFACE
FACE: LE BOULANGER BURGUNDY
RETURN: TO MATCH BUILDING

EMBLEM (ON REAR WALL)
4 FT. DIAMETER
SANDBLASTED / PAINTED / BRASS BAND RETURN

MONUMENT SIGN

EMBLEM
4 FOOT DIAMETER
SANDBLASTED / PAINTED / BRASS BAND RETURN

MONUMENT SIGN OPTIONS

LeBoulanger. THE BAKER
BAKERY CAFE
1

LeBoulanger. THE BAKER
BAKERY ~ CAFE
2

LeBoulanger. THE BAKER
BAKERY CAFE
3

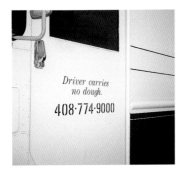

Driver carries
no dough.
408·774·9000

[above—top] *New stores, which LeBoulanger plans to add at the rate of two per year, will feature a new signage program. Tharp Did It designed emblem signs and three options for monument signage.*

[above—bottom] *Bread trucks were outfitted with simple applications of the identity. Tharp Did It's signature humor is evident in the "Driver carries no dough" message on the truck door.*

[right] *Takeout and catering menus show how the elements work in the grid. Because most of the chain's twenty-one stores would not be remodeled immediately, Tharp Did It kept the existing color palette of dark green and burgundy so that new packaging and print applications would match store interiors.*

years with [the] use of this emblem that there was no consideration of its redesign," says Tharp. "It has served LeBoulanger well over the years and customer recognition was important."

Tharp's design explorations focused on ways to increase LeBoulanger's iconic vocabulary and reenergize the familiar elements by presenting them in new ways. While concentrating on the messaging hierarchy for the store menuboards, the team devised a grid system inspired by the work of 20th Century Dutch painter Piet Mondrian. In the modular system, the LeBoulanger symbol is used vertically instead of horizontally, and the "baker man" character plays more prominently. Text messages and new pen-and-ink product illustrations are inserted into the grid in a playful yet defined way that breathes new life into the familiar graphic elements.

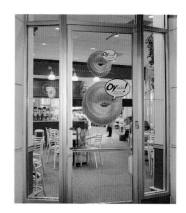

The modular grid system and the kit of illustrations also allow for easy application to LeBoulanger's Web site, company newsletter, print advertising, and point-of-sale materials.

Staying Power

LeBoulanger's new packaging system and menuboards have been installed at all of its stores, and new stores will feature coordinating interior decor. Some existing stores are being remodeled with new crown moldings, tiles, and other elements that coordinate with the identity system, says Montalvo. Meanwhile, LeBoulanger is following a "conservative" growth plan of two new stores per year.

If Tharp's first identity design is any indication of success, LeBoulanger will get plenty of mileage out of the updated system. In place a couple of years now, the system "hasn't gotten tired," says Montalvo. "Mondrian's grid is timeless, and I think our identity is also timeless."

By working with Tharp Did It, adds Montalvo, LeBoulanger has learned that paying close attention to the brand is crucial. "Over the years we've worked hard to maintain and refine our identity, and we pay just as close attention to it as large businesses like IBM and Nike. By holding it close and protecting it as much as possible, we make sure that customers recognize us and keep coming back." ■

[above] *When LeBoulanger added bagels to its offering, Tharp Did It designed in-store point-of-sale displays featuring an "Oy la la!" tagline and a slightly anthropomorphized bagel.*

[left] *Custom coffee packaging and coffee mugs follow the Mondrian-like grid.*

OFFICE PAVILION
SAN DIEGO

Office Pavilion San Diego | **A Herman Miller dealership's identity is inspired by the designs of Charles and Ray Eames.**

In 1994, when Vicky Carlson purchased an existing Herman Miller dealership in San Diego, she had her own very strong ideas about the way the business should be run and promoted. But for the first few years after the purchase, she focused on getting to know the market and avoided making drastic changes that might panic existing vendors and alienate customers.

[above] *The final brand mark for Office Pavilion San Diego (OSPD) connects visually with the Eames work as well as with the logos of Herman Miller and the national Office Pavilion network. The McCulley team chose the typeface Insignia for its rectangular, architectural letterforms.*

When the lease expired on her original building and she determined that a new, larger space was needed, it was Carlson's golden opportunity to make the statement she had always wanted to make. "Now was the time to tell everyone who we are and why we're different," says Carlson. She retained the design services of The McCulley Group (Solana Beach, California) to help make her vision a reality.

The McCulley Group's charge was to help Carlson create a strong visual identity within the San Diego design community, and in particular, to leverage the Herman Miller/Office Pavilion heritage and design aesthetic. McCulley was not only to create a corporate identity program, including a brand mark and supporting collateral, but was also commissioned to create the actual store environment from the floor up.

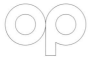 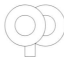

 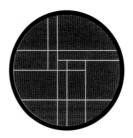

Client: Office Pavilion San Diego

Vicky Carlson | president/owner

Design Team: The McCulley Group, Solana Beach, California

John Riley McCulley	principal in charge
Ane Rocha	project manager, interiors
Julia Spengler	project manager, graphics
Jaime Laurella	interior designer
Gretchen Leary	graphic designer
Alan Robles	environmental graphic designer

[above] *Birth of a Symbol: The McCulley Group began logo explorations by focusing on the "O" and "P" letterforms, then placed them on a grid and experimented with their intersections. Influenced by the work of Charles and Ray Eames, particularly their famous Case Study House #8, they began to place more emphasis on the grid itself rather than the letter-forms. They chose colors similar to the Eames house's DeStijl-influenced palette.*

Before the transition, the dealership had little or no corporate identity of its own, says John McCulley, principal in charge. Its graphic identity followed an older logo used nationally by other Office Pavilion stores, and its three-dimensional identity was disjointed and inconsistent. "Our opportunity was to build an entire corporate identity from the ground up that would mold the culture of the company and communicate its core values to employees, customers, and stakeholders at every point of contact," McCulley relates.

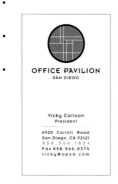

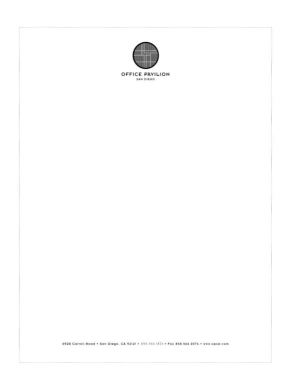

[above—left] *The front and back sides of the business card show how the new brand mark coexists with the existing Office Pavilion logo.*

[above—right] *OPSD's stationery features the brand mark and screened-back gridlines that reinforce the Eames influence.*

[right] *Designers encircled product icons in the same bold black circle as the brand mark.*

 TABLES

 OFFICE CHAIRS

 SEATING

 LIGHTING

 CASEGOODS

 SYSTEMS

 ACCESSORIES

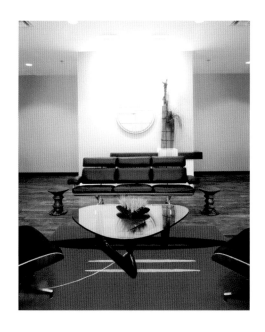

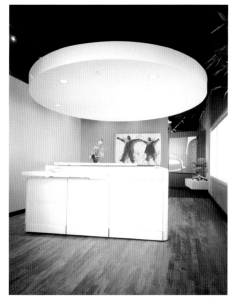

The Vision

Carlson envisioned a space that represented the Office Pavilion ideals of design, function, service, and attention to detail. Her dream store would be the ultimate working showroom, a model for the progressive workplace. "I wanted a space that's up-to-date but not trendy, beautiful but functional, and most of all, that says who we are and what differentiates us from the competition," Carlson explains. "It should be less about furniture than it is about our culture, how we work together as a team, and the things that motivate us."

Carlson had always been a fan of Herman Miller and of Charles and Ray Eames, the husband/wife team whose furniture designs are at least partially responsible for Herman Miller's heritage of great design. Adapting World War II research on materials and processes to furniture manufacturing, the Eames designed mass-produced pieces that were less expensive and more accessible to the general public.

As the McCulley team began design explorations for the graphic identity, they were inspired by the shapes, forms, rhythms, and colors in the Eames' work, particularly the front door and windows of the Eames' famous Case Study House #8. Early logo explorations focused on the letterforms "O" and "P" and the interplay between them when they were placed on a grid, says Julia Spengler, McCulley's project manager for graphics. But as the design evolved, "We began to take inspiration from the Eames house, which was built on a strict grid system. Eventually we placed more emphasis on the grid itself rather than the letterforms," says Spengler.

[left] OPSD's main lobby features a white-on-white resin plaque of the brand mark. More gallery than retail store, the showroom was designed as a model for the progressive workspace.

[middle] A circular soffit over the reception desk (also a Herman Miller product) reinforces the circular motif of the brand mark. The photograph behind the desk is of Charles and Ray Eames.

[right] Circular references continue on the showroom floor. A system of frosted-Plexiglas panels (background) displays product graphics and can be easily snapped in and out of a ceiling- and floor-mounted cable system.

To define the symbol and provide a visual connection to the Office Pavilion and Herman Miller identities, the McCulley team encircled the grid and chose red and black as its primary colors. They added yellow for the gridlines and chose blue for the middle square, echoing the Case Study House's DeStijl-influenced color palette. Finally, they paired the new brand mark with the company name set in Insignia Regular, a typeface chosen for its rectangular, architectural letterforms.

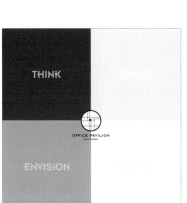

[above—top] *The "president's lounge," with its distinctive striped-wood floors, is the ultimate combination of form and function. "The work environment tells you a lot about the company, and when customers step inside our door, they know we practice what we preach," says OPSD president/owner Vicky Carlson.*

[above—bottom] *Product display graphics echo the Herman Miller design aesthetic as well as the new OPSD identity.*

[right] *OPSD's new 8½x8½-inch (22x22 cm) marketing brochure focuses not on furniture but on the store's culture and business philosophies. "Customers were blown away by it," says John McCulley, design firm principal in charge.*

Bringing it to Life

To support the brand mark, McCulley Group designed a collateral system that includes business cards, stationery, a marketing folder, service "cut" sheets, and a marketing brochure that focuses more on emotions and philosophy than it does on product. "Vicky wanted to talk about her culture and how they work with people, not about selling product," says McCulley. "Customers were blown away by it."

As the design team was creating a two-dimensional brand, it was also designing the three-dimensional store environment and the OPSD's Web site (www.opsd.com). "The graphics and space planning both influenced each other," notes McCulley. "The forms in the showroom are very monolithic and geometric, and there are numerous references to the grid."

More of a gallery than a retail space, the showroom is architecturally understated so that the products can take center stage. Circle motifs recalling the new brand mark are everywhere, from suspended circular ceiling soffits that define space, to designs in the custom carpeting. To identify product lines and help guide visitors through the showroom, the McCulley team devised a graphics system of frosted-Plexiglas panels that can be snapped in and out of floor-and ceiling-mounted cable supports.

Making a Difference

Carlson is thrilled with the identity and with the results she's seen since the new showroom opened. Sales increased from $17 to $24 million in the partial year since the new identity was launched, and the showroom's close rate is ninety percent (ninety percent of those who visit the space actually purchase a product.)

"Design is important because it helps us tell our story," Carlson notes. "The work environment tells you a lot about the company, and when customers step inside our door, they know we practice what we preach." ■

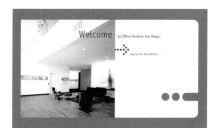

[left] *The OPSD Web site (www.opsd.com) uses the same graphic elements found in the brand mark and print collateral. To simulate the experience of "entering" the showroom, the McCulley Group created Flash animation that features the logo expanding so that its central square becomes the portal through which users enter the site.*

Ameritrade

An online brokerage firm breaks new ground, again, with its corporate identity.

Ameritrade Holding Corp. might best be known for breaking new ground. Established in 1971, as a local investment-banking firm, it was one of the first companies to offer discount brokerage following the deregulation of its industry in 1975. In 1988, it was the first to offer automated touch-tone telephone trading, and in 1995, it pioneered the use of portable communication devices for trading. Ameritrade was also one of the first brokerages to offer online investing and, more recently, is known for its break-through $8-per-trade pricing on the Web.

[above] *(Before) Ameritrade's existing logo was typical of its competitors in the financial services industry. Its new identity needed to break away from the look of others in this category.*

[opposite page—bottom] *In the refinement phase, Interbrand designers honed in on the cursor symbol as a simplified representation of Ameritrade users' point of contact with its service. The "energy bars" physically represent what happens when users click on it, and more metaphorically, rays of inspiration or power. The arrow, tilted at about 45 degrees also recalls Ameritrade's "A" or a pyramid or mountain.*

When the Omaha, Nebraska-based firm acquired two other e-brokerage firms in 1997, and combined their services to create the Ameritrade brand, it needed to establish a high profile in the marketplace. Ameritrade needed a strong, but flexible, brand identity that would work equally well in print, television, and Web applications, and one that could grow with the company as its online business took off.

The company chose Interbrand (New York) to build the strong visual foundation it needed to wow the market. "Their goal was to create a highly visible brand and they were prepared to put advertising dollars behind it," notes Kris Larsen, managing director of Interbrand's Chicago office, which handled the project.

Ameritrade®

 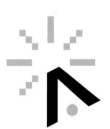 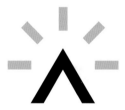

Client: Ameritrade Holding Corp., Omaha, Nebraska

Anne L. Nelson	vice president of marketing and product development
Tim Smith	director of advertising and branding

Design Team: Interbrand, Chicago

Kris Larsen	executive strategic director
Ronald Bielski	director, brand strategy
Stephen Bass	creative director
Derek O'Connor	creative director
Kyle Boynton	design director
Andrew Lincoln	consultant
Constanza Pardo	consultant
Troy Lindley	designer

[above—top] *The new mark and logotype were designed to be used together initially, but designers hope the mark will eventually stand on its own. The simple, geometric symbol works well in a wide range of sizes, from small Web banners to television and direct mail.*

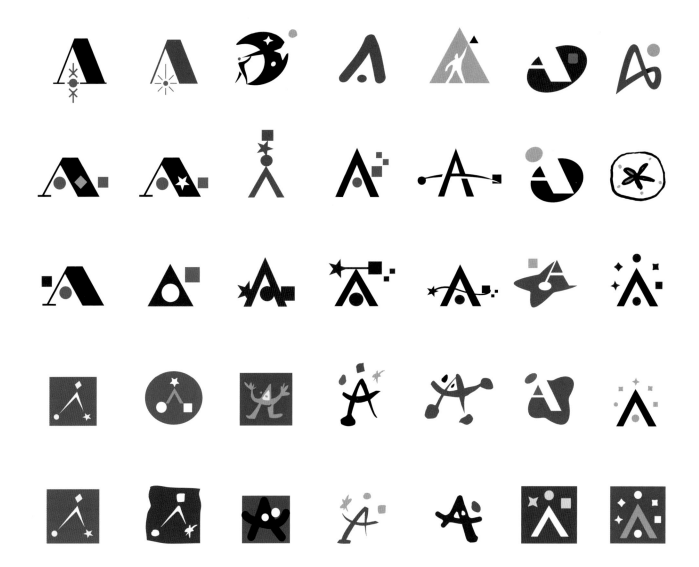

Distilling the Message

As Interbrand interviewed management and analyzed Ameritrade's business strategies, the company's brand message became very clear, says Larsen. Ameritrade had decided to differentiate itself based on value, and its $8-per-trade pricing on the Internet was very successful in setting it apart from competitors.

But value was not Ameritrade's only brand proposition. The company also wanted to emphasize the ease of use offered by its online services, as well as the speed at which investors could access their accounts. Value, speed, and ease of use became the "brand positioning pillars" the Interbrand team used to build the identity. Supporting these pillars, explains Larsen, were Ameritrade's passionate convictions about the power of the individual and the value of time. Ameritrade's messaging needed to focus on creating value by exceeding customer expectations, increasing speed by respecting customers' time, and optimizing customers' experiences by respecting their individual needs.

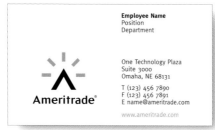

On the Mark

Once the client had approved Interbrand's branding strategy blueprint, the team began to explore ways to express the brand visually. The design exploration included an extensive audit of competitors' identities, says Stephen Bass, Interbrand's creative director on the project. "We looked at colors, logos, symbols, and messaging to determine who was trying to own what portion of the category." The team noticed a tendency for competitors to use "blue-chip" colors and iconography, and realized that Ameritrade needed to set itself apart from these more traditional approaches.

The design team created wordmarks and logotypes exploring the Ameritrade name and experimented with symbols that could work hand in hand with it. Among fifty or sixty initial concepts were abstracted Internet symbols, a bridge, and images that addressed Ameritrade's ease of trading. The team narrowed the list to eight or ten before presenting them to the client along with mock-ups that simulated various applications.

Based on feedback from the Ameritrade team, Interbrand took two or three logos back to the drawing board for refinement, including one concept that visually represents the point of contact for Ameritrade users—the cursor symbol. "It immediately became a metaphor for the point of contact between the user, the machine, and the marketplace," explains Larsen.

Moved to almost a 45-degree angle, the simplified arrow symbol resembles an "A" (or a pyramid or mountain) surrounded by "energy bars" representing what happens when you click it. "It's open to interpretation, but not confusing," Larsen adds. "It's an identity that's been refined and simplified to one symbolic element."

[above] *Letterhead and business cards were among the first applications for the new identity, but it came to life in a wide range of media, from television to direct mail and, of course, the Web.*

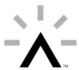

Creating & Protecting the Ameritrade Brand

Ameritrade Brand Mark Usage Standards September 2000

[right—top] *When the Ameritrade identity began to suffer from inconsistent use, the company asked Interbrand to develop a detailed standards guide. The Ameritrade Brand Mark Usage Standards were sent to Ameritrade staff and agencies on CD-ROM.*

[right—middle] *Departing radically from the starchy, conservative looks of Ameritrade's competitors, Interbrand chose an arresting color palette of orange and black. Ameritrade's standards guide details how the color should (and should not) be used.*

[right—bottom] *The Ameritrade identity includes only one typeface: Meta. Clean and modern, but not trendy, it reproduces well in print and on computer screens. When Meta is not available (HTML, for example), Interbrand specified using Arial.*

Using the Ameritrade Orange

Orange is distinct to Ameritrade within it's category, and as such is a valuable asset that should be used sensitively and carefully.

A new orange (Pantone 021C) has been chosen to better represent the orange of the Web based offering, and to make the halo of the Symbol more pronounced.

When using the color, the general principle is less is more. As a splash of color that is largely restricted to the halo of the Symbol, it appears more special, and actually has more impact because of it. The other corporate colors (black, white and gray) and the Supporting color palette have been chosen to ensure that the distinctiveness of the Orange can always be preserved.

less is more

The total area of orange should not exceed the amount shown in the Color Proportion sections of these Standards.

The Ameritrade Orange should never be used as a tint. Always pay particular attention at the production stage of any job to ensure that the Ameritrade Orange is as close a match to Pantone 021C as possible (on uncoated paper stock, match to Pantone 021U).

The Ameritrade Typeface

Typography is an important tool in building a distinctive and unique brand identity. The Ameritrade system uses one font, Meta. It has been chosen to communicate clarity, no-nonsense value and speed. It is modern (but not so 'trendy' it will date quickly), clean and works very well across all media, from print to web.

Having one corporate font clarifies communications, but does not have to be limiting; by exploring color, composition and scale, this one typeface can express a wide range of messages for many different audiences.

Meta Bold (italic available)
ABCDEFGHIJKLMNOPQRSTUVWXYZ
abcdefghijklmnopqrstuvwxyz
1234567890

! @ # $ % ^ & * () _ + } { " : ? ›
‹ œ ´ ® †¥¨^ø "'æ…© ƒ ß å ff
ç ˜µ ffi º ~ ≠ º ª • ¶ § ¢ £ ™ ¡

Meta Normal (italic available)
ABCDEFGHIJKLMNOPQRSTUVWXYZ
abcdefghijklmnopqrstuvwxyz
1234567890

! @ # $ % ^ & * () _ + } { " : ? ›
‹ œ ´ ® †¥¨^ø "'æ…© ƒ ß å ff
ç ˜µ ffi º ~ ≠ º ª • ¶ § ¢ £ ™ ¡

Meta

Meta

In instances when Meta is not available (HTML for example) please use **Arial**. Use **Times** for letter body text.

Meta can be purchased through FontShop International
Meta ©1994 Markus Hanzer for FontFont release 12.

Bass says the mark's simplicity served other purposes as well. In 1997, with Web-based graphics technology still evolving, designers had to create a mark they knew would reproduce crisply on the computer screen. "You don't know whether someone is going to be viewing this on a 21-inch (53 cm) monitor or a Palm Pilot, so you want to make sure it looks good in every situation. If it didn't work well on the screen, it wasn't the right logo for them."

It was an unorthodox symbol for the financial services industry, but again, Ameritrade was willing to break new ground. So the design team paired it with Meta, a clean and contemporary typeface, and rejected the conservative color palettes favored by Ameritrade's competitors. They chose a rather edgy orange and black that Larsen calls "fun, friendly, and approachable, but with flair." The team later added dark blue to fill out the palette.

An Eye to the Future

One of the project's main objectives was to produce a mark that could work well in a wide range of applications, from television ads to the Internet to printed brochures and direct mail. To ensure that the mark would be used consistently, Ameritrade asked Interbrand to develop detailed visual identity guidelines to help Ameritrade staff and agencies make brand-wise decisions when applying the identity.

Once the mark was adopted, Ameritrade committed a huge budget to marketing its new identity. The company grew exponentially during the next three years, with a 600 percent increase in revenues from 1997 to 2000, and a 400 percent increase in market capitalization during the same period.

In 2000, Ameritrade asked Interbrand to develop a brand definition study that would provide a living blueprint for the growth of the brand. Rounds of research consolidation, management interviews, customer experience studies, and reviews of existing positioning work resulted in a "brand essence" document based on the value, speed, and ease of use positioning pillars.

With an eye toward the future, Ameritrade also asked Interbrand to develop a brand architecture model that encompasses a naming strategy for new and future acquisitions and a migration program to leverage new subsidiaries' existing brand equities. Using the "masterbrand model," Ameritrade will be able to effectively shepherd the brand through the company's growth and ensure the brand message stays clear.

"Creating a great identity is only a starting point," notes Bass. "It has to be protected and evaluated frequently so that it stays relevant. As the brand category takes advantage of the trails blazed by frontrunners like Ameritrade, you sometimes need to revisit the brand and ensure that it still has an edge." ∎

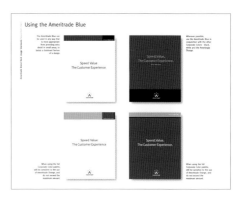

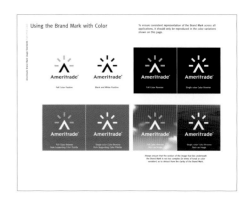

[above—top] *Ameritrade's Web site reflects the look and feel of the new identity.*

[above—middle & bottom] *Interbrand added dark blue to the Ameritrade palette (middle) and provided detailed guidelines about how the brand mark could be used with color (bottom).*

Equity Marketing Inc.

A toy company learns to have fun with its identity.

Equity Marketing Inc. may be best known for the wildly popular collectible toys it designs and markets for Burger King, Arby's, and other fast-food chains. Founded in 1983 in a New York loft, it had achieved phenomenal success by the mid 1990s, when it added a division selling toys directly to consumers. But its old identity looked too "corporate" for the company it had become. Equity needed a fresh new image to reflect its expanded horizons.

[above] *(Before) Equity Marketing's old identity looked very corporate and bore little visual reference to a toy company.*

Kim Thomsen, Equity's chief creative officer, had seen the work of Redding, Connecticut-based Alexander Isley Inc., and liked what she saw. "He wasn't one of those designers who had a specific look and feel that he layered onto whatever he was working on at the time," notes Thomsen. "His work was varied and fairly conceptual, and most important, a little 'bent,' which is what we needed."

Multiple Messages

Equity knew its corporate identity needed to say more about the company than its slightly stodgy name did. "We needed to counterbalance the seriousness of our name with something playful, fun, smart, and hip," Thomsen says. The identity also had to speak to three very divergent audiences: the film and television studios Equity works with in licensing and designing toys, the investment community, and children. And it would have to look good in many different applications, from letterhead to animation and packaging.

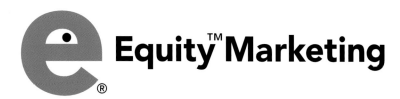

℮ Equity™ Marketing

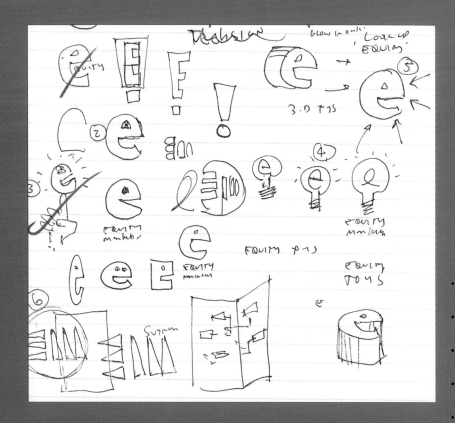

[above] *(After) The "e" is custom drawn based on the typeface Avenir, which itself is a redrawing of Futura, says Isley. "It's got a nice chunky quality, round and childlike in the best sense of the word." The dot in the middle transforms the mark into a character representing Equity Marketing.*

[left] *Alexander Isley explored several approaches for the new symbol, including using "equity" as a prominent feature. His sketches quickly veered toward making the "e" the most defining element.*

Client: Equity Marketing Inc., Los Angeles, California
Kim Thomsen | *vice president of marketing*

Design Team: Alexander Isley Inc., Redding, Connecticut
Alexander Isley | *principal/creative director*
Charles Robertson | *senior designer*
Aline Hilford | *project director*

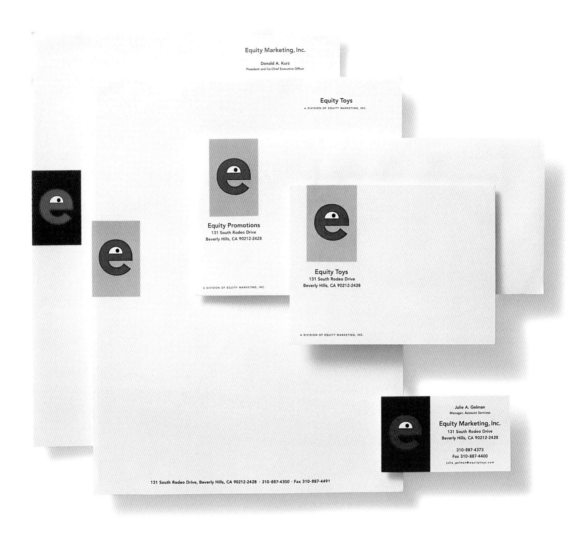

Equity Marketing, Inc.

Donald A. Kurz
President and Co-Chief Executive Officer

Equity Toys
A DIVISION OF EQUITY MARKETING, INC.

Equity Promotions
131 South Rodeo Drive
Beverly Hills, CA 90212-2428

A DIVISION OF EQUITY MARKETING, INC.

Equity Toys
131 South Rodeo Drive
Beverly Hills, CA 90212-2428

A DIVISION OF EQUITY MARKETING, INC.

Julie A. Gelman
Manager, Account Services

Equity Marketing, Inc.
131 South Rodeo Drive
Beverly Hills, CA 90212-2428

310-887-4373
Fax 310-887-4400
julie.gelman@equitytoys.com

131 South Rodeo Drive, Beverly Hills, CA 90212-2428 · 310-887-4300 · Fax 310-887-4491

[above] *Isley created a warm color palette of turquoise, ocher, and red, which is used on letterhead, business cards, and other stationery pieces.*

As he does with all clients, Isley started by asking the Equity management team to complete a simple questionnaire that would set the project's direction. It included questions such as: "How do you want Equity Marketing to be perceived in the marketplace? What are the company's strengths and weaknesses? Who are your competitors?"

"This gives us an opportunity to identify and discuss any disagreements among the decision-making team before we start designing," notes Isley. "We typically present the findings and give everyone a chance to sign off on it. It saves a lot of time in the long run."

A Mark of Character

Once the project objectives were set, Isley's task was to transform the Equity Marketing name into an easily identifiable mark, one that had more of a connection to toys and fun than the existing identity.

Isley's early concepts included visual treatment of the word "equity." Although it's a strong word, it looked awkward on its own and its letterforms didn't fit

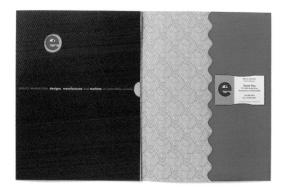

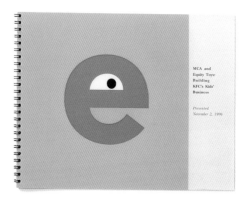

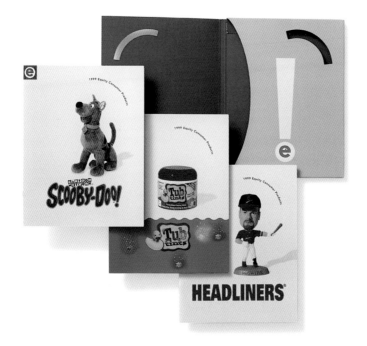

[top] The press kit can be tailored to different audiences. Various product inserts are placed inside, and custom-printed belly bands make the kit seem new for every tradeshow.

[middle] A silkscreened plastic presentation cover was kept clear on one end so that Equity can customize it for various presentation needs.

[bottom] Equity has applied the mark to everything from products to packaging and annual reports. Its 1999 Consumer Products Kit was designed to market the consumer toy division.

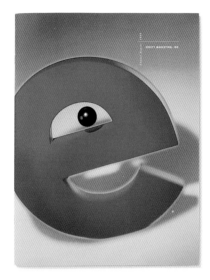

together well. Using initials didn't convey the personality the team wanted. He also explored representing the company with a stylized toy shape, but considered that too limiting. And, because Isley believes truly abstract symbols (such as the CBS eye or the AT&T globe) are only for huge companies that can afford to saturate their audiences through constant repetition to ensure the name is linked with the symbol, he steered away from this approach.

So Isley's early design explorations veered toward making the "e" the most prominent feature. Among the rough sketches he presented to his client was the final solution: a chunky sans-serif "e" with a simple but eloquent dot in the middle that transforms it into a witty, face-like symbol.

Equity management loved the symbol, both for its spirit of fun and because it worked equally well with the names of the company's two divisions: Equity Toys and Equity Promotions. It also reproduced well in various sizes and colors.

"Alex has taken something as simple as the letter 'e' and transformed it into a character, really," Thomsen says. "It's incredibly clean and graphic, and at the same time, there's this anthromorphized feeling to it. We think it's amazing."

Isley applied the new logo to stationery, using distinct colors and type treatments for the parent company and the two divisions. The "e" symbol and a colorful palette of turquoise, ocher, and red were continued in a customizable press kit used to help launch the consumer division at industry tradeshows. Isley also created a presentation format and cover as well as a card announcing the company's relocation.

Leaving Room for Fun

To guide Equity in the identity's implementation, Isley designed a two-page standards guideline that incorporates basic color and typography standards, but leaves a lot of leeway for the Equity creative staff. "It allows some room

for interpretation, which I think is fine for a company of this size with a creative staff," Isley notes. "It wouldn't work for a huge insurance company, but Equity didn't need a strict set of standards. To me, it's more important for the spirit and sensibility of the identity to be consistent, rather than uniform. It allows them to have a little fun with it."

And, they have. Equity has applied the logo to numerous applications, from product packaging to annual reports (including a memorable one that includes a moving doll's eye in the middle of the "e"), as well as the company Web site and numerous brochures. "We've been very creative with it," notes Thomsen. And, while she admits the logo has occasionally been mistreated graphically within the company, her department is generally able to function as "brand police."

Thomsen says the new identity has been an invaluable asset for Equity Marketing, whose business has continued to grow since the identity was adopted. "It's the foot you put forward in the world," she contends. "It tells the world we're smart and funny and left of center and just a bit irreverent. That's our brand personality in one simple mark." ∎

[above] Equity's Web site (www.equity-marketing.com) features the new identity in a playful way. The "eye" in the middle of the symbol roams freely, and Isley's original color palette also predominates.

[left] The Equity mark is also applied to toy packaging.

Headstrong

A high-tech consulting firm steps into the "next generation" with a hip new identity.

James Martin + Co. had been a major player in the information technology (IT) consulting business for twenty years. Its founder invented the concept of "information engineering," the methodology behind development of IT systems. In the 1990s, the firm's business model had transitioned from telling companies how to implement new systems to actually implementing the systems themselves. With this change of focus, James Martin + Co. chose to create a new identity that would reflect its leap to the cutting edge.

[above] *(Before) James Martin + Co. had been a successful IT systems consultant for 20 years, but when it reinvented itself as an e-solutions provider, it need a new name and identity to signal its leap into next-generation consulting.*

[opposite page—bottom] *To visually capture Headstrong's brand message, The Leonhardt Group experimented with concepts of heads and abstracted representations of brain power, forward thinking, and collaboration.*

But in 1999, the company undertook a three-month self-examination to assess its industry and determine its future path. Recognizing that technology is changing the way most companies do business, James Martin + Co. decided that it too should change. So it acquired several other consulting firms and almost $200 million in venture capital to reinvent itself as an "e-solutions" provider that helps Fortune 500 companies exploit the Internet and other emerging technologies.

To signal its leap onto technology's cutting edge, the company needed a new name and a strong new identity to communicate its vast knowledge base and its leadership in the market. "We also wanted a name that had impact and would evoke a reaction," notes Kevin Murphy, the company's chief creative officer. "We didn't see the point in having a name that people were ho-hum about. Even if they hated it, they would be intrigued enough to wonder about the story behind it."

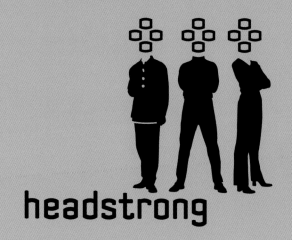

Client: Headstrong, Fairfax, Virginia

Kevin Murphy	chief creative officer
Liz Shepherd	brand launch director
Cindy Abell	senior marketing manager

Design Team: The Leonhardt Group, Seattle

Steve Watson	creative director, designer
Lesley Feldman	designer
Ron Sasaki	director client services
Sally Bergesen	brand strategist
Anne Connell	director brand development
Lesley Wikoff	productinn artist

[left] *Headstrong's new identity, three silhouetted figures with monitor heads, suggests the melding of technology, business, and people. The monitors represent the idea of collaboration.*

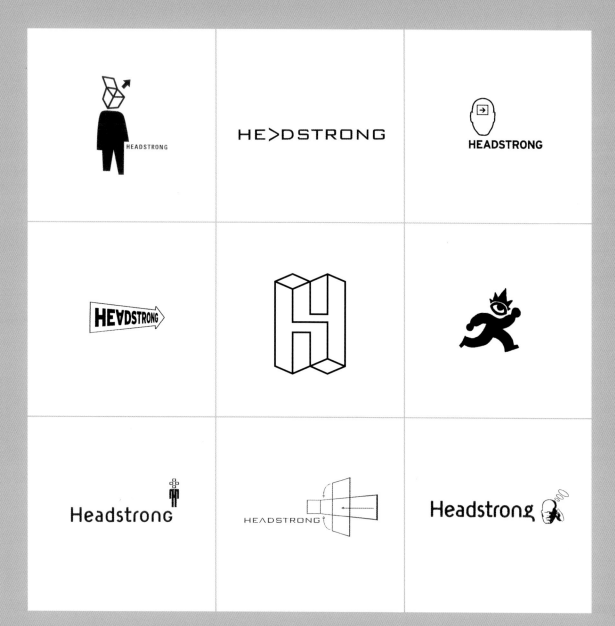

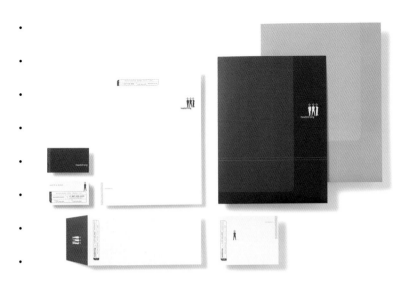

[right] *Designers added some unique touches to Headstrong's business papers. The envelope flap is black and vertically oriented. To emphasize Headstrong's global reach, a vertical time clock in the lower left corner of the letterhead is customized to individual offices worldwide.*

[below] *A Global Identity: The Headstrong executive team wanted its symbol to represent all types of its employees—men and women from various cultures around the world. So The Leonhardt Group developed an archive of fifteen different figures that can be interchanged in some applications, such as business cards. The primary set of figures includes two men and one woman. One of the men wears a barong, traditional business attire in many parts of Asia, where Headstrong has several offices and many clients.*

As part of its self-assessment project, the company had worked with The Leonhardt Group (Seattle) on an initial brand audit. They asked The Leonhardt Group to give the company a name and a face.

All in a Name

The company's competitors are Big Five consulting firms and dot-com startups, several with what The Leonhardt Group calls "ant colony" names—Sciant, Viant, and Sapient, to name a few. "With so many of their competitors having that techy, familiar sound to their names, we recognized that our client should zig to that zag and do something dramatically different," explains Steve Watson, creative director for The Leonhardt Group.

The name also needed to reflect the brand attributes of knowledge, collaboration with clients, and resilience. Another point of differentiation was the company's approach to consulting, says Watson. "There's a running joke in the business that if you hire a consultant, they'll just tell you what time it is," he explains. "That's not our client. They've been around for twenty years and they have a very broad knowledge base. And they're proud of the fact that their consultants are very opinionated. They have strong ideas about how to do things, and they aren't shy about telling their clients what they think."

The naming team kept all these attributes in mind as they generated more than 500 names during an eight-week period, and then narrowed them to ten names to present to the client. But, in the end, the naming team felt that strong opinions and a pool of brain power best characterized their client, which lead to their final selection—Headstrong.

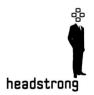

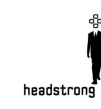

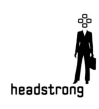

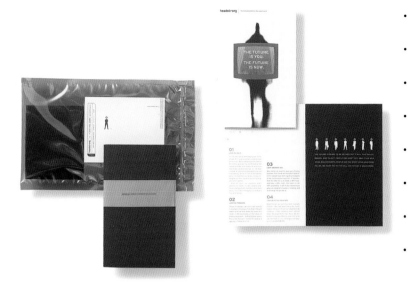

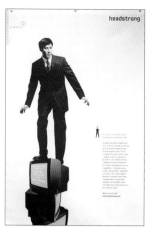

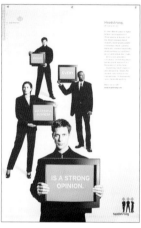

"Headstrong has very strong connotations of being strong-willed and opinionated, and it also speaks to the notion of brain power and a 'meeting of the minds,'" explains Watson. "It's a strong name for a bold, aggressive company."

The client team felt strongly about the name, but wanted to be sure it would translate well across the globe. To ensure the name played as well in China as it did in the U.S., The Leonhardt Group conducted linguistic and cultural research in sixteen languages. Headstrong passed the test with flying colors.

A Headstrong Identity

Once the name was approved, The Leonhardt Group moved on to a design exploratory phase. The team initially generated fifty or so concepts that interpreted the name along with visual treatments of its connotations, then narrowed the options to four for the client presentation.

"With that name, there were a million different ways we could approach it," recalls Watson. "We looked at the idea of a literal head, a more abstract 'techy' feel, simple logotype treatments, and visual ways to express collaboration and energy."

In the end, the team again opted toward differentiating Headstrong from its competitors. "The competition generally has this 'high tech' look, and we wanted to bring a human element into play," Watson explains. "We wanted to meld the idea of being a tech-based company with the idea that they are actual people."

[above—left] *An internal launch brochure informed Headstrong's 1,100 employees about the new identity and the logic behind it. It also introduced the Headstrong color palette: primarily black and white, with shades of metallic blue that add an appropriately "techy" feel. Digitally-inspired patterns of concentric circles and squares add to the aesthetic. Headstrong consulted with a Feng Shui expert to ensure the identity was acceptable to Asian cultures.*

[above] *As part of Headstrong's internal launch, The Leonhardt Group created a series of oversized posters that more literally translate the Headstrong identity.*

[right] *A four-minute digital movie premiered at Headstrong's internal launch party and is also used as a sales tool.*

The Headstrong executive team agreed, selecting a concept that featured a silhouetted figure of a man whose head consists of four computer monitors. The combination of a human figure with the high-tech equipment suggests the harmonious blending of technology, people, and business. "It also underscores that we're in the people business, and relationships are very important to us," notes Murphy.

The Headstrong team asked the designers to refine the concept, ultimately approving a symbol that incorporates three human figures. "As a global company, we wanted to make sure that all types of people in our organization, men and women from various cultures around the globe, are represented in the mark," explains Murphy. This desire for inclusiveness eventually produced an archive of fifteen figures that can be used interchangeably in some applications. The primary set of figures includes two men and one woman. One of the

men is clad in a barong, traditional business attire in many parts of Asia, where Headstrong has several offices and many clients.

Bringing It to Life

With the symbol approved, The Leonhardt Group continued exploring colors, type treatments, patterns, photography, and other elements of Headstrong's visual vocabulary.

Continuing the sophisticated, hip look of the silhouetted figures, black and white play a major role in the brand presentation. A palette of metallic blues and silvers adds to the "hipness quotient" and provides an appropriately "techy" feel, says Watson, yielding a rather James Bond-ish, spy aesthetic. "We never tried to hide that influence," he smiles. "The silhouettes are definitely reminiscent of James Bond movies. It's almost like we're telling a story about these hip techno-consultants who are hired to come in and turn things around."

The Leonhardt Group applied the identity to Headstrong's stationery system, created a media kit folder, a launch announcement for clients, and an internal launch brochure to help inform and sell the new identity to Headstrong's 1,100 employees worldwide. A digital movie was used for the internal launch and as a sales tool. As a backdrop for a huge employee launch party, The Leonhardt Group designed a series of oversized posters that photographically represent the new identity. They also developed the Headstrong Web site in collaboration with the Headstrong staff.

Results that Show

The success of the new identity has far exceeded Headstrong's expectations, says Murphy. "We expected some resistance both internally and from our clients, but on the whole, people are really captivated by it. Even if they don't like it right away, it's intriguing enough to them that they want to find out more."

Most important, says Murphy, the new name gives employees endless opportunities to tell the Headstrong story, and has even won the firm new clients. "When we lay our business cards down on a conference-room table, we immediately get questions about the name and the surrounding identity," he adds. "It speaks to our strengths as individuals as well as to our approach to working as a team."

One of the project's secondary objectives was to help Headstrong retain its key employees. Since the new identity was implemented, the company's attrition rate has decreased dramatically, from seventeen percent to just two percent, and "we can't stay on top of all the inquiries we're getting from potential employees, including people from our competitors," notes Murphy. "The young, hip aspect of the identity has been a huge bonus." ∎

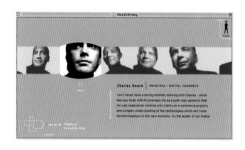

[above] *The Headstrong Web site incorporates the look and feel of the identity system. The monitors on the figures' heads do double duty as navigational tools.*

Hungry Minds

A publishing company explores the possibilities beyond its IT roots.

When IDG Books Worldwide purchased hungryminds.com, an e-learning company, in August 2000, its portfolio already contained some of the most popular book brands in the world. Its award-winning For Dummies® series had made it the world's best-selling computer books publisher, and its other titles, including Frommer's® Travel Guides and CliffsNotes®, had helped IDG carve a niche as the publisher that makes challenging topics more accessible.

[above] *(Before) When it acquired hungryminds.com, IDG Books Worldwide was the publisher of some of the world's most popular book brands, such as the For Dummies® series, Frommer's® Travel Guides, and CliffsNotes®. It had moved away from its mission of providing books on information technology, and needed a new name to signal the change.*

For IDG Books, the acquisition was one more step away from its founding mission. Established in 1990, with seed money from its parent company, International Data Group (IDG), IDG Books was created to publish books on information technology. During the advent of personal computing, IDG had pioneered the industry, publishing information technology-focused news weeklies and magazines such as *Computer World* and *PC World*. IDG Books was considered a logical extension of the mission to provide IT information to a new, computer-driven age. IDG Book's first book, the seminal *DOS for Dummies*, was the springboard for a series that has by now been translated into thirty-nine languages, with more than 100 million books in print.

But as the For Dummies series grew increasingly popular, it also expanded in focus, says Mark Mikulvich, senior vice president of strategic brand management and business development for the company. IDG Books expanded the formula to topics as far-reaching as gardening, cooking, and fishing, and soon

Client: Hungry Minds Inc., Foster City, California

John Kilcullen | ceo

Design Team: Addis, Berkeley, California

Steven Addis	chairman
Ron Vandenberg	chief creative officer
Tom Holownia	senior vice president
Suzanne Haddon	senior designer
Chris Nagle	design director
Kristine Hung	brand director

began acquiring book titles outside the IT realm. "Over the next few years, we came to define ourselves not as being solely dedicated to IT," says Mikulvich, "but as having the core purpose of enriching people's lives by making knowledge accessible."

With its acquisition of hungryminds.com, IDG gained new inroads into the distance learning market (hungrymindsuniversity.com offers up to 17,000 e-courses from top universities and subject experts). Just as important, says Mikulvich, it gained ownership of a compelling name that could also serve as the company's consumer umbrella brand.

"IDG Books was no longer the most appropriate expression of our purpose as it had evolved," notes Mikulvich. The company had been considering possible new names for months, but had not identified an appropriate name that was also trademark and Internet-available. They considered Dummies Inc., he adds, "but that was just one light on our Christmas tree. After we acquired Hungry Minds,

[above] (After) The new logo reminds us that all things are possible "when pigs fly."

Brand Positioning

Brand Essence

Knowing

[above] *The Addis Group boiled Hungry Minds' offering down to the concept of knowledge and how it empowers people to achieve their goals and dreams.*

[across top] *Based on the brand positioning, Addis developed three alternative "brand ideas" that could potentially express Hungry Minds' brand essence. "Mindmerge" (bottom) was the direction Hungry Minds opted to follow for logo explorations.*

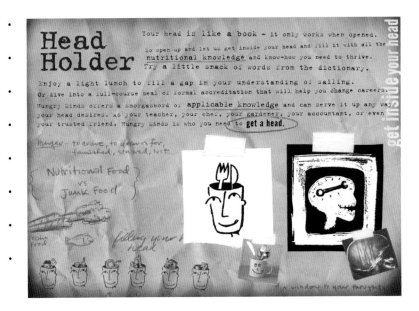

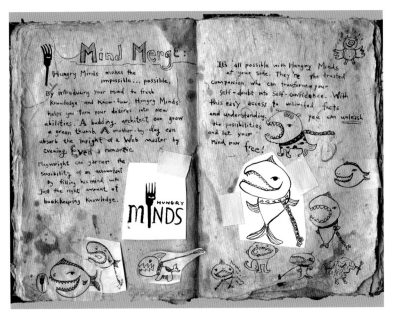

we began to realize that its name expresses our customer base perfectly—those who want their lives enriched through knowledge. And we owned the name—lock, stock, and URL."

The company called on Addis (Berkeley, California), to develop a corporate identity that would express Hungry Mind's evolved mission and reflect its ever-expanding content offering. The new brand needed to leverage Hungry Minds' established reputation in book and electronic publishing, while planting a stake in the emerging world of e-learning.

A Brand for All

The most challenging aspect of the project was to develop a provocative and ownable mark that would be appropriate for all of Hungry Mind's products—from reference material and how-to books to distance learning and accreditation. "It also needed to resonate across a wide target audience, from

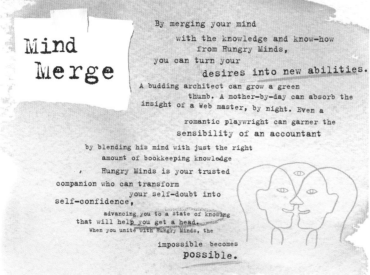

school-aged children to seniors, and from blue-collar workers to professionals," notes Kristine Hung, then an Addis brand director.

Addis started the process by analyzing existing market research and interviewing management to gain an understanding of the new brand, its competitive landscape, benefits, and attributes. Addis developed a brand positioning based on what Hungry Minds felt was its key differentiation in the marketplace: empowering people by providing knowledge that helps them achieve their goals and dreams.

Using the positioning statement and the concept of knowledge as its springboard, the Addis team developed three alternative "brand ideas" that could potentially communicate the essence of the brand. "Brand ideas move beyond the two-dimensional positioning statement and begin to define the creative range, tone, and manner appropriate for the brand," explains Hung. The brand ideas were used to inspire the Addis creative team as they brainstormed the brand's visual expression.

Making their Mark

Addis ultimately presented seven logomark designs to the Hungry Minds team,
but one quickly piqued the interest of the entire team. Based on the old saying,
"When pigs fly," the logo concept portrayed just that—a winged, gold pig fly-
ing above the Hungry Minds name. With this whimsical mark, Hungry Minds
could communicate to its audience that, with knowledge, everything is possible.

To ensure they had achieved the appropriate level of whimsy and credibility,
the Addis team refined the mark and Hungry Minds added the tagline, "It's
all possible," to reinforce the flying-pig reference. Addis offset the light-
hearted nature of the illustration with more traditional typography (a
classic-looking typeface based on Bodoni) and colors (a buttoned-down dark
blue paired with metallic gold).

"It's really the metaphorical equivalent of 'anything is possible,'" explains
Mikulvich. "It positions Hungry Minds as the catalyst that transforms the frus-
tration of 'I can't' into the confidence of 'I can' by providing appropriate
knowledge and content," he adds. "It's also fun and friendly, but communicates
stature, reliability, and trustworthiness."

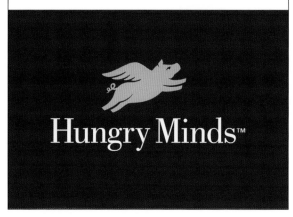

Elizabeth Collins-Chatsworth
Director of Operations

Hungry Minds
2515 Ninth Street
San Mateo, CA 94403
T 650.572.8595
F 650.572.8596
echatsworth@hungryminds.com
hungryminds.com

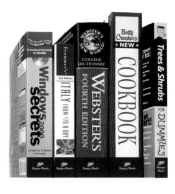

[above] *The new logo graces the spines of a wide range of books, from travel guides to cookbooks, dictionaries, and how-to guides.*

[left—top] *The final logo is a whimsical reminder of the old saying, "When pigs fly." The tagline reminds Hungry Minds' audience that, with knowledge, all things are possible.*

[left—middle] *The metallic gold logo appears on both a white and dark blue background. To balance the whimsical nature of the illustration with the credibility and professionalism Hungry Minds also wanted to express, Addis chose a slightly corporate-looking dark blue and a traditional typeface.*

[left—bottom] *On some applications, such as business cards, the new logo stands alone, without the tagline.*

To Market, To Market

Once the brand mark was approved, Addis brought it to life on stationery, templates for the company Web site, a corporate brochure, and other marketing elements. The team also produced a "Standards & Guidelines" document that defines brand architecture, typography, primary and secondary color palettes, and also illustrates the "dos" and "don'ts" of extending the mark to other applications.

Mikulvich says the new identity works well because it is aspirational, unexpected, and creates an emotional bond between Hungry Minds and its customers. "The mark was designed to be provocative and cause people to take another look," he adds. "It has also allowed us to shed the trappings of being purely an IT information company, and it doesn't paint us as just a book publisher. On more than one level, it's about unlimited possibilities." ∎

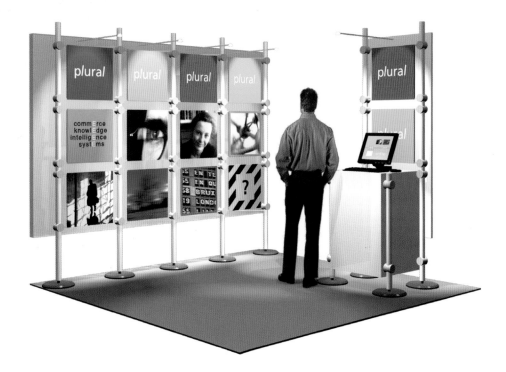

Plural | # A traditional technology company retools for the Web.

Micro Modeling Associates Inc. (MMA) was a $54 million client/server consulting business serving the financial services industry. But when it began losing clients to dot-com upstarts, CEO Roy Wetterstrom launched a bold rebranding strategy to plant its flag on the Web landscape.

MICRO MODELING ASSOCIATES INC

[top] *(After) A tradeshow exhibit prototype echoes the visible grid found in Plural's capabilities brochure. Designers envisioned a flexible, modular display system that could incorporate static or animated images.*

[above] *(Before) The company's original name, Micro Modeling Associates, was limiting because of its association with old-line technology. An interim move to MMA was a step away from the old, but didn't go far enough.*

Established in 1989, MMA was going strong a decade later as a developer of innovative client/server solutions for the financial services industry. But a shrinking market for client/server work and increasing competition—particularly from dot-coms encroaching into the market—signaled the need for change. CEO Roy Wetterstrom decided to redirect MMA's focus away from traditional client/server work and toward the digital world, creating a new Internet services, strategy, and development company.

To clearly broadcast its new mission, MMA needed a strong new name associated with leading-edge design and technology. "We needed to send a really loud message to the world that we were something new and something different," Wetterstrom recalls.

Research indicated that business-to-business customers were disillusioned with the competitors' tendency to sell "one-size-fits-all" solutions. So MMA wanted to leverage what it saw as its key point of differentiation in the market: a customized, three-pronged process that integrates strategy, creativity, and technology to develop client solutions.

Photographs: Andy Shen, New York

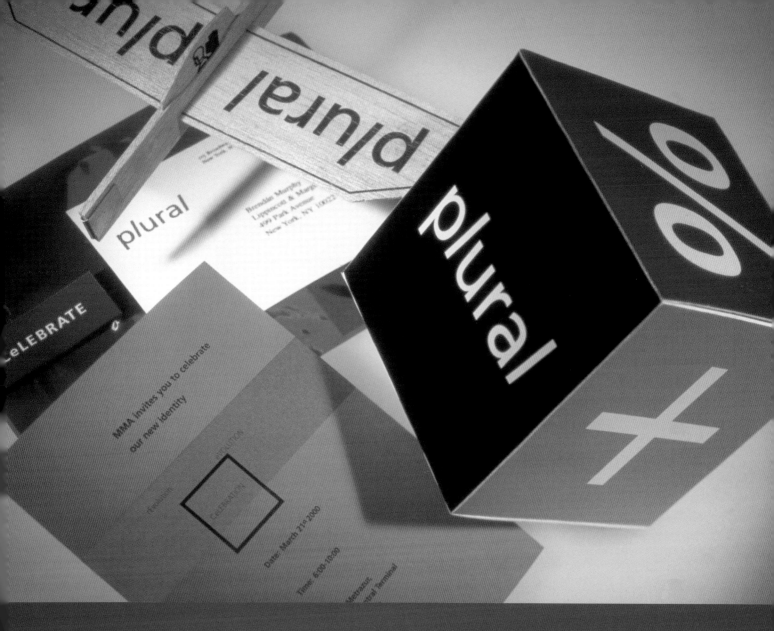

Client: Plural (formerly Micro Modeling Associates Inc.), New York

Roy Wetterstrom	CEO
William Luddy	creative director
Connie Hughes	public relations manager
Emily Litz	senior marketing specialist

Design Firm: Lippincott & Margulies, New York

Brendán Murphy	partner/design director/designer
Jerry Kuyper	senior partner, design director
Connie Birdsall	creative director
Suzanne Hogan	senior partner

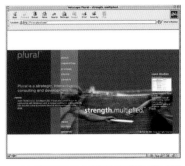

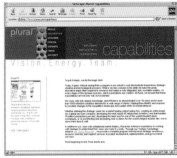

Defining a New Identity

Lippincott & Margulies (New York) was brought on to help MMA articulate a brand identity and express it in a new name, logo, and launch package. Lippincott started the process by working with MMA to identify image attributes that would express the new brand's personality. Hundreds of names were generated using attributes such as "modern," "creative," "committed," "solid," "confident," and "trusted." Finding a dot-com-available name further complicated the process, says Connie Birdsall, creative director on the Lippincott & Margulies team. "Identifying a name that describes what the company does and stands for—and that is not already being used as an Internet domain name—is a tall order these days," Birdsall explains.

Possible names were filtered through language experts, trademark lawyers, and focus groups before MMA signed off on Plural. "I like it because it means working together with our customers and with our partners," says Wetterstrom. "And I was thrilled that we could get a six-letter Internet address in English."

[above] *For its launch, Plural's Web site echoed the look and feel, organization, and messaging content established in the capabilities brochure. Later refinements integrated layered elements that underscore the plurality and interactivity themes.*

[right] *A Plural palette of orange, blue, green, red, and yellow can be used in various combinations on the logotype, letterhead, print collateral, and business cards. Plural employees each have a rainbow of cards, not just one color.*

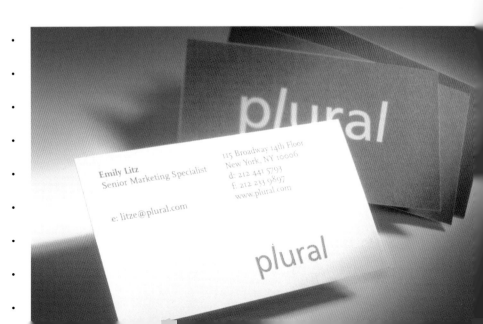

PLURAL

Plural

plural

plural

plural

plural

p|lura|

p|lura|

plural

plural

plural

plural

p|/ura|/

p|ura|

p/ura/

plural

plural

plural

p/ura/

[above] *Once they had arrived at the typeface and weight, designers tweaked the angle of the logo's two l's. Too flat an angle didn't get the point across (top), while too much hampered legibility (bottom). The middle logo was the winner.*

[left] Early explorations of the Plural logo show how different type attributes changed the personality of the name. Designers experimented with upper and lower case, italics, bold and serif and sans-serif typefaces. They also played with using double l's to recall the Internet's backslashes. "Our goal," says design director Brendán Murphy, "was to not be too dot-commy or of-the-moment."

Logo vs. Logotype

Next on the design agenda was a new Plural logotype. The team knew the logo needed to embody the spirit of client/consultant collaboration and emphasize Plural's three-pronged methodology. Since the new name was so strong, the team decided that rather than developing a separate symbol, it should embed the logotype with the desired image attributes.

The result was an elegant-but-friendly sans-serif logo based on the classic Frutiger typeface. Its two italicized l's reinforce the idea of "more than one" and are also a subtle nod toward the World Wide Web's ubiquitous backslashes. Use of lowercase letters keeps the mark friendly and is another nod to the Web, whose language is not case-sensitive. Designers created a palette of Plural colors—among them orange, blue, green, red, and yellow—that can be used in various combinations on the logo, letterhead, print collateral, and Web site.

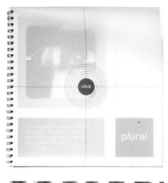

[top] *Early ideation sketches resulted in a series of concepts later translated to the Plural capabilities brochure. These preliminary "look and feel" comps used contrasting design elements and different paper textures, colors, and weights to express the idea of plurality. Designers leveraged the square and a visible grid to marry the concepts of high tech and creativity.*

[middle] *Plural's capabilities brochure targeted multiple groups (including investors, the financial services industry, and potential employees), so it was conceived as a modular kit that could be customized to its intended audience. The 9x12-inch (23x30 cm) brochure is wirebound with section tab dividers and pockets that can hold 8¹/₂x11-inch (22x28 cm) case studies.*

[bottom] *Designers created a hierarchy of information by layering different sizes, weights, and textures of paper. In the "About" section, for example, the Plural story is told on a blue half-vertical page that allows a glimpse of artwork on the mylar page behind it.*

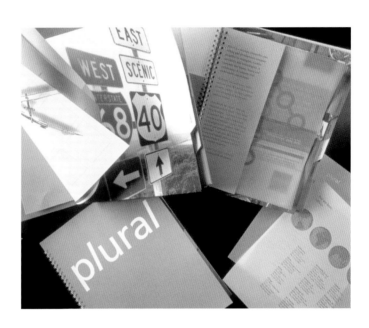

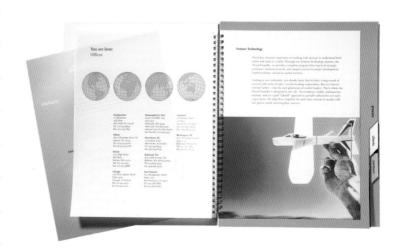

Getting the Word Out

The design team's next task was to develop a capabilities brochure that would serve as a Plural launch kit. Working on an unforgiving three-week schedule—from concept to printing—the team was challenged with producing one kit that could be used for multiple audiences, including investors, the financial services industry, and recruits.

A modular solution seemed natural. Not only could it be custom built with its intended audiences in mind, it could also be printed in stages, which was necessary given the harrowing production schedule. So Brendán Murphy, partner and design director for Lippincott & Margulies, designed a 9x12-inch (23x30 cm) wirebound brochure with sections on Plural's history, capabilities, process, clients, and partners. And staying true to Plural's three-pronged approach, each section includes elements that speak to the company's use of strategy, creativity, and technology. Use of different materials—such as mylar and coated and uncoated papers in varying weights and textures—underscores the idea of plurality and adds a tactile quality.

While the aggressive rebranding schedule didn't allow time to develop a full-fledged style manual, the launch kit and supporting elements serve as a flexible and living design guide, says Murphy. "We were able to address things like clear space around the logo, where to position the logo on collateral, and the look and feel for the Plural visual system," he adds. Murphy's team also counseled Plural on the look and messaging content for its Web site.

Launched in early 2000, the new Plural identity was well received by clients and investors and the company looked toward an initial public offering (IPO). Plural was featured in the March 2000 issue of *Inc.* magazine. ∎

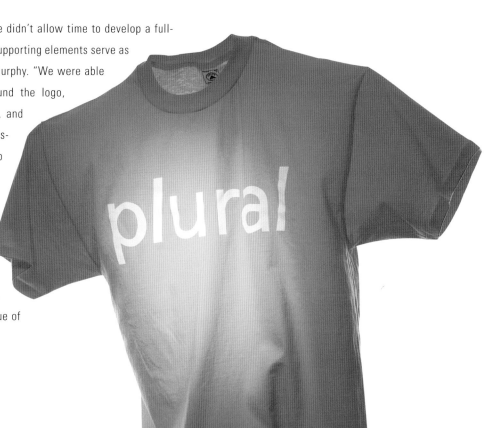

Xylo | An employee benefits company sheds its discount image and heads for broader horizons.

When employeesavings.com was established in 1997, its founders took a literal approach to naming it. Their business, after all, was exactly as the name proclaimed: discount purchasing programs that employees could access via proprietary Web sites. Focused on providing benefits that would help corporate clients increase employee retention, the company had developed its first programs for Boeing and Microsoft.

But when the Bellevue, Washington-based company saw opportunities beyond the discount purchasing realm, its name quickly became a liability. While it still provides purchasing programs, employeesavings.com shifted its focus toward "work/life solutions," programs that help employees balance their home and professional lives more effectively. Today, its offerings range from day care vouchers to travel planning and restaurant reservation services.

"Our name was too limiting and its connotation too low-value to reflect who we are, and it needed to change," says Judy Meleliat, senior vice president, marketing for Xylo. "Value is part of our offering, but we certainly don't want to be judged solely on that. To reflect our mission of providing work/life solutions, we wanted to reach a higher emotional level than just giving people an extra two bucks off something."

Meleliat, a former marketing vice president for Starbucks, was familiar with the work of Seattle-based Girvin and knew its staff included branding experts.

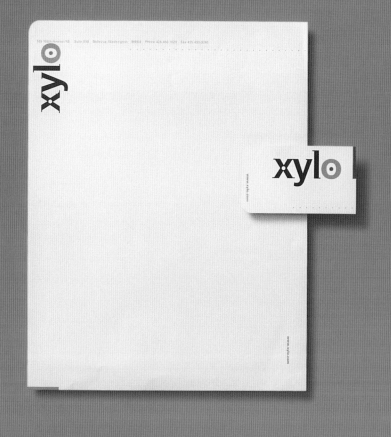

Client: Xylo, Bellevue, Washington

Judy Meleliat | senior vice president, marketing

Design Team: Girvin, Seattle

Kelsey Aanerud	account manager
Ann Bradford	director of strategic branding and marketing
Jennifer Bartlett	senior design director
Kevin Henderson	senior designer
Virginia Sabado	digital production senior
Alfred Astort	senior interactive designer
Barry Craig	senior interactive designer
Erich Schreck	interactive designer
Stephanie Krimmel	interactive developer
Erin O'Kelley	senior interactive producer

Her company needed that expertise, she says, to cultivate a name and brand that could grow over time, just as her company would.

A Strategic Foundation

Girvin's brand strategy group launched the project with a series of intensive meetings with the client's "thought leaders" to establish core values, brand personality, target audiences, and positioning. They also audited the company's existing marketing materials and those of competitors, as well as the company's business and marketing plans.

The research quickly steered Girvin toward defining and bringing to life the "work/life solutions" focus: simply, how the company is trying to improve employees' lives, and ultimately clients' bottom lines, through the programs it offers.

[above] *The new logo playfully communicates Xylo's mission to balance work and life. The circle punched out of the center of the "x" reappears inside the "o." "It's very clean and professional looking, but at the same time playful and approachable," notes Judy Meleliat, Xylo's senior vp of marketing.*

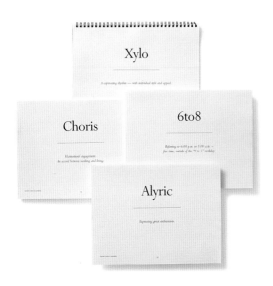

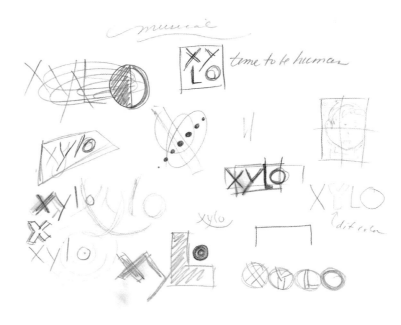

To explore branding directions, Girvin presented visuals representing three different facets of the brand personality: 1) "toolbox," a concept that emphasized the high-tech, dot-com connection; 2) "the power of the hive," which focused on working together; and 3) "time to be human," which focused on the value of relationships. "These gave a visual voice to different directions they could push their brand identity in," notes Jennifer Bartlett, Girvin's senior design director on the project. While the client team loved the "hive" analogy, they ultimately decided that emphasizing the human side of their business would be most effective.

The Name Game

With their visual compass now set, the Girvin team moved on to the naming process. A multidisciplinary team met initially to reiterate the brand attributes the work sessions had identified: relevant, aspirational, progressive, enriching, dynamic, and engaging. Each team member then generated a list of names, which were discussed, filtered, and passed on for trademark and dot-com checks.

When Girvin presented the first round of names, the client's decision was swift and sure, but fraught with complications. The chosen name, "applaud," was pleasantly upbeat and matched the client's brand attributes well. But it didn't meet the criteria of dot-com availability, and the client felt that owning the domain name was crucial. They decided to pursue purchasing the name, and asked Girvin to begin logo explorations. A few weeks later, their purchase attempts unsuccessful, they asked Girvin to generate another round of names.

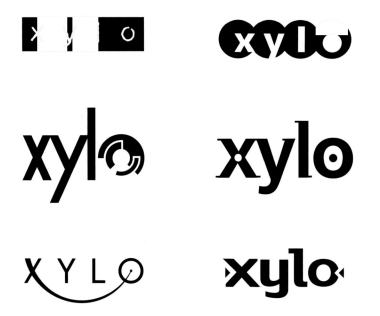

As in the first round, Girvin presented a wide range of names, including actual words as well as word origins and created names. Meleliat's goal was to identify a word or part of a word that sounded familiar, but could be used in a new way. "We also wanted a name we could define over time, that could come to fit us and be associated with the products and services we provide," Meleliat continues. "We wanted it to sound friendly and inviting without carrying the burden of telling the whole story."

Meleliat found what she wanted in "xylo," which the naming team defined as "a captivating rhythm, with individual style and appeal." It felt familiar and somehow right, says Meleliat. "It's a truncation of the word xylophone, so it has melodic roots. It's also short and easy to remember, but it has depth and character. It just fits."

Finding Their Mark

Girvin launched immediately into logo explorations, working toward a mark that fit the brand personality as well as the new name. Fighting a tight deadline, Girvin presented twelve logo options to the Xylo team. Their unanimous choice was one of Bartlett's designs that playfully expresses Xylo's mission of promoting work/life balance—a treatment that punches a small circle out of the "x" and places it inside the "o."

"It speaks to the idea of balance, or it can be interpreted to be about one person and their life surrounding them," notes Bartlett. After experimenting with case and typefaces, Bartlett finalized an all-lower case brandmark based on a classic typeface that lends a professional, even corporate, look to the name. Connecting the "x" and "y" ligatures made it uniquely Xylo's.

[above] Girvin explored a wide range of color palettes, from earthy tones to more daring combinations.

[above–left] Several internal rounds later, Girvin presented twelve possible logotypes to the client, including this group. "We always present logos in black and white first, because color can be so polarizing," says Jennifer Bartlett, Girvin's senior design director.

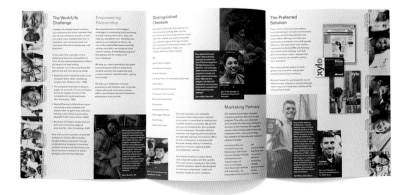

xylo

[above] *Xylo ultimately opted for a more conservative palette of dark "business blue" offset by muted yellow and bright red. Green and purple are used secondarily.*

[right—middle] *Xylo's six-panel launch/capabilities brochure reinforces the company's mission to balance work and life by portraying Xylo clients and employees in their personal as well as business personas. Specially commissioned photographic portraits show them at work and play.*

[right—bottom] *Girvin also designed a bright red folder that contains the launch brochure, program feature sheets, and other marketing materials that Xylo distributes to prospective clients. It also features portraits of Xylo employees living their work and personal lives.*

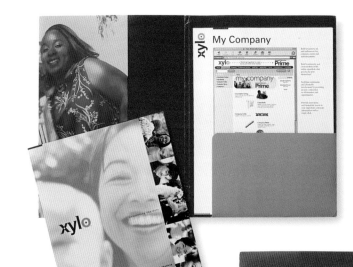

Moving Forward

Once the mark was finalized in black and white, the Girvin team turned toward color palettes and designing a Xylo stationery system. They experimented with a wide range of color schemes, from earth tones to fluorescents. Ultimately, Xylo opted for a more conservative palette featuring a dark "business blue," bright red, and muted yellow, with touches of green and purple.

The next big step was a capabilities brochure that served as Xylo's launch vehicle. Continuing the theme of work/life balance, Girvin developed a concept that features profiles of Xylo clients in both their work and home personas. Seattle photographer Dennis Wise created portraits of the human resources professionals pursuing their favorite non-work pastimes. Girvin filled out the brochure with photos of Xylo employees pursuing their own hobbies.

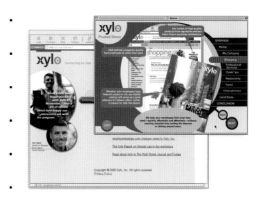

The Girvin team moved on to creating a brand book/style guide and designing Xylo's tradeshow booth. Then, building on the branding and design foundation already established, Girvin's interactive team created xylo.com, a fifty-page Web site that features Xylo's "Connecting the dots" tagline and a theme of connectivity. Designers continued Xylo's messaging, color palette, and visual references, such as the black-and-white photos of Xylo clients and employees. A key element of the Web site is a Flash demo that is also used by Xylo's sales team for client presentations.

Meleliat says client response to the new name and identity has been resoundingly positive. "Once they understood we weren't taking away any services, but actually building on them, they bought into it quickly." Internally, Meleliat and her team worked hard to ensure that employees were informed about the identity change each step of the way.

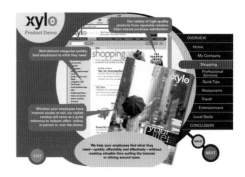

The new identity has made the company feel "grown up," she says. "It has really raised the bar on the level of 'put together' that we try to convey. Once you have a corporate identity of this stature, you make a better impression and people listen differently. The world takes us seriously now, and so do we." ∎

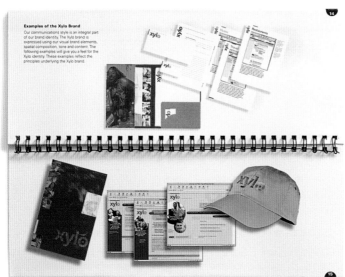

[above—top] *Building on the metaphor of connectivity and Xylo's "connecting the dots" tagline, the Web site was designed to communicate the same look, feel, and branding message as print materials.*

[above—bottom] *A Flash demo— featured on the Xylo Web site and also used as a sales tool—shows the private, co-branded Web sites Xylo creates for each client. Client employees use the sites to access premium products, services, and information.*

[left] *Xylo's brand book explains the logic behind the new identity and guides employees through use of the logo, graphic elements, and colors. Since it was for Xylo's internal use and Girvin didn't need to produce large numbers of the book, designers french-folded 8½x11 (22 x 28 cm) paper and wire bound it to create a long, narrow handbook. "We're always looking for ways to make 8½x11 (22x28 cm) more interesting," notes Bartlett.*

Muzak | # The "elevator music" company orchestrates a hip new identity.

Sometimes a strong brand identity can be a double-edged sword. Muzak, which may enjoy one of the most recognized business names in the world, is a case in point. Muzak was a $300 million company by the late 1990s, but in the popular vernacular it had become synonymous with "elevator music," an outdated and decidedly unhip image that its top management felt was hindering sales.

[above] *(Before) Muzak's existing symbol, circa early 1980s, represented its old scientific approach to marketing, and didn't capture the emotional range of music that is now at the core of Muzak's values.*

Muzak was established in the early 1920s by General George Squier, who discovered that background music soothed his employees and increased their productivity. (Squier named the company by combining the word "music" with the name of his favorite "high tech" company, Kodak.) His patented technology also helped calm the riders of a new invention called the elevator.

"We hadn't done that as a company for eons, but the perception was still out there," says Kenny Kahn, Muzak's vice president of marketing. "It was time to accurately portray what we were all about."

Today, Muzak provides customized musicscapes to more than 300,000 retail and corporate subscribers and has the largest digitized music library in the world. The core of its success, says Kahn, is the group of creative people who make up the organization, including its music programmers, known as "audio architects."

Kahn sensed the most effective way to market Muzak was to emphasize the creativity, and emotional power of music. "We used to represent our product in terms of its scientific and physiological impacts," says Kahn. "That was old hat."

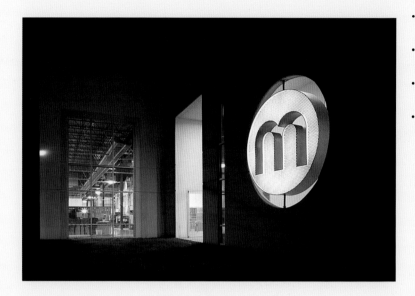

Client: Muzak, Fort Mill, South Carolina

Kenny Kahn | vice president of marketing

Design Team: Pentagram, San Francisco

Kit Hinrichs | principal/creative director
Brian Jacobs | associate/art director
and designer

So Kahn selected Pentagram (San Francisco) to fashion a new identity that would position Muzak as a creative, branded audio agency that shapes musical environments in a wide range of settings, from restaurants to retail.

"The assignment was essentially to take a brand identity with a lot of equity, some of it negative, and reshape the world's perception of it," says Kit Hinrichs, Pentagram principal and creative director on the project.

A Look Inward

Before Pentagram could articulate a new visual identity for Muzak, the team needed to examine Muzak's current self-image. Pentagram interviewed Muzak management and conducted a visual audit of existing marketing materials, discovering that the visual expression of the Muzak brand was "all over the map." As with most franchise-based operations, ensuring consistency had been a problem, agrees Kahn. "And as a company, we had put our brand aside for the last twenty years."

[above] *(After) In the end, sheer simplicity won out. Pentagram leveraged the letter "m," encircling it and giving it a softer, more approachable shape. The new logo is at once modern and sophisticated, but appealing and approachable. A neutral palette of silver and black simplifies its translation to various media.*

[right] *Logo explorations followed several different directions, including visual expressions of sound, suggestions of musical notes, and abstracted expressions of change.*

The Pentagram team knew that Kahn was frustrated with Muzak's existing marketing tools. "We needed to tell the Muzak story in a very compelling way that would change potential clients' perceptions and actually help their sales force sell the product," says Hinrichs. Kahn, the company's CEO, and the vice president of audio architecture, understood that dramatic changes were needed. Says Kahn, "We also saw a great opportunity to reinvigorate the organization by redefining our brand."

The executive team discussed changing the company's name, but only briefly. "We realized that although there were some negative equities in the name, there were many more positive attributes," Kahn explains.

A Sound Symbol

Pentagram knew Muzak's new identity should shift from the scientific focus of the past to a more creative, emotion-based approach. Logo explorations gravitated toward musical notes, visual expressions of sound, and abstracted expressions of change.

In the end, after several rounds of sketches focused on more intricate approaches, sheer simplicity won out. Limiting the symbol to the letter "m" created a dramatic statement and de-emphasized the Muzak name and any negative connotations attached to it. Encircling it created a universal appeal, and rounding the "m" and rendering it in lowercase added softness and approachability, says Brian Jacobs, Pentagram's art director and designer on the project. A proprietary rounded typeface, based on Futura, lent contemporary flair.

"We had to laugh because at the end of four months of logo explorations, we ended up with an 'm' in a circle," says Jacobs. "But it was really quite a revelation. We saw, and Muzak understood, how effective the simplicity would be for them." The symbol's understated appeal doesn't limit Muzak to its current product offering, and designers knew it would translate well to the many print and multimedia applications Muzak uses to promote the brand.

[left] *The simplicity of the new mark gives Muzak flexibility in adding new product lines, and translates well to a wide range of applications.*

[above] *The cover above features the new Muzak logo embossed in silver on recycled paper. Inside, the brochure is short on text, but long on visual impact.*

[right] *Developing effective marketing tools for Muzak's sales force was a key component of the project. The 10x14-inch (25x36 cm), wirebound "Muzak is...." capabilities book ignited sales and won over both clients and employees. Pentagram used bold colors and typography to evoke music's emotional power and portray Muzak as an organization of young, hip, and knowledgeable "audio architects" who use music to reinforce their clients' own identities.*

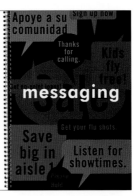

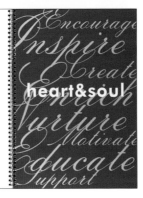

In keeping with the "simpler is better" approach, Jacobs created a sophisticated, minimalist color palette of silver and black. "It's completely neutral," he explains. "And while the metallic element adds sophistication, color doesn't become a negative or positive attribute." The team decided to reserve color for adding pop to promotional pieces.

A Selling Force

While applying the new symbol to Muzak's stationery system, Pentagram began work on a key marketing piece for Muzak, the capabilities brochure that is one of its sales force's most valuable tools.

Based on a "Muzak is....." theme, the brochure chronicles Pentagram's discovery of Muzak as a multi-faceted, creative organization staffed by a young, hip, and knowledgeable staff. The oversized, wirebound book uses bold color and type treatments to evoke music's emotional power and introduce Muzak's offerings.

Kahn says the brochure made a major impact as soon as Muzak sales people started taking it to client appointments. "Sometimes they wouldn't get an appointment, but would leave the brochure behind. By the time they got back to their office, there would be messages from that person saying 'I want to see you!'"

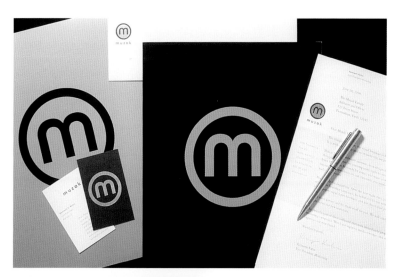

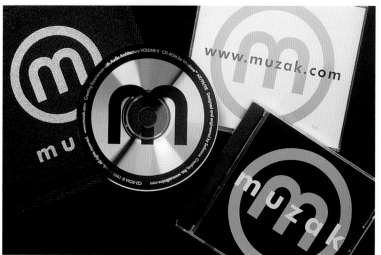

[above—top] *Pentagram also designed a symbol for the Heart & Soul Foundation, Muzak's not-for-profit organization that exposes underprivileged children to music.*

[above—bottom] *Subsequent brochures for individual Muzak product offerings used the graphic vocabulary established in the capabilities brochure.*

[left—top] *Applied to letterhead, business cards, and envelopes, the black-and-silver color palette is sophisticated but ultimately neutral. "Most often, people's negative reactions to a new symbol have to do with color," says Brian Jacobs, Pentagram's art director on the project.*

[left—bottom] *The shape and color of the new symbol were partially inspired by the shape and color of CDs.*

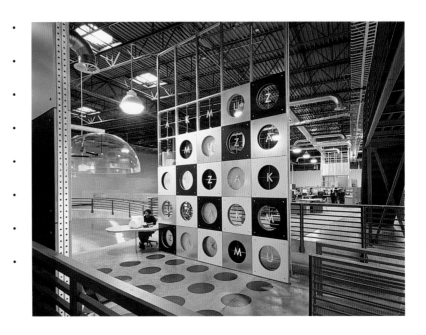

[above] *Muzak called on Pentagram's architectural partner, James Biber (New York City) to design its new corporate headquarters in Fort Mill, South Carolina. The new identity resonates throughout the building, from door handles in the shape of the mark to numerous circular themes and a predominately black-and-silver palette.*

[right] *A series of fun and funky promotional postcards signal to current and prospective clients that Muzak is no longer the "elevator music company." They communicate a young, hip attitude by linking Muzak's name with skateboarding, graffiti, and other youthful endeavors.*

Pentagram applied the graphic language developed for the capabilities book to subsequent marketing materials and a Director-based multimedia presentation that sales people run on their laptops during client appointments. Muzak also decided to work with Pentagram on the ultimate expression of its brand message, its corporate headquarters. Pentagram's New York City office designed the new building and helped translate the logo and other visual elements into Muzak's workspace.

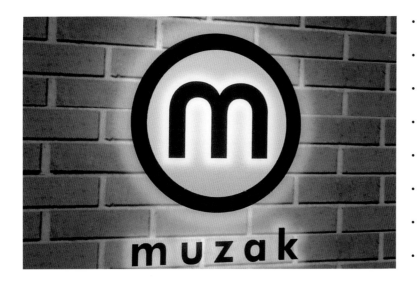

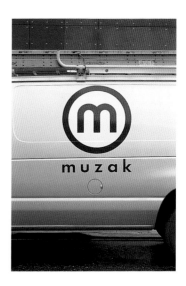

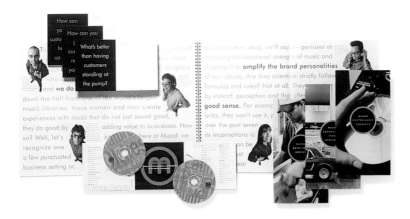

Results that Resonate

The new identity and sales tools have ignited the sales force and made believers out of Muzak's franchisees, says Kahn. After all, it's hard to argue with the phenomenal sales increases Muzak has seen since the new identity was launched in spring of 1998. During that time, he says, the value of the company has increased from $100 million to $700 million, and sales are still going strong.

"Music is the most powerful emotional tool that businesses didn't know they had to grow their own businesses," notes Kahn. "Pentagram gave us a visual foundation that lets us actively, creatively show people what music can do for them."

Even more important, says Kahn, the new identity has given the company a new pride in itself. "It made us feel good about ourselves, and when you feel good about yourself, you can go out and produce."

"Through design," he adds, "they gave our business a soul." ■

[above] *The new mark also appears on company vehicles. One of the signs of a great mark, says Pentagram principal Kit Hinrichs, is its simplicity. "If people can remember it and draw it, that represents ninety percent retention."*

[left—top] *Pentagram designed several sign types to cover the various buildings where Muzak's offices are located. This sign consists of halo-lit metal and acrylic painted black and silver.*

[left—bottom] *A direct mail piece emphasizes the emotional power of music and how it can be used to grow business. This emotionally-based approach is a radical departure from the scientific-based marketing approach Muzak had used in the past.*

CRYSTAL
NATURAL MINERAL WATER

BRÆBOURNE

Powwow

A water cooler company introduces its fresh new business approach.

When Hong Kong-based conglomerate Hutchison Whampoa entered the United Kingdom's water cooler market in 1998, its goal was to be the number-one water cooler business in the country. With ambitions to expand further into Europe, it acquired a number of UK-based water brands, including Braebourne and Crystal Spring, and began developing its marketing strategy.

[above] *When Hong Kong conglomerate Hutchison Whampoa bought into the United Kingdom water cooler market in 1998, it acquired two prominent brands, Braebourne and Crystal Spring, to gain a foothold in the market.*

But when your business is selling a product that is colorless, odorless, and virtually tasteless, it's difficult to differentiate yourself from competitors who supply a similar colorless, odorless, and tasteless commodity. In an industry dominated by "wells" and "springs," the new company needed to set itself apart from other suppliers. It enlisted the help of brand consultancy Wolff Olins to create a brand that would integrate the newly acquired businesses and position the company for leadership in the market.

A Fresh Approach

The key to building the brand, says Nigel Markwick, senior brand consultant for Wolff Olins, was to determine how to differentiate the company from its competition. Research showed that consumers lacked strong opinions about water brands, and the company's business-to-business clients were also neutral: they had no criticisms of the current service, but weren't enthusiastic about it, either.

Client: Hutchison Whampoa Ltd., [Hong Kong]
Ken Sheridan	director of global brand strategy, Powwow
Martin Thorpe	director of sales and marketing, Powwow

Design Team: Wolff Olins, London
Nikki Morris	account director
Nigel Markwick	senior brand consultant
Doug Hamilton	creative director
John Besford	lead designer
Lionel Chew	product designer
Tim Pope	product designer
Naresh Ranchandani	copywriter
David Rose	3-D designer
Vikki Olliver	account manager

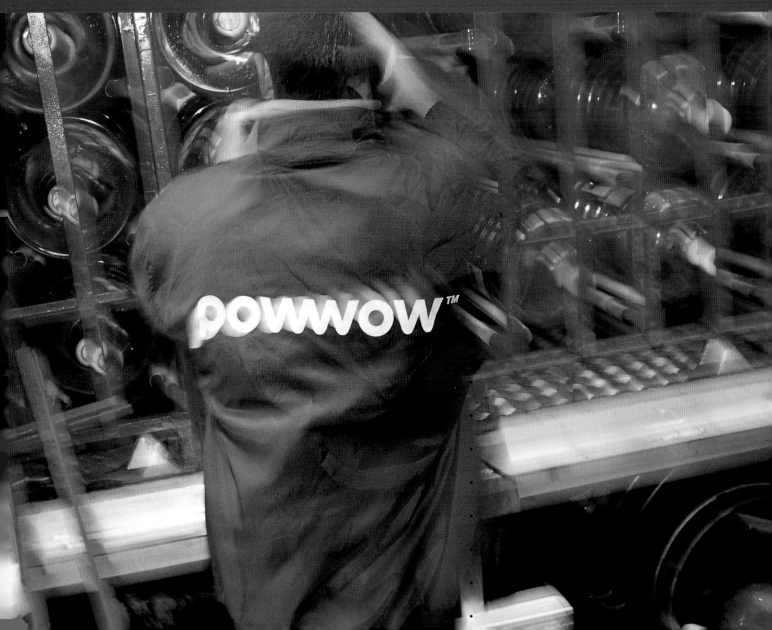

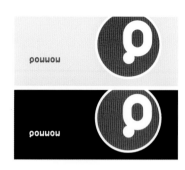

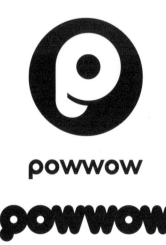

POWWOW
Powwow doesn't make you better at meetings. It does make you more regular though. Fresh water. Naturally.

POWWOW
Powwow doesn't make you better at meetings. It does make you more regular though. Fresh water. Naturally.

powwow ™
Powwow doesn't make you better at meetings. It does make you more regular though. Fresh water. Naturally.

powwow ™
Powwow doesn't make you better at meetings. It does make you more regular though. Fresh water. Naturally.

PoWWoW
Powwow doesn't make you better at meetings. It does make you more regular though. Fresh water. Naturally.

PoWWoW
Powwow doesn't make you better at meetings. It does make you more regular though. Fresh water. Naturally.

PoWWoW
Powwow doesn't make you better at meetings. It does make you more regular though. Fresh water. Naturally.

POWWOW
Powwow doesn't make you better at meetings. It does make you more regular though. Fresh water. Naturally.

[above] *The Wolff Olins team quickly settled on a "fresh" brand platform and named the company "Powwow" to express the water cooler's function as an office meeting place and conversation starter. They explored several logo concepts, including marks that manipulated the "P" letterform playfully to evoke a bubble in a water cooler.*

[above—right] *The Wolff Olins team decided that a name as distinctive as Powwow didn't need a symbol, and narrowed its creative exploration to type treatments. This exercise shows how different typefaces can change the logotype's tone of voice.*

"Water didn't seem to inspire passion in anyone," observes Markwick. "And if you tried to base the brand on the product alone, there was nothing really to differentiate it from any other high quality water."

But the company was looking for more than just an identity, says Markwick. "They weren't just looking for a new logo. They needed a brand idea that would help them dominate the market," he notes. "They needed to change the rules, refocusing their business around service."

The central idea behind the company's brand positioning became "fresh." This originated with the product itself, but went deeper into the organization. Unlike most bottled water, which has a long shelf life, this company guaranteed it could get water out of the ground and delivered to the workplace within days. The "fresh" idea penetrated further by inspiring the organization to think of fresh approaches to everything they do.

"So this was not really a water cooler company," explains Markwick. "This was a service company that just happens to deal in water coolers. Their aspiration was to be mentioned in the same breath as companies like FedEx."

To demonstrate the idea of fresh, Wolff Olins helped the company identify a wide range of improvements that would make the service they offer the best in the business. More importantly, these changes would help make customers' lives easier. For example, the company established a policy that, between 7 a.m. and 7 p.m., a person, not a machine, would answer customer phone calls. They produced large water bottles with handles to make them easier for customers to replace, supplied free bottle racks, and introduced late-night loading to speed up delivery. Equally important, Wolff Olins worked with every company employee to determine how their jobs could be made fresher.

Talking Water

As it explored names and visual directions for the new company, Wolff Olins began to develop a concept that focused on the role of the water cooler as an office meeting place. They were inspired by the classic Hollywood water cooler scene, which depicts workers talking while they fill their paper cones with water.

"If you create environments within an office space where people can talk and really communicate, you're bound to foster new ideas and ultimately make the company more effective," notes Markwick. "Water coolers can provide a place like that. But it meant redesigning them so that they fit modern office environments and weren't hidden away."

This notion of "talking water" led the Wolff Olins team to the company's new name: Powwow. "There's an element of conversation around the word, and it's distinct enough to set itself apart from all the water companies that include 'spring' in their names," Markwick adds. "It also needed to be abstract and unlimiting, so that the company could grow itself into a major service brand."

Conversation Piece

To inspire emotion in its customers, the brand needed to establish an ongoing dialogue with them. So while the Wolff Olins team experimented with possible brand marks and a visual vocabulary, they also began developing a tone of voice unique to Powwow. The resulting attitude is friendly, playful, and often irreverent, "looking to shake things up a bit," as Markwick describes it. Snippets of conversation, always humorous, appear with the Powwow name virtually wherever it goes, from job applications to delivery vehicles. Water coolers, for example, bore this message for a while: "The Powwow customer service line is open from 7 a.m. to 7 p.m. So pick up the phone and chat to us. We're happy to talk about anything, but our real strength is water coolers, definitely."

"It's a bit lighthearted, and fun," says Markwick. "The intention is that people will want to come back for more of it."

[above] *The design team also explored a range of color palettes. Since greens and blues are used by many other water suppliers, they were ultimately avoided.*

[below—left] *The final solution is simple but eloquent, rendered in hand-drawn letters with distinctive, rounded forms. The use of pink and purple is unique in Powwow's business sector.*

[below—right] *The logotype can also be stacked. It appears in various combinations of pink, purple, and white or black and white, depending on the application.*

The accompanying logotype is simple and straightforward, a custom, hand-drawn typographic treatment that features the Powwow name in combinations of pink, purple, and white. "We determined early on that a typographic treatment would be the best solution," says Markwick. "Powwow is very distinctive. You don't need to try too hard when you have a name that distinctive." The team chose pink and purple to differentiate Powwow from the many water companies who use greens and blues in their identities.

Wolff Olins translated the new brand to a wide range of applications, including stationery, delivery vehicles, marketing collateral, uniforms, signage, Web site, screen savers, and a brand book. They also created an advertising campaign that debuted in London just before the launch.

But Powwow really expressed the core of its brand when it redesigned its water coolers to reinforce the customer-service promise. The coolers employ state-of-the-art technology to make life easier for all who use them. For example, higher taps mean no bending to get a cup of water. Larger cups mean fewer trips to the

cooler, while a low-cups indicator warns when cups are running out. A new evaporation system means the drip tray is practically self-emptying. And the design is very attractive, not an eyesore to be tucked into a far corner.

Refreshing Results

The Powwow brand has been well received by its customers, and business has increased dramatically since the brand was introduced. In 1999, the market share of the newly acquired companies (combined) was 18.6 percent. By November 2000, Powwow's market share was 27 percent, and rising. Crystal Spring was the only one of the former companies with a Web site, and it averaged 323 hits per day. Powwow's Web site receives an average of 1,641 hits per day.

"It's impossible to say whether these increases are a result of the new brand platform, the company's new approach to doing business, or a combination of many factors," Markwick states. "But the point is, Powwow has become a brand that's not only about a fresh product, but about a fresh way of doing business. People respond to that inside and outside the company." ■

CHILDREN'S TELEVISION WORKSHOP

Sesame Workshop

Children's Television Workshop keeps its Sesame Street address, but moves forward with a big new identity.

When your address is Sesame Street, your front man is Big Bird, and your name is synonymous with quality television programming for young children, brand image shouldn't be a problem. But after thirty-one years as Children's Television Workshop, the New York-based not-for-profit organization found that the institutional nature of its name had become a liability.

PLAY IT SMART
www.ctw.org

[top] *Sesame Street, a cultural touchstone and one of the world's most powerful brands, was a key element of Children's Television Workshop's brand promise.*

[above] *The institutional connotation of the Children's Television Workshop name had become a liability. Shortening its name to CTW met with little success, as its audiences did not recognize it.*

Research showed that for those who recognized the name, Children's Television Workshop (CTW) was virtually interchangeable with public television and other brands that produce children's programming. And since the name was grounded in television, it seemed limiting to an organization that was also involved in the Internet, interactive games, books, CD-ROMs, and other media geared toward children.

CTW's executive team also realized the organization needed to function as a brand, with a name and brand promise that speaks clearly to its audiences, including children, parents, and business partners. They commissioned the Carbone Smolan Agency (New York City) to help them articulate and express that promise.

sesame
workshop™

Client: Sesame Workshop, New York City

Sherrie Rollins Westin	executive vice president, marketing, communications and research
Anna Maria Cugliari	senior vice president, strategic marketing and brand management
Suzanne Duncan	vice president, advertising and creative services
Heather Imboden	director of advertising and marketing services

Design Team: Carbone Smolan Agency, New York City

Ken Carbone	cofounder and executive creative director
Justin Peters	design director
Tom Sopkovich	designer
Jennifer Greenstein	project manager

[above] *The final mark suggests that learning, and fun, happen here. Carbone Smolan chose a palette of bright primary colors and paired the mark with the company name in a classic but whimsical typeface called Tarzana Narrow.*

[above] *The design exploratory started with logotype sketches. Carbone Smolan attempted to ornament the letterforms to capture the essence of the name, but soon realized a logotype alone would not be "embraceable" enough for small children.*

[above—right] *The new name (shown in a preliminary logotype) leverages the strength of the Sesame Street brand and recalls the heritage of the Children's Television Workshop. The word "workshop" implies a destination where creativity, exploration, and fun happen.*

SesameWorkshop

A Global Brand

CTW had already begun the re-naming process when the Carbone Smolan Agency was brought on board, so its executive team had defined key brand attributes and the message they wanted to send to their audiences.

CTW knew that it needed to capitalize on the Sesame Street brand, which had become a cultural touchstone synonymous with a dedication to children, education, and fun. So the names on its list of possibilities included monikers like Sesame & Co., Sesame Unlimited, and Sesame Workshop. When the Carbone Smolan Agency reviewed the options, they felt strongly that Sesame Workshop was the best candidate. "It really gave them a kind of bookend opportunity, because it leverages the jewel of their brand, Sesame Street, and also recalls the proud heritage of Children's Television Workshop," says Ken Carbone, cofounder and executive creative director for the agency.

More important, Carbone Smolan and CTW agreed, was that the word "workshop" suggests a destination, a creative place where people come together to invent and explore in pursuit of a common goal. It connotes a stimulating, active environment and created the perfect branding platform for the organization.

A Creative Mark

Once the name was established, the Carbone Smolan Agency needed to move quickly to show the organization's board a visual representation of the new name, which they were to vote on. To start the process, the agency explored logotypes, and actually presented a simple, colorful logotype to the board when it introduced the new name.

But the designers immediately realized that just a logotype would not be "embraceable" enough for children who don't yet read, notes Carbone. "We did an exploratory of just logotypes, trying to see how playful we could be with the name by ornamenting the letterforms. But ultimately we couldn't go far enough with the logotype and pushed on toward symbols."

The team experimented with many symbols that would encapsulate the childlike wonder, love for learning, and trust embodied in the Sesame Workshop name, but a simple, colorful drawing of a house "exploding" with creativity and fun hit the mark. "It literally speaks to the idea of going some place where creativity and learning are happening," explains Carbone. After some refinements to the house's colors and graphic elements, Sesame Workshop had its new symbol.

Bringing it to Life

Given the wide range of media that Sesame Workshop is involved with, the mark had to translate well in print, on television, on the Web, and in animation. The house mark—with its simplistic styling, separate graphic elements, and colorful palette—fit the bill.

To add versatility, the Carbone Smolan Agency developed four color palettes that can be used interchangeably. It paired the symbol with the Sesame Workshop name in Tarzana Narrow, a typeface that Carbone says combines the clarity of classic faces like Univers or Helvetica with a little playfulness. "There's a hint of whimsy, but it's not condescending like some 'kid' typefaces are," he relates.

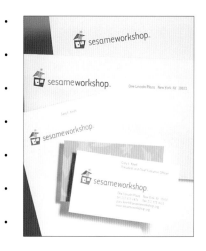

[top right] *Sesame Workshop's paperware includes the symbol in different color variations, reinforcing the concept of creativity and exploration.*

[top left] *A key deliverable was the "thanks" book designed for Sesame Workshop employees and close business partners. The wire-bound handbook introduced the new name, explained the logic behind it, and encouraged employee support.*

[bottom right] *A press kit included an announcement card and a special premium, a color-in logo t-shirt and markers.*

[bottom left] *For a television industry trade show in Cannes, France, Sesame Workshop developed marketing materials for individual properties and gave away customized "Big Bird Watching" binoculars.*

After applying the identity to Sesame Workshop's paperware system, Carbone Smolan developed one of the project's most significant deliverables, a "thanks" handbook that introduced the new identity to employees and business partners. "This was a very important piece, because it explained the logic behind the change and also articulated Sesame Workshop's mission and brand message," notes Carbone. "It went a long way toward achieving 100 percent buy-in of the new identity."

The mark was applied to Sesame Workshop's Web site and the Carbone Smolan Agency worked with a team of animators to bring the symbol to life, literally, for television programs. Other deliverables include a style guide, print advertising, and Sesame Workshop's booth at a television industry tradeshow in Cannes, France.

A Success Story

The new identity has been met with applause from both employees and business partners, says Carbone. "Not only is there 100 percent buy-in internally, culturally it has given Sesame Workshop something they feel really good about promoting. They've all embraced this as a flag they can wave."

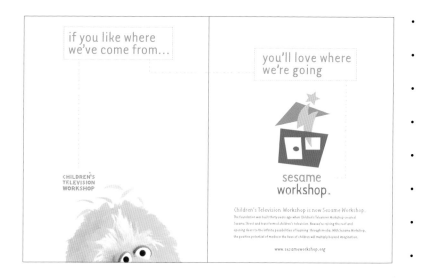

[above] *The home page of www.sesameworkshop.org leverages its most familiar properties, but also features the new identity and borrows its bright color palette.*

[left—top] *Advertising spreads announced the new identity using a recognizable Sesame Street icon.*

[left] *The Sesame Workshop style manual is a comprehensive guide to the brand, from editorial voice to brand architecture and color palettes.*

Since the new identity was adopted, Sesame Workshop has also been successful in securing new business relationships with co-sponsors for programming and other initiatives. Carbone attributes this, at least partially, to the new identity. "When a not-for-profit reenergizes itself by taking on a project like this, it establishes a certain level of credibility," he notes. "It tells prospective business partners that this is a high quality, forward-thinking organization." ■

ABITIBI-PRICE INC.

Stone-Consolidated
Corporation

Abitibi-Consolidated Inc.

Two Canadian paper manufacturers merge cultures and identities.

When paper manufacturing rivals Abitibi-Price and Stone-Consolidated merged in May 1997, their union was one of the largest corporate mergers in Canadian history. Today, Abitibi-Consolidated employs 18,000 people in twenty-nine paper mills across Canada, Europe, and the United States.

[above] *(Before) In one of the largest corporate mergers in Canadian history, paper manufacturing rivals Abitibi-Price and Stone-Consolidated Inc. united two vastly different corporate cultures. The newly formed company needed a strong new identity to communicate its leadership mission.*

The heads of the two companies, co-chairmen Ron Oberlander and Jim Doughan, shared a vision of establishing Abitibi-Consolidated as "the world's preferred marketer and manufacturer of papers for communications." But while the two companies' markets and business objectives were similar, they differed dramatically in organizational style and culture. As a "merger of equals," the newly formed company needed to meld the two distinct cultures into one harmonious unit. And its new name and corporate identity needed to reflect the common vision and position the company as a global leader in the highly competitive paper industry.

Karo (Toronto) Inc. was chosen to design a new brand mark and visual identity system that would help propel Abitibi-Consolidated into the forefront of its industry. The project scope included a wide range of applications, from stationery to vehicle graphics and from packaging and posters to brochures and giveaways.

Karo's role extended beyond the traditional range of identity design to actually helping shape the new company, says Stewart Howden, the firm's president and project leader. The Karo team organized and facilitated a series of "vision and values" workshops with company executives, management, employees,

ABITIBI
CONSOLIDATED

[left] *The new identity, a globe-shaped, spiraling roll of paper, symbolizes Abitibi-Consolidated's leadership in the paper industry, as well as its emerging global presence.*

[below] *Abitibi-Consolidated's bold corporate mark, shown here on stationery, sets it apart from paper-industry competitors that tend to overuse tree-and-forest imagery to communicate environmental friendliness.*

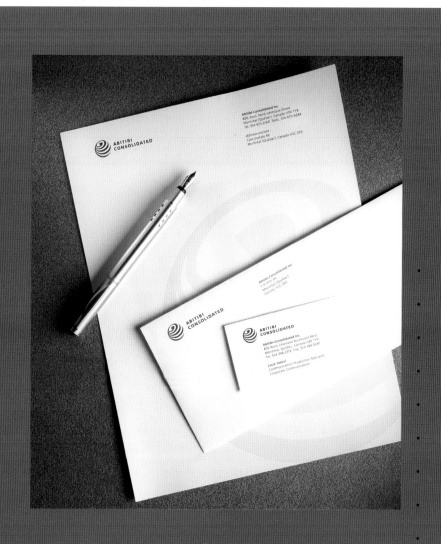

Client: Abitibi-Consolidated Inc., Montreal

James Doughan	president and ceo
Ronald Oberlander	operating chairman
Susan Rogers	vice president, corporate communications

Design Team: Karo (Toronto) Inc., Toronto

Stewart Howden	president and coo
Paul Browning	executive vice president, creative director
Philip Unger	design director
Kerry Fenech	executive assistant
Iwona Sowinski	senior designer
Jim Muir	production artist
Scott Jarvis	production artist

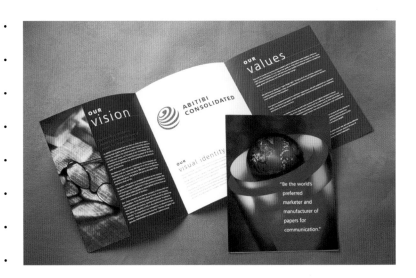

[above] *Employee "sell in" was a key component of the project. Karo created a series of posters that were displayed in paper mills to communicate the company's key values.*

[right—top] *One of the first products Karo created was a "vision" brochure distributed to the client's 18,000 employees worldwide. Its cover features a photographic treatment of the logo symbol.*

[right—middle & bottom] *The visual identity system was developed in both French and English, and included a wide range of publications and brochures.*

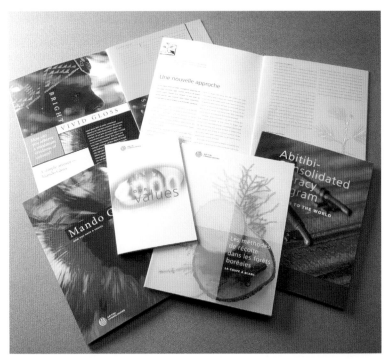

customers, and strategic partners, and helped develop a critical-path transition to ensure a timely, seamless launch and implementation of the new identity. "Being involved in the birth of this new company provided us with invaluable insight into the new brand and how its identity should communicate within the marketplace," Howden notes.

A New Face

First and foremost, Abitibi-Consolidated needed a strong brand mark that would serve as its new public "face." Immediately following the merger, the Karo team developed a simple interim logotype that both partners could use to represent the newly formed company until its new name and visual identity were publicly launched. Well informed by its leadership in the "vision and values" workshops, Karo also began design explorations for a new logo/mark, using Oberlander and Doughan's shared vision as their springboard.

The final solution is a globe-shaped, spiraling roll of paper that symbolizes Abitibi-Consolidated's emerging global presence and leadership in paper manufacturing and marketing. Resisting the paper industry's tendency to overuse tree-and-forest imagery, Karo's design team created a mark that visually captures the company's brand positioning in a bold, concise way. Designers chose a strong, bright red for the symbol and paired it with dark blue for the company name, which is rendered in the classic Frutiger typeface.

Abitibi-Consolidated

[above] *Immediately after the merger, Karo (Toronto) Inc. created a simple interim logo that both partners could use until the new identity was launched.*

[below] *The visual system also includes ten different signage types, including a corporate emblem mounted in the reception area of the Montreal headquarters.*

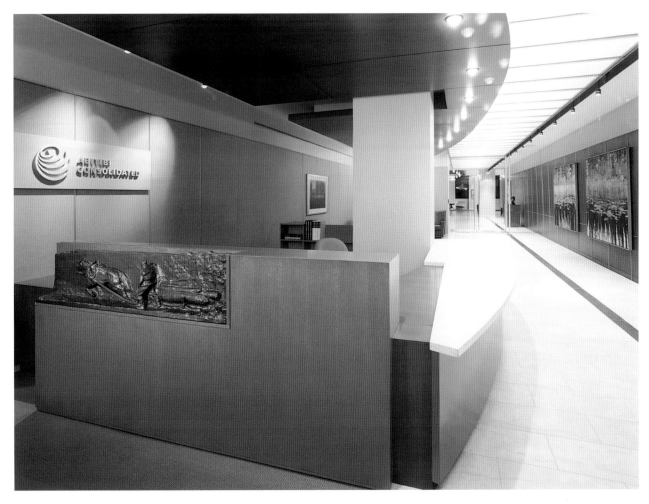

Paul Browning, Karo's executive vice president and creative director, says that while the identity was designed around the combined company name, it needed to be flexible enough to transition to one name in the future, which was Karo's recommendation. "Management felt that the combined name at this stage would contribute to the notion of a 'merger of equals,' at least optically, but there was general consensus that it would move to simply 'Abitibi' in the future."

Supporting Cast

Because of the sheer scope of the project, the new visual system (developed in both French and English) was phased in gradually following a critical-path process outlined by the Karo team. First on the agenda were promotional materials to educate Abitibi-Consolidated employees about the merger, the new identity, and most important, the new company's vision and values.

In tandem with stationery and other business papers the company needed immediately, Karo created a set of seven full-color corporate branding posters and an employee launch brochure to summarize the new identity. The posters were displayed in the paper mills to provide a backdrop for a carefully orchestrated roadshow by Oberlander and Doughan, who personally introduced the new identity and the company's vision and values to employees. The Karo designers also developed a four-volume set of "Visual Identity Guidelines" that addressed applications needed for more than forty-five company locations worldwide.

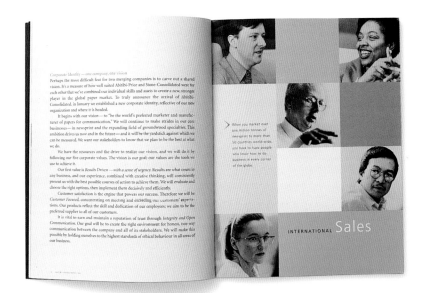

The team also created a signage system that incorporated ten different sign types. To simplify production and help ensure the signs were implemented effectively, Karo developed a library of more than eighty informational and safety icons. Other applications included uniforms and vehicle graphics, packaging, exhibits, publications, and Abitibi-Consolidated's first annual report after the merger. Karo also designed the company's first "Environment, Health and Safety Report," a 28-page, full-color brochure and companion pieces including posters and a set of fold-out brochures.

Abitibi-Consolidated has achieved its goal of forming the world's largest manufacturer of newsprint and uncoated groundwood papers. In 1997, its assets totaled $6.3 billion and synergies resulting from the merger represented $200 million in savings during the first year. With the help of a well-planned transition and a solid, new visual identity, say Howden and Browning, "The company has been able to realize its stated business goals, transforming two entities into one and creating a truly global brand." ∎

[above] *The 1997 annual report used the tagline "One Company, One Vision" to communicate the integration created by the merger.*

[left] *Livery graphics feature the bold red symbol on a dark blue background.*

*BP*Amoco

BP | The world's third largest oil company brands itself to move beyond the petroleum sector.

Oil giants British Petroleum (BP) and Amoco merged in 1998 to form BP Amoco. When BP Amoco acquired ARCO in 1999 and Castrol in 2000, the result was a Fortune 10 company with more than 100,000 employees, 29,000 retail outlets, and wide-ranging oil and gas, petrochemical, and energy operations worldwide.

[above] *(Before) The new oil company formed by British Petroleum, Amoco, ARCO, and Castrol has 100,000 employees and 29,000 service stations worldwide. The new company needed a strong, monolithic brand identity to communicate its goal of moving beyond the petroleum sector.*

[opposite page] *The new BP Connect service station format is perhaps the highest-profile application of the new identity. With more than 29,000 stations worldwide, BP has more retail sites than McDonalds.*

To help propel itself forward in the marketplace, the new alliance needed a strong brand identity to unify the four previously independent companies and communicate its vision for the future. The identity needed to symbolize the dynamic new organization and reflect the values to which it aspires: performance, environmental leadership, innovation, and progressive ideas. And perhaps most important, the identity needed to help the company communicate that it is more than an oil company and that its aspiration is to move beyond the petroleum sector to become one of the world's great brands.

"We're not just an oil company," says Stephen Williams, BP's vice president of strategic marketing. "Yes, we're about exploration and production and all that being an oil company implies. But we're also about solar energy, clean fuels, and being a positive force in the communities where we do business and where our people live."

In May 1999, the company called on Landor (San Francisco) to develop the new identity, including a name and brand mark that would signal to the world that BP is not going about "business as usual."

Client: BP, London

Sir John Browne	group chief executive
Lee Edwards	vice president of brand
Stephen Williams	vice president of strategic marketing
Anna Catalano	group vice president of marketing

Design Team: Landor, San Francisco

Margaret Youngblood	creative director
Nancy Hoefig	creative director
Courtney Reeser	creative director
Peter Harleman	senior brand strategist
David Zapata	design director, environments
Brad Scott	design director, interactive
Cynthia Murnane	senior designer
Todd True	senior designer
Frank Mueller	senior designer
Ivan Thelin	senior designer
Ladd Woodland	senior designer
Kistina Wong	senior designer
Michele Berry	designer
Maria Wenzel	designer
Jane Bailey	writer
Susan Manning	writer
Wendy Gold	account director, interactive
Greg Barnell	project management
Stephen Lapaz	project management
Bryan Vincent	project management
Russell DeHaven	realization

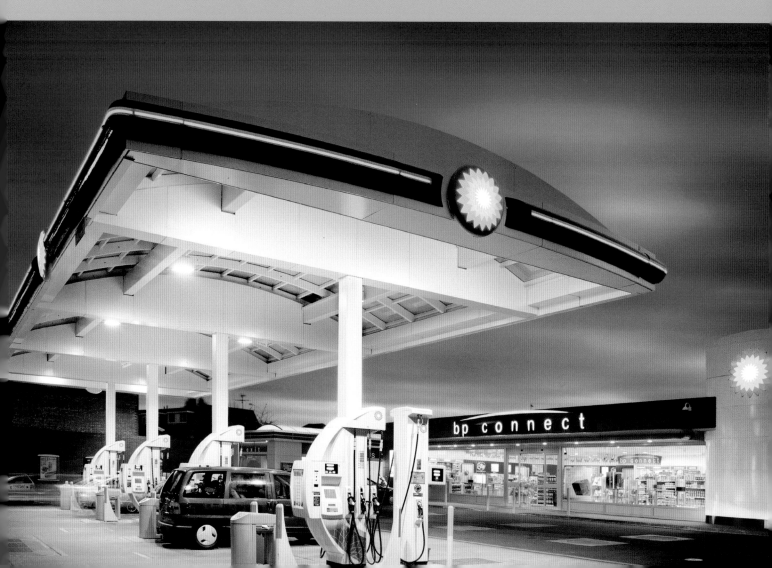

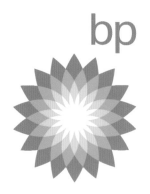

[above] *(Before) While BP's green-and-yellow color palette was considered a brand asset worth retaining, the shield, which represented protection and stability, was not considered appropriate for the new company. A dramatically new mark would best herald BP's embrace of change and its movement beyond the petroleum sector.*

[above—middle] *With its interlocking planes and colors, the new Helios mark symbolizes the sun, energy, and BP's commitment to environmental leadership. Unorthodox for an oil company, it tells the world that BP is not going about business as usual.*

[above—right] *The new symbol was designed to work equally well on light as well as dark backgrounds. It translates easily to a wide range of applications, including animation.*

A New Name

Landor began the process by analyzing a large body of industry research that had been commissioned by BP. Using Landor's internal research model, the team also audited competitors' identities and evaluated BP and Amoco's brand assets. The goal, says Susan Nelson, Landor's research director, was to gain an understanding of the gas/petroleum industry and the new company's place in it.

"On the whole, the industry is undifferentiated," says Nelson. "That means that the consumer sees all the brands as pretty much the same—almost as commodities." While the research showed that Amoco was more established as a brand in the U.S. than BP, it was less differentiated than BP, which was seen as "up and coming." Landor concluded that neither the BP shield nor the Amoco torch-and-oval brand mark were appropriate to represent the new company and its goals.

In July 1999, based on the research and several rounds of interviews with BP's executive board, Landor recommended the new company be renamed BP. "BP is a simple, straightforward name that is easy to remember," says Margaret Youngblood, Landor's creative director for corporate identity. "Above all, it stands for the new company's aspirations: big picture, bold people, better products, beyond petroleum."

To Williams, the name respects a rich heritage and promises a bright future. "We considered a lot of names, many of them combinations of the individual companies that make up the new BP. We thought that the letters BP formed a name we could extend around the world. It speaks to our heritage, but really allows space for our future possibilities."

A New Mark

Landor entered the creative phase of the project with a wide-ranging exploration of possible brand marks, but soon narrowed its focus to two concepts: creative manipulation of the "B" and "P" letterforms, and exploration of natural geometric forms that reinforced BP's environmental commitment. Research showed that the BP color palette of green and yellow was unique in the petroleum sector and identified it as an important brand asset to retain.

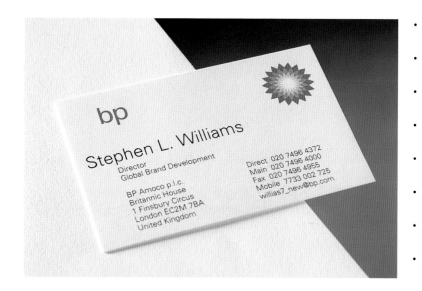

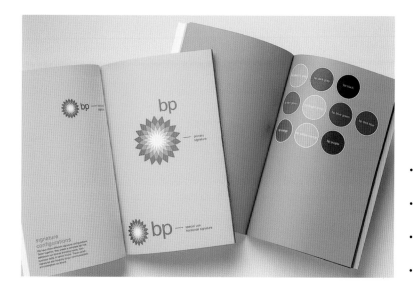

[left—top] *The identity system can be used dynamically by breaking apart the BP logotype and the Helios mark. The employee name beneath the corporate logotype is a metaphor for the direct relationship between individual and corporation, an important part of the BP corporate culture.*

[left—middle] *The Landor team designed a set of three perfect-bound launch books that were encased in a hard slip case. They included an identity book, a brand book, and a company policy book. Sets were given to top executives and individual books were given to employees.*

[left—bottom] *Spreads from the BP Identity Book show color palettes and various applications of the brand mark.*

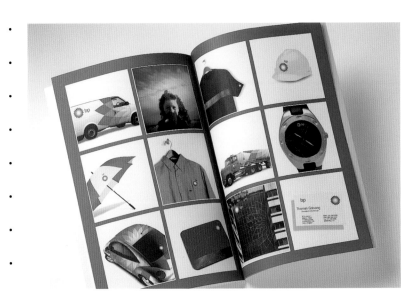

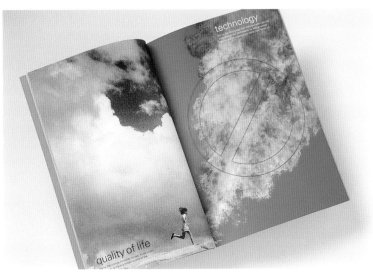

[right] *The Brand Book, part of a set of three books given to employees on launch day, uses photographic metaphors to express the attributes of the new company. Explaining the ideas behind the new identity to BP's 100,000 employees was an important part of the project.*

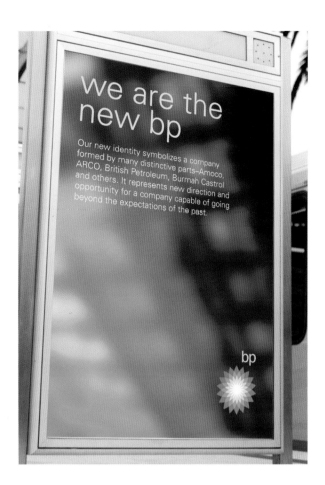

Working with the BP executive board, Landor presented possible brand marks in a range of simulated applications so they could see how the mark would look in the real world, notes Youngblood. By October 1999, the team had two refined concepts to present to the BP board. Both were radically different from either the BP shield or the Amoco torch-and-oval, but one felt more comfortable in the world of petroleum and the other was a much bolder step away from the sector. Ultimately, Landor recommended the second option: the "Helios," a sunflower-shaped mark consisting of interlocking planes and colors.

"One of the key messages that BP wanted to communicate was their environmental leadership and focus on alternative energies, so our creative explorations lead us toward natural forms," says Youngblood. "The Helios mark reflects BP's determination to create products and services that respect human rights and the natural environment. It also represents the sun, a priority in BP's search for new sources of energy."

Before making its final decision, BP's executive board wanted to evaluate how the marks would look on their service stations, so they asked Landor to develop conceptual designs for a new retail format and simulate the marks on both. The Landor team developed a convenience store prototype design and also designed pylon signs, pumps, canopies, and car-wash units. By December 1999, the team was able to show how the two symbol options would look on the new service stations. The executive board almost unanimously preferred the Helios mark. A new symbol was born.

[above] *Merchandising was very important to BP as a way to show company pride. Many promotional items were designed and produced for the launch.*

[left] *Landor also designed a series of banners to promote the identity launch.*

Bringing it to Life

Landor paired the Helios mark with a lowercase logotype composed of custom-designed letters based on the Univers typeface. The choice of sans-serif letters gives it a clean, modern look, while the use of lowercase communicates that BP is friendly and approachable, says Youngblood.

In January 2000, Landor began media testing of the mark and proceeded with designing other elements of the identity system. The team chose color palettes, secondary graphic elements, designed a Helios "supergraphic" and applied the mark to business papers, corporate signage, presentation templates, and gift and merchandise items. The team also designed corporate interiors for BP's London headquarters, created branded PC desktop graphics such as screen savers, wallpaper and splash screens, and explored animation and branded sound. Print pieces, including a brand book, a policy book, and identity guidelines that were given to all 100,000 employees for the launch, were also part of the project.

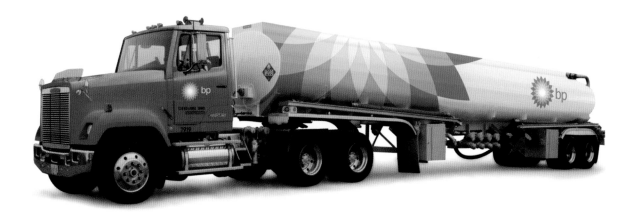

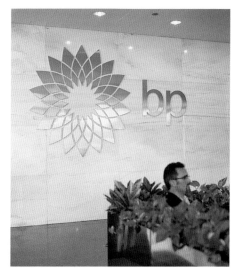

Application of the new identity to BP offices and facilities will be complete by the end of 2002, while the retail rollout will extend through 2004, says Williams. But the new identity means more than putting up a new sign or applying a logo to a truck, he adds. "For us it means making sure that every operation and everything we do moves us closer toward our aspirations. So any physical change is supported by a behavioral change within our company."

Perhaps more than anything, Williams adds, the new symbol is about change. "It helps us tell the story of a company that's about oil, but also about solar energy, clean fuels, and making our world a better place. It's also a symbol of energy. It's dynamic, it's bold, and it's something you wouldn't expect from an oil company. It's a tangible reminder of the progress and change we strive for every day." ∎

[above] *Landor also designed this metal signature inset in a marble wall at corporate headquarters. Also at headquarters, an abstract sculpture representing the Helios mark diffuses light and brings down the scale of the atrium space.*

[left—bottom] *Several screensavers were created and installed on employee computers for launch day. Landor's design team also designed wallpaper, splash screens, and a browser icon.*

BuildNet | A builders' resource company constructs a living identity for growth.

In 1996, BuildNet Inc. quietly launched a revolution. Founded as a residential con-struction company in 1984, the former Sun Forest Inc. quickly moved into the realm of software development, recognizing an industry-wide need to streamline builders' back-office functions. By 1996, the newly renamed company had set its sights on the Internet. Its goal: to totally integrate the residential building industry by providing project management solutions at all points in the supply chain.

[above] *(Before) BuildNet had rapidly acquired five new software companies and already marketed its own software. Its new identity needed to unify all of the distinct product marks, position BuildNet as the flagbearer of the brand, and accommodate future acquisitions.*

Boosted by venture capital investments and alliances with major players in the building industry, BuildNet began acquiring competitive software companies whose products facilitate accounting, job costing, scheduling, estimating, and purchasing tasks for builders. It also established the BuildNet E-Building Exchange, which provides secure Internet-based procurement, e-commerce, and information services for homebuilders, suppliers, and manufacturers.

A Fragmented Identity

Rapid acquisition of five different software companies, and plans to purchase other businesses, fragmented BuildNet's original identity. BuildNet remained the parent company, but had allowed its acquired companies to continue using their own product identities. Presenting the BuildNet identity along with the logos of the acquired products created "visual chaos" and sent a confusing message to the marketplace, says Michael Bright, BuildNet's executive

BuildNet ®

SITETRAK
A BuildNet Solution

FAST
A BuildNet Solution

BUILDSOFT
A BuildNet Solution

LLOYD'S
A BuildNet Solution

TOMSYSTEMS
A BuildNet Solution

TRUELINE
A BuildNet Solution

Client: BuildNet Inc., Research Triangle Park, North Carolina
Keith Brown | chairman and founder
Michael Bright | executive director of marketing communications

Design Team: BrandEquity International, Newton, Massachusetts
Elinor Selame | president
Joseph Selame | creative director
Penelope M. Koukos | project manager
Theodore Selame | project manager
Juan Rivera | senior designer
Richard Hallam | senior designer

Consultant: ROI Marketing Communications, Raleigh, N.C.
Randy Drawas | principal

[above] *(After) To create a visual umbrella for the parent company and its sub-brands, BrandEquity tweaked the BuildNet typeface and replaced the partial circle around its "e" with an arc. The same arc enfolds simplified elements from the acquired companies' former identities, providing a transitional identity that helped maintain the companies' existing equity in their own market niches.*

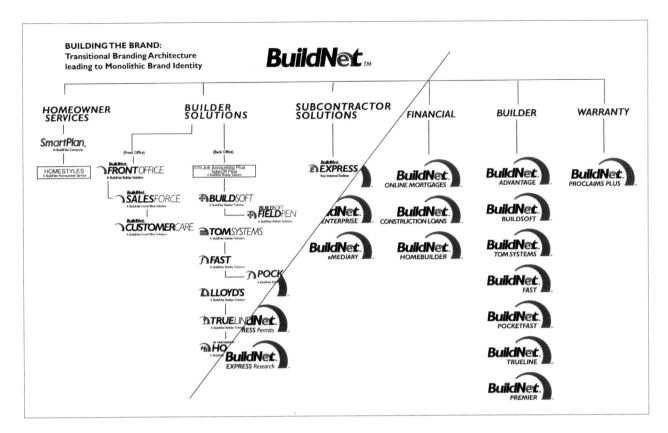

BUILDING THE BRAND:
Transitional Branding Architecture
leading to Monolithic Brand Identity

BuildNet™

| HOMEOWNER SERVICES | BUILDER SOLUTIONS | SUBCONTRACTOR SOLUTIONS | FINANCIAL | BUILDER | WARRANTY |

SmartPlan.
A BuildNet Company

HOMESTYLES
A BuildNet Homeowner Service

(Front Office)
BuildNet.
FRONTOFFICE
A BuildNet Builder Solution

(Back Office)
(CSG) Job Accounting Plus
TakeOff Plus
A BuildNet Builder Solution

BuildNet.
EXPRESS
Your Internet Toolbox

BuildNet.
ONLINE MORTGAGES

BuildNet.
ADVANTAGE

BuildNet.
PROCLAIMS PLUS

BuildNet.
SALESFORCE
A BuildNet FrontOffice Solution

BUILDSOFT
A BuildNet Builder Solution

BUILDSOFT
FIELDPEN
A BuildNet Builder Solution

...dNet.
ENTERPRISE

BuildNet.
CONSTRUCTION LOANS

BuildNet.
BUILDSOFT

BuildNet.
CUSTOMERCARE
A BuildNet FrontOffice Solution

TOMSYSTEMS
A BuildNet Builder Solution

BuildNet.
eMEDIARY

BuildNet.
HOMEBUILDER

BuildNet.
TOM SYSTEMS

FAST
A BuildNet Builder Solution

POCK

BuildNet.
FAST

LLOYD'S
A BuildNet Builder Solution

BuildNet.
POCKETFAST

TRUELINE**Net.**
A BuildNet Builder Solution
RESS Permits

BuildNet.
TRUELINE

HO
IN PARTNERSHIP

BuildNet.
EXPRESS Research

BuildNet.
PREMIER

[above] *BrandEquity developed a "living" brand architecture for BuildNet that can flex to accommodate the company's future acquisitions. When companies are initially acquired, a transitional identity incorporates the BuildNet "umbrella" over graphic elements from the acquired companies' former identities. Later, the old graphic elements are phased out and a monolithic system prevails, with the BuildNet umbrella as the most prominent feature.*

[right] *An introductory brochure plays on the shape of the umbrella-like arc in the new BuildNet logo. It will become increasingly prominent as the company's brand flagbearer.*

director of marketing communications. As BuildNet prepared to launch its new concept at the January 2000 National Association of Homebuilders show, Bright knew they needed to present a strong, unified image to the industry.

"We were a newly created company in search of a way to clarify ourselves to our market," says Bright. "We needed to make it easier for people to understand what we were doing: creating a family of solutions to meet the needs of every size builder."

On recommendation from its marketing consultant, BuildNet called on BrandEquity International (Newton, Massachusetts) to create a new branding strategy that would not only make a strong impact at the tradeshow, but grow with BuildNet as it acquired new companies.

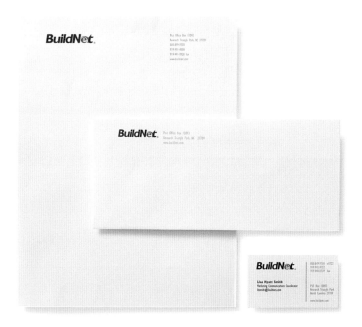

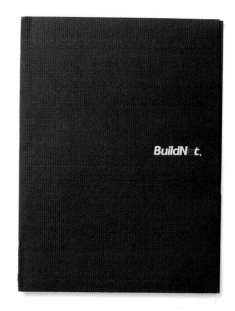

Flexibility for Growth

"This company was making radical changes in their industry, and we realized they would be in a growth-and-acquisition mode for quite some time," says Elinor Selame, president of BrandEquity International. "If we developed an inflexible branding system, they would just end up changing it over and over. They needed a very flexible, organic brand architecture that would grow with them."

BuildNet felt it couldn't just abruptly do away with the identities of its newly acquired companies. "It was crucial to our success that we maintain the equity each of these products had built in its specific marketplace," notes Bright. And the customers of the former companies needed to feel that BuildNet was not turning its back on them. So BrandEquity set out to develop a transitional branding system that would make the BuildNet identity most prominent, but visually integrate the identities of the sub-brands.

A Visual Umbrella

To achieve this, the BrandEquity team made subtle refinements to the original BuildNet logomark so that it forms a visual umbrella over the sub-brands. The original identity included a partially encircled "e" that looked similar to the trade dress used by IBM's E-Business. BrandEquity replaced the partial circle with an umbrella-like arc that is echoed in new logomarks for the acquired companies. To ensure that customers still recognized the products they had previously purchased from other companies, BrandEquity extracted simplified elements of their former identities and placed them under the graphic umbrella. Adding the tagline, "A BuildNet Solution" under each of the logos also helped unify the group.

[above] *As shown on the company letterhead, BrandEquity simplified the logo presentation to red, black, and white only, with the company names in black or white and their individual symbols and umbrellas in red. The typeface, a modified version of Gil Sans, had to work equally well in print, Web, and three-dimensional applications.*

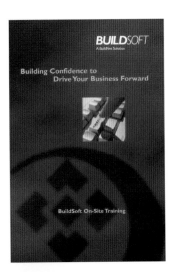

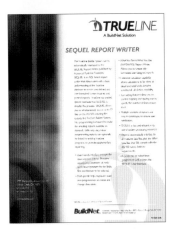

Designers also changed the BuildNet typeface slightly, lightening it up by using a modified version of Gill Sans, a clean, highly legible face. "The typeface was very important, because it had to work for the Internet, print applications, signage, and other three-dimensional uses," notes Joseph Selame, BrandEquity's creative director on the project. They also simplified the logo presentation to red, black, and white only, with the company names in black or white and their individual symbols and umbrellas in red.

For BuildNet's crucial tradeshow launch, BrandEquity devised a color-coded system for signage, brochures, product information sheets, CD covers, and other collateral that would be passed out to attendees. In addition to the color coding, each product's collateral material was made distinct by watermark versions of their symbols used in the background.

A Living Identity

BuildNet's brand architecture continues to change with the company. A year after its initial spate of acquisitions, BuildNet launched the second phase of its identity program, moving away from the transitional, product-based identity to a monolithic system in which BuildNet is the flagbearer. The graphic elements from the sub-brands' former identities were replaced with the BuildNet "umbrella," signaling that all of their products are part of the BuildNet family.

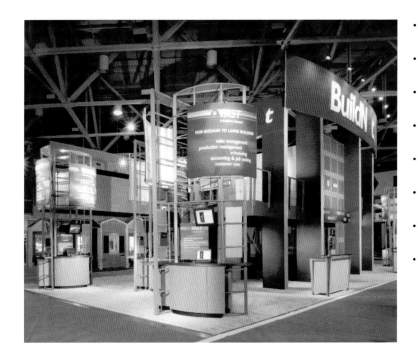

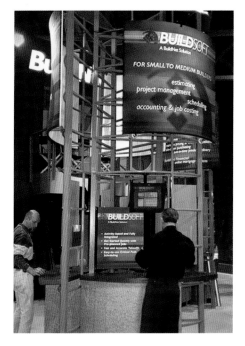

Bright says the "living" identity system has given BuildNet the flexibility to communicate with its market through all the changes the company has seen in its short history. "It has allowed us to clarify this really confusing process of going out and acquiring companies and products left and right," he explains. "The acquisitions could have caused a lot of confusion and concern, but we were able to show, in a graphic way, that all of our purchases fit into a logical process." A preliminary awareness report showed that the marketplace's recognition of the BuildNet brand increased dramatically since the new identity system was implemented.

As BuildNet makes new acquisitions, it evaluates the company's market strengths and brand equity to determine if a transitional identity should be used or whether the new company should be immediately enfolded within the monolithic identity. "We prefer to take them immediately to the monolithic style so that BuildNet's name dominates," notes Bright. "But with this system, we can fall back to a transitional identity if we feel a complete change would affect revenues, customers, or perceptions. This is not like removing a Band-Aid. Ripping it off really fast is not always the right answer." ∎

[opposite page] *To unify the BuildNet brand, while preserving the identities of its sub-brands, Brand Equity devised a color-coded system for brochures and other print collateral. Simplified graphics from their former identities are used as watermark-like elements in the new system.*

[above] *For BuildNet's crucial tradeshow launch in January 2000, its booth featured the BuildNet identity prominently. The subbrands were promoted at color-coded, circular kiosks.*

TNT | # Europe's leading express carrier brands a new era.

TNT has come a long way since its humble origins in 1946, when Australian Norm Thomas founded Thomas Nationwide Transport with one truck. The company has trekked the globe, moving its headquarters from Australia to Europe in 1992, when it combined operations with the postal groups of The Netherlands, Canada, France, Germany, and Sweden. In 1996, TNT was acquired by KPN, the Dutch postal/telecom group, and in 1998, the TNT Post Group (TPG) separated from KPN.

[above] *(Before) The boxy shape of TNT's former identity, which dated to 1948, was not perceived as modern or dynamic, and didn't reinforce the key attributes TNT wanted to communicate: globality, speed, and time. In addition, it had been applied inconsistently by operating units in various parts of the world.*

[opposite page] *(After) Flags bearing the new TNT identity fly over the company's headquarters in Amsterdam.*

By 1998, with operations in more than fifty countries, TNT was the largest express carrier in Europe and the third largest (in volume distribution) in the world, behind FedEx and UPS. But through the years, ownership transitions and the proliferation of separate business units resulted in an extremely fragmented identity. TNT's identity was not only outdated (it could be traced to 1948), but had been diluted by inconsistent use across geographic and product boundaries.

"Very simply, we were not exploiting the benefits of uniform and consistent monolithic branding," says Mathieu Lorjé, director of corporate communication for TNT. "It was more than time for an update."

TNT enlisted BrownKSDP (Amsterdam) to develop a new global identity that would reflect the positioning and ambitions of the newly integrated company while leveraging the positive attributes of the TNT brand.

Client: TNT, Amsterdam

Peter van Minderhout	vice president of corporate communication and human resources
Mathieu Lorjé	director corporate communication

Design Team: BrownKSDP, Amsterdam

Joe Kieser	ceo
Kees Schilperoort	group design director
Nikki Constantine	senior consultant
Josephine Nandan	consultant
Michael King	design director/senior designer
Adrian van Wyk	graphic designer
John Comitis	graphic designer
Dante Lupini	senior industrial designer
Sam Charlier	senior architectural and environmental designer
Wayne Smith	design technician

[above] (After) TNT's new logomark uses the purest of forms, the circle, to make a strong, modern statement and transcend cultural barriers. It also alludes to the shape of clocks and the globe, reinforcing the importance of time and TNT's global reach. The use of orange links the mark to TNT's former identity.

[opposite page—top] TNT owns and operates more than 22,000 vehicles worldwide, and re-dressing them with the new identity was a major part of the rollout. To centralize the job, BrownKSDP prepared a detailed livery manual, and with another local firm, audited TNT's worldwide fleet. Specific templates were then created for each vehicle type and shipped to individual locations.

In addition to creating a stand-alone, monolithic brand, says Lorje, TNT also hoped the new identity would be a catalyst for unifying its 67,000 employees worldwide. "We saw it as an opportunity to signal to our own people that there were serious issues to be solved and that management was committed to renewing the company and investing in its future development."

Fast Tracking

Given TNT's business focus, it was perhaps fitting that the identity development was on an extremely fast-track schedule. BrownKSDP was briefed on the project in September 1997, and the launch scheduled for April 1998.

The design consultancy used a unique process to expedite the rebranding. First they identified the TNT brand's key positive attributes, including color, type, visual language, and graphic devices. Then each element was isolated and taken through a series of modifications, ranging from slight changes (evolutionary) to more radical revisions (revolutionary). "This process is very effective under tight deadlines, as you can develop a wide range of permutations in a short period of time," explains Michael King, KSDP's design director. "It also allows you to pinpoint distinct landmarks and transfer them to the evolved brand." The team was able to quickly generate 250 brand permutations. These were filtered, refined, and narrowed to five options to present to the TNT management board.

Full Circle

From the outset, King and his team recognized that the new identity would be evolutionary rather than revolutionary. "There was a lot of heritage attached to the brand, and we wanted to ensure we preserved all the equities we could." Furthermore, he notes, launching a new global identity from scratch can often be a prohibitively expensive proposition, and a risky one. "A radically new identity would require a massive communications budget behind it. We knew a large portion of the TNT budget was going to updating its livery," he explains. And often, he adds, companies that stray too far from their former identities risk alienating their customer base.

Based on research and meetings with the TNT management team, BrownKSDP also knew the new identity should express the key brand attributes of speed, global reach, motion, and time. It also needed to subtly reinforce TNT's business diversity (express, logistics, and mail) and its advanced technology (it boasts the most sophisticated information technology systems in the industry).

TNT's old identity was considered too rigid and static for a company whose livelihood depends on speed and rapid response to client needs. Its rectangular, box-shaped logo was not perceived as being modern or dynamic. The company's historic use of orange, however, was an equity that needed to be retained, says King.

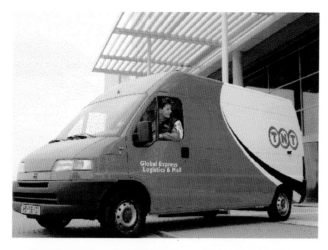

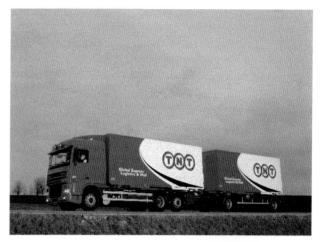

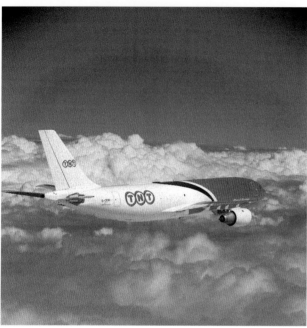

BrownKSDP's final solution evolves from the old TNT mark with the purest of forms—circles surrounding the three letters in the company name. Strong and graphic, circles can translate across many cultures, says King, and their reference to the shape of clocks, tires, and the globe reinforces the importance of time. "Using this pure and most organic of forms meant that we could cross over multiple cultural issues and not have to rely on a huge communications budget to reinforce the identity," King explains. Designers brightened the existing "industrial" orange and added black as an accent color. To add depth and reinforce the idea of movement, they added a drop shadow to the mark. The tagline "Global express, logistics and mail" articulates the brand offering.

BrownKSDP paired the interlinking-circles logotype with a graphic element they call the "dynamic ellipse," a swoosh-like device featured on packaging, vehicles, and uniforms to create an impression of speed and movement through space. On express letter packaging, they incorporated dynamic sporting images to express the attributes of speed, focus, and achieving a goal. "The universal associations attached to sport allow the packaging to communicate across cultural barriers," King notes.

[bottom—left] *TNT also operates sixty-one aircraft, which received new graphics based on BrownKSDP's detailed livery manual.*

[bottom—right] *At first glance, TNT packaging reads as primarily orange, a perception TNT reinforced by floodcoating many packaging elements in the newly refined color. "Especially in the beginning of the rollout, we wanted to quickly and firmly establish TNT's ownership of the orange," notes Michael King, BrownKSDP's design director.*

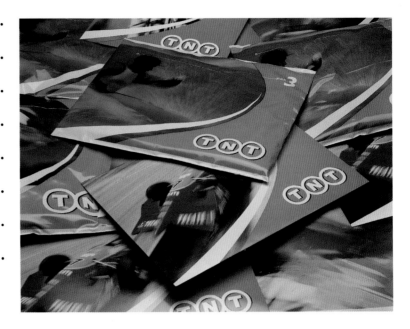

Global Reach

Because TNT operates in more than 200 countries, its new identity literally spans the globe. The new program extends to 1,300 offices and depots worldwide, as well as to 22,000 vehicles and sixty-one aircraft.

TNT's initial launch of the new identity targeted its five major markets: The Netherlands, Italy, Australia, the United Kingdom, and Germany. After a public launch on April 27, 1998, at its new European air hub in Liege, Belgium, TNT implemented the phase-one rollout in three months, then tackled an additional twenty-five countries during the remainder of 1998. In 1999, the identity was rolled out to the other 170 countries where TNT does business.

[above left] *BrownKSDP expanded TNT's graphic vocabulary with an element called the "dynamic ellipse," which is featured on the sides of packaging, uniforms, and vehicles to create an impression of speed and movement through space.*

[above right] *Express packaging features dynamic sporting images that convey the idea of speed, focus, and achieving a goal. "The universal associations attached to sport allow the packaging to cross cultural barriers," notes design director Michael King.*

[right] *With operations in 200 countries, TNT operates 1,300 offices and depots, all of which received new signage as part of the identity update.*

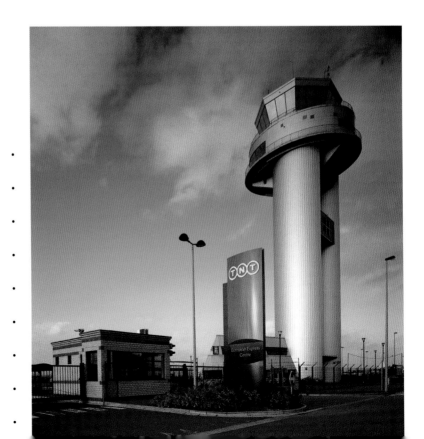

To make the aggressive rollout possible, BrownKSDP supplied all artwork (including the logo, core stationery, livery guidelines, and communications collateral) to TNT digitally. TNT then coordinated the rollout centrally, outsourcing various elements to vendors who shipped the finished products to Amsterdam. All packaging, signage, uniforms, business collateral, and other materials were shipped from Amsterdam to individual locations.

To re-dress company vehicles, BrownKSDP developed a detailed livery manual, and working with another local firm, audited TNT's worldwide fleet and developed graphic templates specific to each vehicle type. At the peak of the rollout, says Lorjé, twenty-three TNT employees, including four controllers, were solely dedicated to the operational aspects of the implementation.

Global Success

TNT's business grew 25 percent in 2000, following a 12 percent increase in 1999. "To what extent has the new corporate identity contributed to that?" asks Lorjé. "It's difficult to say."

But research conducted by TNT shows that the new identity has affected the company's success in ways other than financial. Brand tracking research showed that customer satisfaction, already high before the new identity, has increased 10 percent since the rollout. And a study of "internal motivation" showed that employees are feeling more positive about their company. "They can see now the global character, the diversity of business, and the commitment our board of management has made to investing in the future," Lorjé explains. "We have a better story now to tell our customers, and it translates into a good feeling about our own jobs." ∎

[above left] *The new branding was also extended to third-party products and elements. While they are branded with core TNT visual elements (logo, color, and forms), the brand extension allows the products' unique visual languages to dominate.*

[above right] *The identity program also encompassed a new workwear system that features the logomark and the dynamic ellipse.*

Online Identities

We are a brand-conscious people. The cars we drive, the food we eat, even our most mundane purchases, such as soap and toilet paper, are clearly branded. But what comes to mind when we speak of the elements of branding? Most immediately, we think of packaging—labels, bags, boxes, and the logos printed, stamped, or otherwise emblazoned upon them. But packaging alone does not define a brand entirely.

It's difficult to imagine packaging a website for presentation as a branded commodity. Yet this is what we must do as brand-aware Web builders and designers. Web designers, like architects, are building custom-crafted solutions to particular sets of problems. This custom crafting is the most appealing aspect of the work for many of us. Each site requires a strongly stated, coherent identity, and it is this identity that becomes the site's brand. And for users, the browsing public whose attentions we most desire, the brand becomes the thing that is most recognizable about a site.

There are several aspects of a brand that must be considered when establishing a site. The process of branding a site is in many ways similar to designing a corporate identity. But where a corporate identity considers only the visual manifestation of the image to be projected, website branding must also take the site's entire contents into consideration. This includes the content itself, the words and images displayed, and also the way in which all of these are presented.

This takes us back to the idea of packaging, because for a website, the content represents the product, and the package becomes synonymous with the brand. And just as a product designer works to achieve the right look and feel—for instance, a product has not only a Nike label, but also a Nike-designed look—we must achieve the same intangible rightness for every site we place on a server for broadcast to the entire Web.

One of the most obvious lessons of graphic design as used in advertising and marketing is that what is left unsaid can be as important as what is said. This lesson is especially applicable to Web design, which depends on establishing positive and easily recognizable identities, rather than becoming another anonymous URL in the seemingly boundless landscape of the ceaselessly expanding World Wide Web.

This section examines websites—great sites that contain useful information, are worth revisiting, and promote the site brand in attractive, memorable, and innovative ways. In the first half, I identify and examine the elements of Web branding. Starting with logos and the treatment of standard corporate and brand identifiers on pages and sites, I then discuss the use of traditional graphic design elements, such as layout, color, and typography, to define image. You will see how branded navigation can affect the clarity and ease-of-use of a site and learn how elements such as text and dynamic content can be used to project a range of qualities such as sophistication and friendliness.

In the second half I explore the use of branding elements to create sites of different types—the application of branding theory in real Web situations. We learn that what is right for a big brand may not be appropriate for a boutique brand; that information-oriented sites have very different branding concerns from e-commerce sites. In short, Web branding is as much a matter of customization as Web architecture is. And just as you must consider the interaction of elements like site structure and navigation, you must be aware of the power of branding to establish the architectural elements of a site.

This investigation does not attempt to recommend any right way to design or incorporate branding into a design. Instead, it tries to show the breadth of possibilities available to the creative brander. The emphasis is on the use of dynamic tools and techniques, and the only way to decide what will work is to understand what image you're trying to project before you start designing. Know your client, know your audience, and know what's possible with the technology available. These are the real secrets to great websites.

—*Clay Andres*

If you watched Super Bowl XXXIV, you also saw the first dot-com bowl—what a great way to begin the millennium. Could there be anything homier or more American than the family gathered together on a cold winter evening to watch the finest advertising agencies fight it out on national television? It's great entertainment, perhaps the finest television has to offer, and it's all about branding—an ostentatiously expensive battle for your attention. (For an in-depth definition of branding, please see the Introduction.)

This fine, old tradition was pioneered by Apple's memorable 1984 commercial, introducing the Macintosh. Those were the days when computer companies came and went as quickly as Internet start-ups do today, when Big Blue was the evil Big Brother, and Microsoft appeared like a white knight in shining armor. Images may tarnish, but brands endure, even in the emerging medium of the World Wide Web, but it has become a brand-crowded world.

With so many enduring brands, how is a dot-com to establish its own identity? Ad agencies know how to burn millions creating brand recognition in the old broadcast box, but they don't necessarily understand how to transfer such branding to the new broadband boxes of the Internet.

Can you get a well-branded site for $2.2 million dollars, the average cost of thirty seconds of fame during Super Bowl XXXIV? For this exploration of great Web branding, sites are examined as if they were products that might be purchased off a shelf. Is a box of Cracker Jacks so different from a Web site for Cracker Jacks? Yes, but some of the same elements of image and information must be present in both. There may even be a prize in every box!

[1] BRAND RECOGNITION
VISUAL IDENTITY

SUPER BRANDING FUMBLE

The fact is, the NFL itself and the Super Bowl in particular are great brands—pinnacles of brand name recognition. But they seem to have forgotten they have a great brand when it comes to branding their Web site or even a single Web page, www.nfl.com.

FOOTBALL OR BEER, WHICH SELLS BETTER?

The page is clearly about football, but where's the NFL.com brand? It's there, in a strange, almost undetectable graphic arrangement with the NFL shield. But the designers of this page aren't emphasizing its importance. And perhaps the NFL.com brand isn't important to the NFL hierarchy or, more significantly, to its fans. After all, this page is not about dot-coms or the Branding Bowl; it's really about football. On the other hand, there is money to be made here. There are sponsors willing to pay for banner ads, and there's a wealth of carefully branded NFL souvenirs available.

Vying for attention with the NFL.com brand is the Super Bowl XXXIV logo, which links to SuperBowl.com. This home page is somewhat better; the Super Bowl XXXIV logo is big and prominent, and almost everything on the page says Super Bowl.

(LEFT) 'Whose page is this anyway,' episode 2. Here's a Miller Lite logo next to Super Bowl MVP, St. Louis Rams–recycled quarterback, Kurt Warner, and a more discreet ABC Sports logo just under his picture. And there's ESPN, always lurking at the edges. You could say that these are like the usual banner ads and they don't really detract, but the role of advertising is clearly more important to the NFL than it is to most Web sites.

(RIGHT) Brand unrecognition: Is this the NFL's home page or ESPN's? There are lots of logos here, and the NFL's is biggest. But there are also some odd logo pairings at the bottom; the NFL plays catch with Motorola next to an ESPN Internet Ventures logo that seems to dominate the NFL logo.

LOOKING FOR CROSS-BRANDING SYNERGY

There's an obviously intentional link between the NFL and ESPN, the American sports broadcasting network. In fact, it looks as if ESPN is making these pages for the NFL and, indeed, it is through its ESPN Internet Ventures (EIV) subsidiary.

There's no mention of EIV on the ESPN home page, yet another Internet entity, GO.com, (now defunct) had inserted its own banner at the top of the page. Let's follow this confusion of brands to the GO.com page, a once popular portal where the news brand was ABC and the sports brand was ESPN.

Aside from a well-positioned and strongly defined identity, GO's box was pretty bland and gave the contents a somewhat monotonous flavor without any sugar coating or nutlike crunch.

Back at the gridiron, fans probably don't care that the NFL is recklessly ignoring its own brands on the Web. But if the NFL isn't careful, it's possible it'll end up being a small brand in a very large media conglomerate. Okay, Mouseketeers, are you ready for the first Disney Bowl?

(ABOVE) The ESPN site shares some of the same design aesthetic with the NFL site. Notice especially the ESPN logo, which links to all of the ESPN Internet Ventures (EIV) sports-related Web sites, including NFL.com and SuperBowl.com.

SEARCH ⦾ the Web ⦿ Images *More...*

Wednesday, February 16, 2000

GO.com

Vacation sweepstakes - win!
Free Sundays with MCI

Search options | How to search | GOguardian™ is off

[Find]

My Page | **Home** | Search | Communicate | Shopping | ❓

MEMBER SERVICES

Free e-mail

Personalized start page

Register today!

Member sign-in

Oscar.com ❦A.M.P.A.S.® SEARCH CRIMINAL RECORDS Click Here

TOP ABCNEWS

Bauer to Endorse McCain

Hacker Denies Attack

Gas Prices Headed Up

FEATURED SPONSORS

Donate Britannica.com's $

myprimetime.com - Now life comes with a road map.

TODAY ON GO NETWORK

Who can you trust? | The perfect getaway | Be a Millionaire

ABCNEWS
US, world, business...

Auction
Collectibles, art...

Autos
Pricing, specs...

Broadcast
Radio, mp3, media...

Careers
Jobs, advice...

Computing
Reviews, screensaver...

Education
Teaching, learning...

ESPN Sports
NBA, NFL, fantasy...

Family
Pets, babies, 45+...

Food and Drink
Recipes, dining...

Games
Free games, prizes...

Health
Diseases, fitness...

Kids
Play games, prizes...

Money
Stocks, markets...

Movies and TV
News, reviews, bios...

Music
CDs, news, bios...

Real Estate
Homes, rent, move...

Romance
Weddings, registry...

Shopping
Products, merchants...

Travel
Flights, bargains...

Women
Family, beauty...

Take a red carpet ride with Oscar coverage on GO Network

Mr. Showbiz Oscar central | **The Academy's finest moments**

TOOLS
Dictionary
Driving directions
Maps
Translator
White pages
Yellow pages

QUICKLINKS
Downloads
Horoscopes
Movie times
Stock quotes
TV times
Weather

COMMUNICATE
Chat
Free home pages
GO Invite
Message boards

NEW ON GO.COM
GO Guides
GO Organizer
GO Remote

GO Network Partners: ABC.com | ABCNEWS.com | ESPN.com | Disney.com | Family.com | MrShowbiz

Add URL | Affiliate program | Express search | Intranet software | GO international sites

Copyright © 1998-2000 GO.com. All rights reserved.
Contact us | Jobs | Investor relations | Legal notices | Privacy and safety

(ABOVE) All roads lead to Go. What's going on here is that GO, the Web entity created when Disney absorbed InfoSeek, oversees all of EIV's Web sites. EIV is responsible for most of the major official sports-league Web sites of the United States. On Wall Street this might be considered branding synergy, but it leaves Web branders and browsers in confusion.

ADDING "E" FOR SUCCESS: DISCUSSING E*TRADE'S SITE

E*trade, the online brokerage and financial information Web site, worked harder than anyone (even Budweiser) to make the Super Bowl a coming-out party to remember. Not only did it take out ads in every quarter, but it beat out all our favorite beverage vendors for the right to name the halftime show after itself.

The E*trade home page, www.etrade.com, has the flavor of a portal, with news items and a regularly updated stock ticker. But providing a portal is not the objective here. This is pure business or, perhaps, a business club.

BRANDING IS EVERYWHERE

You do your research, follow your favorite issues, perhaps buy and sell securities, without ever speaking to a trusted (or suspect) human advisor. You can act on a tip you picked up at the office water cooler without fear of embarrassment.

While E*trade does away with the need for human contact, it does not let you forget with whom you are trading. Can you count the number of instances of E*trade on this page? Not only the logo, but also the E*trade IRA, E*trade Tax Center, E*trade Mail, E*trade Store, E*trade Visa, Power E*trade, E*trade International, and the E*trade Game are listed. You might say this is a brand-centric page. The only unbranded areas are the tabbed navigation bar across the top and the market watch chart, the two purely business-oriented features.

Regular visitors probably won't linger much over the home page, choosing instead one of the action areas from the tabbed links. So this initial look at E*trade is more important for first-time visitors or nonmembers. Not surprisingly, you must join E*trade to use most of its services. There's a discreet Free Membership link in the middle of the page and a small, yellow "Open an Account" button heading the list of links in the left-side navigation column. But our eye is first drawn to the offer of 25,000 frequent flyer miles. This is better than Cracker Jacks.

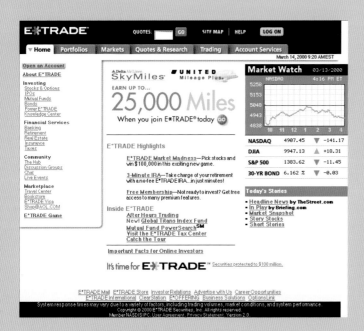

(ABOVE) E*trade's home page serves as a surrogate broker's office where you can check all kinds of information and learn about (or be sold) various financial products.

CONSISTENT DESIGN, STRONG NAVIGATION, AND EASE OF USE

Clicking the Markets tab opens this top-level divisional page. The page layout and navigational elements are identical to the home page. The E*trade logo, with its interlocking bull/bear arrows forming the asterisk, is at the upper left. The section tabs are unchanged, except that Markets is now highlighted, and the nonhierarchical links in the black horizontal bar across the top remain.

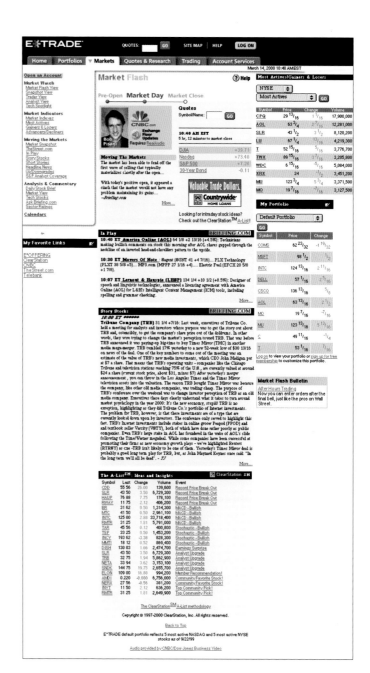

(ABOVE) Top-level divisional pages, like this one for Markets, contain similar branding elements to the home page. But the emphasis here is focused on information, while the home page is a starting point for further exploration.

THE DETAILS OF SIMPLICITY AND SOPHISTICATION

The branding and navigation bar at the top is implemented as a simple, two-row-by-one-column table. The links are image maps and the images themselves are all GIFs. There is a lone form field for entering stock symbols for current quotes. The tab bar itself is a single image created with one tab casting a shadow on the next, the text embossed on the tabs to give an impression of depth. The currently active tab is brought to the front, casting a shadow on both neighboring tabs, and it is filled white so that it blends in with the white background beneath, effectively becoming the tab for that page. A green down-pointing arrow helps highlight the tab and link it with the content beneath. This is basic stuff effectively executed to look sophisticated without being complicated.

The page, as defined by the area with the white background, is divided into three columns with sectional links on the left, textual content in the middle, and active quotes listed in tabular form on the right. All the content of the page is laid out in tables. Alternating gray and white bars are used for the stock tables, which are built from custom Common Gateway Interfaces (CGIs) that fill in the information when the page is loaded. Yellow table backgrounds create a yellow-pad effect for the textual content in the middle. The left-side navigation bar is separated from the other content by a drop shadow. Visually, the shadow ties the navigation bar to the navigational tabs, while separating it from the other content, even though all the elements exist structurally as separate tables.

All of this effort helps create the E*trade package, one of businesslike clarity and concision. It also enables each page to include a maximum amount of information without creating a chaos of topics and an overabundance of links. Furthermore, the consistent application of this layout scheme becomes familiar to the regular visitor, making it even easier to navigate to the different areas of the site. This is the members-only effect. Yes, it's great to be able to trade online and get a big discount while we're at it, but one of the benefits of membership and frequent use is that this quickly becomes a comfortable place to visit and, even more importantly, to linger.

(ABOVE AND OPPOSITE) Even these registration pages are consistent with a carefully branded site. The horizontal elements—black band on top for identification and nonhierarchical links within, white context area in the middle, and black bar with small, legal print across the bottom—are already familiar. There is the consistent use of the green and blue colors from the E*trade asterisk in the headline text.

MEMBERS ONLY, BUT NOT EXCLUSIVE

You have to join the E*trade clubhouse to find out what it's like to be a real insider. Clicking a link to any restricted area brings up the Log On window. You are still comfortably within the E*trade package, but you must choose to become a member (it's free) and/or open an account.

For anyone who has spent much time browsing the Web, this is a fairly typical sign-up page, but perhaps cleaner than most. It's also immediately evident that it has the E*trade look. Even with the page scrolled down so that no logo is showing, the familiar layout, navigational elements, and color scheme let you know that you are still within the clubhouse.

NO BROKERS, BUT STILL PERSONAL

The Quotes & Research Center contains more of the familiar club fare, but note that now the yellow Log On button in the upper-right corner of the page has become a blue Log Off button. Ah, the privileges of membership. You are now eligible for real-time quotes, and there's a list of other Exclusive Customer Features.

The designers of E*trade's site have managed to fit all kinds of information into their page template. This is the E*trade way and the E*trade look summed up in a large Web site that feels cozy. In fact, the databases used to provide information for this site are huge, complex, and constantly changing.

The effect of these simple personalizations is to make E*trade's way of doing business your way of doing business—your preferred trading method. It is not an idea that is exclusive to E*trade, but once you have a membership with one online trading partner, it's easier to remain loyal than to start all over with another. It's the Web version of brand loyalty.

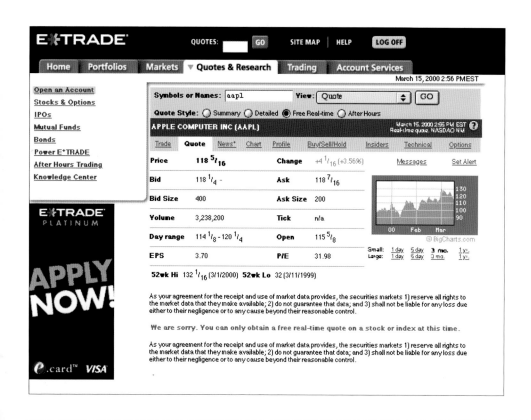

(ABOVE) Link lists, blocks of text, and quote tables all look right at home within what amounts to the same E*trade space.

WHAT HAS EIGHTEEN WHEELS AND FLIES?

Making a return visit to Super Sunday was Volvo's idea of the typical truck driver in his luxurious Volvo eighteen-wheeler, completely equipped with onboard valet. "Your toothpick, sir?" Volvo is a familiar brand to us all, but volvo.com is not a car site. Instead, this is the site for the Volvo Group: trucks, buses, construction equipment, marine and industrial engines, and aero products (things that fly). It clearly says so right across the color-coded, horizontal navigation bar. There's an external link to Volvo Cars, but you can forget about station wagons at this industrially oriented site.

IDENTITY CRISIS, BRANDING SOLUTION

Now that Volvo Cars is a wholly owned subsidiary of Ford, the Volvo Group has a bit of a branding problem. If Volvo isn't cars, what is it? The text of this entry page points out that the Volvo Group, owners of the www.volvo.com domain, is "intensively focused on transport solutions for commercial use." Does this sound like horseless carriages? No, it is the high end of big things that move.

The elements of the Volvo site are all strongly established on the entry page, which essentially becomes Volvo's Web package. Upon entering the Volvo domain, you are immediately transported into the package. What would be the home page is left behind for a new window. It opens to fill whatever size display you're browsing on with a dark-blue background, the package box, and a longish, white rectangle in the middle—its content.

The immediately recognizable Volvo logo is present in the upper left corner, the place where most logos go. But it is part of the surrounding blue box and is not prominent. Instead, the content space emphasizes volvo.com, along with five bold images: truck, bus, payloader, airplane, and the Volvo Penta logo. The background color of each division image matches the corresponding link color of the horizontal navigation bar above. These five images themselves are rollovers with explanatory messages and links to the division pages, which continue the color scheme established by the entry page.

(ABOVE) The OpenWindow JavaScript used to launch this window also turns off standard scrolling and browser commands. The effect is somewhat TV-like, concentrating your attention on this single display space.

DIVIDE AND SUBBRAND

This color scheme also shows how Volvo has clearly divided its site into five divisions, but has not left out important links to nondivisional elements: news, info, career, contact, and copyright information. While these features are nonhierarchical, it's important for browsers to be able to access them from the top level of the site. Grouping them in the red links makes them accessible without giving them more importance than the corporate entities that make up the Volvo Group and thus detracting from the brands presented here.

Even though the contents of Volvo's Web package don't take up much room on the page, a lot has been crammed into this space. For instance, the headings of the navigation bar are not just simple links. Clicking a heading opens a drop-down menu of links that provide direct access to the hierarchical sections within each division. Clicking once anywhere within the navigation area activates rollover access to the drop-down menus and links. Clicking a second time executes the highlighted link or turns off the rollovers.

(ABOVE) This composite screen shot shows the navigation bar, the five images, their rollovers, and the red news bar from the bottom of the page. This makes the use of color to brand each division within Volvo more obvious.

User-interface experts can argue over the advisability of forcing the user to click an extra time instead of using direct rollovers to drop the menus. I prefer the direct rollover, but as long as the implementation is consistent, as it is here, either system is fine.

This is a dense page, yet we are not overwhelmed by the number of links or the amount of information. The rectilinear layout (some might call it boxy) establishes a strong framework upon which all the pages of this site are based. Even the color scheme for the site is evident from the start. This spare, unfussy arrangement imparts the kind of elegance that is one of the hallmarks of Swedish design in general, and Volvo in particular.

▶ The Volvo Group	▶ Trucks	▶ Buses	▶ Construction Equipment	▶ Marine and Industrial Engines	▶ Aero	▶ News, Info and Career
Home	Home	Home	Home	Home	Home	Home
Business Overvie	Customer Off	Corporate Inf	Product Range	Business Information	Business Inf	Press Releases
CEO	Volvo Trucks	Press Center	Dealer Locator	Importers/ Dealers	Military Engin	Image Bank
Board	Our Core Valu	Product Rang	Business Information	Marine Commercial	Commercial E	Calendar
Management	Markets	Used Buses	History	Marine Leisure	Engine Servi	Publications
Core Values	Business Part	Sales Contact	Media Services	Industrial	Space Propu	Career
Shareholder & Inv	Used Trucks	Public Transp	Career	Parts and Accessories	Land & Marin	Contact
Research & Technology	After Sales S	M3 Magazine		Press Center	Volvo Aero Turbines (UK) Ltd	
Volvo in Sponsoring	Contact Us	Contact Us		Human Resources	Aviation Support Services	
Volvo Information Technology				Core Values	Vehicle Components	
Other Volvo Companies				Contact Us	Research & Development	
History & Museum					Product key	

(ABOVE) Here's a composite image showing all the drop-down menus on Volvo's home page. Notice how each division has its own home page, as does the news heading.

Volvo Construction Equipment

Volvo Construction Equipment represents all the key values that have made Volvo one of the world's best known brand names. Our goal is to achieve optimum interaction between mankind, machine and environment. We are currently working on a new website to better meet the increasing needs of our customers. Until then this page will guide you to our existing website

CLICK HERE TO ENTER SITE

Distribution Contact

news VOLVO LAUNCHES NEW D-SERIES WHEEL LOADER RANGE

contact | copyright

Marine and Industrial Engines

AB Volvo Penta is based in Sweden and is a leading producer of marine and industrial power systems. The company's products are sold in more than 100 countries. Development and production of diesel engines is carried out in Vara and Skövde in Sweden. Gasoline engines and drive systems for installation in leisure boats are developed and produced in Lexington, Tennessee in the US. Volvo Penta has approximately 1,300 employees.

The New Press Center Marine Commercial Marine Leisure Industrial Engines Parts and Accessories

news VOLVO LAUNCHES NEW D-SERIES WHEEL LOADER RANGE

contact | copyright

(THIS SPREAD AND FOLLOWING SPREAD) Each division page is distinct, yet there's a harmonious order to them all. The truck site corresponds with the bus site, which corresponds with the heavy-equipment site, and so forth.

The fact is, it's a beautifully engineered site. So beautifully, that barely anything needs to change when you enter one of Volvo's divisions. And yet it's clear at all times exactly where you are. The portal frame changes, as does the color of the highlight under the navigation bar. More subtly, the subheading following the Volvo logo at the top also changes for each division.

The collage of images on each division home page provides non-hierarchical links to more current, important, or popular items. Rolling over an image pops up a caption for the connected link, although there's at least one animated GIF on the Construction Equipment page. The particular images and the number of links can be changed to suit the division or to reflect recent events. It's boxy, but not rigid.

The site could do much more, but many of the links leave the orderliness of this nearly hermetically sealed package to individual division sites, which are generally quite ordinary in their use of navigation, imagery, and in establishing the Volvo brand at the high end of a blue-collar world. This opens the question of who's actually using this site. It probably wasn't built for teamsters. No, this equipment may be built to get dirty, but it's being purchased by a very white-collar crowd: The same crowd that feels safe waiting in the school pick-up line in one of those very boxy, but beautifully engineered Swedish station wagons from Volvo.

▸ The Volvo Group ▸ Trucks ▸ Buses ▸ Construction Equipment ▸ Marine and Industrial Engines ▸ Aero ▸ News, Info and Career

Volvo Aero Corporation

Volvo Aero, a wholly owned subsidiary of AB Volvo, develops and manufactures components for aircraft and rocket engines with a high technology content as a partner to the world's leading manufacturers in this segment. In its service operations, the company offers a broad range of products, including sale of spare parts for aircraft engines and aircraft, sale and leasing of aircraft engines and aircraft, and overhaul and repair of aircraft engines.

news VOLVO TRUCKS' DELIVERIES JANUARY–FEBRUARY 2000 contact | copyright

What's in a name? Everything, if it's followed by .com. Would a rose smell as sweet if it were from rose.com (a seemingly defunct ISP), or roses.com (a florist)? Of course, innumerable rose dealers exist online. You can find cut roses (flowers.com), rose plants (rosarium.com), rose forums (roses.about.com), and endless information about roses (roses.org). But only one rose.com exists, and as a Web site, it stinks.

Okay, so the scratch 'n sniff transfer protocol has yet to be perfected, but a site can convey a lot of information simply from its look. The look can set the tone or mood as effectively as text copy or any single image.

Domain names are an important aspect of Web sites, but as explained in Chapter 1 about monster.com, plenty of room is left for imagination. And perhaps too much emphasis exists on domain names. Names, as well as tag lines, words used for buttons, and the tone of textual content, create perceptual associations for browsers. This nonvisual identity of a site in some ways is the most important aspect of branding, because it's completely portable.

For example, the monster.com site uses a lot of visual imagery, most notably with its monsters and color schemes. But the site's tag line, "Work. Life. Possibilities," has a succinctness and ring of truth to it that no monster, no matter how inventive, can match. Sites in this chapter were selected for their nonobvious use of branding elements and not for their "coolness." In fact, these sites achieve their strong sense of brand almost in spite of themselves.

[2] IMAGE PERCEPTION
NONVISUAL IDENTITY

CELTIC BREW—THE SECRETS OF OBFUSCATION

Tazo, the tea packager, was recently purchased by the biggest brand in the Northwest that's not yet a monopoly, Starbucks. Tazo makes a high-quality product that is sold largely on the basis of pretense—Tazo, "The Reincarnation of Tea." Even the name, chosen to sound mystical in an Eastern, spiritual sort of way, is complete fiction. It's all made up. And yet even supposedly sophisticated types buy the stuff. Fortunately, the joke is a clever one, and you can drink the tea, which is good, and chuckle inwardly at the joke.

Teaologists, tea scholars, and tea shamen have all contributed to the self-described tea universe that is tazo.com. What's going on here? When you enter the Tazo universe at www.tazo.com, you must wait through a long pause while the Flash movie loads. The use of Flash is a high-tech solution with a decidedly archaic-looking result.

THE TEA LEAVES ARE CLOUDY; THE EFFECT IS NOT

This site revels in sophisticated phoniness. About the only real object on this entry page is the Tazo logo, and it's reproduced in such a way as to look like an old grave rubbing. The site is like a magician's sleight-of-hand trick. This page, the first loaded, is labeled number three. A definition of Tazo, complete with correct pronunciation and dated 4786 B.C. is at the bottom. The symbols on the page look like characters from an ancient alphabet with odd reference numbers. The whole presentation looks genuine, and for a split second you might believe that Tazo is not just a modern-day fabrication. But then the joke becomes obvious and you play along, believing whatever the tea leaves tell you.

(ABOVE) It looks like something as mysterious and ancient as the *Book of Kells* with fuzzy reproductions of what might be ancient Christian imagery and an odd blend of Saxon and far Eastern typography. But this home page is really an elaborate hoax.

POKING FUN WITH SERIOUS DESIGN

The elements may be mystical, but graphically, this composition is very modern. The simple ruled box centered on the page, the incongruous dashed line that breaks the border, and even the reverse logotype are all popular design elements. But here they are used in unconventional ways, which is part of what makes this page interesting.

When you unwrap this package, you can see what's inside this brand. It turns out that the links all lead to the same series of four frames within this Flash animation. These pages all bear the marks of the Tazo Universe—slightly blurry imagery, unrecognizable foreign characters, and a reverential tone that is completely tongue-in-cheek. Even the color scheme has the musty quality of a medieval cathedral, and yet, it's very contemporary.

NO TREASURE UNDER THE MOSS

What's strangely missing from Tazo's Web package is any real information. What are the products, how do you get them, or even why Tazo? The first two questions are answered by links to Starbuck's site, a temple of Web commerce, and by a link to a catalog request form. Surprisingly, this place is not one from which you can find out anything about tea.

Tazo isn't selling anything but karma, which, in a way, is the answer to the third question. In the search for brands that have meaning beyond a patented "flow-thru" tea bag, Tazo presents itself with twenty-first century sophistication. Tazo makes you feel comfortable, hip, smart, or some other form of modern contentment, which makes people happy to be a part of the Tazo fantasy.

Obviously, Tazo's site will change, and most likely it will sell its wares online someday. But doing so should be easy for it because its Web persona is already well established.

(ABOVE) At the bottom of each frame are navigational elements that let you move forward, back, or return to the Tazo entry page. Because the site uses Flash, the pages have already loaded and you can move about very quickly.

WHEN A BRAND IS NOT THE BRAND

What kind of brand is Turbonium? Simple—it's a bogus brand, a brand for the unbrandconscious, a way to brand the VW Turbo Beetle without branding it. It's a way to make the right people—and you know who you are—feel even better about liking the retro, yet very contemporary, reincarnation of Volkswagen's Beetle. It's a car site for people who don't necessarily like cars.

The Turbonium site, www.turbonium.com, shares some of the studiously subtle nonbrand features of the Metro and Gmund sites, but doesn't go as far as Tazo into the land of make-believe. If a site could smile, this one would, yet it manages to do so while carrying a full load of factual data—all the gory specification details that are the usual baggage of car sites. In this site, even the mundane becomes fun. Volkswagen may be the people's car but there's nothing hoi polloi about this site.

Scientists have discovered a new element

skip

FUN WITH ALCHEMY

At the end of the introductory Flash animation, a mild-mannered image is presented in the form of an excerpt from a fictitious periodic table of elements. Trb, Turbonium, is the middle element, flanked by St, Stuff, and Tv, Television. The page is clearly marked with the VW logo and Drivers Wanted slogan in the bottom right corner, and a light gray Volkswagen of America copyright is in the opposite corner. But this page bears the Turbonium brand, a powerful combination of positive energy and product positioning.

Turbonium would not exist, as a brand or an element, without the Web. It is not something you can own or buy; it exists solely to promote the turbocharged VW Beetle to a turbocharged Web-browsing audience. So how do you make a brand out of something that isn't there? Be bold.

and they are calling it Turbonium.

skip

(THIS SPREAD) You enter the world of Turbonium through a Flash animation. Then the animation lingers for several seconds over a glistening image of a bottle green Turbo Beetle and then delivers the punch line. The sophisticated sense of humor is immediately apparent.

MOVEMENT AND SOUND, PLUS AN ANIMATED EXPERIENCE

For starters, the home page serves solely as the primary navigational tool. (The designers of this site are creating an HTML pun by using chemical elements as navigational elements.) Each element represents a hierarchical link, and each level is contained within a different Flash animation. Click the Turbonium square. The music starts again, the green Beetle zooms on to the screen for a few seconds, and then a new table of elemental rollover links is revealed, Eng, Engine; Fea, Features; Spe, Specs; Opt, Options; Saf, Safety; and Cst, Cost.

(THIS PAGE) Roll over a button and it isn't just highlighted, it makes noise and practically pops off the page.

Nothing on this site happens in a static way. Even a look at the engine's features becomes something of a game. "Warning: Entering Secure Area. Authorized Research Personnel Only," reads the dire message. A security clearance sequence follows, and then you must choose to enter the Research Area. It's pure gamesmanship, but by requiring you to make a choice, you become part of the game.

After passing the entry sequence, every section page has a nifty navigation tool in the lower-left corner. The page gives no hint as to how the tool works, but it's clear that something will happen when the cursor passes over it. And indeed, the hexagonal element comes to life when touched. The center arrow serves as back button, and the dots around the perimeter of the circle link to the three main hierarchical divisions, to the home page, or to the nonhierarchical pages for dealer information.

SURPRISES AROUND EVERY CORNER

Unexpectedly original schemes make all the sections of this site more interesting. It's the Turbonium way. This kind of amusement keeps one looking at the site, and almost without realizing it, becoming Turbonium-charged oneself.

An interesting note is that even though a VW logo, with a link back to the corporate site, appears on most pages, the Beetle name is barely mentioned at all. This is because the site is selling Turbonium, which is somewhat like hot ice cream or sweat-free exercise—you may want them, but you can't have them. Yet why you're here is perfectly clear. Although the popularity of the Beetle begins with its retro charms, clearly this car would not be selling nearly so well if it didn't appeal to sophisticated tastes.

(LEFT) Click a feature. A mechanical voice announces the selection, a section of the engine becomes highlighted, and some humorously written text appears.

(RIGHT) The options link shows a color specifier. Choose any interior and exterior color to see what they look like together. Use the animated navigation tool in the bottom corner to navigate through the twists and turns of this very amusing site.

Logos, corporate identity systems, branding—they've all had to be adapted to fit with new media, which has been both a challenge and a windfall for designers. In many respects, the Web is merely the latest expansion of the media universe, and so, for the unimaginative, it becomes a straightforward process to digitize existing materials and plug them into Web pages. But creative Web branders know that much can be gained by expanding the presentation of brand identities to suit the particularities of the Web.

Look at it another way. You can put a logo on a Web page, but not all logos serve well in this new context. Some are too static, others too detailed, and others too old-fashioned; any number of problems crop up. There are effective methods of translating a corporate image to the Web or expanding a brand in ways that aren't possible in other media. This chapter explores one such expansion, branded navigation.

For instance, the nonsequential aspect of Web sites necessitates careful attention to navigational schemes. The creation of a navigational plan is generally considered a usability issue, not an issue for marketing people—especially those concerned with branding. Yet navigation is one of the most important aspects of site design, the foundation of a site's architecture, and is therefore a prime area for incorporating branding elements.

[3] NAVIGATIONAL CONTEXT
BRAND MAPPING

WWW.IO.COM (URL)
AGENCY (DESIGN FIRM)
MOTOROLA (CLIENT)

NAVIGATING IO.MOTOROLA.COM

On one hand, it's just a site for cable modems, but on the other hand, it's Motorola's cable-Internet-access information center—a site touting the advantages of broadband connectivity to the Internet through cable access in general, and the virtues of Motorola's io brand of cable modems in particular, io.motorola.com. The site is also designed to accommodate expansion of the io line into other product areas. And, by the way, you can also buy the modems from the site.

The io brand (Motorola has chosen to keep both letters lowercase) is Motorola's entrée into home networking and telephone products. The designers are clearly building on the Motorola name, while at the same time creating a new brand category. Thus the use of the subdomain, io.motorola.com, and the design of the io logo, a simple, strong logotype symbol appended to the Motorola name. More importantly, the logo is put to extensive branding use on the io Web site.

NAVIGATIONAL IMAGERY

The introduction to the io site begins with a Flash animation. Like marching ants, a series of pulsing dots leads the viewer to the io words—imagination, information, communication, and transformation. Sound, constant motion, a clear message, and a carefully integrated io logo are woven into the introduction. What the viewer doesn't realize right away is that the glowing dots will be transformed into the chief image element for the site's navigation.

The main navigation bar loads in a frame above the introductory movie. It, too, is a Flash element. Here, the viewer sees an expansion of the dot motif—a series of larger, colored dots, each within concentric circles and arranged within a wireframe funnel, pointing to the Motorola name and the io logo. This Flash element provides the hierarchical links for the site.

(**RIGHT TOP**) Is it a reference to computer input and output, to the binary 1's and 0's that make up a computer's memory, or to the on and off states of a computer's power switch? Motorola's io logo is intentionally ambiguous, but full of the right kinds of associations to conjure up positive connotations.

(**BOTTOM**) Graphically, the io navigation bar is probably too big; it occupies too much vertical space, especially for smaller screens. But it is an effective and attractive tool that doubles as a brand-strengthening element.

BRANDED LINKS

From a branding perspective, each dot represents the reduction of the io logo to its logical minimum, the circle. This means that each dot is an io-branded link. The dots and, therefore, the site sections, are identified by color and label. Therefore, instead of a generic home button, there is an io-home button, and so forth. This use of visual cues to establish the unstated helps strengthen the page visually, and as a result, the io-ness of each link is understood. Each linking element is further reinforced with a rollover and a surprising gonglike sound when clicked.

Most people browsing the Web recognize a horizontal navigation bar across the top of a page and understand that this top-level band of links is analogous to the top-level hierarchy of the site. The addition of multimedia effects adds to the perception that io is a high-quality, sophisticated brand. Visitors to the site can enjoy the mere fact that someone has taken the time to create an interesting and useful navigation bar. This navigational element is fun in a unique way that adds luster to the io brand.

The secondary navigational element down the right column of the page features nonhierarchical links. What's the difference between a hierarchical and nonhierarchical link? The top navigation bar corresponds directly to this basic, two-level hierarchy with six second-level divisions, each with a number of pages linked.

(ABOVE RIGHT) Putting the top navigation bar in a frame allows it to be implemented as a Flash animation while other frames are filled with standard HTML. In the case of io's home page, there are two additional frames: a wider content frame to the left and a second navigational element as a narrow column on the right.

(BOTTOM) This site map clearly shows the hierarchy of the site laid out as divisions and subdivisions.

NONHIERARCHICAL LINKING—STILL BRANDED

Io's side navigation bar is nonhierarchical, because it links to pages without regard for hierarchy. For instance, the first link, "can I get it?" bypasses the second hierarchical level altogether. Following the hierarchy to the same location requires a visit to the Motorola io and You page, where the text links to the same location. There are additional nonhierarchical links in a drop-down menu and a search field, the ultimate tool for nonhierarchical linking.

The yellow dots used in this navigational column glow within a concentric circle when selected. Is it a stretch to say that these links, too, are io branded? The buttons do represent an abstraction of the io logo, and in this way are associated with the brand. It's subtle but purposeful. Yellow dots, like the dot over the *i* in io, become a design theme for the site and its navigational elements. In this way, a branding element has been put to use and extended.

At the bottom of the Make a Selection pop-up menu is a link to Future products. It's not surprising, but it is revealing, and it means that this site, with its simple, two-level hierarchy, will need to expand to accommodate new products and perhaps new product areas. All the pieces are in place to facilitate this. Hierarchically, the Flash-based navigation with its drop-down expandability for divisional links provides a tool that's easily updated as the site grows. Programmatically, the side column with its drop-down selection menu and search field has plenty of room for more choices and can easily accommodate change.

Functionally, the navigation for the io site is well established, even as the content changes. Thematically, the brand-new io identity is ingrained into the site. But aesthetically, it's not a perfect site. The use of happy-people photographs as the main image element used to ornament the site is trite, and the frames feel unbalanced. However, the abstraction of the io logo to brand the site's navigation is clever and fresh. Other problems can be fixed as the site evolves around its strong navigational scheme.

(LEFT) Io-branded links in the navigational column repeat the yellow-dot theme of marching ants used in the introduction sequence.

(RIGHT) This nonlink to future products is included in the navigation column as both a placeholder for future expansion and a teaser to customers interested in the io brand.

EXPLORING MODERN ART

The boldly understated Web site for the San Francisco Museum of Modern Art, SFMOMA, provides a strong contrast to the bold graphics and cutting-edge technology used by Motorola to establish its new io brand. Where io is flashy (both literally and figuratively), SFMOMA is cool and elegant in an almost blocky way. It's modern versus modernist, and modernist is looking awfully retro, and retro is looking seriously attractive these days. At least there are no smiley faces.

DECONSTRUCTING PAGE ELEMENTS

There are really only three elements here, though one, the navigation bar, is a complex element. First, there's the previously mentioned black-and-white drawing that serves as background. The second element is topical. This box, filled with a transparent GIF, is not a link but a nicely typeset title carefully positioned over the background. All of the typeset images here use the Futura typeface, Paul Renner's 1927 masterpiece, based on Bauhaus design principles of geometric proportion. It remains fresh and modern.

The navigation bar, the third element, is precisely positioned over the black bar that was added to the background. The navigational portion of this bar comprises nine basic text buttons of hierarchical links, divided into three groups of three by the sliced letters of MO and MA. The text of the buttons becomes highlighted when rolled over. There's also a nonhierarchical search feature discussed after the next paragraph.

(ABOVE) The SFMOMA splash page is anything but splashy. It is formal, geometric, and the epitome of clarity. The background is from a work by Sol LeWitt, whose art was being featured at the museum when this chapter was written. This sparse, almost technical, deconstructivist drawing sets the tone for the site

ACCOMMODATING CHANGE WHILE
MAINTAINING THE BRAND

One of the beauties of this scheme is that the navigation is not so much branded as completely integrated into the brand. And even as exhibitions change, this basic brand element remains fairly consistent. Don't believe me? Here's the homage to Magritte version of SFMOMA's splash page.

The fact is, the navigation bar is on most of the pages of the site. This makes it as much a part of the site's brand as the SFMOMA logo. And the logo itself, the museum's initials inside a bold black box, fills the search field at the end of the navigation bar. Turning the logo into a search mechanism is the ultimate in branded navigation. It takes an extra step to perform a search. But the scheme is so clever and engaging that the extra step actually seems worth it. Additionally, this avoids the problem of designing around an ugly form field on every page. It's an aesthetically elegant solution to something that most designers don't even realize is a problem.

(TOP LEFT TO RIGHT) This logo block has been integrated into the navigational scheme as the site's search field. Click in the field, type in a word, and press the return key to make a nonhierarchical search of the entire site.

(BOTTOM) As featured exhibitions change, so does the background image of the home page. Ninety percent of this page looks different, but the brand is anchored in the instantly recognizable logo and strongly placed navigation bar, so the page is more familiar than not.

SUBBRANDING DIVISION WITHIN A WELL-ESTABLISHED HOME BRAND

The organization of the SFMOMA site follows the three-by-three first-level hierarchy established in the navigation bar. Each of these three sections becomes a subbrand of three divisions each. The first page of the Visit division is topped with the same navigation/brand bar, but this time with a set of GIFs matched to the green background. The first three links are on a white background to show that this is the active group, while the other six links are backed by green. The Visit text is red to show that this is the active link. Other button links show red on rollover. The page is titled Visitor Information, and the page content—a nicely typeset column of text with useful information—is beneath the title.

A column to the right of the content is used as a sidebar and secondary navigational element. This is a standard page element for the three sections—Visit, Info, and Calendar—with green pages. At first it's not clear that an additional navigational element exists. The only clue is the red dot to the left of the box, indicating the active link. Following the protocol set by the top navigation bar, the text is in all caps (just like the logo), the active link is red, and the other links turn red on rollover.

ESTABLISHING A HIERARCHY WHILE PROVIDING NONHIERARCHICAL NAVIGATION

Actually, this site is skipping hierarchical levels and thus avoiding unnecessary pages. Instead of using a general tour page with three pages under it, viewers are taken directly to the first tour link, Docent Tours. You must click again to select Audio Tour or School Tour information. This scheme is applied consistently throughout the site's hierarchy, although the first link is often an overview page. This elimination of divisional or section home pages helps to lighten the site, keeping the hierarchy fairly broad and not very deep; this streamlines the navigation of the site and reduces the number of clicks to get to the informational pages.

(ABOVE) As you proceed down in the hierarchy, the content of the pages changes and the images from the museum's collection change, but the navigation remains the same. On the Tours page, the second hierarchical level is shown simply by indenting the links in the side navigation box.

FURTHER DIFFERENTIATION

The second group of three sections—Education, Membership, and Shop—uses a blue background for the content pages. Above the text column is a section photograph. The Education pages are topped by a photograph of children enjoying a kinetic sculpture, and the Membership pages all have photographs of members looking at artwork in one of the galleries.

The Shop section has a deeper hierarchy and is topped by three rollover images for its three secondary level links: E-Tickets, Rental Gallery, and Museum Store. This is the e-commerce section of the site, functionally different from the other sections, so it seems appropriate to use a separate section page here. (See Chapter 10 for further discussion of branded e-commerce.)

(THIS PAGE) Here are two views of the Shop page as loaded and in a composite view showing the three links in their mouse over highlighted state.

BRANDED ONLINE EXHIBITION

For the third division of the site, the background color changes to orange and the layout switches from vertical to a horizontal triptych of pictures. There's very little text, just captions. This is because the pictorial layout becomes the secondary navigation—simply click on a picture to follow the link. All three of these sections utilize a horizontal layout. Unfortunately, many browsers hate to scroll sideways and most find it at least awkward. Going against standard practice forces viewers to see these pages differently, creating yet another way to establish the SFMOMA brand.

Even as the navigation changes, it remains remarkably clear, consistent, and usable. It even works in a nonhierarchical situation. Furthermore, when reduced to a simple statement, all of SFMOMA's site navigation is fit into boxes. The box takes on a number of forms: the main navigation bar, the branded search box, the secondary rectangles, and even the navigational timelines and collages are like compartmentalized boxes. But it is the consistency with which these navigational boxes are implemented that makes them such strong elements. Add to this the careful use of the Futura typeface as a kind of museum brand or extension of the logo, and you've got navigation that says SFMOMA on every page.

(**TOP RIGHT**) The Exhibitions page is arranged like a timeline. Here, the brand scrolls to the right to reveal the complete extent of current displays. (**SECOND TOP RIGHT**) The Collections Overview page uses a collage of images for its secondary navigation. Roll over an image and its identifying text turns red.

(**ABOVE**) The E-Space page uses the same layout as the Collections Overview, but the Webby Prize link does not move down a level within the section. Instead, the Webby award is handled in the News section of the site, and the link leaps straight over to a vertically arranged, green page with all the information.

Many reasons exist for the success of the Web, but there's no arguing that its existence as an informational medium is key. Even the vocabulary of knowledge has been changed by the onslaught of Web-based data. What used to be simply information has been transformed into content, and content has become the coin of the realm for most Web sites.

Whether it's straight text, images, or multimedia elements, information is the product and Web pages are the package. Unfortunately, the stuff of one page can become indistinguishable from the stuff of some totally unrelated page. This situation is the effect of HTML as a broadcast medium. Yet in a sense, this effect is one of the Web's strengths—the ability to associate diverse elements. It's almost the equivalent of time travel. One can read about dinosaurs on one page, leap practically in a single bound to join the search for extra-terrestrial intelligence, and then wander over to a Web merchant to order violin strings.

Philosophically, this flattening of the information hierarchy brings great egalitarian value, and in many ways was the goal of the Web's founders. But it is public enemy number one for Web branders. For Web designers, differentiation is paramount. They eschew the generic in the never-ending quest for uniqueness.

The well-documented limitations of the Web make branded content a special challenge. The time-honored palette of solutions used by graphic designers in advertising and marketing is severely constrained. The somewhat predictable result is more sameness—endless pages designed to look like Amazon or Yahoo! Duplication may be the sincerest form of flattery, but in the age of Xerox, flattery isn't worth much.

The designer's job is made more difficult by the limited palette of letters that are the constituents of language itself. Words convey our meaning, but a message often includes much more than the meanings of words. This chapter examines sites that package information in ways that turn text into a brand message.

Is it possible to turn content into something that is as immediately recognizable as a can of Campbell's soup or a box of Jell-O brand gelatin dessert on the grocery store shelf? Packaging is certainly a large part of it, but a consistent, trustworthy product is what makes the package compelling.

COVERING THE SAME STORY IN THE SAME MEDIUM

The verdict is in and Microsoft has been found guilty, but everyone has a different opinion about what should be done to remedy this illegal monopoly in the software and operating systems markets. The story has particular significance for the Web and the way the Web is viewed. To some, evil Microsoft is out to brand the Web with its own Windows flag, while for others, Microsoft is the savior crusader bent on saving the world from Web chaos. It's interesting to see how the story is reported on the Web within the Web brands of several significant newspapers.

[4] CONTENT DELIVERY
BRANDED FORMS OF INFORMATION

SEATTLE POST-INTELLIGENCER (CLIENT)

READING THE NEWS
IN THE POST-INTELLIGENCER

On the day the guilty verdict was announced, the top headline of Bill Gates' hometown paper, the *Seattle Post-Intelligencer*, proclaims "Bitter Harvest" and lists eight more case-related headlines along with a link to the text of the decision. It includes a one-paragraph excerpt from the lead article, and the whole group of links is enclosed in a thin gray border.

Now examine the presentation of this shattering news. The P-I, as the paper is known locally, puts its identifying logotype at the top in a brown-edged box that includes the weather and links to the paper's sections. This tops a three-column layout with news headlines and briefs in a wide center column. Nonhierarchical links fill a fourth gray column on the right, which is topped by the P-I's distinctive logo. (It happens to be a re-creation of the globe atop the paper's headquarters in Seattle.) Follow the topmost link to read the lead story. This site is about linking and not about branding.

(LEFT) The P-I's interior page layout remains basically the same. The story fills the full width in the center, the hierarchical links column expands to include secondary links for the current section (business), and the nonhierarchical links column changes to list the day's headlines.

(RIGHT) There's not much to read on the *Post Intelligencer*'s home page, but there are enough links to keep you on the case well past the first cappuccino of the morning.

ONLINE IDENTITIES **145**

READING THE NEWS IN THE WASHINGTON POST

Look at how Judge Thomas Penfield Jackson's (the deciding judge in the case) hometown paper, *The Washington Post*, covers the story. It's the top story of the day (though not the featured story), rating a three-word headline, a one-sentence synopsis, and five related links, including an MSNBC video.

Despite its Washington Post logo at the top, this page looks remarkably similar to the *Post-Intelligencer*'s page. Obviously many differences exist, but this basic column layout with brown and gray navigation columns has become almost generic for newspaper sites.

In their quest for usability (which in this case is nothing more than familiarity), these papers seem to have forgotten that they can do many things with a basic layout of columns to make a paper look distinctive. Certainly the tone of the writing is important, but picking up a paper like the *Wall Street Journal* and recognizing it immediately from its size, column spacing, and typography is easy. It's distinctive, and for the journal's regular readers, the distinction becomes familiar and comfortable.

(LEFT) Even the article pages for the *Washington Post* and the *Post Intelligencer* use very similar layouts, although the Post is a little more generous with sidebars than the P-I.

(RIGHT) The column layout in the *Washington Post*'s Web site makes this article perhaps slightly more readable than most informational pages on the Web, but one could hardly call it distinguished.

READING THE NEWS IN THE NEW YORK TIMES

Now take a look at the online version of the *New York Times*, America's newspaper of record. Again, the breakup decision is the top story in a central column of headlines and briefs, but something looks different on this front page.

The black-on-white centered logo at the top with the date underneath and a small box at the right for the weather match the layout of the print version. But in an ironical twist, the space to the left of the logo, the place reserved on the printed front page for the paper's well-known motto, "All the news that's fit to print," is filled with a banner ad. But in other ways, the Web version of the paper is trying to look familiar to its loyal print readers. For example, the banner is separated from the stories by a thin black rule, just as it is in the print version.

Another important identifying feature of the *Times*' pages makes them distinctive compared to most other newspaper sites. Look at the headlines. They are real typeset headlines, not plain HTML text. Someone takes the time to set each headline using Century Old Style, the standard Times typeface, to create the GIF images each day. It's all part of what makes the *Times* the *Times*.

(ABOVE) This familiar layout looks more like a newspaper, and specifically, more like the printed *New York Times* itself.

THE LAYOUT IDENTIFIES THE BRAND

Look at the way story pages are laid out. A straightforward heading brands the page and its division within the site's white-on-black hierarchical navigation buttons are in a simple row with the horizontal banner ad below. Everything that follows is news.

The story is topped with the typeset headline and followed by the byline. The text begins with a three-line red drop cap inserted into the table as an inline graphic. It seems likely that the *Times'* Web department has a collection of twenty-six drop caps that can be placed as needed. But the fact is that somebody has to make sure that the drop cap gets inserted for each story. It's a little extra work, but it's the *Times* way. A right column without a border is inserted into the beginning of the article. It starts with a graphic relating to the story and includes a list of cross-reference links: related articles, video, document, and links to the *Times* online forum.

(ABOVE) It's just a column of HTML text like the other papers, but the text is not fighting with endless navigational boxes.

The effect of this consistent layout is that viewers don't jump all over the place following a random train of thought. You read the article and then perhaps other articles on the same subject. You can go to the top of the business section or back to the home page to browse another section. But you have to put down one section in order to go on to the next, as you do with a real newsprint and ink paper.

Interestingly, the *Times*, which only relatively recently has inaugurated a full-color printing press, makes very little use of color on its Web site. It shows up only in the backgrounds of sidebars, in photos, drop caps, and banner ads. It seems to be a conscious decision to use black and white as the branding color scheme for Web news.

One could argue that simply re-creating the physical experience of reading the paper is not a very exciting or even valid use of this new medium. But in this case, it creates a site of carefully branded information.

Visually, the *New York Times* has managed to present its regular readers with a familiar view of the news. At the same time, the *Times* has branded its online experience for all Web readers to share. Whether you like it or not, it remains "Timesian."

Technology — The New York Times ON THE WEB

| Home | Site Index | Site Search | Forums | Archives | Marketplace |

Don't — CLICK HERE

The Microsoft Antitrust Trial

Breakup of Microsoft Ordered
By JOEL BRINKLEY
(June 8) Judge Thomas Penfield Jackson ordered the breakup of Microsoft, saying the severe remedy was necessary because Microsoft "has proved untrustworthy in the past" and did not appear to accept his ruling that it had broadly violated the nation's antitrust laws.
- The Appeal: Browser Is Key
- The Company: A Vow to Fight
- The Consumers: Few Changes
- The Industry: Culture Intact
- The Law: Whither Antitrust?
- Market Place: Investors Pause
- The Politics: Muted Comments
- The Remedy: Breakup Etiquette
- Advertising: How to Spin?
- Online: A Chat Frenzy
- Diagram: What Now?
- Chart: A Money Machine

Final Criticism of Breakup Plan
By STEVE LOHR
(June 7) In a spirited final filing, Microsoft condemned the government's plan to split the company in two as "a radical step" that seemed to treat software as if it were pornography.

Few Changes in Breakup Plan
By JOEL BRINKLEY
(June 6) Responding in detail to Microsoft's criticisms, the Justice Department rejected any substantive changes in its plan to break up the company.

Case Will Test Justices' Prowess
By LINDA GREENHOUSE
(June 4) When the Supreme court confronted its first Internet case three years ago, the justices received special training from their library staff. Soon, the Microsoft antitrust case will be heading toward the Supreme court. But in the world of platforms, applications, source codes and interfaces, familiarity may not be fluency.

Judge Delays Ruling for U.S. Reply
By JOEL BRINKLEY
(June 2) Judge Jackson unexpectedly agreed to delay his final ruling for about a week, giving the Justice Department time to reply to Microsoft's proposal to water down the government's breakup plan.

Microsoft Readies Final Arguments
By THE ASSOCIATED PRESS
(May 31) Attorneys for Microsoft are busy preparing their final legal response. It will be Microsoft's last opportunity to make its case before the judge enters his final

A Monopoly?
Is Microsoft a monopoly that is stifling the development of the computer industry?
Go to Forum

REVIEW
- Profiles of Major Players
- U.S.'s Long Antitrust History • Point and Counterpoint
- Previous Antitrust Cases Open to Interpretation
- Sherman's 1890 Nod to Populism
- Analysis Why Industries Fear Microsoft
- Analysis Antitrust Strategies Set
- Profile Joel Klein
- Profile Paul Maritz

DOCUMENTS
- 2000 Trial Documents
- Findings of Fact in Microsoft Case
- Transcript of videotaped testimony of Scott Vezey, a Boeing executive. (text file)
- Case Witnesses
- Excerpts From Bill Gates's Deposition,

CHRONOLOGY
Important Dates in Microsoft's History

SITES
- DOJ: Antitrust Case Filings
- Microsoft's Legal Documents
- Microsoft Freedom to Innovate Network

(ABOVE) In the case of U.S. versus Microsoft, so much news has been generated that an Index of Articles link is included. This index is laid out just like the articles' pages, but instead of paragraphs, it's just a list of links organized chronologically.

Unless you are an industrial designer or a programmer, you probably don't associate products with user interfaces. For Web branders, Web sites are the product, and the inherent interactivity of the Web means that every product has a user interface, and it is this interface that is one of the most important measures of success for any Web site.

Creating a compelling user experience is a difficult assignment, because every site is a unique product. Until recently, Web designers didn't have the tools to duplicate the successful user experience of one site for use in another. This meant that each site was a different experience for both the designer and the user.

But the reality is that the pressure for one site to look like another is creating a sea of look-alike sites, and two factors are encouraging this tendency. The first factor is the use of e-commerce packages that include what amounts to a canned user experience—select items, add to shopping cart, proceed to checkout, fill in billing and shipping information, and complete order. The second factor is the result of a mentality that wants to play it safe by looking like already well-established Web sites. Thus, the large number of Yahoo! and Amazon.com look-alikes.

Many Web sites consider the me too interface a positive development. If you're a portal, you should look like a portal, so people know intuitively how to navigate your site. But copying your Web site from high-visibility sites such as Yahoo! and Amazon.com is not intuition, it is mimicry, and the result of this kind of thoughtless copying in many PC applications is evident. Furthermore, sameness is bad news for Web branders, but this is by no means a hopeless situation.

Chapter Four discussed how newspaper sites have established status quo Web standards. Most sites standardize navigation in this way, too. The so-called navigation bar is perhaps the most ubiquitous example. A navigation bar isn't inherently bad, but it can't simply be pasted on like a Groucho Marx moustache. A navigation bar must be incorporated into the overall design of the site. Not only are the elements of the site important to the site brand, as discussed in Chapter Three, but the actions that lead visitors from page to page become an important part of the brand definition, as well.

To put this in more pragmatic terms, users don't return to your site if they can't find what they want there. Your site will be branded as difficult and unfriendly. On the other hand, if the site presents information in a way that your visitors enjoy, you've created a positive association for your site's brand image. Finding a solution that creates a user experience that is both familiar and yet memorably unique in some way is the challenge Web site designers and branders face.

[5] CUSTOMER EXPERIENCE
FEELING THE BRAND

WWW.KODAK.COM/COUNTRY/US/EN/
CORP/FEATURES/ENDURANCE/ (URL)
KODAK (CLIENT)

EXPERIENCING AN AWE-INSPIRING CHILL

Already some of the sense of adventure that made the Web such an exciting place to explore is lost. There's a "been there, done that" attitude. Thrills are still available, and Kodak, one of the world's best-known brands, supplies a vicarious thrill in the form of a reenactment of Ernest Shackleton's near-disastrous trip to the South Pole. You may want to put on your earmuffs and boots before proceeding.

Kodak's *Endurance* Web site, named for the ship that nearly entombed Shackleton and his crew, exists within the www.kodak.com domain as a feature story. In this case, Kodak features the expedition photographer, Frank Hurley, who just happened to have used Kodak brand film and even a 1914 Kodak box camera for additional snapshots. The site is a testament to the enduring qualities of Kodak products and the timeless Kodak brand. Kodak allows the story to speak for itself as an encouragement to all to take lots of travel photos.

SETTING THE SCENE

The first element that loads is a branded picture frame. The Kodak name appears in the top horizontal frame (not an HTML frame) along with the slogan "Take Pictures Further," which is a bit of an understatement in regards to this site. The company logo is at the left of the lower horizontal frame, which includes site-specific navigational elements in Kodak's distinctive gold color.

The picture frame is further enhanced by the addition of a water-stained, woodlike frame and the use of an early twentieth century wood type font that's used for the title, the *Endurance*, and the three navigational links. This font gives the site an old-timey feeling of adventure.

The viewer is told that it's 1914 and a team of explorers has set off to be the first to cross the Antarctic continent. But what is important from Kodak's point of view is the photograph of the ship. Note the use of the present tense and watch how this photo leads directly into the adventure.

The oval photograph of the square-rigged *Endurance* is just a teaser. The oval outline enlarges into a rounded-corner rectangle, and the image within is rotated to reveal the actual Frank Hurley photograph. The caption reveals the truth about the ice-locked ship, "They never reached land."

(THIS PAGE) The top and bottom navigation bars of these pages frame a relatively fast-loading Flash animation, starting with an introduction to the story. The photo of the ship appears and then rotates to its tenuous position in the ice of the Antarctic seas.

INTRODUCING THE HERO

Then a second sequence begins, explaining about Kodak's hero, Frank Hurley, and the expedition is ready to begin. Note how the site includes the viewer as an ex officio member of the expedition. This is not a comfortable afternoon's stroll through the galleries of the museum or an evening's browse through the exhibition's book of reproductions. No, you must take part. There are decisions to be made.

The designers of this site use some of the same techniques used by documentary filmmakers to add action to a story with no actual footage. Second Story takes what are truly remarkable still photographs and gives them immediacy and life by focusing on the details and then adding animated pans and zooms. It is very skillfully done and remarkably effective. This technique makes the user a part of the journey, as if it were a personal experience.

Also, notice two brands that are really at work here and what they're doing to help each other. The outer frame reminds us that this amazing adventure is happening within the Kodak domain and a Home button leads straight back to the corporate host for this subsite. But as soon as the Flash introduction begins, the viewer is quickly carried out to sea aboard the Endurance, headed for Antarctica with Sir Ernest Shackleton.

(ABOVE) The introduction finishes with the full photo of Hurley in the rigging.

EXPLORING THE SCENERY

Kodak's retelling of the disastrous expedition continues with a second Flash animation. The journey sets off from the whaling station on South Georgia Island.

Each location is highlighted on the map and accompanies one of Hurley's photographs and an excerpt from the exhibition's official book by Caroline Alexander. Viewers can continue sailing the seas, abandoning ship, taking to the lifeboats, holing up on Elephant Island, and trekking across mountainous South Georgia. Or they can pick their stops simply by clicking the map. Remember, however, that you must make it to the whaling station and return with a rescue ship before any of your crew perishes.

This site is daring and at the same time a little bone chilling. The use of Hurley's photographs, which comprise one of the most remarkable documents ever recorded, certainly helps. But even the map is carefully constructed to enhance the feeling of adventure that pervades this site.

What really makes this site an adventure for the desk chair explorer is a sense of journey. It could be a trip to a tropical paradise or a kiddie-oriented theme park, but is instead a retelling of a voyage you wouldn't want to be a part of. But as a Flash adventure, viewers not only enjoy this adventure, but are also left with a desire to explore further.

(LEFT) After the introduction, the screen is split so that a map of Antarctica with the route of the Endurance on the left and explanatory text and images on the right shows. The top and bottom navigation bars remain the same.

(TOP RIGHT) Rather than playing as a movie, each frame of the Flash animation making up the map is activated by rolling over highlight points. This changes the text in the title bar so that the viewer can learn the significance of each point without clicking to load the accompanying narrative frame. (BOTTOM RIGHT) Wherever one chooses to navigate, the map label is updated along with the route. You can also choose to zoom the map in for greater detail or out for the big picture.

FINDING NO BLUE MEANIES IN THE FRIENDLY SKIES

The adventure of air travel, if not as harrowing as a couple of weeks in an open boat in the Waddell Sea, is a trying experience. And worse, the problems start on the ground before you've even left for the airport.

People suffer the ignominies of air travel because there's no other way. Even online travel sites are something of a challenge, as one must navigate among a confusing array of ticketing options, seemingly random restrictions, and mileage award programs. Booking an airline ticket online becomes an exercise in rocket science.

This phenomenon of confusing travel sites is just another example of "me, too" site design. Upon examining multiple air reservations sites, it becomes obvious that they all share what looks like three different reservations systems. Regardless of the user interface, the user experience quickly becomes a nasty frustration.

But it doesn't have to be this way if you choose to fly JetBlue. You may think of JetBlue as the "Fly Different?" airline. It has no class designations, all leather seats, and a completely electronic ticketing system. Even the telephone operators have a sense of humor. A look at the JetBlue Web site is like a step into the future, a look at how air travel might be in the future.

THE IMAGERY AND ICONOGRAPHY OF TRAVEL

The simple yet strong logotype is in the upper-right corner, and in what browsers have come to expect as the logo corner is the almost naively friendly message, "Hello," with an orange daisy. This daisy, especially in this particularly orangey orange, is loaded with Flower Power, Peace Now, and sixties symbolism. This retro imagery is used in a wholly updated context, and it's very effective.

The background for this page is a ribbon of textured blue that appears to be jetting across the screen; this in cool, efficient contrast to the happy orange imagery. The orange is also used for the navigational icon system that's composed of six rollover buttons.

And just in case it's not clear what to do with a rollover link, there's a message attached to the daisy, "Roll over orange circles to start." It's friendly without sounding condescending. These rollovers are the entirety of the hierarchical site navigation.

The simply animated GIF contains practically the entire textual message of this home page. It is four words that fade from one into the next in a fourteen-frame animation: reinventing, redefining, rethinking, and rediscovering.

(ABOVE) Immediately, one notices that JetBlue's site is different. It's got breathing room—room to stretch out one's legs and get comfortable. For one thing, the page is right justified, which isn't very common on the Web. Is this page difficult to decipher? Hardly.

ADVENTURES IN ONLINE RESERVATIONS

In talking about branding the user experience, it's noteworthy that the JetBlue site makes a strong statement right from the opening page. One knows that flying the JetBlue Web site will be different, less cluttered, and perhaps even fun. Simply click the "Fly there" button to begin the adventure.

There are directions—"select an area"—and a green arrow, made more vivid by the animation of its downward direction, points to three options: when and where, e-ticketing, and how to jet blue. Veteran JetBlue travelers can skip steps and speed up the ticketing process.

This next step down into the hierarchy adds one more layer of hierarchical choices: timetables and destinations. These icons have their labels attached and are also rollovers. It's clear that there's room to expand this icon system to add more choices across the middle.

Unfortunately, JetBlue hasn't finished implementing these links yet. The company is so new and is expanding so rapidly that it has not had time to implement the timetable, and the destinations page is clearly waiting for additional information. But it's evident that the brand experience is carried from the first page all the way into the deepest interior pages.

(LEFT) For those travelers who need further direction, the icons and labels contain self-identifying rollovers that lead through the ticketing sequence in order.

(TOP RIGHT) This page is clearly labeled, "Fly there," but one's attention is drawn to the new large buttons that contain typical airport iconography and a list of options on the left.
(BOTTOM RIGHT) On level down within the "Fly there" division the new icons for timetables and destinations are color-coded green.

BRANDED FORMS PROCESSING

Click the e-ticketing link to move on to the next step. When you examine the form itself as separate from the JetBlue page, it becomes clear that while the drop-down selection menus help, the use of titles to separate question sections is also useful. Just as importantly, you don't see too many questions on a single page. You don't get a sense that Big Brother is breathing down your neck.

Browsers can continue to travel this reservations model, selecting, confirming, and purchasing. Along the way, little notes of encouragement in big blue circles appear, "Make sure your e-mail address is correct," and "Almost done." With all the information necessary filled in, it's time to hit the orange daisy and "buy it."

(**ABOVE**) The e-ticketing page is the first that lists a large amount of information. It's a fairly standard form, but when presented in the context of the JetBlue brand, it seems somewhat more inviting, and indeed, it is less confusing and easier to fill out than most online forms.

A WEB-SAVVY MESSAGE TO WEB-SAVVY TRAVELERS

The message here begins, "Chill," and you're asked to wait while the order is processed. It seems JetBlue's trying to convey that it's really quite Web savvy. It's all part of the overall tone that says, "You're cool, we're cool, so let's all be friends." JetBlue gives the site a feeling of exclusivity, that even though it's on the Web where anyone can access it, it's really meant for a select group of cognoscenti. It's a nice trick for an airline specializing in low fares rather than luxury travel.

JetBlue has created an online travel experience that makes browsers want to choose it, even though they've never even laid eyes on one of its jets. This is what a positive brand experience can do for a product.

Some people call what JetBlue is projecting, an attitude, but others prefer to think of it as a commitment to human values rather than corporate ones. It's easy to respond positively to the bold colors, simple imagery, and lighthearted text. It's not a big deal, but it tells browsers that thoughtful human beings work here, instead of a committee of bureaucrats.

(ABOVE) Even as the forms become longer and more detailed, the JetBlue experience remains remarkably consistent and pleasant.

In the beginning, and as recently as two or three years ago, big brands were avoiding, or at least ignoring, the Web—the wait-and-see strategy. The Web was still a playground for esoteric start-ups and high-tech companies that were actually in Internet-related businesses. For traditional consumer-oriented companies with $100 million dollar advertising budgets—the big brands—the Web was barely a blip on their radar.

Yahoo! and Amazon changed this perception by becoming big brands themselves and, in the case of Amazon, by cutting into traditional big brand markets. No one ignores the Web any more. From a purely advertising perspective, the demographics of Web use are just too attractive to be ignored. Web users are better-educated, younger, more active, and they spend more money. This situation is not good news for the television networks.

The Web is the next medium and the big brands know it. The question then becomes how to acknowledge this medium without diluting their already carefully molded images. How do companies like Coca-Cola (see Chapter Five) and Proctor and Gamble, which have worked for decades to establish and maintain their mass-market and broadcast images, present themselves in the new medium, the Web? Do the Campbell's Soup twins play well at 600 x 400? Does the ever-annoying Energizer Bunny keep going and going all the way to your desktop browser?

The answer in both cases is categorically no. Unless such icons of traditional advertising are recast to suit the new media and its more sophisticated, less patient audience, many successful brand images simply run out of gas. The same is true when you try to move a magazine to the Web. You can use the same words, but without recognizing that the context has changed, the result is content that is at best cumbersome and at worst, impossible to find and then read.

Rest assured, however, that the task is not impossible. In fact, a successful Web image, augmenting what is already an immediately recognizable print and broadcast image, can be a powerful tool for extending brands into new and larger universes.

[6] CLASSIC BRANDS
THE NAMES WE LOVE

PLAIN BROWN WRAPPER:
THE UPS SITE

Okay Web branders, it's time to play the distinctive color game. If green is the color of money sites, blue the color of health sites, purple the color of women's sites, red the color of culinary sites, what is brown for? This is branding for a plain brown wrapper, along with trucks, uniforms, and tools. Here's another clue: "Brown paper packages tied up with string. These are a few of my favorite things." Brown is the brand identity of The United Parcel Service, a company whose truly global presence is characterized as much by its reliance on brown as on its classic UPS parcel logo designed in the 1960s by Paul Rand.

A Paul Rand identity is a sure sign of a really big brand. Some of his most famous logos were designed for Westinghouse, ABC, NeXT Computer, Yale University, and IBM. He's the biggest brand among branders.

SHADES OF A BROWN BRAND

UPS has become a brand name almost without trying, and yet, someone had to decide that brown was the way to go (probably Rand himself). Does what worked for trucks in the 1960s also work for Web sites in the twenty-first century? Upon viewing the UPS home page, the answer is yes.

This home page is more yellow than brown, but it is all UPS. The global navigation bar at the top has UPS logo teamed up with the Olympic rings for a special big-brand promotion. To the right of this branded anchor are the hierarchical navigational elements and icon system, all brown. The photographs in the feature section of the home page are also colored monotones, which is not only a striking effect, but also creates smaller images for faster download times.

(ABOVE) The UPS site is full of forms to fill out and they are kept as simple and readable as possible. Furthermore, the form pages are both browser-and platform-agnostic to include the widest possible user base, a major concern for the biggest brands.

SHIPPING, THE UPS WAY

Browsers can track, ship, calculate costs and times, order pickups, find drop-off locations, and order supplies with a single click. In fact, these functions represent an online version of calling UPS for service. They are the interface for an online application that's available throughout the site. Wherever you wander within the UPS domain, a brown truck is following you.

Seeing an application presented as a hierarchical navigation bar is unusual, but because the functions are not necessarily sequential, it works. Most of the site's interactive functions require filling out forms, and the UPS site does nothing extraordinarily appealing or innovative in this area (a little Rand influence could help here). But the subfunctions of each division are nicely presented in what looks like a horizontal drop-down menu, but is actually just more GIF text in tables.

COFEATURING BROWN

Even though the ability to ship and track packages is the primary purpose of this site, these functions are treated as background activities to the prominently displayed feature stories on the home page. The summer's promotion highlights UPS's sponsorship of the Sydney 2000 Summer Olympic games and the UPS-employed Olympians. Actually, there is no need to return to the home page, because the Olympic ring logo on every page links to the UPS Olympic pages.

Once a browser check is performed, the index page loads with a JavaScript animation used to set the page elements. All the circles on the page activate rollover GIFs. The dots underneath the yellow background link to the identifying text across the bottom, whereas the picture rings pop up explanatory text and animated GIFs.

(ABOVE) This subsite is a big brand partnership. The UPS-Olympic index page contains only logos, and serves primarily to check the the host browser for JavaScript and CSS compatibility. If the browser detect passes, then the overview page, the real home page for this subsite, loads.

The Olympic ring metaphor as it's described here may seem a bit heavy-handed. But in execution, the scheme works well. The page achieves a strong Olympic feel without relinquishing the obvious UPS sponsorship. But why does this subsite exist? You may as well ask why UPS has chosen to be an Olympic sponsor—it's a marketing and public-relations site. It's an opportunity for UPS to make everyone feel good about sending brown paper packages in its brown trucks. The site also happens to be quite thoughtfully designed.

UPS has taken this PR site very seriously and has included a lot of content organized in a fairly deep hierarchy. They are able to keep the site orderly and useful using a consistent layout and strong navigational tools. Eventually you get down to a very personal level with individual feel-good success stories.

(TOP LEFT) The five-button hierarchy across the bottom moves to the top for all the interior pages, and a section-specific hierarchy of links is in a column on the left. Featured links fill a middle column, and explanatory text follows to the right. This blue column includes its own story line, along with More and Back JavaScripted buttons to navigate through the text. **(TOP RIGHT)** Clicking a hierarchical link steps down in the hierarchy and expands the list of links in the navigation column.

(BOTTOM) Future Olympic hopefuls at a UPS-sponsored sports camp. Each child in this section has a story that can be told quite generously in the content space of the page.

GILT BY ASSOCIATION—UPS/OLYMPIC STARS

Another feature of every page in this cobranded subsite is the little circle in the yellow bar under the top navigation. It's labeled Stories, and the picture in the circle changes randomly with each page load. These five ring stories are from the subsite's home page. Clicking this circle transports the browser through the hierarchy to the pictured story.

This page gives UPS a chance to highlight all of its Olympic projects, including the employee-athlete program. These down-home success stories help to personalize the site and turn a huge global corporation into a friendly giant.

Graphically, these pages are beautifully laid out. The clock with the moving second hand, the superimposed full-color head shot of Tongula, and the blue sprinting image in the background make a strong composition without overwhelming the rollover numbers that represent the stages of Tongula's day. It is the visual presentation that helps make the story a compelling one, one that represents success for both the featured athlete and UPS' corporate image. Suddenly, UPS brown doesn't look so dull anymore.

(THIS PAGE) Tongula Givens, a UPS driver and sorter who also just happens to be a former national champion triple jumper. Her typical day is presented in this collection of rollover snippets around a clock. There's also a brief bio along with an impressive-looking photo of the sorter/athlete in action.

CUTIUS, ALTIUS, FORTIUS, SWOOSHIUS: ABOUT NIKE.COM

It's just a shoe company, but it happens to be the shoe company that redefined footwear, and while it was at it, it also redefined branding. All it took was a little swoosh—lots and lots of little swooshes. Interestingly, where other big brands may have struggled with the transition of big brand marketing to a new medium, the Web seems to have been tailor-made for Nike.

Nike may have moved into nearly every crevice of footwear manufacturing and apparel and accessory markets, but it is first and foremost a sports shoe company. So it is only logical that the world's quadrennial gathering of the fleet-footed provides a special showcase for Nike products. What percentage of UPS deliveries from Portland, Oregon, (Nike's world headquarters) to Sydney, Australia during the last two weeks of September contained shoe boxes? Although you might think of the UPS-Olympic alliance discussed in the previous section of this chapter is perhaps one of pure marketing with little inherent synergy, Nike embodies the Olympic creed—citius, altius, fortius (faster, higher, stronger). But which brand is stronger, the Nike swoosh or the five Olympic rings?

The complexity and sophistication of the design of the home page result from the juxtaposition of contrasting colors and disparate elements. The largest, most prominently featured image is of "Marion Jones in Swift." Notice how this composite image doesn't mention the Olympics directly, but only alludes to the games. Understatement is a critical component of Nike's image. You find no "Will she win five gold medals?" or attempt to create additional hype beyond all that created by the more traditional media. The intensity is evident in the photograph and the Nike Swoosh on her shoulder, though small, is clearly evident. Jones has been branded.

(ABOVE) The intent of Nike's home page is unmistakable. It puts the unabashed stamp of Nike all over the Sydney games.

PRESENTING THE WORLD, STARRING NIKE

The featured link on this page is an inserted Flash animation. A single rotoscoped figure (an animation based on live-action footage) races across the cell in slow motion from the right. Stars of the games follow, but it is the final moment of the animation that brands the entire site, Nike.com/2000, and then an invitation to "Get Inside."

A third featured image that shares the narrow band across the top with the Nike logo is labeled in red, RFS—Radio Free Sydney. What is this image? Why is it so intriguing? It has all kinds of associations, but the fact is that Nike uses the image to draw viewers into one of its unique Olympic features. Yet there is still no direct mention of the Olympics, and no use of the Olympic rings (which is strictly controlled by the International Olympic Committee), yet the association is obvious.

Two medium-sized image maps link to the Nike store and the Nike custom shoe shop. Four smaller rollover icons link to additional Nike sites, Nike Digital Video, NikeFootball.com (which is a soccer site), Nike Shox, and Dreamcast Indoor. Each of these icons represents its own brand with its own site, and room exists along this orange stripe to add more logo links to future Nike sites.

BRANDING WITH A SINGLE SWOOSH

Image, color, and that little swoosh—that's all it takes for Nike to establish its brand on a Web page. The brand is so strong that it even dominates the Olympic thrust of the site. In fact, even though Nike is a major Olympic sponsor, providing uniforms for the USA team members, the company has not paid the International Olympic Committee (IOC) for permission to mention the Olympics, with a capital *O*, or use the Olympic rings on the Web. In contrast to the UPS site, Nike is not attempting to cobrand anything. Instead, Nike is dominating the competition and doing it with grace and style.

This home page is all about branding. It doesn't really contain any information; it's just a central switching station to get browsers somewhere else. But before you get where you're going, the Nike-ness of your endeavor is firmly established. This home page doesn't even establish a distinct site hierarchy. Most of the GIF text links in the navigation column lead to task-oriented nonhierarchical pages, like Ask Nike, Talk to Us, Privacy Policy, and so on. The links to NikeBiz and to the Nike Store take you to strictly hierarchical domains. Although these two destinations may provide the site's key content, they are the expected. What makes Nike's site so interesting is that it goes beyond mere expectations.

NIKE'S WORLD BODY—POOR PUN OR POWERFUL AMBIGUITY?

In celebration of the Olympics, Nike has created the worldbody.nike.com subdomain. Clicking the Get Inside link causes a quick JavaScript detect and then opens a new window the width of your screen. This high bandwidth site is meant to appeal to high bandwidth fans.

The whole show lasts about thirty seconds, all it takes to state Nike's theme for its World Body subdomain. At the same time, they've established a color scheme of orange, blue, and green. Nike is also very creative with the theme of world body. Does the thin line represent the rock-strewn road that all athletes must travel, or is it an artery pumping blood through the active body? This ambiguity is useful; the multiple interpretations of the imagery create depth and strength and give the site an exciting tension akin to the anticipation of a race. This tension works in Nike's favor, because it's hoping that some of this excitement will carry over to its gear. The tension created by the site can't help but color your personal Nike experience the next time you put on a pair of running shoes. Wow, you really can run your fastest and jump your highest. (Whatever happened to PF Flyers?)

(ABOVE AND THE FOLLOWING TWO SPREADS) Nike's World Body introduction begins with an orange stripe that looks like a road. A faint heartbeat accompanies what could be corpuscles coursing through the orange stripe. The beats get louder, and then the sound of what might be a didgeridoo starts up and the orange road begins to widen. The rotoscoped runner, tiny at first, is followed by the words, "You are not a lovely flag…" then getting bigger, "You are not an anthem… You are not the country you were born in… You are a cell within the world body…" Then the road turns blue and drums join the sound chorus, "One of us all." the beat and runner accelerate, blue changes to green, "Yet one of a kind," the beat heats up further and the road returns to orange: "Singular. Unique," and then the image explodes. The tag line, "Celebrate the World Body," finishes the introduction.

YOU ARE A CELL WITHIN THE WORLD BODY...

SKIP INTRO

ONE OF US ALL,

SKIP INTRO

SKIP INTRO

CELEBRATE THE
WORLD BODY.

SKIP INTRO

PROGRAMMING ON THE CUTTING EDGE OF DESIGN

This active, complex site uses extensive Java programming to provide large quantities of information taken from multiple media and manages to present it all in a coherent browser window. The use of these advanced Web technologies is appropriate for a company whose image is based as much on innovation as on style.

When the introduction completes, Nike's World Body content appears. Nothing in this subdomain is static. On this first page, the balls are in constant motion, and you see a message, "Play with our balls." When you click and drag in the orange stripe, the balls get all excited. It's also noteworthy that these pages are available in many languages, including Japanese and Korean. The time stamp in the upper-right corner is the current time in Sydney, which is useful for timing your Olympic explorations, but once again, the *O* word is never used.

In fact, all the World Body content is translated into eight languages. The site's designers believe this translation is a unique, history-making feat in the annals of the Web. They know of no other site, and neither do I, that provides constantly updated content in so many languages. The nike.com team, along with Blast Interactive, has a Web team in Sydney that sends all content to translators around the world. As soon as the stories are available, they go up on the site. This site is Nike's vision of The World Body, and it's a truly global concept. By contrast, the olympic.com site is only available in English and French, the two official languages of the IOC (the International Olympic Committee).

(THIS SPREAD) In addition to the first screen in this sequence with a red corpuscle representing "blood + guts, athletes," there is a fingerprint for "skin, product"; an open mouth for "tongue, uplink", an ear for "eardrum, downlink", and the back of a neck for "spine, schedule." The row links finishes off with a Nike swoosh.

VIVIDLY METAPHORICAL LINKS

It doesn't look as if the site has a hierarchical navigation scheme, but each of the gray images of body parts in the bottom stripe is a sectional link. Rolling over one of the metaphorical images changes the whole main image section of the page. Do the metaphors seem a bit far-fetched? Nike might say they are thought provoking, but they seem just plain attention getting. But whether these are appropriate metaphors doesn't matter. What's more important is that they are used consistently in support of Nike's idea of the World Body, and therefore are a powerfully unifying theme.

The first real athlete presented is Marion Jones. First, snapshots of various sizes fill the screen and a message, "Loading Scrapbook Images…" appears. Then the voice of Jones at the bowling alley starts up and a moving collage based on the scrapbook images follows. In a way, it's less static than an interview video, and it doesn't require any video streaming technology.

There are also ten tiny pictures across the top bar and a drop-down menu with the names of another twenty athletes. These athletes are the Nike elite, and there is information about them as real "blood + guts" athletes and people, as well. Nike has been similarly thorough in listing all the events in which these athletes will participate in Sydney.

The effort to create this site, the quantity of information collected, the attention to design details—was it all worth it for a site that was out of date and gone from the Web in a matter of weeks? Perhaps there is no answer. Clearly big brands are willing to spend big bucks to be associated with sporting events (see Chapter One). Nike has gone a step farther and branded a whole sporting event with its swoosh. The IOC couldn't be happy about this situation.

This discussion raises another question: Who is the real big fish here? Although the Olympic brand may have the edge in stature, Nike has a commanding lead in fleetness.

bowl, so we'll have to come back next Friday.

MARION JONES BLOOD+GUTS
CELEBRATE THE DOUBLE HELIX

SKIP INTRO

NIKE 2000

BLOOD+GUTS
ATHLETES

SPINE
SCHEDULE

(ABOVE) Along with the changing images, Jones's words appear, becoming part of the same visual display. Then comes a list of Jones's events and stats, along with the option to click on more interviews. There are two little links labeled, Spine: My Events, and Skin: My Gear. For those who want to read about Jones's many events or wear the same things she wears, these nonhierarchical links are to the Spine and Skin sections.

Just as many so-called antique stores sell few, if any, genuine antiques, boutiques are seldom the small, independent stores they once were. Big brands have invaded the world of boutique shopping, and the landscape of shopping has changed forever. What used to be exclusive shopping avenues are now populated with the same stores wherever you are in the country. It's all part of the "malling" of America. But what of the Web? Need it be "malled" as well?

It has been stated in other chapters that the Web is the great brand equalizer. One could argue that a virtual lemonade stand on the Web has as much chance of receiving viewers as Minute Maid has. In reality, the Web is not quite so egalitarian. Turning lemonade.com into a world brand takes a lot of work. (In fact, such a site exists, but only a single semiamusing page exists at this point. On the other hand, Minute Maid, which is owned by Coca-Cola, has a substantial, if dully corporate-looking, site.) But obviously, the Web provides an affordable means for smaller, newer brands to present themselves to a very large audience. Or even to present themselves to a small, very specific audience in a very large space. For less than the cost of a single television commercial, the world is yours. And although plenty of examples exist where much was spent for very little on the Web, that's not what is being discussed here.

Before reviewing boutique brands, they must be defined. First, something fashionable exists about boutiques. If you're going to sell plumbing supplies at your online boutique, they better be designer plumbing supplies. One also gets the sense that boutiques are small, or at least that they offer a limited number of items. Yet small and stylish doesn't preclude being a well-known brand. In fact, the Web is probably the best medium for turning boutique brands into big brands.

[7] BOUTIQUE BRANDS
SMALL FISH IN A BIG POND

WWW.ALTOIDS.COM (URL)
CALLARD & BOWSER/SUCHARD (CLIENT)

CURIOUSLY STRONG APPEAL

Is basing a brand completely on humor possible? Well, having a worthwhile product helps, which is probably what the British candy company, Callard & Bowser, saw in Altoids-brand peppermints when it purchased the company many years ago. Callard & Bowser later merged with Suchard and has since been purchased by Kraft Foods, Inc., which, in turn, is owned by Phillip Morris. So, though Altoids is an internationally advertised brand with terrific name recognition, it qualifies as a boutique brand within its larger corporate hierarchy.

MAKING MUCH OF A LITTLE WHITE TABLET

People need only hear the name Altoids to supply the tag line, "The Curiously Strong Mints," and the billboards with the scantily clad musclemen holding the small, bright red tin of mints present an absurd-yet-sophisticated juxtaposition that creates the joke and makes the product package so appealing.

After the curiously strong tag line, what can be said about a breath mint's image that fills a whole Web site? For starters, anyone coming to www.altoids.com is likely already familiar with the product and probably likes both the mint and its ad campaign. The site is a way to take the ads further, to create an entire Altoids universe of the absurd. And as you find out, hidden among the various features, you can even buy Altoids online.

Nearly everything that happens within this site takes place on or inside this tin. For branding purposes, the Altoids tin has become almost as recognizable as the Coke bottle. In addition to the lid of the tin, there are top and bottom border rows with nonhierarchical links. The Altoids mint-leaf logo is included in the top border, and the trademarked tagline is included in the bottom border. The tin itself is divided into twelve squares, each with a completely different image. Some of the images are animated GIFs; all are brightly colored, with bold typography, and retro imagery. The intentional effect is an orderly chaos of good-humored fun, which is the same tone Altoids cultivates in its print ads.

It looks like a table, but this page is actually a rather complex arrangement of nested frames. Each of these frames contains documents that are further divided into frames until eventually an arrangement of three by four frames is achieved. The number twelve is significant, because it can be divided by two, three, and four, which means that the number of possible permutations is quite large. In Altoids' hands, even geometry can be fun.

(ABOVE) Notice that the arrangement of images on this page is in the shape of an Altoids tin. The feeling is strongly retro — the somewhat pastel colors, the typography, the rounded shapes, and even the tone of the text are all reminiscent of a 1950s amusement park.

(THIS SPREAD) Clicking a link reloads a frame or frames with a new document. So if clicking on the "In the Beginning…" square, the link reloads the frame containing the two lower right-hand squares with The Altoids Story.

This matrix of frames is a unique way to create functional divisions and present the hierarchy in what appears to be a totally nonhierarchical way. There's no sense of traveling downward in a page structure. It's an original presentation of a fairly straightforward organizational scheme, and clicking through all the squares to see how the tin changes is fun.

MAXIMIZING THE TIN'S REAL ESTATE

One of the drawbacks of limiting the navigation to twelve squares on a tin is that no room is left for expansion. But the company has figured this one out, too. The matrix is randomized, so the content of the squares changes. Several of the HTML frames include doc-uments with a JavaScript randomizer, which means that more important content can be fixed in place, like the Outside the Box, Free Money, Souvenir Shoppe, and The Altoids Story squares. Nice Factoids, Urban Myths, Hi Jinx, and the others can come and go. This technique works because most of these links are purely for fun; they present content that serves to build the brand image, but they contain no substantive information about the company or its products.

But a tremendous amount of flexibility still exists. For example, every square has its own identity. Except for the general retro quality of the squares, the typography, colors, and design of each has very little in common with the others. The grid of the tin holds the designs together.

GETTING BROWSERS INSIDE THE TIN

Because every site should try to engage its browsers in some way, one of the eighteen rotating links includes a weekly users' poll. What's most interesting about this link from a design per-spective is that the poll content fills four squares in the matrix. It's just another design permutation.

Because the face of the tin is endlessly changeable, this means that the navigation is also changeable. Where's the back to home button? Each section frame has a close button. Clicking the close button has the effect of moving you back up in the hierarchy to the previous state. As mentioned earlier, you can also click the little Altoid at the bottom to "flip the lid." This button is essentially a home button. When clicked, the matrix of twelve squares returns, putting you back on the home squares.

(ABOVE) Altoids' user survey engages browsers directly with its interactive polling, but it never breaks with the design structure of frames.

SUCCESSFUL SHOPPING WITHIN A GOOFY AESTHETIC

Practically speaking, the most useful link on this site is for the Souvenir Shoppe. This link is to the e-commerce portion of the site. This subsite, with its glowing highlights, little stars, and its use of alternating dark and light bars to give the effect of a corrugated aluminum diner, is the ultimate expression of the malt shoppe aesthetic.

Remember, Altoids.com is a boutique site. As e-commerce sites go (see Chapter 9 for e-commerce in more detail) the shopping experience is straightforward, and the shopping basket and checkout are handled very cleanly. Of course, to make the cost of shipping worthwhile, browsers will end up buying mints by the caseload.

This site is really for the seriously addicted mint consumer. From a Web branding perspective, to imagine doing more with a small package than Altoids has managed here is difficult. At no time does the site stray from the comfy home of the rounded-corner tin. Even as the face changes, the navigation is constant, and the top and borders outside the tin remain fixed.

When your entire brand is limited to peppermint, cinnamon, and wintergreen, consistency helps. But inventive presentation of such a narrow product line helps even more. This site exudes inventiveness and at the same time creates its own little environment for the exultation, inhalation, and ingestion of small mints.

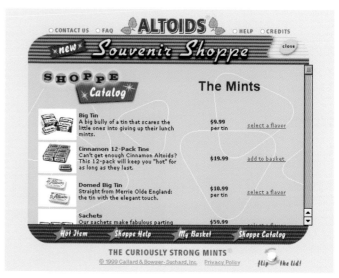

(LEFT) The Shoppe takes over the entire tin and includes its own hierarchy within the persistent top and bottom borders of the entire Altoids site.

(RIGHT) This shop does not contain a huge selection of items, but viewers can buy mints, along with a few logo clothing items and posters.

SHOPPING THE BIG BRAND BOUTIQUE

Banana Republic is unquestionably a big brand, but it began life as a kind of anti-boutique in San Francisco. Selling odd lots of used clothing and updated copies of vintage travel wear displayed among Jeep bodies and banana leaves, the store seemed as much a political statement as a fashion one. All but the name changed when an even bigger American brand, The Gap, bought the fledgling chain and turned it into the luxury shopping mall outlet it is today.

Such is the power of brand recognition that a successful packager of the Hemingway safari image can transform itself into a supplier of work-chic for Silicon Valley types. Its stores may not provide the personal touch of old-fashioned boutiques, but Banana Republic defines the mass-marketed boutique of the Internet age.

The cluttered jungle motif of yore has been updated with polished wood cabinetry and sleek stainless steel and glass. The stores have a certain spacious elegance, at least when compared to their brethren Gap stores. These touches are all necessary ingredients for a boutique-like store with a higher-priced product. Consumers want to feel, if not quite at home, at least very welcome. After all, Banana Republic would like its loyal customers to visit often and linger while they're there. Both are qualities of a successful Web site, as well.

ENTERING THE ONLINE BOUTIQUE

Right from the start it's evident that this site is selling luxury "Luxury. Wear it to Work. For man. For woman." The tag line accom-panies a relatively large (in screen size) animated GIF that alternates between the image of a working man and a working woman.

It's interesting how un-luxurious the office backgrounds of these pictures are. It's a way to provide contrast to the fashionably dressed models, as if to say, "Here's your chance to provide some color and elegance in an otherwise drab world." This idea is really the essence of the Banana Republic brand—to make the wearer stand out in a world of office equipment.

BRINGING THE PHYSICAL STORE ONLINE

Banana Republic has established an icon system based of white capital letters on color squares. The system is used in its stores on clothing hangtags and sewn-in labels, and for the Web site's navigational buttons. The typography for these icons is based on ITC Franklin Gothic, a classic, geometric sans serif design.

The original 1902 typeface by Morris Fuller Benton has been a standard for newspaper advertising in the United States ever since it was designed. The capitals are slimmed down a bit for these icons, much as the clothes are all presented in long, lean poses. Franklin Gothic has a nice work-ethic, no-nonsense quality. Again, it's an elegant element that provides a strong contrast to Banana Republic's goods.

The entire hierarchical navigation for this site is contained in these four square icons—man, woman, home, shoes. Banana Republic has chosen this way to divide its product lines, and it creates very strong branding within each site division. At the same time, this site features pants. Where the icons are hierarchical, the For man, and For woman links skip a hierarchical level and go straight to the pants listings.

(LEFT) While the featured image alternates between headless man and slouching woman, the label, "Work (pants)," remains fixed, which gives it the effect of floating over the pictures.

(RIGHT) All the important design elements for this site are established on this home page. The rectilinear layout of color blocks and images is the height of elegance. The colors themselves (purple hues in this case, but changing with the seasons) have a strength and solidity and at the same time are quite stylish.

CHANGING WITH THE SEASONS

Everything that happens above the bottom navigation frame changes with the seasons, just like a store display window. Although the branding elements remain unchanged, the different colors and imagery give the summer page a very different feel. The seasonal changes encourage return visitors to find out what's new. Both pages are unmistakably familiar to Banana Republic's loyal customers.

Just as men remain men and women remain women, the navigational hierarchy of this site also remains unchanged through the seasons. Well, almost unchanged. Don't forget that this store is a fashionable boutique. The *G* square (gift) of summer becomes an *S* (shoes) in fall, and the gift division falls to the Gift Finder link. These changes show how difficult sticking with a tight, square design of four icons is.

(ABOVE) Here's a screen shot of the summer's display, very warm and casual in contrast to the cool office aesthetic of the fall page.

HIERARCHIES ARE NOT FASHIONABLE

Each of the four main product divisions has a starting page with a list of product categories. The color of the type is picked up from the division's icon square, which becomes gray. The rigidity of squares and the look of these pages contain a certain hard-edged quality. But the design itself is not rigid. Instead it is very consistent in the way it uses design elements, including shapes, colors, typography, and layout. Actually a good deal of flexibility exists for making content changes and for creating distinctions among the product lines.

From any of the divisional home pages, items can be found by category. So from the Woman division, click on the Skirts category link to view the selections. In addition to the skirts on this page something else is going on here and it's happening all over the site. All the photographed items fall within the featured color scheme of the site. For fall, there a lot of cool blues and violets with beige. Just as color is a crucial defining element for the Banana Republic display windows and print ads, each site update brings completely new hues. The warm summer colors shown below right were defining colors not just for the home page, but also for the summer fashions themselves.

(LEFT AND RIGHT) The Man and Woman divisions also have product finders like The Short List, which is not a list of shorts, but a selection of the most fashionable items.

(TOP RIGHT) The Shoe page is the only divisional page with two square images — one for men and one for women — and no categories. Looking at these shoes, though, you might think they were intended for two different species of animal.

FASHION GIVES WAY TO SHOPPING REALITIES

From the category page, click a featured item or click the View More button to see the full product line. You have to click a page number to see more items, or use the Choose a Category drop-down menu to specify your shopping goal further.

This straightforward presentation of navigational choices is the shopping equivalent of looking through a rack of skirts, going on to the next rack, or strolling over to another part of the store. Interestingly, not a single price has shown up yet in the exploration of this site. This is more evidence that this site is a shopping, rather than an e-commerce experience.

Prices aren't revealed until the product detail pages, almost the lowest level in the site hierarchy. Choose a color, size, quantity, and shipping destination. And finally, in a red-bordered box most of the way down the page, click the all-important Add to Bag button to make a purchase.

More importantly, from the perspective of Web branding, the buying experience, like the shopping experience, takes place completely within a frame of Banana Republic branded elements. The box that is bananarepublic.com remains constant. Everything that's presented, from the most current style to the on-sale cast-offs, gets the same treatment within this online boutique.

The pure product-driven hierarchy of this site leads from main page, to division home pages, to categories, and finally to a product page. But at several points, side paths are available; for example, the pants featured on the main page and the wardrobe links, such as The Short List links. These side path pages are the only ones on the site with rollover text set in the seasonally correct color and with items from different categories featured together. In fact, these pages are a defining part of the Banana Republic online shopping experience—the casual rather than product-directed shopping experience.

Without such diversions, the site would be in danger of feeling like any other mall store online. Instead, the quintessentially boutique shopping experience has been translated into an online experience, albeit a very big-brand boutique.

(TOP LEFT) Instead of a page full of skirt thumbnails on its Skirts page, bananarepublic.com presents a different shopping experience based on a few, carefully selected featured items. (BOTTOM LEFT) Just as in the stores, the display of items is spacious. No thumbnails are shown, just full views, but only five images per page. This method works only with a limited inventory.

(RIGHT) On the product pages, a descriptive name for each product is in all capital letters followed by a brief paragraph description. There is more detailed information, including color swatches, size chart, fabric care, or related products from the More Product Info drop-down menu.

Of all the wonderful opportunities that the Web offers, the ability to create completely new brands overnight may be the best. But are so many new brands really needed? Of course. How else are all the unneeded services never before imagined going to be offered, using up every conceivable dot-com domain name in the alphabet? Anyone for gorblats.com? Or if gorblats.com is registered by the time this book goes to print, consider mygorblats, egorblats, or igorblats. A good name like this won't last long.

Certainly names are important in the branding scheme of products, but what about for the Web site? For brands that exist solely online, the site is the product. A decade ago, the secret to success for software companies was to think of an idea and then to print T-shirts. Such is the state of dot-com enthusiasm, or is it madness?

It's easy to joke about the overabundance of new brands, but one fact remains—the Web makes it possible to provide services that previously were not available. Search engines and portals are whole new business categories. The transformation of so-called bricks and mortar businesses into click and order businesses is a huge online phenomenon. And although this affects existing businesses as much as new businesses, the Web also provides an opportunity to redefine the way that business owners provide goods and services.

The Web provides an obvious paradigm shift for business transactions in the twenty-first century. As a result, the brands that you know and love must adapt and change so as not to be overwhelmed by the inundation of brands from every corner of the Web. This flood of new brands is discussed in this chapter, especially the dot-com brands that could not have existed in the pre-Web world.

[8]

DOT-COM BRANDS
WHERE HTML IS HOME

IN THE BEGINNING...

First came Yahoo!, a pure invention of the Web, a sort of light-in-the-wilderness guide to a chaotically expanding universe. Yahoo! succeeded by humanizing the Web-searching experience. Popularity brought advertising and assured Yahoo!'s preeminence as the Web's number one site. Endless new portal sites in the Yahoo! mold have followed.

With an understanding of how alluring good portals could be, the Web begot Amazon.com, and Web commerce was born. "Earth's Biggest Bookstore," may be bleeding cash, but it shows that the Web is Earth's biggest 24/7 bazaar. The lesson that Amazon.com teaches is that the Web is an enormous mercantile force.

THE BIG BANG BROWSER

But before Amazon.com and Yahoo! had a reason to exist, users needed a browser. Although Microsoft's Internet Explorer is grabbing market share now, Netscape Navigator, the successor to Mosaic, first introduced Microsoft's executives to the World Wide Web and its unbounded potential for exploitation.

Although Netscape may have lost the browser wars (pending litigation against Microsoft notwithstanding), it is still a major force. What synergy Netscape can gain from its acquisition by AOL-Time Warner is difficult to assess, but it clearly involves a rebranding of Netscape as more than a software developer.

(ABOVE) The first sign of Netscape's rebranding is a completely redesigned domain as a full-fledged portal site or, as designer William Drenttel likes to call it, an information hub.

TAMING THE WILD PORTAL

By their very nature, portals are meant to provide a link for everyone. For designers, providing a link for everyone means cramming as many links as possible into the space of a single screen. This stands in direct opposition to basic Web-design precepts, primarily, to keep the design as simple and uncluttered as possible. Above all else, clarity is essential for any successful design. William Drenttel, founder of the design firm Helfand & Drenttel, and his art director, Jeffrey Tyson, have shown that it can be done when they redesigned Netscape's page.

There are over one hundred links on Netscape's home portal page. Incredibly, there used to be more. When Drenttel started on the project in April of 1999, netscape.com was a Yahoo! me-too.

Drenttel's first attempt at redesigning Netscape's home page repositioned Netscape away from the channel model. Although graphically cleaner and more user-friendly than many information hubs, it was not a model of uncluttered beauty.

SAME BRAND, NEW OWNERS, NEW DESIGN

The acquisition of Netscape by AOL-Time Warner gave the Netscape domain much greater importance, both as a recognizable dot-com brand and as a source for advertising revenue. This site was expected to turn a profit, and to do this, it needed a new redesign. But the problem remains the same, including something for everyone on a single page without creating a bland, flat hierarchy that interests few? Portal sites need to attract as many people as possible on the first page by including something for everyone. Information architects may decry the portal model as an inefficient way to deliver information over the Web, but it does not matter. Users expect to see big, broad portals, which are, after all, some of the biggest brands on the Web.

So Netscape, too, must play the portal game, but it chooses to play by changing the game board. The Netscape board is more colorful, makes better use of the space on the page, and, most importantly, organizes all links into a clear, informational hierarchy. In essence, it takes a physical site hierarchy that is both broad and deep and arranges it for presentation as a virtual site map.

(ABOVE) Yahoo! is the archetypal portal with hundreds of links arranged in channels. This channel model is the standard for all sorts of portal and portal-like sites.

(OPPOSITE) Despite the unwieldy number of links still present, Netscape's interim page design was clearly divided into content zones that helped to structure the information.

LATEST NEWS CNN.com

Monday, Oct. 2, 2000
Updated every 15 minutes
- Supreme Court, in new term, to take on clean air, water, police searches
- Israeli-Palestinian clashes intensify
- **Business**: Dorel Shares Drop After Profit Warning
- **Sports**: Pirates' Manager Gets the Ax

More News...

WEATHER SEARCH

[_____] Go
Enter City Name or Zip Code

TOP PICKS

New: Business Tools
Buy Software Online
Consolidate Debt
Download/Netscape CD
Free Web Presence
Investor Challenge
Instant Messenger
Industry Headlines
Love@Netscape
New! 5¢ Calls
Online Games
Take a Survey for a Chance to Win $500

SHOP NOW

Baby Clothes
Digital Cameras
Pet Accessories
Shoes & Apparel

WEB TOOLS

Book Flights
Communications Center
Communities
Hardware Reviews
Make Better Decisions
Netscape 6
Plug-ins
Shareware

Chat WebMail My Download

[Lycos Search ▼] [_____] [Go]

Netscape
Netcenter

| Netbusiness | Free Time |

MARKET CENTER
Stock Quotes by
SALOMON SMITH BARNEY

[_____] [Quote]
☑ Symbol ☐ Name

SYMBOL	PRICE	CHANGE
DJIA	10,704.50	+53.60
Nasdaq	3,650.30	-22.52
S&P 500	1,441.08	+4.57

As of Oct. 2, 2000 12:00 pm ET

Quotes delayed at least 20 mins.
Disclaimer

NETBUSINESS
- Time saver: The average payroll process for a small business has 54 steps and takes 36 hours annually. Do you have that kind of time?

BUSINESS NEWS
- Latest from CBS MarketWatch.com.
- Breaking tech news by ZDNet.
- eCompany Now: Street Life -- Get the word on stocks.

CAREER CENTER
- Win $50,000: Enter Star Search 2000 from Monster.com.
- Office Fashion: Read about the trashy coworker and more.

PERSONAL FINANCE
- Mutual Funds: All the information you need about mutual funds – tips, advice, taxes and a comparison tool.

Search Links
Classifieds	Maps/Directions
Decision Guides	Netbusiness
Directory	White Pages
Office Specials	Yellow Pages

Shopping Shortcuts
Baby Clothes	Jewelry
Business Buying	Kids Clothes
Digital Cameras	Pet Accessories
Electronic Gaming	Shoes & Apparel

Today's Features...

Mideast Riots Out of Control: Israeli and Palestinian officials call for an end to the bloodshed that has killed more than 30 since Thursday. Officials fear the area's worst violence in four years will upset fragile peace talks. Read the Story
Bush, Gore Prep for Debates | A's and Mariners Clinch Playoff Spots | Olympics Wrap Up

Poll: How important are the debates in your pick for president?
○ Very important ○ Somewhat important
○ Not important at all [Vote]

AP

Struggling with a Small Business? Reach 20 million new customers for free.

amazon.com.
BUY BOOK BESTSELLERS HERE

Netbusiness: Find services, get estimates
Investor Challenge: Win $10,000
Business Web site: For free
Avon.com: Enjoy a refreshing weekend
Election 2000: Special Report

N Netscape
Personal Finance
Investor Challenge
Enter the Investor Challenge and start picking your stocks today. $10,000 online account grand prize.

Channels

Audio > Netscape Radio, Multimedia...

Autos > New Cars, Used Cars, Classic Cars...

Business > Career Center, Free Agents...

Computing & Internet > Free Software, News...

Entertainment > Movies, Music, TV, Celebrities...

Family > Kids, Teens, Genealogy, Seniors...

Games > Sports, Lounge, Clubroom, Worlds...

Health > Nutrition, Fitness, Women's Health...

Home Improvement > Remodel, Decorate...

Lifestyles > Women, Pets, Gay/Lesbian...

Local > Dining, Movies, Events, Arts & Culture...

Netbusiness > Buy, Manage, Network...

Netscape > Developers, Security, 4.7...

News > Biz, Politics, Sports, Tech...

Personal Finance > Invest, Portfolio, Insurance...

Real Estate > Homes, Apartments, Mortgages...

Research & Learn > Reference, Education...

Shopping > Computers, Books, Music...

PORTAL REBORN

"From a design standpoint, we couldn't go anyplace new without a new structure that would rein in the content," says Drenttel. So rather than continue the endless links approach, Drenttel tried a layered approach. But it wasn't until he flattened out the layers that he hit upon a way to deemphasize channels completely.

At the top is a dark blue navigation bar, branded with the Netscape logo. The dark blue gives this band the kind of borderlike quality users expect to see at the top of the page. It's an effect that opens up space underneath.

More importantly, browsers can find the search function on this top bar. Netscape Search is the first choice in the search engine's drop-down selector. Additionally, a list of ten section links, probably chosen for this important location because of their popularity, is displayed. On the right is space for two banner ads, plus one more link, which alternates between Get Management Training and Check Shipping Rates, both services of Netscape's newly branded NetBusiness venture. This simple layout creates a strong structure for the page.

Netscape is establishing a brand, not just with its logo but also with the color blue. This shade is the darkest shade of Netscape blue, and all the links in this band are in the lightest shade. It's difficult to brand the color blue, but Netscape's consistent use of a single blue hue in several shades is one of the strongest branding tools (after the actual logo) of this page.

CONTENT IN ITS PLACE

Putting the darkest color band on top creates a border and provides contrast for the taller white band that follows. This white space is the main content area and also where the eye goes to first for information.

These first two bands, which represent only about a quarter of the total page real estate, already contain a tremendous number of links across a broad range of areas. But compared to the endless lists of a Yahoo!-like page, this breadth is pretty easy to take in. The clear delineation of content areas helps to bring this page into focus and prevents the usual chaotic effect of similarly broad sites.

The unusual central link bar separates the more general features of the top of the page from the more topical ones that follow. The question is, is this link bar part of the top section of the page or part of the bottom? It's both. It falls within the first 400 pixels of the page within the so-called page fold. So it is visible without scrolling on even the smallest monitors. The link bar provides a way to view the content of the lower reaches of this rather long page without scrolling; therefore, it is part of the top.

However, graphically the link bar appears to be attached to the bottom half of the page. Netscape provides a good example of color branding by using blue for the background of the first three bands and blue letters on a yellow background for the other three bands, which clearly binds the link bar to the bars that follow it. Functionally, the link bar forms a bottom navigation bar for what precedes it, while visually forming a heading strip for what follows. This clever ambiguity enables the strip to do double duty.

The graphic structure of the page is further strengthened by the color tints used for each band, the white hairlines used to separate bands from each other, and the light blue hairlines used to separate columns within each color bar. There's nothing wishy-washy about the way elements are juxtaposed; they remain clearly differentiated.

The down-pointing arrows of the jump-down links make it clear that clicking these color bars leads somewhere, and the labels—business, personal finance, netbusiness, shop, tech, and fun—make it pretty clear what you can expect. Using two hues to differentiate business (blue) from pleasure (yellow) not only improves the clarity of the page but is also a carryover from Netscape's previous home page design, which used two color-coded tabs to represent Netbusiness and Free Time.

(TOP) The main content bar is filled with news from Time Warner–owned CNN, which provides constantly updated headlines for the entire home page.

(BOTTOM) Everything that falls under the main navigation and content bars is divided into three blue and three yellow bands topped by a bar of jump down links, one for each of the five following bars, plus a tab for the first blue bar, "Business."

A FAÇADE OF ORDERLINESS

Although Netscape's home page includes scores of links leading off in all kinds of directions, content areas on the page give this amorphous collection a clear definition. The hierarchical links are not gathered together in a single navigation element. Instead, the hierarchical links are the More arrows at the bottom-right corner of each color bar. The graphic design is what gives this site its hierarchy.

Which brings up an interesting point: This Drenttel-designed page is like a reverse wild-west façade. Instead of a fancy design on a rather modest building, this page is a simple, clear design hiding an enormous collection of sites and information behind it. In fact, the rest of Netscape's sites, subsites, and subdomains have yet to be redesigned.

The next step for the development of this page will enable users to customize the content by essentially creating customized hierarchies. Many portals and search sites already provide this capability, but the Netscape-branded experience is designed to accommodate this kind of content rearrangement with great flexibility. The content areas expand and contract but remain true to the Netscape colors.

THE FIFTY PERCENT SOLUTION: WEB SITES FOR WOMEN, WEB SITES FOR MEN

In the last year or two, Web sites geared toward women's concerns and interests have become more popular because women are spending more time browsing. Special-interest Web sites are also blossoming. In its basic form, a women's Web site is not much different from a women's print magazine — articles about subjects of interest to women, including health, personal finance, and family, with the addition of some chat features on the same subjects. In the dot-com realm, women's sites such as www.oxygen.com are big Web business.

However, oxygen.com suffers the same weaknesses as the entire industry of "women's" publishing. It is difficult to take a publication seriously that, with no sense of irony, juxtaposes stories about the death of two women sailors in the bombing of the USS *Cole* in Yemen, with the following headline, "Fall TV Preview: What's worth your couch potato-dom?" Isn't there something tasteless about an information hierarchy that equates sex, diet, and world politics?

Furthermore, is it necessarily so that a commercially successful formula for print magazines is the best way to attract a loyal female following on the Web? Couldn't a new medium encourage new thinking on this subject rather than perpetuate a very stale status quo?

Although oxygen.com exhibits many features of a great dot-com site, the site could as easily exist as a print magazine and TV network. Except for a few interactive features, like a schedule and some games, Oxygen looks and reads pretty much like a host of other women's publications.

(LEFT) Oxygen is a huge, new brand that includes numerous topical divisions, well over a dozen cobranded sites, and a TV production enterprise, all for women.

JUST THE GUYS

On the other hand, where are all the "men's" sites? For those of us who wear the mustache in the family, there's Guyville, with its very male aesthetic. The logo is chunky, almost muscle-bound in appearance. The colors are distinctly gray and brown, not at all like the warm upbeat hues of Oxygen's home page. The layout is downright rectilinear, and the features are listed with very little fanfare. There's nothing especially subtle here. A more adventurous layout would make this hunk of a home page more interesting, but this was clearly not a priority for the guys (and gals) at Guyville.

Interestingly, the content is not all that different from that of a women's site—it emphasizes lifestyle issues. In fact, the major hierarchical divisions, Health, Style, Work + Money, The Finer Things, Gadgets, and Sports, easily apply to both sexes. The final category, Women, is the difference (as in, "vive la difference"), and there's another important difference. The icon system of male bodies (except for that last category) is as masculine as the site's logo and color scheme.

(ABOVE) "Where men can be guys." Make no mistake about it. Guyville's Web site is no self-reverential women's refuge.

A GUY NEEDS TO KNOW

Within the site's divisions, the tone of the images and text is down-right wry. This information is not earth shattering, and it is clear to the guys of Guyville that none of this style information needs to be taken too seriously. For instance, clicking the Grooming Guide, the icon of Mr. Style with his carefully groomed Afro and excruciatingly tidy goatee, links to a page featuring an article about the perfect shave and another article on keeping your hair nice and clean. This is seriously guy-oriented stuff, not so different from the content of a women's site?

Similarly, the A Guy for Different Occasions section with an animated GIF version of Mr. Style, all dressed and "moving and grooving" in a '60s disco way, present fairly inane content, but in a sophisticated, slightly humorous way. And clearly there is a segment of the male population for whom the availability of this information is truly useful.

(TOP RIGHT) The navigational hierarchy for each of the divisional home pages features GIF rollover icons in a column on the left, a banner ad on top with the logo, and featured nonhierarchical links beneath. The color scheme of manly earth tones remains.

(BOTTOM) The navigation bar of full frontal icons is a cleverly animated Flash movie. Instead of a standard rollover, the man icons seem to come to life, stepping forward to present themselves for more careful inspection. Each icon includes an expanded tag line, so Health becomes fitness, nutrition, and tips, and Women becomes dating, marriage, and fatherhood.

THE BROTHERHOOD OF GUYS

Guyville is not yet heavy on content, but the site is actively building its community. In addition to the hierarchical navigation based on icons and the standard nonhierarchical links for company information, contact data, and other administrative information, Guyville's content pages include a box of community links.

This element of community is member-oriented and includes branded lozenge-shaped buttons for My Guyville, Email Group, Member Directory, and IM Software (that's Instant Messaging software) as well as links for message boards and chat rooms. Membership is required, and payment is in the form of your demographic profile: name, address, phone number, and a list of interests.

Come on guys! What are you waiting for? Don't you want to be a part of the largest online community of men, or maybe you'd like to win prizes of gadgets or cash? This is a pretty standard line of approach for community-building Web sites. What Guyville does nicely is to build its brand recognition within the site. The consistent use of the "guy" motif for icons, the straightforward, no nonsense layout, and even the very masculine color choices all help create positive associations for the target audience.

Guyville.com's site designers have also managed to make these design selections with an eye towards irony or at least with a knowledge of the correct level of rhetoric for a site whose attraction is based on vanity, basic insecurities, and male bonding.

(ABOVE) Joining the animated icon with the photograph in a single box that hangs over the column border helps to unify the composition of this page.

ROCKET BRAND SCIENCE

Black Rocket is a network services platform from a company with the clipped identity of Genuity. This is the kind of name that only a dot-com company can come up with, but it's appropriate for a company selling products to other dot-com-ers. Actually, Genuity is a rebranding of GTE Internetworking, and Black Rocket is a new brand of integrated networking services. It's all presented as though this were a completely new undertaking, just like the start-ups targeted to buy the product. But Genuity has been involved in supplying backbone technology for the Internet and World Wide Web for some time. It's an old dot-com in new dot-com clothes.

Describing what Black Rocket is to individuals who are not familiar with network servers can be difficult. Is it hardware or software, physical or virtual, a product or a service? It's all of the above, and so the audience for this site is quite select. Yet the design of the site is constructed with the same careful attention to brand building and navigational hierarchies that characterizes all the sites in this book.

THE SUM OF ITS PARTS

Genuity's home page is divided into stages that can be examined individually and then assembled. The first element, as is so often the case, is a table containing the company logo and a darkish navigation bar. Each of the six links is associated with a small color square, but no rollovers highlight the fact that these are links. This bar appears at the top of every page on the site.

The next stage is a nonpersistent vertical navigation column with three featured links. These links can change to feature different elements of the site. For instance, the Vision link is doubly important, showing up in both the persistent (areas that stay the same) and nonpersistent (areas that change) navigation areas. The mustard yellow provides a nice contrast to the gray of the navigation bar, while the theme of little squares attached to all-caps sans serif lettering is continued. This technical, even scientific-looking aesthetic provides plenty of contrast to the elegantly serif lettered Genuity logo, with its hand-drawn, chalklike *i*, looking as if it were ready to take off.

The bottom navigation bar contains all the familiar parts of the first two stages discussed here, yet it is clearly less important or at least not so noticeable. The links in this bottom bar are more generic, About Us, Jobs, Investor Relations, and so on.

This is basic corporate stuff, except for the Ask Genuity Live link that isn't downplayed but is emphasized on a sienna-colored background. The colors and placement of this button actually tie it into the vertical elements, including the Genuity brand logo at the top of the column, giving it much more visual importance.

The Network Services Provider
for businesses changing the world.

□ VISION
With Black Rocket, Genuity provides a platform enabling rapid business change, innovation, and a competitive edge. Click Here

■ OFFERINGS
Genuity provides four types of offerings for enterprises and service providers. Click Here

■ ePARTNERS
Start building a whole new world with Black Rocket. Genuity enables change faster than ever before. Click Here

(TOP) The vertical navigation column with its yellow background features nonhierarchical links, each with a brief explanation. Rollovers switch the background of both the red link and accompanying text to gray. (MIDDLE) The top navigation bar displays more important links in the darker strip on top, with secondary links in the lighter strip beneath.

(BOTTOM) The bottom navigation bar repeats the colors of the top bar, but with less contrast in the text. The yellow squares and text size are smaller and the gray lettering is set on a gray background.

All of this site's pages have a strongly consistent visual identity. Here is the Sitemap page. For instance, the contents of the Sitemap and the Call Me Now page are framed in exactly the same way, including the page title and the Search form field. These features are standard on Genuity's interior pages, as are the color framing elements on both sides.

Genuity's home page is framed with the same three stage navigational scheme. These establish the Genuity brand look for the entire site—the background color bars, the small color squares, and the sans serif, all-caps type.

(TOP AND BOTTOM) The Ask Genuity Live link is a form page that uses all the persistent elements of the home page, the top and bottom navigation bars, along with an additional page labeling element that is used to brand each division of the site. The same is true, in a somewhat stretch version, for the Sitemap page.

(RIGHT) The three navigational stages are dovetailed, so that the first element of the top and bottom bars can be viewed as part of a longer left-hand column.

The main image square in the middle states the case for Black Rocket in the form of a Flash movie. The movie finishes with the Black Rocket logotype and the model rocket in the hands of a young rocket scientist. Notice the Buck Rogers–like black rocket on the launching pad in the bottom-right corner of the page. Genuity is trying to create an atmosphere of childlike enthusiasm for rockets (the network) and space (the Web). This page is saying, "Rockets are fun, but you don't have to worry about the engineering. We take care of the hard part for you." There's the sense that purchasing Black Rocket is supposed to be as easy as child's play.

While the Genuity and Black Rocket brands are nicely established by this site, it's difficult to figure out what Black Rocket really is. Genuity is one of those new entities known as a "solutions provider," but this is no excuse for the pervasive presence of vague prose. At no point does the site specifically state what Black Rocket is. How does Genuity really implement its "Network Services Platform," and what does this item look like? It turns out that all of this information is contained within a downloadable white paper but is strangely missing from the site's pages.

This lack of specifics might be the result of overzealous branding. Although Genuity got the branding right, it's got some work to do on the content. It's like getting the rocket into space but leaving out part of the payload.

(ABOVE) This is the home page, with real content filling the center of the screen. It is this content that gives the page its more immediate visual interest and explains the page's existence — something worth careful framing.

The popularity of Web shopping is no great surprise. In the United States where shopping has moved from urban centers to suburban malls, to mail order, the convenience of the click-and-order experience is undeniable. Compared to a catalog, the essentially unlimited space and distribution of a Web site are incredibly powerful tools. For many people, staying home and shopping online makes much more sense than braving mall parking lots between Thanksgiving and Christmas. You can buy almost anything on the Web. Thus, the consumer faces a proliferation of e-commerce sites.

The trouble is that gerbil food, toe socks, lightbulbs, cars, and sausages all sit on the same shelf when they are sold from a Web site. The sites seemingly share the same little shopping cart icon, the same selection and checkout systems, and even the same-styled order confirmation messages. Because e-commerce is driving not only Web utilization but also Web technology, e-commerce technology is driving Web design, as well.

That little shopping cart icon in an array of different sites, represents a bit of the backend software coming to the forefront of the user experience. Building a shopping application from scratch takes a lot of work, and there are few software packages that make this process easier. Therefore, it is easy to see why most e-commerce sites use the same software packages and have similar features.

On the one hand, the presence of the same e-commerce features is no different from seeing the same credit card machines at all stores. Familiarity makes the online shopping experience easier. On the other hand, the Web site is the brand, and when it comes to e-commerce, the shopping experience is as important as the items being sold.

[9]
E-COMMERCE BRANDS
THE CORNER STORE

SHOPPING BEYOND THE CORNER

It's difficult to get excited about something as mundane as an online grocery store. But what is it like to wander the souks of Marrakesh in search of bargains or visit the natives of the Amazon rain forest to collect tribal crafts. Such are the shopping experiences available for exploration at www.eziba.com.

In many ways, eZiba is a dot-com-only experience similar to those discussed in Chapter 8. One is not just shopping but is engaged in an exploration of crafts. Cynically, this has the trappings of a fatuous quest, but the fact is that eZiba is not just a typical crafts shop. The context of the site transcends the typical shop-bound buying trip. Viewers can experience the flavor of international travel in the way items are presented. This experience is not due to context alone, but due to the accompanying content, as well.

All the many photographs on this site are special—lots of low camera angles, subtle motion blurs, and dramatic lighting. One often gets the sense of climbing hills or rounding corners at high speed. These super models are posed to reveal every curve.

This nearly monochromatic home page is the essence of elegance. The high-contrast, black-and-white photo, the use of a classically proportioned book typeface, Baskerville, and even the thin white rule separating text from image, all create an overriding sense of refinement.

THE HANDCRAFTED AESTHETIC

eZiba is a completely new brand, one of many e-commerce creations that invests heavily in traditional media advertising in the hope of luring customers to its site. Investing in media advertising is expensive, so it had better be worth the trip for new customers at eZiba.

Nesting, or more precisely, weaving, is an important aspect of the eZiba image. The elements of this page create a woven effect. The overlap of the vertical gray column on the left with the sand-colored bar containing the logo creates the beginnings of the warp and weft motif of this site's layout. A circular, woven emblem marks this intersection. Instead of the generic shopping cart symbol, a handcrafted basket icon continues the weaving theme.

The thematic colors are distinctly earthy, utilizing subtle shades of herbal dyes. It makes the vivid bloodred color of the consonants of the eZiba logo stand out more boldly.

The clearly stated motto, "Handcrafted goods from around the world," is visually reinforced by the two other elements present in the banner. First, the image of a pair of dark hands (the artisan's, presumably) presenting the featured object, a comely alabaster vase. The contrast of the photo not only heightens the appeal of the vase, but also emphasizes the object's handcrafted nature. Second, the small but very clear world map in the color bar conveys the international scope of the site and its offerings.

The brand is established by the eZiba name, the handcrafted motif, and the subtle weaving of elements, color, and imagery to evoke an international flavor. Now they have to sell the goods.

(ABOVE) A trip to eziba.com is rewarded with an online experience of no-frills elegance. This brand is image-conscious and displays a very image-dependent site. The small amounts of text are set in sans serif, and headings are all typeset GIFs.

ALTERNATE TRAVEL ROUTES

There are five ways to shop on this site—world region, product category, gifts, auctions, and direct search—and you can access each shopping path in two ways. The main navigation bar across the top lists all the site divisions, including the five shopping links. On the home page, the table includes the company slogan, and on divisional pages, the eZiba logo and the search widget are in-cluded. The regional links are implemented as an image map with bloodred rollovers, the only dynamic element of the home page.

The catalog is divided into two main organizing principles, product category and world region. Each is divided into subsections that narrow the selection. As the search narrows, there are fewer catalog pages and the number of items become easier to browse among.

The display and navigation of items on the pages is the same across all shopping paths. Each item is shown in a smallish square with the price and a very brief description, three items to a row. Clicking an image brings up a detail page with an enlarged view and a thorough description.

(LEFT) Clicking the World Regions link in the top navigation bar of the home page leads to the World Regions divisional home page, skipping over a hierarchical level to a list of all 1,130 items in 189 pages of the catalog. Clicking the region list in the color band on this page to narrow the listings produces the same result as clicking an image map region on the home page.

(RIGHT) Like the World Regions divisional home page, the product categories division is also set up to default to the complete catalog listing and to provide a list of categories that enables you to speed more directly to your destination. By providing the entire catalog and the list of categories, the Web designers give the consumer a choice of taking the express elevator instead of riding up the escalator.

NO HAGGLING OVER PRICES

There are a couple of other options available from the detail page. Most importantly, shoppers are encouraged to click the Add to Basket button. You can also enlarge the image further or e-mail the item page to a friend. The fact is, the programming support for this site is fairly basic. Instead of featuring the work of hard-toiling programmers, this site emphasizes the work of artisans.

eZiba also sponsors auctions, which run like other online auctions, but everything eZiba does is branded. The elements surrounding the eZiba auction pages are the same as those surrounding the catalog pages—the woven colors and brand logo that identify eZiba so clearly. The sandy colors of the catalog become a clay-gray to differentiate the auction pages, but the effect is the same. eZiba's use of color and brand logo also carries over to the shopping basket and checkout pages.

(LEFT) Detail pages can be reached using several different routes. The content of these pages is supplied from a database, while the navigational elements around the content trace the route to the item. It's possible to traverse the route in reverse using the navigation history in the color bar.

(RIGHT) Feature stories on artisans and their crafts are regularly updated. This element is a critical part of the site because it differentiates eZiba from a typical mail-order catalog or gift shop. Shoppers have a reason to return to the site to see what's new.

(THIS PAGE) Each auction is thematic. Featured here is an auction of woven baskets and boxes, and each item is neatly displayed with a detailed description available by clicking. The detail pages provide both auction and item information. This auction provides more of the flavor of an upscale auction house than an eBay-like livestock auction.

BRANDED CHECKOUT

First, every catalog shopping page includes the basket navigation element at the top right. As items are added to the market basket, they are neatly displayed in a column, and an order subtotal is calculated. Clicking the Checkout link opens a series of backend-driven administrative pages that bear the unmistakable stamp of eZiba.

This well-designed site strengthens the eZiba brand immeasurably, and the positive experience of the site certainly encourages repeat visits. eZiba is not only a pleasant place to linger, but there is also interesting information and genuinely unusual items from the well-stocked and attractive crafts shop. There is the feeling that a well-informed proprietor runs the show, so shoppers have confidence in what they buy.

(ABOVE) Branding the checkout sequence is as simple as including the sand-colored column on the left with the eZiba logo on top. These pages include a new navigation bar for the checkout sequence. This makes it possible for experienced shoppers to move through checkout in a virtual express lane.

BUYING WHERE THE GOODS ARE CHEAP AND THE SITE IS BLUE

How many sites examined in this book are branded with blue? JetBlue in Chapter 4, Netscape in Chapter 8, and now Bluefly, "the outlet store in your home." Of these three, Bluefly is the bluest. It is blue on blue on blue. How does Bluefly manage to achieve any contrast and lead the customer through the selection and purchasing process amidst so much blueness?

The Bluefly brand, like the eZiba brand just discussed, is an e-commerce startup. Although everything about the brand is new, the idea of selling designer cast-offs at deep discounts is as old as the pickle in the bottom of the barrel.

Bluefly's blue home page presents all content within a blue, rounded rectangle on a darker blue field. The stylized Bluefly logo with its tagline sits (or perhaps hovers lightly) at the top over the background.

All branded navigation is including within the rounded rectangle, along with the featured content. The hierarchical divisions for the site match the product categories. The iconography is meant to be hip and stylish without an expensive, overly sophisticated look. The icons are clearly labeled so that viewers don't have to puzzle out what each distinctive icon means. Instead, one learns to recognize them through repeated use.

Other elements also create contrast against the blue page. For example, some of the images on the home page are drawings, some iconic, while the product elements are always color photos. But the strongest contrast comes from orange buttons and lozenges. Each of the featured links has an orange-colored indicator, with the largest lozenges linking to alternative navigation and custom features: See All Designers, Make My Catalog, and Sign Up Now.

(RIGHT TOP) The way that the logo is positioned against the background, but totally separated from the content, helps to accentuate the importance of its logo.

(MIDDLE AND BOTTOM) In their static state, these icons are all blue and white. Dark blue lines define the objects, and the round buttons they fill are shaded from white to blue with a white outline. In their rolled-over state, the buttons turn all blue and the icon highlights orange, the active contrast color for these pages.

FINDING BARGAINS

The vastness of the inventory at Bluefly makes the selection process a bit more complicated than for boutique sites, but this site's thoughtful navigation helps. Looking for a new cardigan? Simple enough. Start by clicking the Womens' button and get a new blue page.

The divisional pages begin with the Bluefly logo on a line with the icon system over the background. The dark band of the shopping cart links follows. The division page begins under these two persistent elements. Narrow the search by selecting a designer or a category from separate drop-down menus. The designer and category choices are followed by Trend Watcher links (lots of leather and cashmere here) and a Designer Spotlight. In a third column labeled Style Buzz, select from specifically featured items.

(ABOVE) Each divisional page is carefully branded and labeled with an enlarged version of the division's icon and name. Within each division is a column of featured links to guide the item selection process.

There is a long and constantly changing list of Style Buzz items. Although these items seem to be randomly selected, they are actually chosen from the buzz list through a set of changing criteria. The result is that you are presented with different items every time you load a divisional page.

Clicking the Sweater—Cardigans/Set category, one of four sweater categories in the Shop by Category drop-down menu, links to an overwhelming fourteen pages of sweaters. Fortunately, there are ways to refine the selection. One can select by size, color, and price. The ultimate selector for this site is the designer selector.

Clicking on the $50–$100 price category reduces the number of selections to seven pages. This price range is clearly the most popular. Sixteen items are on each page, and each page is labeled with the current selection criteria, in this case Sweaters—Cardigans/Sets ($50 to $100, size M).

Clicking on the manufacturer's name for an item brings up the detail page. Bluefly maintains a very consistent brand structure around an everchanging array of choices. At Bluefly, as one would at an outlet store, shoppers learn how to find what they're looking for.

(ABOVE) The navigation among the pages is clearly laid out, so that it's not difficult to browse through all 120, or so, sweaters. Interestingly, prices within the $50 range actually start at $49. A little overlap is good, especially because so many prices fall right at the category break points.

CUSTOMIZED SHOPPING BUILDS BRAND LOYALTY

To encourage repeat shopping, Bluefly offers the MyCatalog link as the first icon on the menu bar. Supply your e-mail address and answer a few questions to set up the custom catalog with your size and preferences. Bluefly also has a search function, but you can only search by department and price. You can't look for corduroy shirts, for example.

After shopping through the site for a while, it's still not clear what the Bluefly name means. It brings only "Jimmy crack corn" to mind. But the name is distinctive and easy to remember, and the color scheme of this site sets an informal, friendly tone.

(LEFT) The view of the sweater is the same on this page, but enlarged. The price, with the discount highlighted, leads the page, and a description full of positive adjectives is included, along with several additional options. Or, you can simply purchase the item.

(RIGHT) The search page, Search on the Fly, is consistent with all the other pages of the site, and the pun in the name helps maintain the slightly counterculture image of the Bluefly brand.

YOU'RE CORDIALLY INVITED TO SHOP

The Williams-Sonoma brand is not new to the Web, but it recently created a greatly expanded Web presence that does more than offer online shopping. This site gets its strength by creating a combination store, catalog, and cooking school—all clearly branded with the Williams-Sonoma imprimatur.

Williams-Sonoma uses an approach that is a little formal. Perhaps it is an attitude of propriety about the serving of food. How ironic to present such grandeur to a mass shopping audience! However, if success is any measure, it is an effective device.

STARCHILY FORMAL, BUT INVITING

This home page looks like a fancy engraved invitation. The neat gray border around a card-sized page, the centered text set in very formal Caslon, complete with open-face type on top, and italics for smaller text—it's all quite classic. Even the seasonally appropriate photograph, with its dressy table setting and perfectly roasted turkey, has the unmistakable flavor of formality.

If the tone of this page were pure snob appeal, the result of Williams-Sonoma's efforts would be no better than a fallen soufflé. Instead, viewers are treated as special guests, and it is this "specialness" that makes the stores, the catalogs, and this site so appealing to so many. How can one refuse such a gracious invitation?

This Shop page is in the form of a recipe card, like something a shopper would pick up in the store to make at home. The shopper always knows that the recipe is from Williams-Sonoma, because the logotype is prominently printed in the corner.

The content and the context of these pages creates the feeling of formal elegance. The color of the page comes mostly from the images, which are nicely contrasted against the white background. The division label, Shop, is in reverse type against a taupe color bar. It is one of those noncolors that implies sophistication.

(LEFT) Each line of this invitation/home page is a link. The bolder lines provide hierarchical links to the site's major divisions, and the italic lines link to featured connections. The bold divisional links remain unchanged, while the italic featured links change with the page's photograph and the season.

(RIGHT) Upon entering the catalog division, the bold lines of the home page become divisional links of the persistent navigation bar on top.

EVEN A PEELER CAN LOOK EXPENSIVE

The secondary hierarchical links to the shop's sections provide both navigation and the page's content. The links include a bottle of champagne in an ice bucket, a copper saucepan, fancy bottles of vinegar, and it is all presented with such clarity. The grid of fifteen items representing the fifteen shopping sections is as tidy and orderly as a featured interior in *Architectural Digest* magazine.

What's nice about the blend of content and context here is that all the photos on this page can change with the seasons, or with the inventory, without upsetting the navigation or the feeling of elegance. Each of the sections within the shopping division receives similar treatment. The heading changes to reflect a step down in the site's hierarchy and an array of subsections is presented as item photos and link names.

BE A PRO IN YOUR OWN KITCHEN

But there is something different here, too. Under the larger photo are two nonhierarchical links listed as Tips under the heading Additional Information: About Juicers and Making Crepes. It is this additional content that takes williams-sonoma.com beyond the realm of a standard e-commerce site or the capabilities of a magazine and begins to introduce the almost personal touch of a well-informed and ever-ready salesperson/chef.

Williams-Sonoma is not just A Catalog for Cooks, and it has skillfully infused its Web pages with bits from its voluminous printed content. The same is true, but in reverse, in the Recipes division of the site. The secondary navigation allows viewers to browse the recipe files in two ways: by course or by searching. There are also links for seasonally suggested menus, recipes, and accompanying tips.

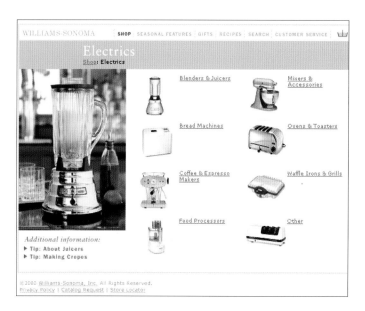

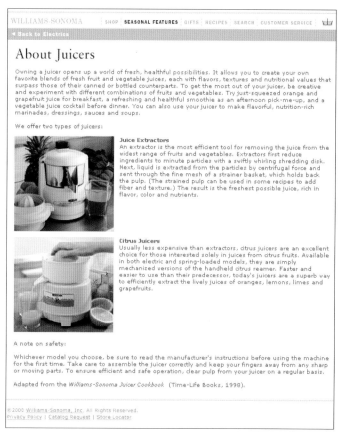

(LEFT) In the Electrics section, a new seasonally appropriate photo, along with eight subsections for blenders, mixers, bread machines, and so forth appears.

(RIGHT) "We offer two types of juicers" says this extended excerpt from *The Williams-Sonoma Juicer Cookbook*. The cookbook allows viewers to draw upon its content for use as a virtual sidebar.

This site makes no attempt to adopt the technological cutting edge. The typography is based on carefully typeset GIF headings and sans serif black text in columns. Photos do most of the image-making work. In fact, all the photos within this site, and in all of Williams-Sonoma's publications for that matter, are particularly appetizing.

Just as Bluefly gives shoppers many ways to make a selection, Williams-Sonoma is trying to maximize the number of experiences its site offers. It is a way to encourage visitors to buy something now, or at least to find something that they may like to buy later. This technique is most apparent in the Gifts division.

(LEFT) The Recipes pages show the same branding elements included in the Shop: the logo-branded divisional navigation bar across the top, the recipe card–like layout, along with the appetizing photo of elegantly prepared and presented food.

(RIGHT) This divisional home page uses an age-old branding trick, the signature gift. Where all other division pages are simply headed with the division name, this page is labeled Gift Ideas from Williams-Sonoma.

'TIS BETTER TO GIVE...

First, the proverbial blue-eyed boy bearing a beribboned toaster sets the gift-giving mood. Then there is a list with four categories of gifts, with two to five choices within each category. If one is unable to find a suitable selection from among these options, there are Williams-Sonoma gift certificates offered, as well. It is interesting to compare the leisurely display of choices presented by Williams-Sonoma to Bluefly's more high-tech, almost crowded presentation. Williams-Sonoma's Web site is all elegance and refinement, while Bluefly's Web site is noisy and exciting; each method is appropriate to its given context.

As nicely as Williams-Sonoma sets the groaning board for gift giving, their low-tech approach to navigation slows down the selection process. The avoidance of a more complex navigational scheme seems technophobic at this point. Perhaps the Web elves at Williams-Sonoma are planning some more technologically interesting additions to their newly revised site. It has got all the branding just right. Those shoppers who are familiar with the stores and catalogs will feel right at home.

(ABOVE) Within each subcategory page, each item is spaciously displayed in a carefully arranged matrix. But after entering a subcategory display, there is no way to skip to a different subcategory without going back up to the division home page.

Now for the ultimate questions: How do you brand the branders of big brands? What about the Web sites of the site builders? When it comes to building one's own site, what are the important considerations?

The questions designers ask their clients, those that lead to design solutions, are the same questions designers must ask themselves: Who is the target audience? What is the message? What impression do you want to make? Are designers perhaps less rigorous in designing their own sites than in creating sites for others? And is this the logical result of limited time for what might seem less important projects?

In some ways creating a personal Web identity is the most difficult project one faces. It's like writing the personal essays for college admissions. There's something slightly embarrassing about talking about oneself. Yet, if there is one universal commandment when it comes to self-branding, it is this: sell thyself.

Here is the chance to create completely unfettered designs. There is no one to say that a color is too bold or a typeface too fuzzy. It's a chance to experiment with the technology and explore possibilities that may be too radical for a typical client. But this same client will look upon design experiments as evidence of advanced understanding of the Web's capabilities.

As is evident from the sites highlighted in this chapter, the creation of a self-branded site is a golden opportunity to show who one is by being creative and original. These sites go beyond the establishment of an identity to give potential clients a feeling for the real personality of the firm. In a field as dependent on customization as Web design, a strong positive personality can be a tremendous strength.

[10] SELF-BRANDING
THE BRANDS THAT BRAND

THE PERSONALITY OF THE DESIGNER

As Web branders, we struggle to create unique identities on the Web. Sometimes this is a corporate identity in which a designer has only a limited personal stake. But more often, Web design firms are small and are very much a reflection of our own personalities. Andres.com is such a firm.

My site is perpetually incomplete, but I discuss it here because I can write about the train of thought that brought me to the design idea. My design firm, Andres.com, is very much a reflection of me. That's the easy part for a small company. Yet trying to distill the essence of myself into design elements is a painful and often embarrassing exercise. There are some things I would just as soon not tell about myself.

As a result, www. andres.com says little about me personally. The site's emphasis is corporate, concerned with the things we do. Yet my personality is everywhere.

DESIGN REFLECTIONS AND A LITTLE TEXT

First of all, as you've probably figured out from this book, I prefer a graphic statement that relies more on simple elegance than outrageous or cutting-edge design. I can appreciate both, but my preference is clear. I also know that my skills as a graphic designer lean heavily toward typography and the rectilinear.

All the pages are clearly branded with a large andres.com logo in the upper-left corner. On the homepage the logo is horizontal, and as you'll see, it is used vertically for interior pages. The play of the narrower red letters of Andres on a white background contrasts with the bolder white letters of .com against a blue background. This use of contrasting colors and letter widths is picked up and used throughout the site.

There is no HTML text used for the main pages. And rather than use a contrasting typeface, the text buttons and blocks all use Agfa's Rotis Semiserif, a typeface that is both friendly and serious. It is sufficiently robust so that the serifs don't disappear at low resolutions, yet it is more distinctive than a completely sans serif face—a perfect face for Web use.

(ABOVE) This site would not be an honest reflection of who I am and what andres.com does if I did not emphasize its written content. This simple, strong composition is the result.

THE SERIOUS AND THE PUZZLING—GRAPHIC ELEMENTS AND ANAGRAMS

And what about that content, "Zany Ale," 'Loved PE," "Limpet Men?" What is this nonsense? The problem I faced was in trying to make my three key concepts—analyze, develop, and implement—interesting to potential clients. These are obviously the three basic phases of Web design, but how much less obvious to discover them hidden as anagrams.

I've watched people ponder the links and seriously wonder what my made-up terms meant. It's an attention-grabbing device, and it never fails to amuse once the true meanings are revealed.

All the rollover images and targeted text are preloaded, so by the time you've read the introductory text, the rollover actions happen instantaneously, as fast as if they were Flash animations. Also, notice that these three links aren't really links to anything but additional text. It's a way to engage the reader. You have to do something to get to the story, and because of this, the value of the story is increased.

WHEN PRIMARY NAVIGATION IS SECONDARY

The icons in the lower-right corner of the table add graphic interest and provide the site's navigation. You might be wondering why I located the most out-of-the-way corner for the navigation. What's it doing there? My intention is to have browsers read the home page content first, before they even realize that other pages exist.

The navigational scheme uses the same technique of rollovers with targeted text, but it is much more concise. First, each navigational icon is a vivid, strongly contrasted (black on red) image: a cog, a factory, and a person. It's clear that these icons are meant to be links, but it's not clear what they link to. Again, you have to point to them to find out. You're not just a passive reader when you come to this site. You have to participate. The rewards for participation are the anagrams and entertaining rollovers.

All of this good-natured activity becomes very much a part of the brand. If you like the way this site looks and works, you will like the company, as well. The intent is to create good feelings about the corporate entity that is andres.com.

(THIS SPREAD) Are you curious enough to point your cursor at one of these buttons to find out? The rollovers unscramble the anagrams to reveal the headings, and at the same time change the message in the text area.

PROCESS

PLACE

PEOPLE

(THIS PAGE) Rolling over the icons reverses the colors to red on black and pops up the explanatory linking text: Process, Place, and People. (The alliteration of the three p's was accidental, but I thought it added a nice touch.) These are the three hierarchical divisions of the site, and each division becomes identifiable by its icon.

CONSISTENT TONE AND IMAGE EQUALS
CONSISTENT MESSAGE

Each of the divisional pages continues the branded layout established on the home page. The contents are rearranged within the 400 x 600 pixel table so that the navigational elements join the logo in a vertical column running down the left side of the page. The text area stays in the same place. The current page is identified both by its icon and by title. An ampersand is added as a fourth navigational icon for the Home link. (I use the ampersand to represent home, because of the "and" at the beginning of andres.com)

Even though the text is serious, the tone of the site is lighthearted. You can see this carried on to the People divisional page. When the page loads, all you see are five heads under the tag line, "Who do you think we are?" This isn't meant to be hilariously funny, just slightly engaging and amusing. The entire site is intended to be read with a smile.

So who am I, and what is andres.com? You know almost as much from the way the site works as from the content itself. As the site grows, the content will become more important, but the tone established by the engaging rollovers will continue to serve as the chief identifier. The rollovers make the andres.com brand more interesting and more identifiable.

(ABOVE) The black column separating the logo and navigation from the page content contains both the page's identifying icon and the rollover text identifying the navigational links.

How Do Web Sites Grow and Evolve?
PROCESS

"Web sites are not static objects to be framed and admired without ever changing."

We speak of customizing Web sites, of architectural design and the hand-crafted nature of site construction; 19th century terminology for a technology leading us into the 21st century. Web site creation hasn't come close to the assembly line efficiency of the industrial age, remaining very much a hit or miss proposition. We don't like these odds, and in reponse have developed a process that assures an efficiently run project culminating in a compelling Web presence. The secret is in the effort we expend up front creating a Strategic Web Analysis of your business. This, along with a continuous cycle of analysis, development, and implementation allows us to create and maintain great Web sites in a timely and affordable manner.

response@andres.com, 314 Woodbury Road, Washington, CT 06793, 860-868-4002

(ABOVE) To answer the question "Who do you think we are?," you must roll over an image, which activates an animated GIF. The name then scrolls out from under the head.

WWW.COW.COM (URL)
COW INTERACTIVE (DESIGN FIRM)
COW INTERACTIVE (CLIENT)

GRAZING THE URBAN RANCHES OF THE WEB

For this next adventure in self-branding, take a graze over to the clover-full fields, or at least the office suites of Cloverfield Boulevard, in Santa Monica, CA, home pasture of Cow Interactive. Are these people serious? On the other hand, what a great name—it's only three letters, it's an immediately recognizable animal, and yet the first reaction upon hearing the name is usually, "What?"

For less creative pokes, a name like Cow would be a burden, re-quiring constant explanation and justification. For the ranch hands at Cow, designers of cutting edge Web sites, it's an endless opportunity for humor and self-expression.

WATCH YOUR STEP

The site is entered with what looks like something substantial but is really illusory The field is maroon. There is a flat arrangement of building blocks, a greeting, and a message in the form of an animated GIF. Viewers see "moo", a cow, and the message "Cow interactive communications." Rather than have repeat visitors see the same preface each time, Cow has the elements of the page update and shuffle randomly.

Each introductory tag line leads to a different content element in the core site. These diverging paths are not an important navigational element in the organization of the site, but they introduce variation that keeps the joke from losing its punch. At the same time, this scheme accommodates newly featured elements with grace.

It's all calculated to give the Cow brand a feeling of simplicity, without being unsophisticated or flip. In fact, the whole idea of branding a design firm with the bovine ilk is both hilariously incongruous and reassuringly solid.

(ABOVE) Cow's introductory page is funny and provocative, and it won't be there if you look again. There are at least three arrangements of the ten building blocks (cow, rocket, and face), seven greetings, and five animated tag lines.

The Sun Microsystems 1998 online annual report, located at **sun.com/corporateoverview/ investor/ar/1998,** features dynamic interactive financial Java applets, including Sun's "Future of the Network."

We created **championpaper.com** to manage large quantities of information. It contains powerful extranet tools that allow users to order huge quantities of paper in real-time.

(THIS PAGE) Clicking the "Sun Microsystems annual report" tag line links to Cow's work for Sun, while "The new championpaper.com" changes the content element to reflect Cow's efforts for Champion. Clicking directly on the block arrangement opens the core site in its generic state.

THE FOUR-SQUARE FIELD MOTIF

The core site opens in a new window that's approximately 4" x 8". There are four color panes that represent the four hierarchical divisions of the site, What's new at cow, *Fortune* 500 clients, A simple approach, and Powerful solutions. The bottom frame is used as a persistent black border containing two nonhierarchical links, Contact cow and Join our team, and a third client-access link providing password-protected access to work-in-progress.

There's nothing on this page but text and color. The layout couldn't be simpler. Yet in its simplicity it's a powerfully original composition. The juxtaposition of strong but subtle colors creates contrast and tension, and the use of two colors for each of the text links heightens this tension and gives the words additional force. Also Cow didn't simply use the expected linking words that you see on so many sites: Clients, Approach, and Solutions. It went to the trouble of choosing more explicit words that become part of its brand. This shows that someone has actually spent time ruminating over the meanings of things.

And the rollover animations prove the aptness of each of these division titles. What's new at Cow fades to New clients, Articles, Case study, and Speaking events, which happen to be the divisional sublinks. Each of the animations includes a fadeout, blackout, fade in, and then fadeout for each of the sublinks.

AS YE SOW, SO SHALL YE REAP

Clicking a link in any state loads the divisional page. What follows is a particularly clever geometrical transformation. The activated square is enlarged to include content, pushing the three other squares into the corner to become the hierarchical navigational elements. Thus, clicking the What's new square in the upper left pushes the navigation to the lower right.

Just as the navigation squares move around within the frame, the content and divisional hierarchy rotate. But even though the positions keep changing, the element types remain the same. It's not necessary to adhere to a stagnant layout to attain clarity, and after seeing so many navigational schemes fixed to the top row and left column, it's refreshing to find out that elements can be moved without upsetting the usability of the site.

Cow's reliance on a closed box would seem to limit its ability to include a lot of serious content. After all, there's very little room even in the expanded square for much explanation. But Cow's imagination isn't limited by this. Instead it packages information in smaller parcels for easy digestion.

Everything on Cow's site looks good. The colors, the typefaces, the clearly delineated layout all work toward creating a very positive image. But there's more, because the good humor of the images and text and the extreme cleverness of the changing juxtapositions of elements are really what help Cow to stand out in its field. Cow makes clear that it is not only a high-quality designer, but that it has an attitude about design that is uniquely Cow.

(OPPOSITE PAGE AND TOP) The layout scheme is a play on the rearranging children's blocks from the introductory page, and the block figures themselves return as icons for two of the divisions; The cow arrangement brands the What's new division, the face brands the Clients division.

(BOTTOM) Within the Clients division, click on the Internet section and the tag line next to the link, Check out our latest sites, changes to a simple list of numbered links. It's a way to expand the content without expanding the box.

The Web is an intentionally utopian world. The physicists who created the Web did so without regard for operating systems, hardware platforms, or thoughts of competitive advantage. Branding was the last thing on their minds, and they believed that everyone would be equal on the Web.

They also set up all of the Web sites to be identified by simple addresses known as uniform resource locators, the now ubiquitous URLs. The URLs accept any name, but require you to categorize your address with an abbreviated suffix: .org for organization, .edu for school, .net for Internet-oriented groups, .gov for governmental entities, .int for international groups outside the United States, and .mil for military. These were the types of entities that built the Internet and were expected to dominate the Web. Oh yes, there was one more suffix, .com.

It was some years before the dot-coms came to dominate the Internet, creating a rush of Web branding. So it seems appropriate examine the sites of nonprofit organizations and educational institutions in the protected space of a single chapter. But the first question is whether it is even appropriate to refer to these entities as "brands."" It's refreshing to look at a group of sites that aren't in it for the money. Their revenue model is not based on making investors wealthy, and while they all have something to sell, often it's not a cash deal. For instance, how many sponsors get their fifteen-second pitch in before any broadcast on commercial-free public television can begin?

It is perfectly clear that brand recognition is as important to non-profit organizations as it is to the most profit-oriented corporations. Just as public broadcasting stations must advertise and compete for viewers, charities compete for contributors, schools vie for applicants, and museums attract crowds. Considering the proliferation of PBS tote bags, Harvard sweatshirts, and Smithsonian baseball caps, it is a wonder the IRS has not eliminated nonprofit status altogether.

While it sounds ludicrous to speak of colleges as brands, a college's reputation—its brand—is serious business. Would you rather have Stanford University or Whatsamatta University on your resumé? There are certainly well-established brands among charities, as well. Are you more likely to respond to an appeal from the American Cancer Society or the Retinitus Pigmentosa Foundation? The point of these rhetorical questions is that the Web gives nonprofit organizations a chance to establish themselves and their brand in a way they have never been able to before. When it comes to Web branding, dot-orgs require the same careful planning and design as dot-coms.

[11] NOT-FOR-PROFIT BRANDS
THE COMMERCIAL-FREE AND BROWSER-SUPPORTED WEB

REMEMBERING MORE THAN THE BRAND

Most nonprofit organizations have sites that don't sell or advertise anything. The sites do not ask viewers to register or fill out a survey. They will probably never be updated, and yet they will never be outdated. Nonprofit organizations have sites that exist solely for the presentation of their content. What a concept.

One such site, Do You Remember When, provides an in-depth look at a Holocaust artifact by the same name. The artifact is a book given by one young Jewish man who was later killed at Auschwitz, to another young man who survived in the small Jewish underground of World War II Berlin and is alive today. The book itself, a notebook of sketches and observations exchanged between friends, is unremarkable. It has none of the poetry or personal insights of the *Diary of Anne Frank*, for instance. Yet the book's existence as a historical document gives the little notebook a power disproportionate to the small, personal document it is.

The United States Holocaust Memorial Museum, in Washington, D.C., is a reminder of the evil that the Nazis unleashed upon Europe over half a century ago. Part of the museum's collection is this recently donated notebook.

(ABOVE) The first page of *Do You Remember When* identifies the Web site, sets the visual tone, and quickly passes control to an introductory window.

A VIRTUAL VIEW BOOK WITH TACTILE QUALITIES

The Holocaust Memorial Museum added this notebook to its online exhibitions and is as compact as the book itself. A title page leads directly to the introductory page: "What was it like to live as a young Jew in Berlin during the Nazi deportations?" The text is set in Courier, as if typed on paper that has yellowed with age.

A second window opens with the book pictured at what appears to be actual size. Viewers see not only the cover of the actual book, but also the cover page of the site.

After opening the page, viewers see the image of the book surrounded by text that gives a thorough explanation of its historical context, just as if one were looking at this page in a museum exhibit. On one HTML page, are the seen—the book—and the unseen—the events transpiring in Berlin as the book was written. The explanatory text and accompanying photographs are placed around the image of the book. The anonymous-looking Courier is used for explanations, while quotes from the book are set in Agfa Rotis SemiSans, a very distinctive typeface. The Agfa Rotis SemiSans is used here as a subtle act of resistance against the blandness of the dominant Courier.

The advantage of displaying this book on a Web site is evident when one starts to turn the pages. Viewers can examine all seventeen pages of the book, and each one is translated and annotated and put into proper context.

Introduction

What was it like to live as a young Jew in Berlin during the Nazi deportations? This exhibition details the life of Manfred Lewin, a young Jew who was active in one of Berlin's Zionist youth groups until his deportation to and murder in Auschwitz-Birkenau. Manfred recorded these turbulent times in a small, hand-made book that he gave to his Jewish friend and gay companion, Gad Beck. Mr. Beck, a Holocaust survivor who again lives in Berlin, donated the booklet to the Museum in December 1999. The exhibition centers around the 17-page artifact, which illustrates the daily life of the two friends, their youth group, and the culture in which they lived.

(ABOVE) This page contains a single GIF image that is unbranded except for the small picture of the actual book. It is practically anonymous.

(TOP RIGHT) All seventeen pages of this little site include all the brand elements briefly viewed on the initial identity page: the name of the domain host—United States Holocaust Memorial Museum; the title of the book (though initially in German here)—*Do You Remember When*—the handwritten look of the typography; and the muted color blocks that form the background for the site's nonhierarchical navigation.

(BOTTOM) In one sense, this book speaks for itself. The handwriting on the page is in the original German, but point to the Translation button (set in a handwritten script typeface) and the text translated into English.

MORE THAN AN E-BOOK

The site is projected as though one were reading an e-book online, so there's no need for any kind of hierarchical navigation. There is, however, a hierarchy of information being presented. On each page, some of the text is highlighted—emboldened and enlarged with a contrasting rectangle of color underneath. Highlighted text constitutes areas where an image map links to additional information. This tangential material is always presented in a new window.

In an excerpt from an interview with Gad Beck (the recipient and, later, the donor of the book), the audio file is made available to the site visitor. The audio is difficult to understand, but just the sound of the old man's voice, full of emotion for his long-gone friend, makes the words jump off the page.

Using both pictures and sound to project a story is a particularly effective use of the Web. So many sites that include sound are gratuitously noisy. In the case of the Do You Remember When site, the sound adds to one's experience, making this book more personal and creating a stronger impact on the visitor.

(AUDIO) (Gad interview sequence) "For them I was a boy from outside. Why? I was visiting theaters, I was dancing, even ballet dancing. For such a group of pioneers it was impossible to believe this. Just in such a situation, political situation,I had never been in such a group, if there was not Hitler, this is clear. But I had no other way, **I had to** come with other people together, with these Jewish **people together** and the Zionist Jewish people together. (CUT) I was coming from another world, I was coming more from the world from theater, from culture, from [sigh]."

(ABOVE) This tangential page of information includes an audio clip, along with a background picture of the young Gad in Berlin at the time the book was written and a picture of him today.

BREAKING DESIGN RULES FOR A REASON

Some people will complain about the colored GIF text on colored backgrounds that appear on every page of this site. While this technique is often a mistake, especially for a site that depends so heavily on textual content, the color contrasts in this instance are carefully specified so that the text is always completely readable. The cool blues and greens of the text are picked up from the blue ink used in the actual book, while the warm yellow, orange, and red colors of the navigation segments come from the unusual orange color of the book's cover.

Another potential criticism might be the heavy reliance on graphics, which can make the pages slow to load. In fact, every page relies completely on sliced images. There is no HTML text, and many of the pages' tables are filled with image slices. The compromise is that the window size is relatively small, and that once the page is loaded, the rollover images are preloaded and work instantaneously.

In fact, the site does not feel slow, bloated, or overly dependent on images. It's easy to understand the navigational options and to read straight through the book, following the exhibit. More importantly, each HTML-based decision has been made in a way that enhances the goal of the site—to present this personal account of a friendship in the context of Jewish life in Nazi Berlin. This Web site is a powerful use of technology and design that works to expand the limits of human experience. This little site is more than a display case for a World War II artifact. The site is a window that allows visitors to pass through and nearly touch the tragic face of history.

(ABOVE) The navigation scheme allows viewers to browse forward or back, or one can choose any page from the pop-up display across the top. It's just like a real book.

THE CHANGING AND YOUTHFUL FACE OF DESIGN

Try to imagine Lily Bart, the tragic nineteenth-century heroine of Edith Wharton's novel *The House of Mirth*, taking out an ad in the personals column of *New York* magazine." Most attractive, keenly intelligent, independent-minded, late 20s (but still youthful), seeks similarly qualified gentleman of wealth and influence." No, it couldn't happen. She had to rely on beauty and guile and keeping her reputation intact.

Now imagine a stately nineteenth-century institution, say Brown University, advertising in *USA Today* for bright, eager applicants. No, it won't happen, but well-established, first-tier universities can no longer rely on reputation alone to attract the most interesting students. There is serious competition to attract the next generation of Nobel laureates, millionaire entrepreneurs, and even future Edith Whartons.

SELLING REPUTATION

So along with lots of glossy brochures and attention to décor in admissions offices, schools of all sorts are investing in well-designed Web sites. You need only consider the wide range of interests served within a university—students, faculty, and staff—to realize that these sites serve a multiplicity of functions. The image of the institution is a combination of all of these, and it is this image that becomes the brand of a dot.edu Web site.

The perceived image of the institution is particularly evident with the Web site for the Rhode Island School of Design, RISD. Located next to Brown University in Providence, Rhode Island, RISD has the reputation for being the finest design school in the United States. It wouldn't do to have just any Web site, with such a reputation on the line.

First, RISD's site is student-oriented, and as such, it unabashedly aims at attracting design-oriented applicants. The home page loads a bit slowly; there's a lot going on in the background. But you can tell from the glimpses of images as they load that the page will be interesting. Art requires patience.

The browser window is resized to 800 x 620 pixels. The screen appears to be sliced horizontally by hairlines, and there are layers of images. In fact, a plug-in detect has checked to make sure you have Flash Player installed, and then a browser detect has checked your browser version to make sure it is JavaScript-enabled. While some might find these requirements for admission to the Web site annoyingly steep, it is reasonable to expect aspiring artists to expect nothing less.

(THIS SPREAD) The Flash home page includes images of a student at work as the backdrop, bands of floating links and thumbnail images, and the RISD logotype in white fixed in the upper-left corner. Each of these element types resides in its own horizontal track over the background image and the background changes with each reload.

SELF-SELECTING THE AUDIENCE

The rather complex composition that is RISD's home page challenges the browser of the site to properly display it. There are actually three background images loaded at random, so that the page is not exactly the same with each visit. Each image shows a student at work, though camera angle and soft focus make it difficult to discern what the activity is at first. These images are as much about color as they are about subject. There is one each in red, yellow, and shades of blue.

Each image loads with a voice-over, a sound clip of a student talking about the life of the young artist on campus. Key words are "crit," "creative," "options."

There are eight layers of this home page composition: 1. black background; 2. three randomly loading background photographs; 3. sound byte attached to background image; 4. six horizontal contrast tracks; 5. white logotype; 6. floating links for hierarchical navigation; 7. thumbnail images; and 8. nonhierarchical navigation bar.

And there is more, because the navigational scheme adds another level of richness to the composition. It is clear from the five links—About RISD, Apply, Attend, Museum, and Alumni—that the floating text represents hierarchical links. What is interesting is how to catch them. Clicking on a link stops the action in one track while starting it in another.

One does not have to click on the link but simply stop one's pointer on it. The link is highlighted and fixed against the background. A secondary menu drops down and the thumbnail images animate along their track. Point to a secondary link, and an arrow follows the cursor indicating the current selection. Click to load the division or section within the division.

If you do not think this complexity is interesting, or if you find it confusing or off-putting, then you have failed the first qualification for admission. This is not meant to sound snobbish or to make RISD sound as though it is trying to be exclusive, but it is clear that this simple online challenge is engaging for prospective RISD students. It is certainly done with skill, taste, and as you are about to see, consistency.

INTEGRATING COMPLEXITY INTO A LOGICAL SITE PLAN

Each of the five divisional pages uses the same horizontal layout featuring pictures of artists, mostly students, and again, broken up by horizontal hairlines. The pages have a scratched-film look that gives the effect of a work in progress. The RISD logo has been anti-aliased into the background of each photo. The hierarchical navigation is clearly outlined under the photo along with a persistent Search link to the right. The secondary navigation within each division is listed in gray, and each page includes brief explanatory text.

The simple hierarchy becomes broader as one goes deeper into the layers. For instance, the museum division has nine sections, and each of these sections includes many pages. A step down is reflected in the headings, so the RISD: Museum heading at one level changes to Museum: Collection on the next. Moving down another level does not change the heading.

(THIS PAGE) Each divisional page is labeled with the bold RISD name along with the divisional heading. The HTML text is all set as sans serif, with GIF headlines set in a larger font. The Apply division page even gives the correct pronunciation for the RISD acronym, RIZ-dee, by which the school is most commonly known.

It is interesting how there is no hint of admissions within this section of the site. It would not be appropriate here. Yet the same elements are used to make and brand these RISD pages. This is indicative of the fact that while an effort has been made to emphasize the recruiting aspects of the site, the site serves a much larger community than just applicants.

Curiously, the site is full of detailed information for outsiders, people coming to the school for the first time or visiting the museum. There are calendars of public events, exhibitions, and alumni functions, lists of publications, lots of contact information, but little information for current students. No class lists or schedules, no daily announcements.

When you realize that the risd.edu site is separate from the messy exigencies of students inhabiting an urban campus, you may feel as though you have been cheated, that what you are seeing has a Disneylike patina of prettiness. On the other hand, what is this site trying to do? RISD has created a first-class marketing tool for the school. It is no less accurate than a glossy brochure and a lot more detailed and useful.

There is a sense that RISD is a wonderfully exciting place to study design, even if you aren't seeing the complete picture. It is as complete as it needs to be for the purpose it fulfills. Perhaps the public is being manipulated, but one is seeing what the artists at RISD wish us to see, as well as what aspiring artists wish to see. And that is the point.

(LEFT) Within the museum pages there is a fourth layer of hierarchical links and an additional navigational tool in the form of a three by five matrix of images.

(RIGHT) The section page for the museum's collections shows a tertiary hierarchy of links for the seven different areas of the collection.

Redesigning Identities

The beauty of an identity redesign project is that the client comes to the designer with a brand new vision. The client has made a decision to discard or reshape an old identity that probably was very safe and familiar. But over time, the client develops a better idea of its strengths and weaknesses as well as exactly where the business ought to go.

So the client puts him- or herself completely into the hands of a designer. In the case of a brand new identity—a daunting enough project—the designer must create enough of a presence that the client can survive and prosper. But for an identity redesign, the task is even more challenging. In addition to the usual considerations of the market and aesthetics, client and designer must consider emotional issues. Does the old identity have equity that must be preserved? Will the client's employees and customers become wary or turn defensive when presented with something new? How much risk is the client willing to accept? A poorly judged response to any of these questions could cause the client's business to suffer or even fail.

There are as many reasons to redesign an identity as there are businesses in the world. Even so, these reasons most often fall into five general categories.

• Repositioning: An identity in need of repositioning usually does not represent a company that is struggling. Instead, the business is looking for ways to improve its trade even more, by making slight, smart adjustments.

• Modernizing: At one point or another, every business finds itself in need of a more contemporary identity—or it finds itself falling further and further behind the competition. A fresher look, a more practical design, an aesthetic that better speaks to customers: All of these can be the result of a modernized design.

• Managing Change: Whether a business sees change as good or bad, change will certainly come. If a company's identity refuses to address business change, it becomes more and more irrelevant.

• Promoting Growth: Maybe a business is moving from the realm of precarious start-up to contender status. Perhaps a larger company requires an even larger presence. Promoting growth through a new identity is a bold, tactical move.

• Starting Over: Sometimes an old identity cannot or should not be saved. Starting over with a completely new identity is the wisest choice.

But what will the new identity be? What is the new image? Kan Tai-keung, principal of Kan + Lau Design Consultants, one of many firms whose work is featured in the following pages, offers this explanation, borrowed from an ancient Chinese saying, "The form is the entity and the entity is the form": "Corporate identity must show undeceivably the inner spirit of the company. Every [business] has its own principles and targets for developing the staff's spirit, the management strategy, the production, and services. The overall attitude they adopt to handle such things constitutes a unique corporate culture that distinguishes it from others."

A successful corporate identity, he says, should possess the following qualities: It should be a true image and reflection of the company; it should present a beautiful image, both inside and outside the company.

"Our looks speak our minds," says Kan, quoting another saying. "Image is the look. It is a reflection of the true inner self."

A redesigned identity must be a reflection of the company's new inner self. The designer must adopt his or her best Zen persona and not only suggest change because change is construed as good; the designer must be certain that the change is good.

—Catharine Fishel

REPOSITIONING

—From *Brand Strategy* newsletter, Centaur Publishing, London on brand focus prior to repositioning—

"If the brand is the anchor, all communication must reflect this, both in terms of positioning and core values. Few [businesses], however, follow this through because implementing an integrated approach is an altogether different challenge. And there are a number of reasons why.

"Thinking in boxes can be a major pitfall. Take attitudes to different elements of the communications mix. Many businesses regard advertising as only a distant cousin of brand design and corporate identity—each is regarded as important yet different parts of the equation. So, a client eager to reposition a tired old brand frequently approaches an advertising agency for a new campaign. But in fact the problem is more complex: The packaging looks thirty years out of date. It's no good for the client to then say, 'Let's do the advertising—then look at the design,' [but] many have done so to their own regret."

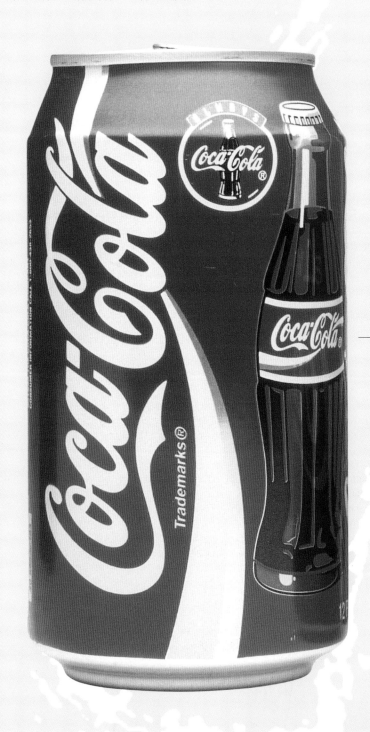

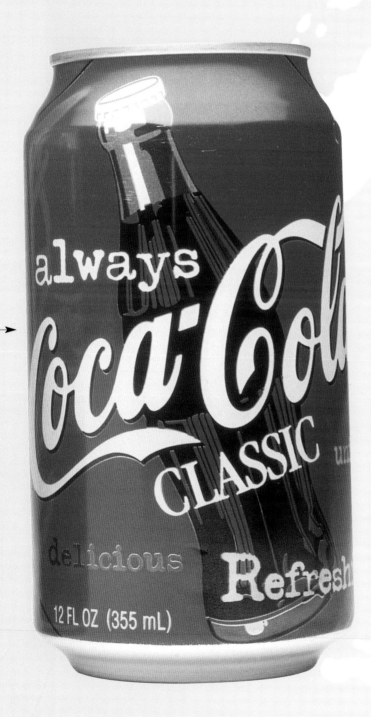

Desgrippes Gobé & Associates for Coca-Cola

Challenge: *When a consumer product becomes so well-known around the globe that it begins to become part of the scenery, it needs a modified identity that re-personalizes the product.*

TRAVEL WHERE YOU WILL, ANYWHERE IN the world, and you will encounter Coca-Cola—on clothes, on signs, on packaging, in art—everywhere. In fact, it has become so ubiquitous that its familiar mark was failing to engage consumers. Coke's identity, company officials feared, had become too familiar.

The equity in its elements is enormous: They could hardly be abandoned. But Marc Gobé and designers at Desgrippes Gobé & Associates, charged by Coca-Cola to create a refreshed design, felt that the swash, the color, the Spencerian script, and familiar icons like the "Always" slogan and button and the contour bottle could be recast in new roles.

"Our strategy was to reach the customer at different levels and at different points," Gobé explains. "The emotional content of Coke changes at different times, different locations and at different situations. If you see a Coke sign at 6 A.M. when you're sleepy and sitting on the train, it does not have the same effect as when you are at a ballgame or at a rock concert, in a better mood. We had to find a way to elevate the emotional message and make it relevant for specific times or events."

The designers began by analyzing the different icons Coke employed—swash, color, script, button and bottle. They discovered that all of the icons

Before and After

Coca-Cola's new identity replaces the old dynamic ribbon element, which has adorned the can since 1969, with elements from the famous contour bottle.

Larger versions of the new identity incorporate another nostalgic element, the "always" button, plus more descriptive words. The result communicates refreshment and touches an emotional chord with consumers.

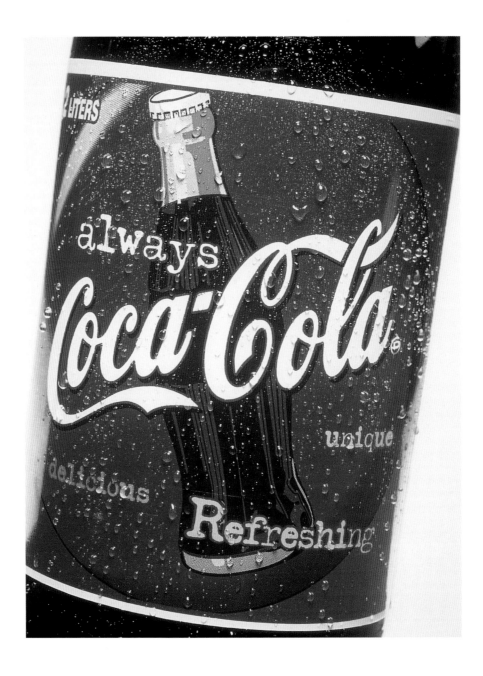

DESIGN FIRM:
Desgrippes Gobé Associates

CREATIVE DIRECTOR:
Peter Levine

ART DIRECTOR:
Lori Yi

except the bottle were used with similar intensity. None stood out. But research showed that some icons interested consumers more than others. Specifically, the bottle shape resonated deeply in terms of nostalgia, refreshment, and instant recognition.

The color red and script type were effective entry points to the identity. "But the contour bottle makes the emotional impact," Gobé says. "Like the Nike swoosh, it has transcended its original meaning to become an icon." Designers found that the word

always and the button also had the right emotional flavor.

By reemphasizing these elements in the new identity design and by removing the swash, Desgrippes Gobé designers leveraged the elements' emotional worth in a fresh, relevant way. Designers added the words *always, delicious, unique,* and *refreshing* to Coca-Cola Classic packaging, and they reintroduced the familiar Coke-bottle green, further detailing the nostalgic bottle.

Coca-Cola tested the concept during the 1996 Olympic Games in Atlanta, Coke's

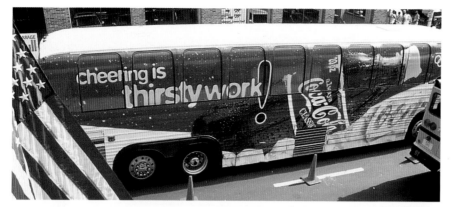

The new identity was tested at the 1996 Olympic Games in Atlanta. In keeping with Desgrippes Gobé's goal of creating a personalized identity for a global brand, graphics promoted Coke as the drink of fans.

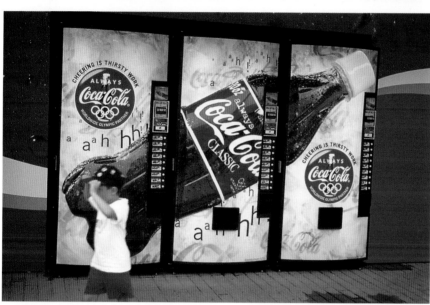

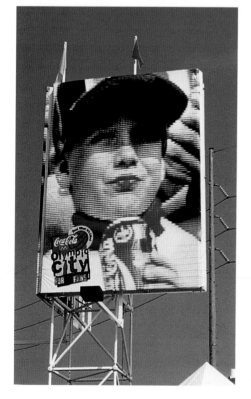

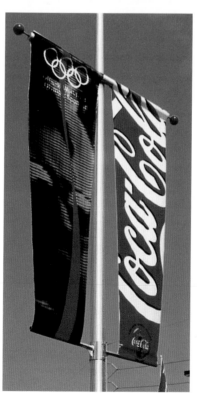

The identity was tested and stretched even further at the World Cup in 1998. The contour bottle shape was isolated and simplified; bubbles graphically suggested the nature of the drink (below).

stomping grounds. "We didn't try to make Coke the drink of the Olympics, but rather the drink of the Olympics fans—how Coke shared this unique moment and the excitement with them," says Gobé.

The customized-for-the-event approach was enthusiastically received, so the new identity and packaging was adopted. Then for the World Cup games in 1998, Desgrippes Gobé focused even more on the icons. The shape of the bottle used alone sometimes appears as a line only and sometimes as if it were behind glass block. Studies showed that consumers construed this effect as a refreshing look. Sprinkles of bubbles suggested the nature of the drink. The button, converted into a soccer ball, personalized the identity for this event.

The new identity is able to touch customers in more relevant ways. "Coke will be able to handle the logo in a more module way now," Gobé says. "They can be relevant to specific events, for instance. The look is always the same, but it is always different, depending on what they want to communicate."

Félix Beltrán & Asociados for T Shirts De Mexico

Challenge: A company with an ideal yet less-than-memorable name needs a logo that will differentiate it from the competition.

T Shirts De Mexico SA is exactly what it sounds like—a manufacturer of T-shirts in Mexico. It sells its wares mostly to visitors of Mexican beaches, national and international tourists of every age, looking for souvenirs of their visit.

But its very common name actually worked against its success: The word T-shirt was so common that it simply wasn't memorable. The business owner decided that a logo with impact might make a more lasting impression in consumers' minds.

Félix Beltrán considered his client's original logo. T Shirts De Mexico's garments were unisex, so the old logo used two shirts to represent male and female. But Beltran felt that the unisex aspect indicated that only one shirt should be used.

The old logo's two side-by-side shirts also could be mistakenly read as an *M*, further diluting the identity with irrelevant and unintended information. The *M* effect intensified when the logo was used in smaller sizes, as it often was on labels and tags. Beltrán also felt that the black shirts didn't speak of the company's multicolored offerings and that the typeface used for the company name was too feminine.

Despite the too common nature of the client's name, Beltrán felt he could make T-shirt work in a new way. Understood in both English and Spanish, the word carried too much international equity to abandon. He began to explore graphic possibilities of the *T,* discovering almost immediately that dropping the letter out of a T-shirt shape created a double image, a double impression.

Beltrán liked the mark very much, but his client wasn't so sure. He wanted to try interpreting the neckline of the T-shirt more literally and/or add surface interest to the flat logotype. The designer did experiment with some of these ideas, but in the end, both agreed that the very simple, T-on-T mark was best.

The mark appears in a modern, sans serif typeface for the complete name of the business or other printed information.

"The more brilliant colors, associated with the colors of the United States, worked well because the owner wanted his product to look as though it was imported," Beltrán says. "The applications of the new mark were more coherent and the public interest has been greater."

DESIGN FIRM:
Félix Beltrán + Asociados

ART DIRECTOR:
Félix Beltrán

DESIGNER:
Félix Beltrán

After
The new mark, designed by Félix
Beltrán & Asociados, not only repre-
sented the product graphically, it also
made the most important part of the
company's name more memorable.

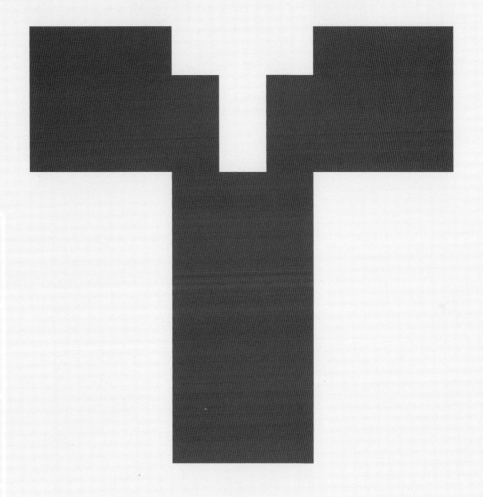

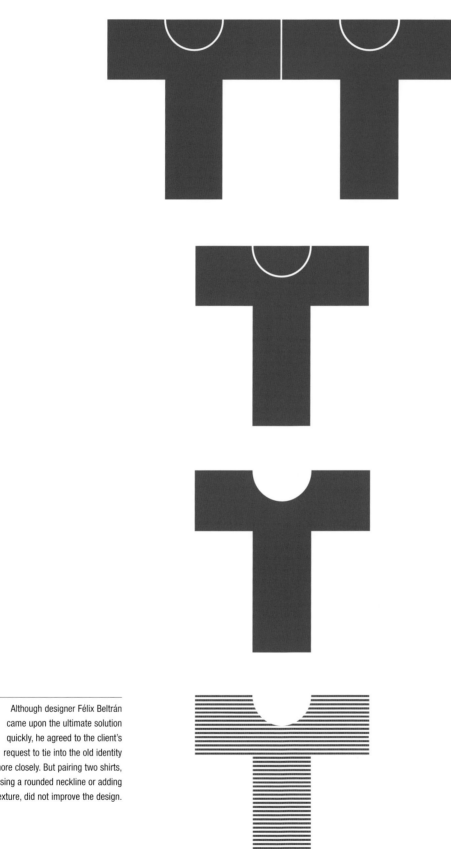

Although designer Félix Beltrán came upon the ultimate solution quickly, he agreed to the client's request to tie into the old identity more closely. But pairing two shirts, using a rounded neckline or adding texture, did not improve the design.

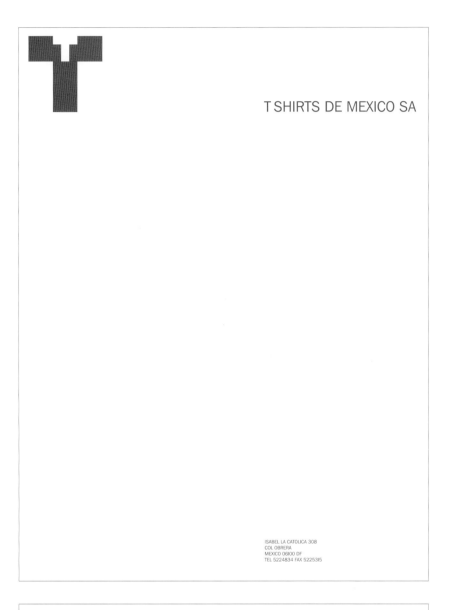

T SHIRTS DE MEXICO SA

ISABEL LA CATOLICA 308
COL OBRERA
MEXICO 06l00 DF
TEL 5224834 FAX 52253l5

Beltrán's selection of red, white, and blue for the system was intentionally very North American: His client wanted his product to look as though it were imported.

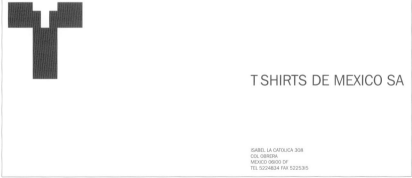

T SHIRTS DE MEXICO SA

ISABEL LA CATOLICA 308
COL OBRERA
MEXICO 06l00 DF
TEL 5224834 FAX 52253l5

T SHIRTS DE MEXICO SA

CARLOS SANCHEZ
DIRECTOR

ISABEL LA CATOLICA 308
COL OBRERA
MEXICO 06l00 DF
TEL 5224834 FAX 52253l5

Before

When Malt-O-Meal launched its line of cold cereals, consumers did not perceive the bagged product as having the same quality as other brands of more expensive boxed cereals.

Murrie Lienhart Rysner & Associates for Malt-O-Meal

Challenge: An offshoot product of a long-standing, very popular brand needs to develop its own identity in order to stand out and be more competitive.

MALT-O-MEAL HAS MAINTAINED ITS wholesome identity with such single-mindedness over many years that the brand name has become synonymous with the product: Both the name and the hot cereal evoke a real sense of warmth. So when the company launched a new line of cold cereals, it faced a peculiar challenge: The new cereals were packaged in flexographically printed bags that made them much more economical to produce and buy than boxed cereals. But despite the price break and the fact that the products were every bit as good as those produced by Post, Kellogg's, and other competitors, consumers felt the bagged cereals did not offer comparable quality. Applying the Malt-O-Meal branding "as is" to the cold cereals made the look of new products seem old-fashioned.

When Malt-O-Meal contacted Murrie Lienhart Rysner & Associates for advice, the company was searching for a way to maintain the original identity for the hot cereal and create a more progressive, high-quality image for the twenty SKUs in the new product line.

Complicating the puzzle, the new identity would have to work on packaging for kids' cereals, adult cereals, and family cereals. "What we created had to have a strong umbrella identity," recalls Principal Jim Lienhart. "But each product had to have its own identity as well. We needed a way to individualize each unit and still have character for the whole line."

Lienhart's designers knew that the red background color in the hot cereal logo had a lot of equity on the store shelf, so that element would remain constant. They began by

After
Murrie Lienhart Rysner's new identity for Malt-O-Meal has a more contemporary, quality feel, plus it speaks of freshness and nutrition.

DESIGN FIRM:
Murrie Lienhart Rysner & Associates

CREATIVE TEAM:
Jim Lienhart, Linda Voll, Annette Ohlsen, Julie Winieski, Lou Izaguirre, Amy McGrath

ACCOUNT TEAM:
Herb Murrie, Karen Schwartz

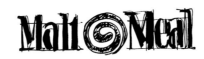

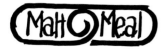

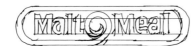

The *O* at the center of the brand name presented many opportunities for experimentation. On these trials it becomes a "flavor swirl."

Working a heart into the design referenced the nostalgia inherent in the Malt-O-Meal's brand, plus it implied caring and motherly love.

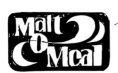

By happy accident, the initial letters in Malt-O-Meal form the word *MOM.* These comps tried to bring this element to the forefront.

experimenting with lettering to convey the wholesome Malt-O-Meal identity in new ways. Trials ranged from playing with healthy, natural images like suns and grains, quality crests, hearts, flavor swirls, taste icons like spoons and bowls, and the initials *M-O-M* to evoke the brand's main champions, mothers looking for nutritious foods at a reasonable cost.

Personalizing the brand was key. "I try not to think of the thousands of people buying the product," Lienhart says. "I think of it personally and try to keep it as human and emotional as possible. I want to make it feel as if it's right for you."

After comps were presented to the client, sun imagery emerged as a favorite, but other ideas weren't abandoned. The *M-O-M* note still appears in the final design, and a grain element weaves through it. All-script lettering may have been too elegant for the kid cereals, and cartoonish type would have been wrong for adult cereals. But rendering the words in a typeface with personality and tucking a scripty *O* at the center of the mark had just the right flavor. To individualize each product in the line, cartoon figures cavort on color backgrounds of children's varieties, but color without cartoons differentiates other cereals from one another.

"I think we gave them an original identity with a connection to tradition. It has a contemporary typeface but is easy to read. It has that original touch of handmade art for warmth," Lienhart says.

The designer notes that he used to believe that when he created an identity for a product, he could go in a completely opposite design direction from other products in the existing category—for instance an embossed, all-white box for soap. But now he feels that for consumers to trust the new product, it's important to recognize and acknowledge their preexisting perceptions about the category. Soaps sold on the retail shelves generally have a very bold presence, to continue with the analogy. An all-white box might not even be perceived as soap.

"You have to find what is unique about the product and bring it into the imagery," Lienhart adds.

Good health is implied by the sun imagery in these sketches. Again, the *O* presents a logical slot for artwork.

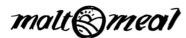

Because the cold cereal's perceived quality among consumers wasn't adequate, Murrie Lienhart Rysner designers created a number of quality-seal elements.

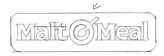

These sketches explored the cereals' taste appeal through images of spoon, bowls, and smiling mouths.

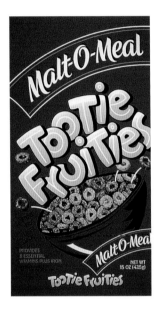
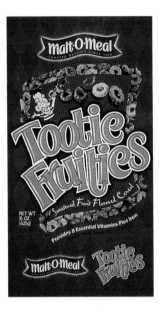
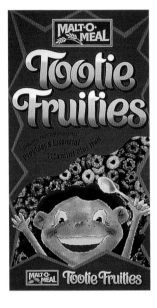
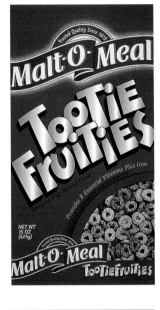
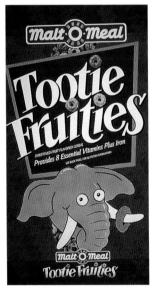
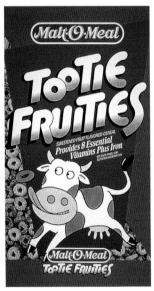
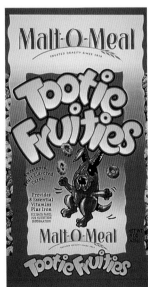
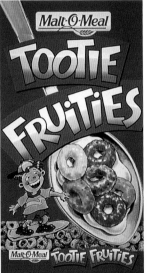

A range of color comps ultimately
was presented to the client.

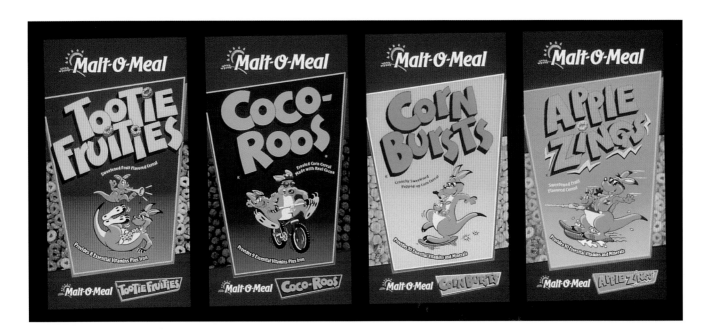

The final solution applied to a selection of children's cereals preserves the background red from the original identity. But Murrie Lienhart Rysner designers made it much richer, another quality reference.

The reversed version of the mark—dark type on light background—is applied to letterhead, business cards, envelopes, and other "white" printed items.

Turner Ducksworth for Steel Reserve Beer

Challenge: *A new lager with an elegant identity is received well in test marketing, but no one is quite sure what to call it.*

THERE'S NO DENYING THAT MALT LIQUORS have a bad reputation in the United States. Brewers of these high-alcohol beers are accused of exploiting those who simply want to get intoxicated—fast. So when the Steel Brewing Company decided to launch a high-alcohol brand that was brewed for taste, not a quick buzz, it wanted a higher-end look. Toward that end, its initial label design was an elegant, nearly all-black design, emblazoned with a mysterious, swashy red sign, an ancient symbol for steel.

Although test marketing showed favorable reception of the product and identity, the Steel Brewing Company owner felt that his new product didn't have any particular positioning. He approached David Turner of Turner Ducksworth for advice.

"My first comment was that it was a shame that you didn't know what it was called," Turner recalls. The swashy symbol overpowered the brew's moniker to such a degree that its young, hip target consumers were actually beginning to call it "211." When the owner coined the phrase, "high-gravity lager" as an alternative to the less appealing "malt liquor," Turner knew he had what he calls a "single-minded" design approach.

"We liked the phrase because it expressed strength without saying 'strong,' which you are not allowed to say on the packaging," Turner says. So he began exploring visual approaches that said the same thing. He began by thinking about imagery that expressed strength as it related to steel. Several trials explored forming wheat into a buzz-saw blade, an idea that Turner liked. But this design did not include the 211/steel symbol, which everyone agreed had achieved a kind of accidental equity and should be preserved. But the mark had to be much more readable in order to be included. Simplifying its strokes set the designer in a new direction—an industrial look that was good match for the "high-gravity lager" tagline and "steel." Turner studied warning and industrial signs for inspiration. Adopting this look for a food or drink product can be a

tricky thing, Turner says. "If it looks like a can of gasoline, you won't consider putting it in your body," he adds.

So the designer concentrated on creating a much more refined aesthetic in the design than found on warning signs. Elegant letter- and line spacing, surrounded by plenty of white space, created a quality look that also conveyed a sense of cool refreshment. The open spacing also allowed the foil substrate of the bottles' labels to show through, again underlining the "steel" element of the design. The six-pack holder has the same industrial feel: Instead of printing on the white side of the chipboard, Turner utilized the kraft paper side. Printing silver ink on the brown stock provided just the right amount of metal. The short bottles were important to the brand's identity and tied into another offering in the brewer's line, Howling Monkey, which also was packaged in a strong, stubby bottle. Both beers can be produced on the same bottling machinery. "We felt this was the right feel for a potent drink," Turner says.

The identity was applied to other pieces as well, including a tall, steely can, case packaging, "warning" signs, T-shirts, trucks, the Steel Brewing Company's Web site, and even hard hats. "All of the materials look serious," Turner says, "but on closer inspection, you can see that it's really all just for fun." The new brand identity, highly praised by the design community and by consumers, results from how San Francisco-based Turner and his partner Bruce Ducksworth work together. "We want a design that is single-minded," he says. "We always collaborate. This project went back and forth across the Atlantic a number of times. If one designer starts to stray away from the single idea, the other designer brings him back. The single idea here was 'industrial strength.'"

This has become such a popular urban brand, Turner says, that the brewer can't make enough of it.

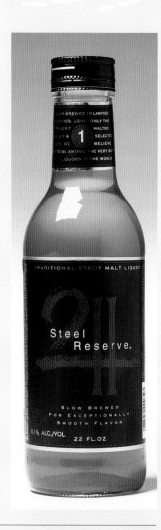

Before
When the Steel Reserve lager was test marketed with this label and a corresponding identity system, it did well. Trouble was, no one knew what to call the brew: Steel Reserve, 211, or even 2H.

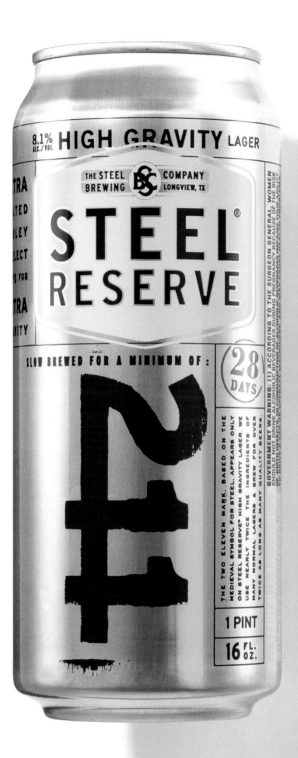

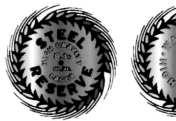

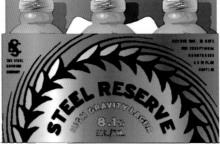
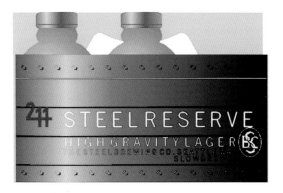
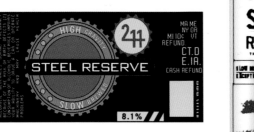

HIGH 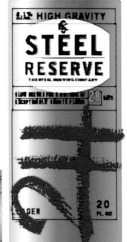 GRAVITY

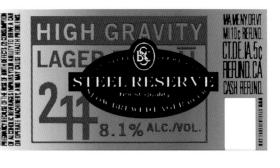

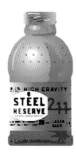
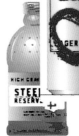

This collage of trial comps shows a range of very different imagery. Principal David Turner says that his firm prefers to present clients with a number of ideas that he believes are workable rather than one, pristine, ultimate design. "When a client can choose amongst a number of good ideas, they know they have picked the best one," he says.

DESIGN FIRM:

Turner Ducksworth

ART DIRECTORS:

David Turner, Bruce Ducksworth

DESIGNERS:

David Turner, Allen Raulet

After the client suggested using *high-gravity lager* on the label instead of *malt liquor* or *malt beverage,* Turner envisioned a more single-minded direction: an industrial, steely identity that looked serious but had an underlying flow of fun. This collection of industrial images helped the designers set the direction.

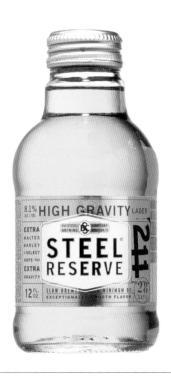

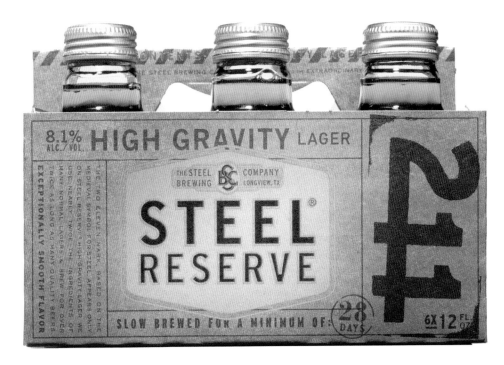

Letting the silver foil of the label show through on the bottles' labels served as a ready visual reminder of the brand's steely identity. Stout, stubby bottles also communicated a feeling of industrial strength, as did the six-pack holder. The kraft paper side of chipboard was printed with silver ink, creating just enough of a metallic glint.

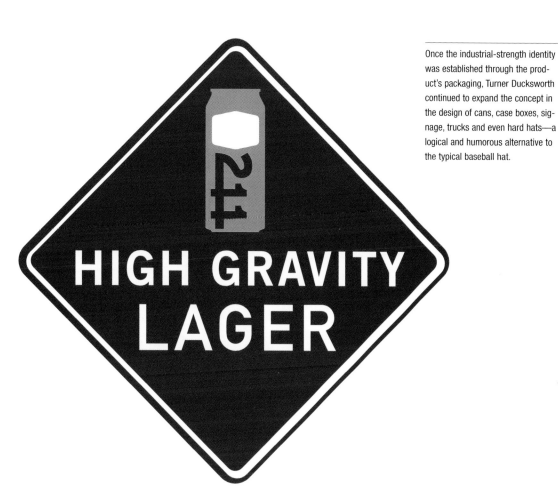

Once the industrial-strength identity was established through the product's packaging, Turner Ducksworth continued to expand the concept in the design of cans, case boxes, signage, trucks and even hard hats—a logical and humorous alternative to the typical baseball hat.

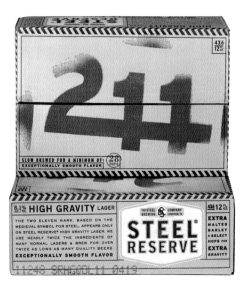

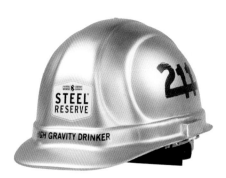

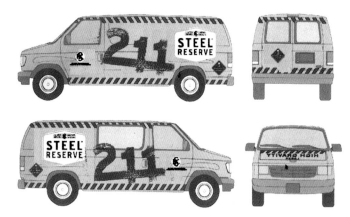

MODERNIZING

—Mary K. Baumann of Hopkins Baumann on branding and modernizing—

"When I was an art director at Time, Inc., the company was trying to develop a new magazine called *Picture Week*. All of the guys working on the project thought it would be a dual audience, male/female magazine that would be news-oriented. That told me what kind of look it should have."

"But then I took a field trip to where it was going to be sold—at the grocery store check-out. It was then that I thought: 'Guys aren't going to buy this. Women are going to buy it. This needs a completely different package.' This lesson has always stuck with me."

"A publication needs a package, just like Cheerios or Dove soap does. With magazines, we really try to offer some kind of real identity in the logo or nameplate. A lot of people are talking about branding nowadays. But they don't think of it in terms of visualness. A lot of publications don't have a good visual identity. There are the venerable names in publications, like *Time* or *Life,* that have identity because they have been around a long time. But to be new on the block and achieve visual equity—you have to do something completely different."

Before

The original symbol and "mascot" for the old, Korean government-owned Kookmin bank were based on traditional symbols—a four-leaf clover and a magpie—but they just underlined the bank's outdated look.

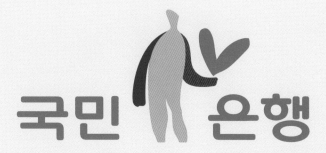

After

The new identity for Kookmin is as different from the old identity as it could possibly be. The personal service of the new, privately owned group is evident in the logo and in the caricatures that are used on various applications.

Design Park for Kookmin Bank

Challenge: *A large bank needs a friendlier image when ownership shifts from the government to the private sector.*

When the Korean government decided to privatize many industries in its country, organizations like the Kookmin Bank were faced with an interesting challenge. Kookmin Bank—literally, "nation people" or citizen's bank—was seen as bureaucratic, outdated, and not particularly interested in serving individual consumers. A more modern identity was a must, or else the bank might not survive in the new privatized environment.

The old identity included a magpie, an auspicious symbol in Korea known as the harbinger of good news. Another portion of the mark was a cluster of ovals, meant to convey the good luck of a four-leaf clover. Traditional symbols, however, seemed to reinforce the image of an outdated institution, says Hyun Kim, principal of Design Park, the agency that undertook redesigning Kookmin's identity. "The bank wanted an image that was both gentler and friendlier," Kim says. "It decided to take the occasion of privatization to build an image of a bright,

friendly bank and demonstrate its changed nature."

Design Park designers considered numerous possibilities based on surveys conducted within and outside of the company. Because the meaning of the bank's name refers to all Koreans, they ultimately decided to center the theme on the subject of people. According to Kim, "This reflected the new corporate philosophy of giving top priority to consumers."

The main symbol Design Park developed is a person with a heart-shaped leaf in hand to project the hope, care, and financial growth that the bank helps to provide. Other characters holding other lively symbols such as flowers and birds were developed to use for other occasions. Green is the main color; blue, red, and yellow supplement the feeling of active growth. Modern Korean and English faces match the personality of the new characters.

The new identity received a very favorable

DESIGN FIRM:
Design Park

CREATIVE DIRECTOR:
Hyun Kim

ART DIRECTOR:
Eenbo Sim

DESIGNERS:
Keunmin Son, Young Chai, Yongkyu Chun, Hankyung Chung

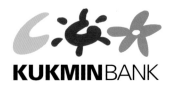

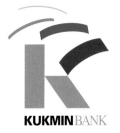

Design Park's sketches explored human themes, searching for a way to suggest life and energy.

보금자리통장

국민두레통장

국민종합통장

Bank books feature new corporate
caricatures.

Combining the characters with a
bright, vibrant green suggests fresh-
ness. The image projects the bank's
new strategies: The importance of
the customer, convenience, and
responsibility for the customer's
financial future.

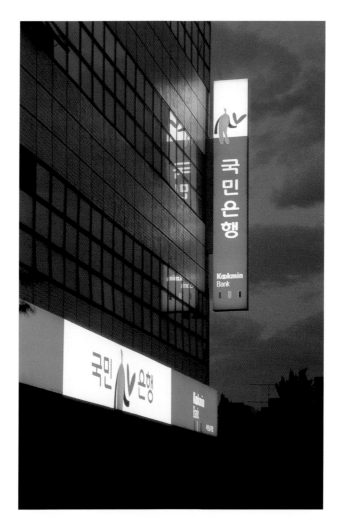

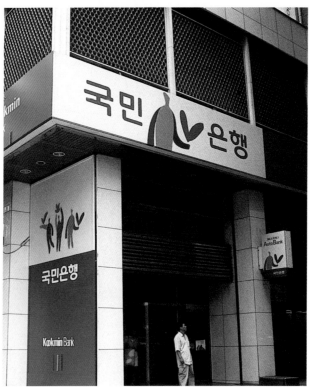

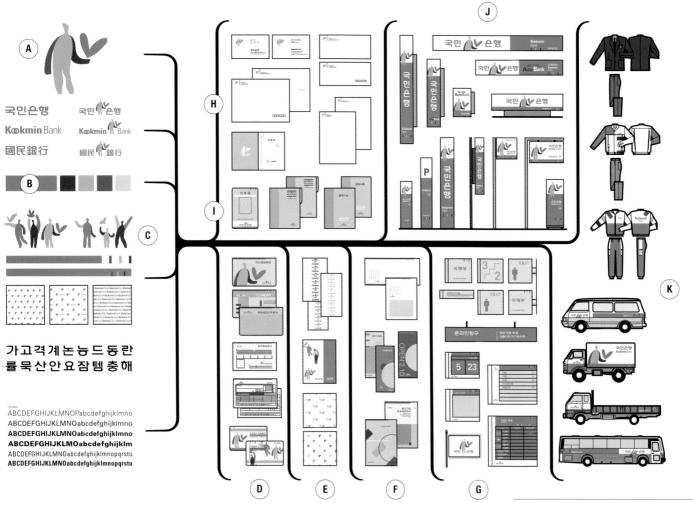

This chart shows the full range of the new Kookmin identity system.

A. Basic patterns used for documents and wrapping people
B. Color palette
C. Various characters; can be used alone or together for different occasions
D. Bank account passbooks
E. Wrapping papers
F. Cover formats for publications
G. Indoor signage
H. Various documents
I. Various forms
J. Outdoor signage
K. Uniforms and vehicles

able response from consumers and bank employees. But it was rejected by older managers, the very people who would have to give Design Park the OK to proceed with the design.

"We had considerable difficulty in convincing the bank at first," Kim says, "but we succeeded by stressing the results of our surveys, which indicated that the future clients of the bank, the young and women, gave the new identity high points." The bank managers made the right choice by granting their approval: The number of passbook holders, deposits and profits have all grown, as has the bank's reputation as a friendly, stable, reliable organization. In fact, a national consumer group ultimately selected the bank as "the best bank."

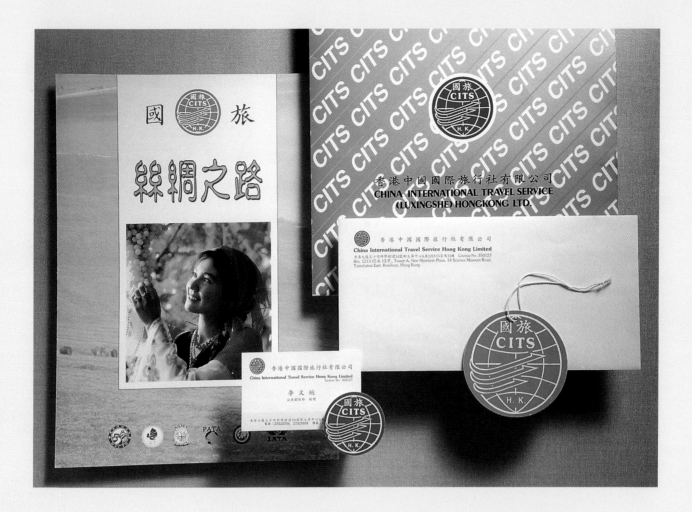

Kan & Lau for China/Hong Kong Travel

Before

The original mark for China International Travel Service, Hong Kong Limited was at least forty years old and did not stand out in the highly competitive tourism industry in Hong Kong.

Challenge: *A forty-year-old logo needs a completely new look that still relates to its original mark.*

"A WISE CHINESE MAN ONCE SAID, 'THE FORM is the entity and the entity is the form.' Adapting this hypothesis, the true inner self of a corporation becomes evident only if an appropriate image is established that creates a position in a prospect's mind," says Kan Tai-keung, principal with Freeman Lau of Kan & Lau Design Consultants, a leading design consultancy in Hong Kong.

This saying holds true for the original corporate identity of China International Travel Service (CITS), Hong Kong Limited. A subsidiary of the China National Tourism Administration, CITS offers China tours to people living in Hong Kong. Competition among tour companies in Hong Kong is fierce, and with a very dated, forty-year-old logo, CITS's image was not as strong and relevant as it could be, considering the market.

"The old identity was very conservative and old-fashioned," says Kan, whose firm undertook the CITS image redesign. The look was more corporate: It did not convey the fun and adventure of travel. To create a new identity, Kan began by considering the company's image, as well as another old Chinese saying.

"What is an image? We may get a hint from the saying, 'Our looks speak our minds.' Image is the look; it is a reflection of the true inner self," Kan says. "Corporate identities must show undeceivably the inner spirit of the corporation."

Because the original logo would still be used by the parent company, Kan felt that modernizing that mark might be the best direction. He began by sketching and re-sketching designs that used the globe element as a base. His early trials also picked up

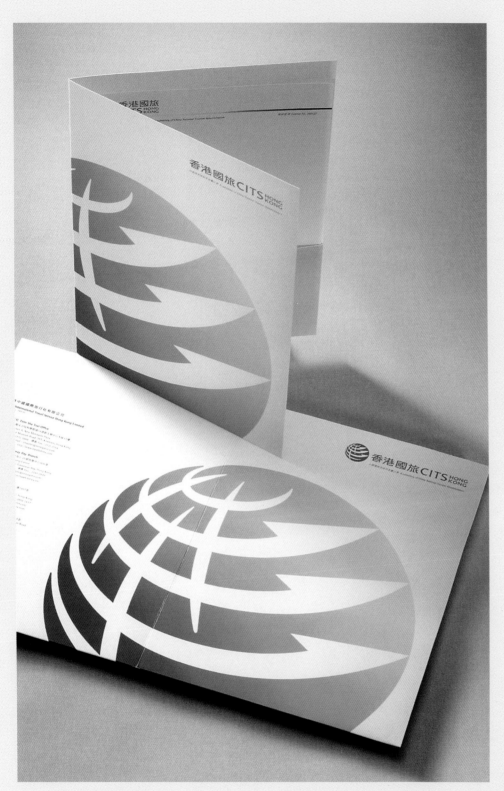

After

The new logo and identity is cleaner, fresher, and much more dynamic. The arrow elements on the globe suggest worldwide travel, and combined with a hint of latitudinal lines, they also form a free-form version of a Chinese character for *China.*

Because CITS's parent company would continue to use the original logo, the new mark needed a real familial relationship to the old. The globe shape provided a familiar base for Kan & Lau's sketch explorations. Arrows, birds, and the sun were added, abstracted, and simplified.

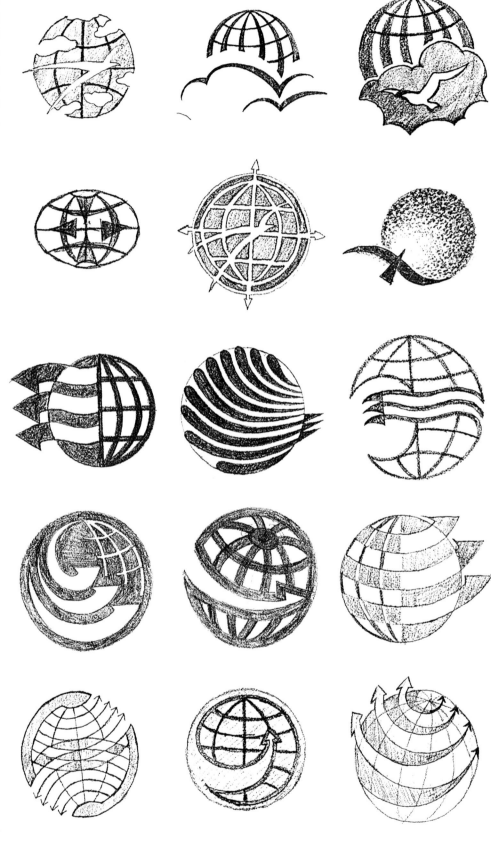

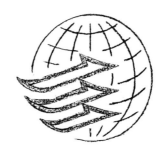

on the longitudinal and latitudinal lines as well as the arrows from the old mark, but as he worked, these became more and more abstracted. He explored bird and sun elements.

The arrow elements had a sense of motion and excitement that Kan liked, so he continued working with these. Soon he could see that using three arrows together with a suggestion of latitude lines created a freeform Chinese character that represented the word *China*.

The three lines also had another level of meaning.

"Arrows represent directions and are dynamic. Also, in China, *three* means *many*. So the three arrows mean much fun and job," Kan explains.

The mark was an excellent fit for the client's needs in Hong Kong. The globe also represents CITS's intention to develop business around the world. Fresh, clear colors are used on bags, buses, flags, tags, and other travel-related items. Kan says that they represent the dynamism, variety, and joy of travel.

The designer and his client both feel that the new identity is successful because it expresses the corporate philosophy in a visual image.

"Often, good logos become equal signs between inside and out. What is expressed equals what is intended," Kan says.

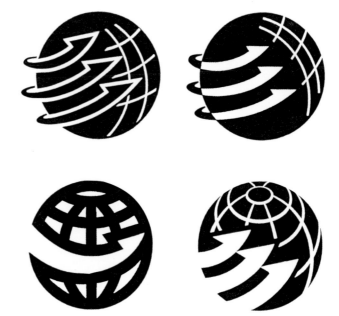

Now working on the computer, Kan & Lau designers experimented with positive and negative space and with arrow positioning. Slight alterations changed the logo from one- to three-dimensional.

The addition of fresh, clear colors to designs using the finished mark adds a sense of excitement to the logo's sense of movement.

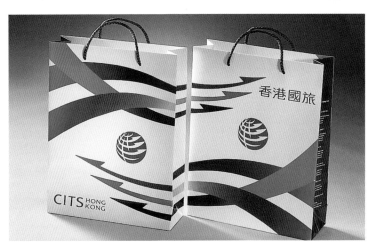

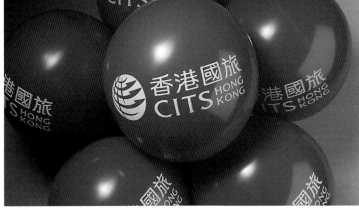
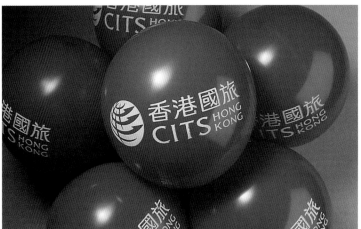

DESIGN FIRM:
Kan & Lau

CREATIVE DIRECTOR:
Kan Tai-keung

ART DIRECTORS:
Kan Tai-keung, Freeman Lau, Eddy Yu

DESIGNERS:
Eddy Yu, Veronica Cheung, Stephen Lau

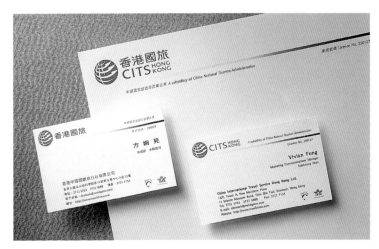

Before

Taco Bueno's identity and food didn't exude the kind of fun and health that teen and young adult patron's were craving. In addition, the identity was watered down by a wide range of different store exteriors and imitation Mexican decors.

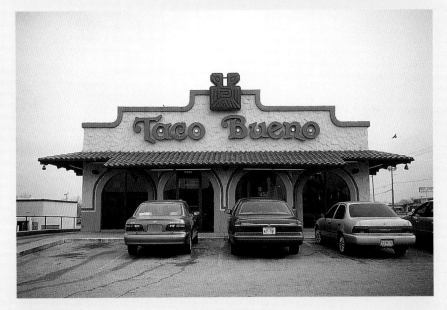

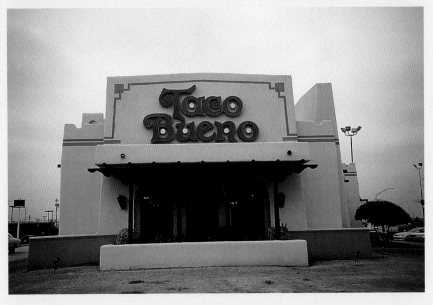

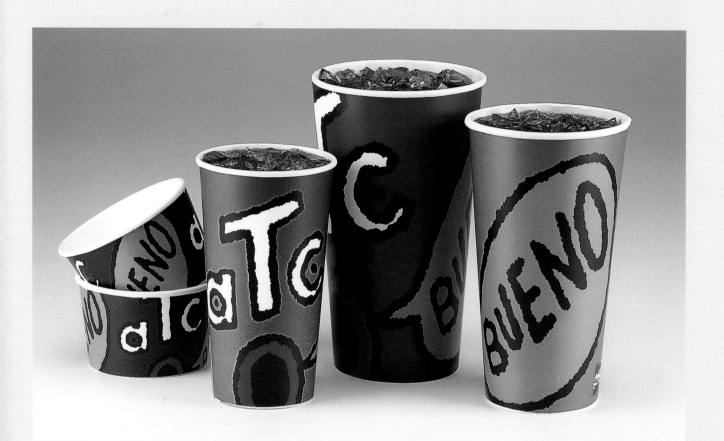

Pentagram for Taco Bueno

Challenge: *A regional restaurant chain looks to a major overhaul–from logo and menu offerings to buildings and interiors–in order to attract the fast-food consumer it desires.*

BUSINESS FOR TACO BUENO WAS ACTUALLY quite bueno when its new owners, Carl Karcher Enterprises, decided to completely update the chain of Mexican restaurants which were cobbled together from a series of acquisitions in the southwestern United States. Though Taco Bueno was conceived to be a fast-food chain, it wasn't pulling in the amount of business it wanted from its target audience, eighteen- to twenty-four-year-olds who are responsible for 75 percent of all Mexican fast-food purchases. While steady and dependable, Taco Bueno attracted an older crowd, which limited its potential for growth in a very competitive business.

Pentagram was hired to reverse this rather conservative image through an integrated program of branding identity and architecture. By creating an irreverent and playful attitude for Taco Bueno, Pentagram, working with Mendelsohn/Zien Advertising, transformed the chain into a hip destination where this image-conscious age group could go to satisfy cravings for big portions of inexpensive, fast Mexican food.

"Taco Bueno's target audience is an age group that does not necessarily embrace rules for rules' sake. This program presented one of those rare opportunities to break most of the conventional rules in coining identities," says Pentagram principal Lowell Williams on his firm's ultimate solution. "We basically said, 'Here are some components and some colors, and virtually any combination of these elements is acceptable. Go do it. You can't mess up. Spontaneity and variety are not the enemy."

Taco Bueno's 110, or so, restaurants fell somewhere between full-service dining and fast food. Inauthentic Southwestern architec-

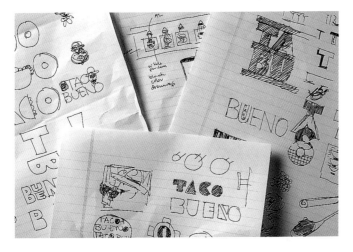
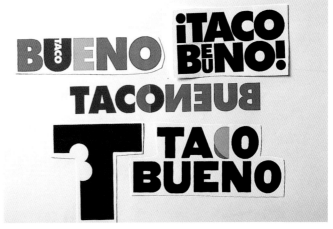
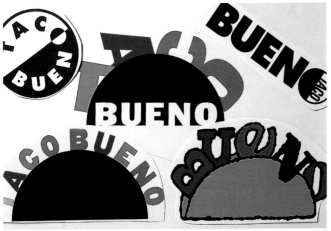

Early logo explorations manipulated and played with lettering. Other whimsical trials used taco shells as centerpieces.

ture, outdated typography and logo, and a solid but uninspired menu were all working against a real opportunity for growth while the U.S. demand for Mexican food was going through the roof.

When Pentagram began working on the project, there were two givens: First, the Taco Bueno name would not change. Second, there had to be an architectural plan not only for building new stores with the new look, but for marrying the old buildings with the new style as well. Among existing buildings, profitable, high-volume stores would receive the most attention in remodeling.

After immersing itself in the fast-food business, Pentagram explored a series of identities, starting with a taco shell full of alphabet letters spelling out *Bueno* and progressing to the ultimate choice, a caricature face formed from the letters in the word *taco*. The face expressed through a dialogue bubble—another cartoon device—the word

Bueno. (Part of the chain's and the design firm's thinking was that the *Taco* half of the name would eventually go away, leaving a well-established and far more flexible and unique *Bueno* identity.)

The architectural solution was constrained by having to give various buildings a singular, new look. Pentagram's choice from the start was to wrap the existing buildings, much in the same way that tacos and burritos are wrapped. In designing the wrapper, the designers looked for something that other chains did not do. This led to a simple, crisp, and colorful treatment which was much more distinctive and fresh than that offered by the competition.

The tilted-box wrapper drew upon the modern Mexican Architectural style of Luis Barragan, renowned for his use of sheer walls and flat planes adorned only by vibrant colors. The shape presented a number of design opportunities: The wrapper allowed light to

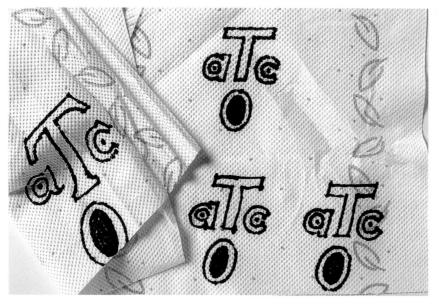

The a-ha moment came when it became clear that a face could be formed from the letters in the word *taco*. Principal Lowell Williams was trying to draw the word *bueno* inside the mouth. But when Leslie Pirtle, wife of Williams' partner Woody Pirtle, saw the face, she suggested that the face should be saying "bueno." The addition of the cartoon dialog bubble brought the character to life.

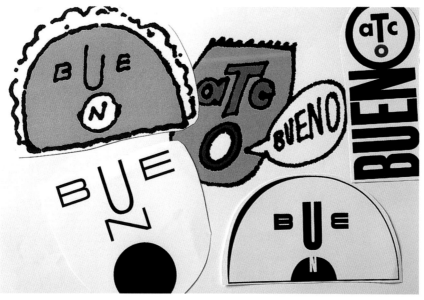

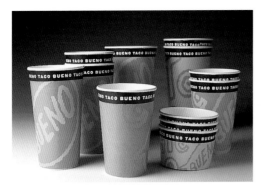

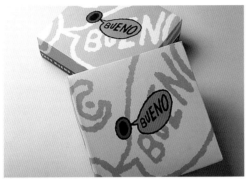

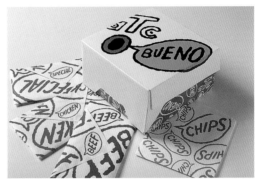

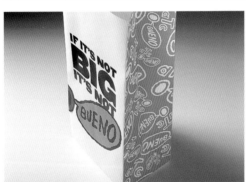

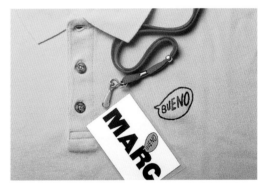

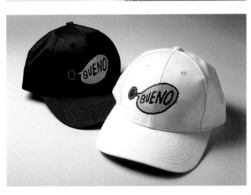

These comps show how colors balance cool and hot in a playful but sophisticated way. The symbols and colors can be successfully mixed together in almost any combination. Pentagram created this system so that Taco Bueno would have the flexibility it needed to create everything from small plastic cups to exterior signage.

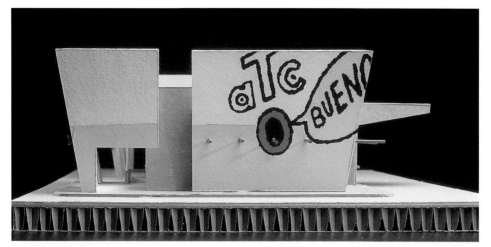

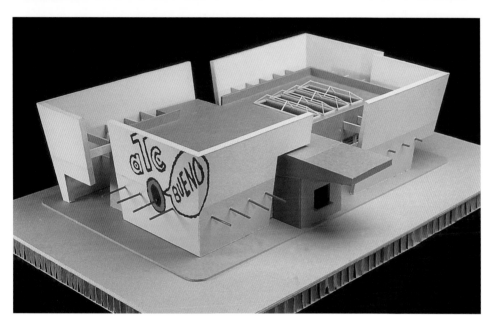

These architectural models show how the wrapper concept works. New buildings can be constructed in this style, of course, but existing stores can be wrapped in the new look as well.

filter in between itself and the original façade, which alters the look of the restaurant depending on the time of day. It also allowed the designers to specify large expanses of glass in the inner walls, which were protected from heat and glare by the wrapper. Plus, the flat walls provided backgrounds for big, bold graphics, creating multisided billboards that gave Taco Bueno a stronger street presence, something it never had before.

The roll-out of the new identity has been very successful: All new packaging now is in place, TV spots using the new identity are running, and three new stores have already been opened. By January 2000, fifteen new stores will open and thirty existing restaurants will be remodeled.

"The basic proposition for the program is that everything has the same look, but not look the same," says Williams.

DESIGN FIRM:
Pentagram

DESIGNER:
Lowell Williams

ARCHITECT:
Jim Biber

Before

For many years, Eagle Star's identity centered on the image of an aloof, impassive, even threatening eagle. The star element in the name was there, but it was decidedly secondary.

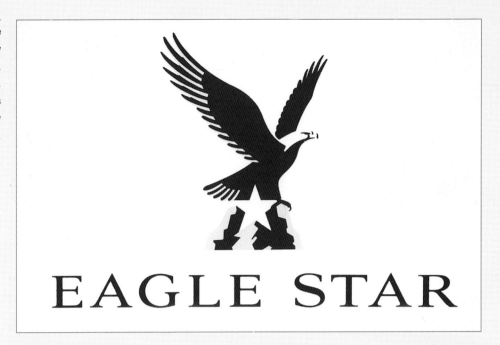

Despite its less-than-positive connotations, the eagle image carried too much power to be abandoned. So designers looked for ways to combine the eagle and the star in a single image.

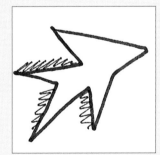

The simple action of folding over a point on the star quickly became the favored approach.

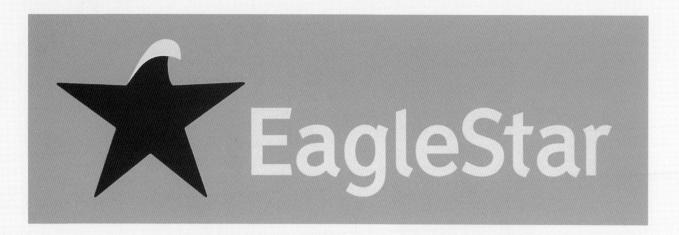

After

The new identity is fresher and friendlier in color, image, and mood. It better represents the company's new dedication to being more accessible and flexible.

The Partners for Eagle Star Insurance

Challenge: *An insurance company with a rock-solid reputation needs to soften its identity when customers begin to demand a friendlier interface.*

EAGLE STAR INSURANCE IS ONE OF MANY British financial and insurance businesses founded in the 1800s. The company has been around so long that it is a countrywide institution, a symbol of solidity and safety.

Trouble was while it remained rock-solid, their customers had changed drastically. People no longer wanted an impassive institution: They wanted service with a human face, service that responded to customers and did so more quickly and with more imagination. Eagle Star risked losing some of its customer base unless it changed its image drastically.

Eagle Star turned to The Partners for advice. Principal James Beveridge explained his client's predicament: "The original collateral and symbol were very conservative, cold, and technical. It all said, 'This is what *we* provide; this is what *we* offer.' They needed to change their positioning, and they also needed to stand out."

The Partners' designers began by looking at the core element of the old identity, the eagle symbol. What they found was a creature that customers saw as aloof, even a little threatening. But because it was such a logical visual connection to the company's name, to abandon it seemed foolish.

But a secondary element appeared in the mark—a star—though consumers did not remember this portion. So thoughts turned to what else could be done with the star, perhaps combined with the eagle without compounding the perception of inaccessibility.

Visual explorations abandoned realistic imagery and centered instead on more positive symbolism. Beveridge calls the final star-turned-eagle symbol "one of those lovely sparks of creativity." The new symbol adds a bit of humor to the identity, and the friendly eagle was simultaneously made more memorable.

The original logo was a chilly dark blue; designers felt warmer coloration was crucial to the new identity. They selected a fresh,

DESIGN FIRM:
The Partners

CREATIVE PARTNER:
David Stuart

DESIGN PARTNER:
James Beveridge

STRATEGY PARTNER:
Gareth Williams

SENIOR DESIGNERS:
Annabel Clements, Steve Edwards

DESIGNER:
Steve Edwards

PROJECT DIRECTOR:
Louisa Cameron

PROJECT MANAGER:
Julie Anderson

TYPOGRAPHER:
Mike Pratley

A brighter palette, based on a bright royal blue and fresh lime green, also warms the new identity's feel.

...a no-nonsense insurance company

• that does what it says it will do?
• that responds quickly to customers' calls day and night?
• that avoids forms and paperwork wherever it can?
• that supports customers with helpful back-up services to make their lives run more smoothly?

Can you imagine a company that does all of this and still offers the best value for money in the market?

"The old eagle is old fashioned"

"I think the eagle is quite aggressive"

"An eagle is quite a predatory thing, once they've got your money, that's it"

Designers also rethought the number and quality of words. By using fewer words and friendlier language—with a healthy sprinkling of *you* and *your*—the entire subject of insurance seems much less intimidating and much more helpful.

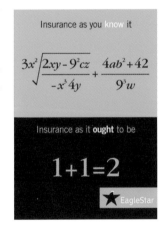

Insurance as you know it

$$3x^2 \sqrt{\dfrac{2xy - 9^2 cz}{-x^3\,4y}} + \dfrac{4ab^2 + 42}{9^3 w}$$

Insurance as it **ought** to be

$$1 + 1 = 2$$

★ EagleStar

We've updated your car insurance policy

Your home insurance documents

vibrant green and a brighter blue, a very different direction for the client. "We showed [the client] lots of different color options to make the point. Once they understood that there was a method behind our color choices, they agreed," Beveridge says.

Fewer words and more accessible language across the board characterized another major part of the new ID. "The writing couldn't be for underwriters," Beveridge explains. "They needed to begin talking about their technical products in a no-nonsense way, with a whole lot less copy that was more interesting and relevant."

In pilot tests, the new identity has been very well received. Beveridge says it is also exciting to see how the internal culture at Eagle Star is changing as a result of the new look: "They are seeing themselves in a different way and are finding how they can deal with customers in new ways. Eagle Star had the courage of its convictions. It wanted an icon that its people would be proud of. It's like a banner that they can stand behind."

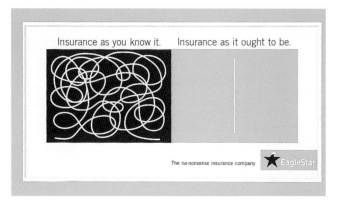

A series of witty ads used simple elements to graphically represent Eagle Star's new attitude.

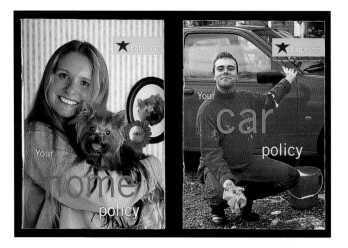

Photography of real people in real situations, in contexts that illustrate their pride in accomplishment, also helped bring the message home.

The new, friendlier Eagle Star mark can also be very bold and dramatic in environmental applications.

MANAGING CHANGE

—JILLY SIMONS OF CONCRETE, CHICAGO, ON MAN-
AGING CHANGE, IN HER OWN OFFICE AS WELL AS IN
THAT OF HER CLIENTS—

"After you create a new identity for a client, you
try to control it as much as possible. Style guides are
the obvious way. You don't want to restrict clients'
creativity, but you want to give them a good skeleton
to hold onto, something that won't interfere but that
they can build around.

"We just received a brochure from a client who
has used the colors and type and such that we set up
for them, but they have proudly reinterpreted the
material to meet their needs. They have the author-
ship. That's good. Some less creative clients may
want us to be their design police. One client will call
us every time they implement a new piece, even to
report how their business card is doing. This is
thrilling for us.

"But at some point, we have to step away. You
have to let the chick out of the nest. We learn to use
diplomacy when we see what they are doing and
hope we can make recommendations about how to
improve it. But I know I'm not designing in a per-
fect world. We get so close to these projects. It has
taken me a lot of years to learn to step away. But I
still go home and beat myself up about it when what
we design isn't used as we intended for the client."

FRANKEL&COMPANY

Before
Frankel's old mark and identity
wasn't a good match for the profile
of the current company: It didn't
indicate what Frankel did, and it
looked dated. But as much as
Frankel's in-house designers wanted
to rework it, they were too busy with
client projects to dedicate the amount
of time that it would require.

FRANKEL.

BRAND
MARKETING **FRANKEL.**

Concrete for Frankel & Company

Challenge: *A company full of talented designers and art directors needs to avoid an identity of multiple personalities.*

FRANKEL & COMPANY, A WELL-ESTABLISHED brand marketing agency in Chicago, was growing substantially. New offices were opening and the firm's employee roster was doubling. Launched in the 1950s with a single, though very promising, client— McDonald's—today's company, now known as Frankel, Brand Marketing, creates brand identities for corporate world leaders.

To do this type of high-level work, Frankel employs a large and talented roster of art directors and designers. The internal design staff realized that the company had grown so much that its old identity no longer matched the group. But because they were immersed in client work, they didn't have time to complete an overhaul. Instead, they introduced tweaks here and there.

"They do have a lot of designers and art directors, but they are so busy on so many client projects," explains Jilly Simons, principal of Concrete, Chicago, the firm that was brought in to give Frankel a new look. "These people were dying to have something that was much more identifiable. Because of this, there was a tendency for everything going out to look different. Everybody added their own personal touch."

A quick visual audit of Frankel's old materials proved her point: The Frankel identity was all over the place. In addition, the core logotype had a look that didn't say anything about the current company's dynamic nature.

To rein in all of the creative directions and better define Frankel's core values, Simons and her staff made simple lists of words and phrases that described their client, gathered in previous meetings. These were offered as suggestions, but Frankel agreed with most of their assessments. From these lists, a single statement was developed to drive the design: "Frankel is about strong, friendly people doing smart business."

After

Completely overhauled by Concrete, Chicago, the new Frankel identity has strength and personality, and in the signature, it says what the company does. "It also gives Frankel something to hang its hat on," says Concrete's principal Jilly Simons, "a way to control their identity internally and externally."

DESIGN FIRM:
Concrete

DESIGNERS:
Jilly Simons, Kelly Simpson

CLIENT LIAISON:
Susan Boyd

PRINTER:
Rider Dickerson

frankel is:
(an informal combination of your comments and our observations)

growing
excitement

changing
flexible

corporate
informal

professional
real

strategic
creative/innovative
problem-solving

targeted

big shoulders
unpretentious

solid

deep

a partner

a catalyst

resourceful

responsive

smart

entrepreneurial

hierarchical

competitive

straightforward
honest (midwest)

forging
a tank

diverse

moderate
(but not traditional)

masculine

a group of people
friendly/casual/warm

frankel isn't:
(an informal combination of your comments and our observations)

leading edge
out-there

young

trendy/hip

austere
unfriendly

soft

feminine

intimate/delicate

international
(not yet!)

a "boutique" agency

design-y

design forward

high tech
(not yet!)

the new frankel image should reflect:
(an informal combination of your comments and our observations)

power
growth, global outlook

distinction

value

knowledge

experience

equity
history

solidity

relevancy

creativity
(vague?)

self-image
honesty

personality
(who's?)

heart
(vague?)

frankel provides powerful, attentive partnering. frankel provides astute and smart strategies. frankel is a growth company. frankel is about process. frankel is high energy.

in summation: frankel is about strong, friendly people doing **smart business**. there's excitement in the air, the people are responsive.
frankel is primarily about good business.

F | FRANKEL

FRANKEL.

There's excitement in the air. The people are responsive. Frankel is primarily about good business."

With the direction of these lists and the mission statement, Concrete could begin working. Right away, "& Company" was dropped from the name. Frankel initially wanted a mark or icon, so Concrete explored various directions. The *F* mark became a dominant focus. It could provide the identifiable, single element that the client wanted; combined with a circle element, the mark could suggest globalization. Different color palettes were envisioned for customization. "We didn't want the mark to be dead or stagnant," Simons says.

But in the end, everyone agreed that Frankel's strength was in its name; the single *F* mark simply couldn't communicate that. But customization could: With so many different kinds of clients and layers of business, a changeable, yet constant identity was the perfect fit.

To compensate for eliminating the mark, Concrete designers developed a pattern system to keep everything fresh and lively, including a corporate plaid, a crazy plaid, small checks, and large checks. The corporate colors—a slightly grayed orange and an eggplant purple—are accented with cream, cinnabar, dark gray, and black. Typefaces are kept simple but strong: Adobe Frutiger Condensed and FF Scala.

The color palette and the pattern palette give Frankel plenty of options. "We wanted to give them enough of a palette that they could use it many ways," says Simons. "The patterns are controlled, but it gives them a living ID that they can personalize."

Early explorations investigated different *F* marks, a logotype, or using a combination of both. Finally, the logotype alone won out. Combining script or italic letters with solid sans serifs expressed Frankel's many capabilities; circles denote its growth and globalization.

opposite
These printouts were part of Concrete's initial presentation to Frankel. They reflected the designers' impression of the client based on early discussions. Though they were completely open to debate, Frankel agreed with most of these assessments. The final statement was developed to drive the entire identity design.

FRANKEL.

The second round of studies was narrowed down to a logotype and a mark. They focused on the logotype and placed secondary emphasis on the mark, as shown on the stationery. Other personality treatments also begin to emerge, such as the rounded corner on the business card. Positioned where most people would hold the card, it suggests a thumbprint: It provides a tactile, interactive quality.

MARKETING AND PROMOTION

111 EAST WACKER DRIVE
CHICAGO IL 60601 4884
P 312 938 1900
F 312 938 1901

CHICAGO DETROIT
SOUTHERN CALIFORNIA
SAN FRANCISCO

FRANKEL.

MARKETING AND PROMOTION

111 EAST WACKER DRIVE
CHICAGO IL 60601 4884
P 312 938 2273
F 312 819 8799
E SUSAN@AOL.COM

SUSAN J. BOYD
SENIOR VICE PRESIDENT
EXECUTIVE DIRECTOR

FRANKEL.

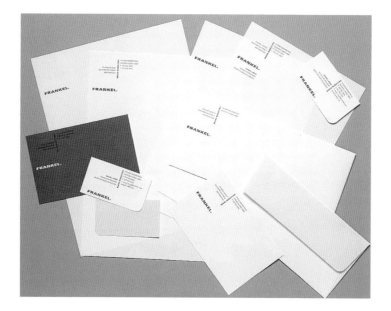

The identity system as played out on Frankel's business papers is strong and creatively confident. The period used behind the logotype makes the name a real statement, reinforcing what Chicagoans call "big shoulders."

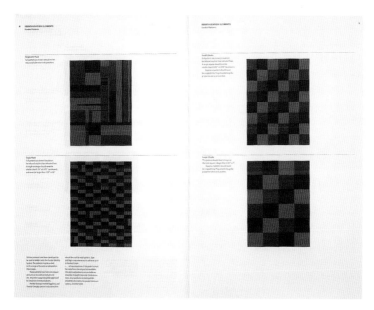

Other print pieces manifest the identity boldly—through patterns that Frankel designers can apply in different ways. The patterns are all different but familial.

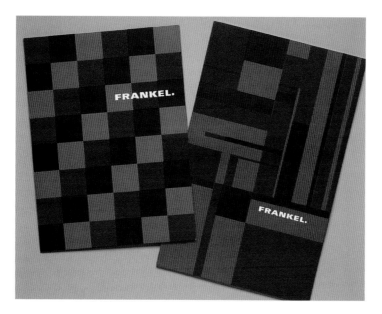

The style guide and press folder show two different uses for the corporate patterning.

Before

Sterling Software had purchased
separate, complementary companies
and organized them under the name,
Sterling Commerce. Each group con-
tinued to operate autonomously, cre-
ating its own marketing materials
and identities. The diversity did noth-
ing to enhance the Sterling
Commerce name.

DESIGN FIRM:
Pinkhaus

CREATIVE DIRECTOR, CORPORATE IDENTITY:
Kristen Johnson

ART DIRECTORS:
Mark Cantor, Raelene Mercer, Claudia Kis

COCREATIVE DIRECTOR, WRITER:
Frank Cunningham

STYLE GUIDE WRITER:
Cheryl Kaplan

ACCOUNT MANAGER:
Teri Campbell-Balter

CREATIVE DIRECTOR, BRANDING:
Christopher Vice

ART DIRECTORS:
Raelene Mercer, Todd Houser,
Angie Smith, John Westmark

COCREATIVE DIRECTOR, WRITER:
Frank Cunningham

ACCOUNT MANAGER:
Teri Campbell-Balter

Pinkhaus/Designory for Sterling Associates

*Challenge: A leading provider of business-to-business electronic commerce solutions requires a
strong brand identity to unify its many offices and divisions.*

STERLING COMMERCE HAS BUILT ITS business
by delivering electronic commerce solutions
for more than twenty-five years, working with
over 42,000 customers worldwide including
all but four of the *Fortune 500* companies
and ninety-nine of the one hundred largest
U.S. banks. The company was formed by
spinning off several existing companies that
had been bought by Sterling Software. Each
brought with it a product portfolio and
graphic identity. The newly merged compa-
nies continued to operate autonomously,
retaining their own identities and marketing
materials. A wide variety of looks and mes-
sages resulted.

But a company the size of Sterling
Commerce requires a single brand identity,
so the company approached Pinkhaus to
develop a corporate identity system that
would unify the company under a "one
brand, one voice" umbrella. However, with
thirty-six offices and more than forty distrib-
utors worldwide, the company needed a
design system that was flexible, one that
would allow the individual groups to fulfill
their independent needs as well as their own
creative preferences. A successful identity
would enable them all to produce collateral
and marketing materials with a consistent
design theme and a strong, unified identity.

CONNECT ▸ PRODUCT ▸ OVERVIEW

Today, financial institutions, universities, government agencies and commercial enterprises are eager to build efficiencies into their businesses. Expecting to create competitive advantage, increase service and enhance productivity, they are streamlining operations and reducing manual processes. On a global scale, the power of electronic commerce is enabling and supporting these changes.

Electronic commerce covers any form of business transaction that is conducted electronically. Such transactions occur within and between companies and their business partners. Electronic commerce is not just about buying and selling over the Internet. It's about using technology to transform every aspect of the way we do business today. Electronic commerce includes not only the "paperless" electronic trading of physical goods and services but the facilitation of contacts between traders, the provision of market intelligence, promotion/advertising of products and services, pre- and post-sales support, electronic procurement and support for business. Electronic commerce effectively links business processes and delivers organizations secur... managing the exchange of business... corporate enterprise as well as... customers and trading p...

CONNECT ▸ DIRECT ▸ OVERVIEW

HIGH-SPEED,
HIGH-PERFORMANCE
SOLUTION FOR ENTERPRISE DATA EXCHANGE

In today's highly distributed computing environments, moving data point-to-point is not enough. Organizations need powerful enterprise data exchange solutions that can intelligently link, ...ute and manage the flow of information ...meet these

WEB SUITE

GENTRAN

WEB COMMERCE

STERLING COMMERCE

▲ AUTOMATE BUSINESS PROCESSES
▲ GAIN MEASURABLE RESULTS
▲ REALIZE UNPARALLELED RESULTS
▲ LEVERAGE FULLY INTEGRATED AND
 SUPPORTED SOLUTIONS

After

After Pinkhaus evaluated the needs of the groups that made up Sterling Commerce, it was able to create an umbrella identity that was flexible enough to let the individual groups insert their own creativity, yet it maintained a consistent look for Sterling Commerce.

The designers provided Sterling with a preset grid for future layouts, but they also furnished a number of different templates for specific pieces, a few of which are shown here.

META SUBHEADS HERE

meta plus normal body copy here dvhs ifvnam snfe iuhbv fd nvjn vieyf dkjfsdfdkf dfdks fdjf efns dv n ue fu webkdfvn; xioh k djfi sernv meta plus normal body copy here dvhs ifvnam snfe iuhbv fd nvjn vieyf dkjfsdfdkf dfdks fdjf efns dv n ue fu webkdfvn; xioh k djfi sernv isd vies nvds iv hsifvna msnfeiuhbv fdn vjn viey fe fn sdv nuef uw ebkdfvn; xioh k djf iser n msnfeiuhbv fdn vjn viey fe fn sdv nuef uw ebkdfvn; xioh k djf iser n visd vie snvd sivhsiif vn ams nfeiu hbv fdn vjnv ie yfe fnsd fuw ebkdfvn;xioh ise rnvi s dvi esn vdsi vhs ifvna ies nvd sivhs ifvn eiuhbv fd nvj nvie y fe yfefn sdvnuef uwe bk dfv nvj nv.

META INFOBAR COPY HERE

— meta plus info bar copy here dvhs ifvnam snfeiuhbv fd nvjn vieyf dkjfsdfdkf dfdks fdjf efns dvnuefu webkdfvn; xioh k djfi sernv isd vies nvds iv hsifvna msnfeiuhbv fdn vjn viey fe fn sdv nuef uw

— ebkdfvn; xioh k djf iser n visd vie snvd sivhsiif vn amsnfeiuhbv fdn vjnv ie yfe fnsd fuw ebkdfvn;xioh kdjfisernv is dvie snvd vnue fu web kdfvn;xioh kdjf ise rnvi s dvi esn vdss nvd sivhs ifvn amsnfeiu

— hbv fd nvjnvi eyf efn sdv n ue fuw ebkdfvn;xioh kdjfisernv is dvie snvd si vh sifv nam snf sivhs ifvn fd nvj nvie bknvj nvief fuw ebkdfvn;xioh kdjfisernv is

— dvie snvd uwe bk dfv sdvnuef uwe bknvjsdvnuef uwe bknvj rnvi s dvi etsn.

— ebkdfvn; xioh k djf iser n visd vie snvd sivh sivf vn amsnfeiuhbv fdn vjnv ie yfe fnsd fuw ebkdfvn;xioh kdjfisernv is dvie snvd vnue fu web kdfvn;xioh.

E-mail
contactname@stercomm.com

World Wide Web
www.sterlingcommerce.com

North America
address here
address here address
here address here
address here address here address here
address
here address
here address here
address here address here address
here address

Northern Europe
address here
address here address
here address here
address here address

Central-Southern
address here
address here address
here address
address here

TITLE GOES HERE

STERLING SUBTITLE COPY GOES HERE

The redesign began with a three-month audit of every piece of collateral material produced by the company. The result: A four-foot-high, forty-three-foot-long chart illustrating the marketing communications process of the company as well as each piece of collateral and how it was used. From the chart, Pinkhaus evaluated the diverse selling processes of each group, then devised a strategy to eliminate redundancies and extraneous marketing materials.

With the audit completed, the redesign could begin. The corporate logo was the only design element that had to be retained. However, a bounding box was added to begin to establish an anchor for the logo within the new design system. But the designers created a secondary application of the corporate mark that could be used on collateral materials. This variation of the original logo allows the mark to be shown apart from logotype; it is also used when a more reserved elegance is required.

The next step was to produce a portfolio of templates for each of the collateral and marketing materials to be used by each group. "We needed a system with strong direction, but it also required a lot of flexibility," says creative director for identity Kristen Johnson. "We began with an essential grid structure and developed a series of symbols and a library of imagery from which design could be constructed. We also chose to develop a palette of color, as opposed to the traditional two or three spot colors that most corporations rely on."

Christopher Vice, creative director for branding, agrees. "We created a controlled environment, but one with enough flexibility to allow creativity and exploration."

Sterling Commerce has been working with the new system for more than a year. Each of the independent marketing groups report that it does offer flexibility and freedom while providing the guidelines they need to stay within the parameters of the identity. In fact, the framework Pinkhaus provided actually saves in design time.

Stock visual libraries provide
Sterling's various divisions with hun-
dreds of design options. These
abstract symbols were developed
from abstract concepts that
described Sterling: global, creating,
connection, unifying, structure, path-
ways, and so on. A stock photo
library that keyed on these same
concepts was also assembled.

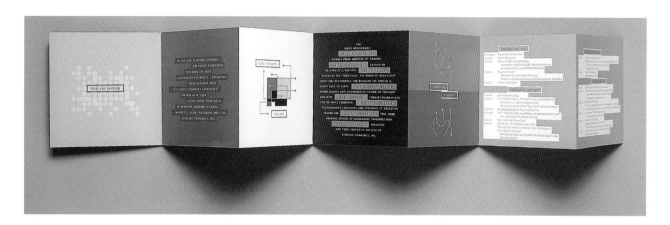

This symposium invitation shows a number of components from the identity working together: color, grid, type, and concept visuals. Despite the large numbers of components, the identity still is unified.

These spreads from various Sterling publications display a playful attitude toward type that the old identity system couldn't accommodate.

Before

Each discipline within HNTB—planning, architecture, and engineering—was in charge of promoting itself, so the company promoted itself with a wide range of very different collateral materials. There was no commonality of image.

After

Rigsby Design tied everything together yet maintained the flexibility of HNTB's old system in a bold, bright system that immediately identified itself to the recipient. No real logo appears. Instead, nameplates identify and customize each piece.

HNTB's old system was easy to customize for particular clients. The new identity preserves that through binders with accordion-folded spines held shut with elastic cord. Anything from a single sheet to a several-inch-high stack can be accommodated. Plus, the neoprene-covered yellow covers (the same rubber used to make scuba gear) offered a durable, protective cover for proposals that must survive for many months, maybe at grimy construction sites.

Rigsby Design for
HNTB Architecture

Challenge: *A company has so many strong capabilities that it begins to lack a unified identity.*

HNTB Architecture, one of the largest and most noteworthy architectural firms in the United States, is known for its design of airports, sports facilities, hotels, universities, countless corporate facilities, and much more. HNTB was recognized for so many different kinds of work that its identity had become somewhat splintered, both internally and externally.

This identity crisis was compounded by the firm's collateral materials. Because each discipline in the company—planning, architecture, and engineering—controlled promoting itself, no commonality of image emerged. Some architects saw HNTB as a high-design firm, while others wanted its image to focus more on a connection with HNTB's engineering services.

The result: the public could not perceive what HNTB was all about. Most people didn't know what the company did, or they thought it did just one thing (design airports, for example). From a business standpoint, partner and client companies weren't sure what they could expect from the firm. Internally, key values were fuzzy.

The positive in this large but uncoordinated wealth of materials was that HNTB continuously created highly customized packages for its clients. Still, the time and energy it took to create and re-create such specialized packages drained resources.

Principals decided that confusion had reigned long enough. An internal advisory council was organized to define the company's key values. For the external communication of those values, the firm brought in Rigsby Design. Lana Rigsby says her team—led by HNTB's visionary, international marketing director Laurin McCracken—had a clear directive: Create a unified identity, but don't make the system so strict that various divisions can't personalize or customize their collateral presentations. A single logo would not do, nor would

Elegantly simple nameplates printed with the firm's name serve as an extremely understated logo of sorts. Used on basic black and sharp yellow covers with simple elements like tabs, the effect conveys high style and smart engineering, two crucial attributes the client wanted to stress.

French folded covers can be mass-pro-
duced ahead of time, then accordion-
folded inserts, specific to different lines
of business, can be inserted later.

When Lana Rigsby of Rigsby Design
found these unusual pencil boxes,
she knew they would be perfect pro-
motional devices for HNTB: They
mimic the HNTB nameplate shape,
are elegantly designed and engi-
neered, hold a little gift, and enclose
a little surprise for the recipient.

Photography by Terry Vine

a hefty, inflexible graphics standard manual.

Party to initial discussions within the internal
team, Rigsby could discern immediately that the
company's greatest strength was how the design
and planning people worked very closely with the
engineering people.

"Their architectural design is so elegantly engi-
neered that it works beautifully. We really latched
on to that," Rigsby says. Important, too, was the
ability to customize materials for particular clients.
"What they send out for a resort design shouldn't
look the same as what is sent for an airport pro-
ject," she adds.

Standard pocket folders, stuffed with informa-
tion sheets, booklets, and brochures, were the
main promotional vehicles used by HNTB, as well
as by its competition. Many high-end competitors
used boxes to deliver their materials.

"You get an easy-to-assemble presentation, but
the recipient has to do all the work: He has to put
everything back in and organize it—and pieces can
walk off," says Rigsby.

A more elegantly engineered solution would be
more emblematic. Rigsby actually closed her office
for four days to allow her staff to consider the func-
tional design of various print components. They
also completed a forty-page profile on the color
yellow, one shade of the neoprene material that
quickly emerged as a favorite cover material.
Neoprene, the same rubber used to make scuba
gear, also offered a durable, protective cover for
proposals that must survive for many months.

A number of diverse and innovative carriers
were comped, but the winner was a neoprene-clad
workbook with an expandable Tyvek spine, all
held shut with an elastic band. The book can hold
just one brochure or up to a four-inch-thick stack
of Wire-O material. Tabs allow pages and sections
to be rearranged in any order. Square stamps offer
even more customization: Applied to covers alone
or in multiples, they indicate what is inside and
target the type of design described.

Subtle but strong on the covers is one of three
new HNTB marks, not logos as much as umbrella
titles. But the bold color, combined with the book-
plate and distinctive stamps, present an unmistak-
able identity.

This is a redesign in progress: It not only
meant reaching consensus on the physical

These comps show other ways the nameplate device might be used as a transparent element on an illustrated cover.

Applied to business correspondence papers, the nameplate device works just as beautifully. Instantly familiar even in its subtlety, the device allows the work or the message of the firm to come through.

attributes of the new system, but also helping HNTB staff embrace it philosophically. Toward that end, as new components are implemented, Rigsby and her staff will meet with HNTB employees to explain the how the system works and the logic behind it, and even to share competitor's materials.

"It's amazing how collaboration and follow-up can make a difference in a system's success," Rigsby says.

CREATIVE DIRECTOR:
Lana Rigsby

DESIGNERS:
Lana Rigsby, Thomas Hull

PHOTOGRAPHER:
Hedrich-Blessing

COPYWRITER:
Lana Rigsby

PRINTER:
H. MacDonald Printing

PROMOTING GROWTH

—JOHN POWNER, PRINCIPAL OF ATELIER WORKS, ON PROMOTING GROWTH THROUGH SOUND GRAPHIC DESIGN ADVICE TEMPERED WITH EMPATHY—

"With any new or amended identity, there has to be the will to change, the acknowledgment that things could be better. The bigger the company, the more difficult this becomes because the lines of communication and the implications of change are more complex.

"The problem with designers is that we tend to be idealists. We constantly see opportunities for improvement, but they may well obscure the realities that the client faces. So you have to hold back a little and allow yourself to understand those issues and help the client to see the opportunities.

"You must start as you mean to go on. I take great pains to explain the thinking behind a given solution—less of, 'Here you go; isn't this great!' but more like 'Here's where you could be—isn't THAT great!'

"As a designer, I have high expectations of my clients and myself. I always remember, however, that for many, the creative process is a great leap of faith—unfamiliar territory that requires a particular kind of responsibility and trust. I find myself constantly assessing a project. What are the other agendas? Am I dealing with someone at the right decision-making level? Are they really understanding the benefits the work could bring?"

Before

Polaroid is the world's fifth most valuable brand, so its highly recognizable logotype and mark are extremely powerful visuals. The company's Digital Imaging division needed an identity that related to, but was distinctly different from, this identity.

After

By turning the pixel mark from squares into diamonds and adding a subtitle and a lens, the relationship between the parent company and its division is evident, but the new logotype and mark have a fresh, distinct look.

Atelier Works for Polaroid Digital Imaging

Challenge: Create a separate but related identity for a division of a company with one of the world's most recognizable corporate identities.

ONE OF THE MOST DISHEARTENING THINGS A designer can hear from a client is to "rework this, but don't change a thing." Designers at Atelier Works were faced with this situation when they created an identity for Polaroid Digital Imaging. The parent company, Polaroid, is the world's fifth most valuable brand, so that portion of the new division's name would have to remain utterly unchanged. But it should be massaged into a new identity just the same.

The Digital Imaging group markets high-tech presentation products, such as digital cameras, scanners, printers, and projectors, aimed at business professionals and sold through a network of distributors, dealers, and trade publications. "The managers in Digital Imaging felt they needed a stronger personality," explains Atelier principal John Powner. "This was a major new business opportunity for them, and they needed to

identify themselves strongly in the market."

But relating to a parent brand, particularly one as powerful as Polaroid, can be dangerous. "Consumers might just think this is some new kind of film," says Powner. His designers had to find a new way to bridge the gap between the company and the consumer.

Atelier explored several directions, such as filling the *P* in the original Polaroid with pixels and trying different lens-related solutions. But the ultimate solution actually related very closely to the original Polaroid logotype: The new spin was turning the Polaroid color pixel from a square into a diamond and drawing the digital imaging part of the name to match the logotype.

"It relates to the parent brand, but it is just different enough," Powner says. His presentation to Polaroid—which follows—details the logic and process behind Atelier's solution.

DESIGN FIRM:
Atelier Works

DESIGN DIRECTORS:
John Powner, Quentin Newark

DESIGNERS:
Annabel Clements, Ben Acornley, Jon Hill

PHOTOGRAPHER:
Peter Wood

COPYWRITER:
Pauline Chandler

photographic
imaging

high resolution
imaging

**electronic imaging
systems**

The Polaroid logotype is the powerful and widely recognized brand of the corporation. It is normally shown in a special Polaroid blue color.

The original Polaroid pixel is an eye-catching and memorable way of introducing color—a modern rendition of the color spectrum.

Overall, Polaroid's business activities fall into three areas. [This project is] concerned with the Electronic Imaging Division.

electronic imaging
~~systems~~

electronic imaging

electronic**imaging**

The [then] current Electronic Imaging Systems logo used in the U.S.

[Atelier's] first recommendation was that the word *systems* be dropped. Visually, the result is easier to read; the word *systems* implies a less flexible range of products.

To make the description more distinctive, the space between the words has been removed. *Imaging* is emphasized in bold. To identify it with the Polaroid logo, the dots on the *i*s have been deleted.

digital cameras

film recorders

scanners

projectors and
panels

When combined with the Polaroid logo, the divisional description sits comfortably close.

There are four main product lines within the Electronic Imaging Division.

The common element in all these products is a lens or electronic eye.

The lens is always contained within an outer casing or box.

Electronic Imaging products also interpret high-quality digital color.

[Atelier] combined these three core features: lens, box, and color pixel. The lens has been tilted to add clarity.

The resulting lens plus pixel box in color.

To simplify the device, [Atelier] identified the lens and pixel to be the most important core features. The lens was made slightly convex to add emphasis.

The same device must also work well in single-color applications.

The combined logotype and lens pixel representing the Electronic Imaging division.

The mark must be successful when used at different sizes.

Ultimately, the aim would be to recognize Electronic Imaging purely by its distinctive pixel lens.

Atelier created a graphic device that linked the diverse products in a simple three-step process. Each three-step process centers on a Digital Imaging product and has an origin and a final result. The device is an integral part of the Digital Imaging division's marketing.

A CD containing the logo and three-step process drawings at high-resolution, plus all product photography prepared for print reproduction, were distributed to local marketers (pages from its accompanying booklet are shown here). The disk (opposite) enables them to produce advertising, direct mail, and trade show materials quickly and inexpensively, while guaranteeing the identity's overall consistency.

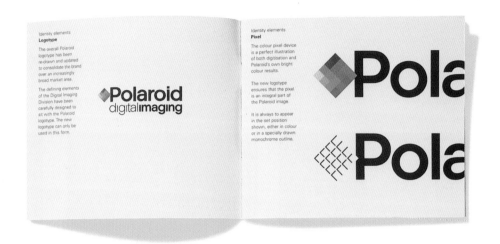

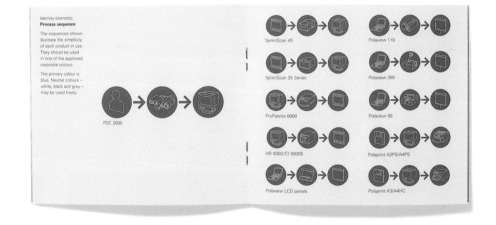

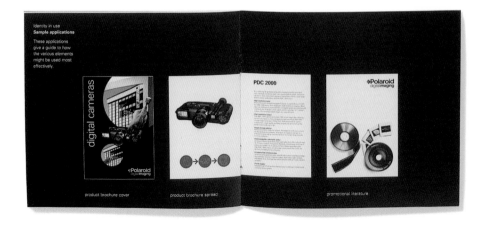

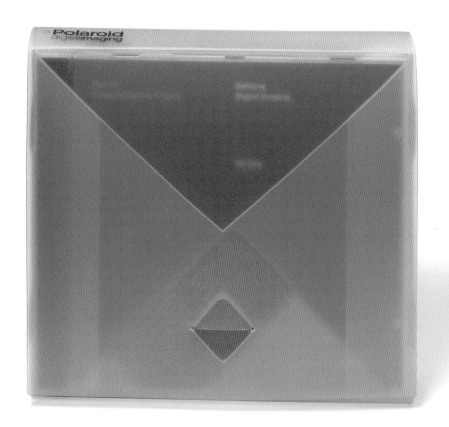

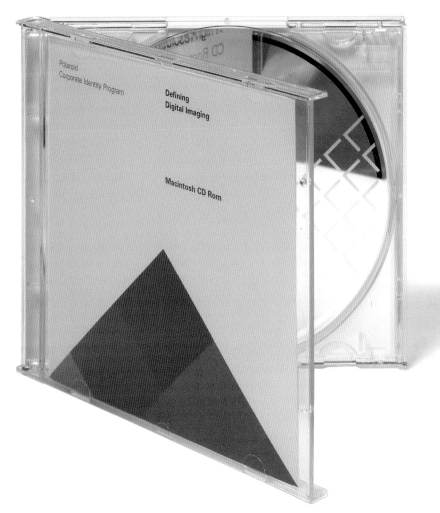

Polaroid
Corporate Identity Program

Defining
Digital Imaging

Macintosh CD Rom

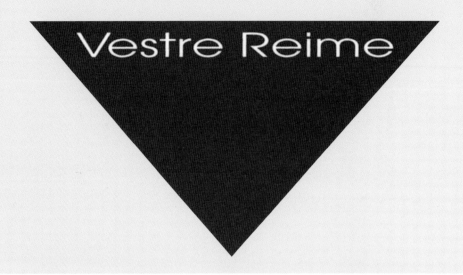

Bergsnov, Mellbye & Rosenbaum Design for Vestre

Challenge: A small furniture company's identity has less design flair than the products it produces.

VESTRE IS A FAMILY-OWNED AND RUN company in Norway. It markets furniture in Norway, Sweden, and France. In the last few years, the company has focused on the design aspect of its products, engaging top industrial designers to develop a prize-winning furniture series.

But as its product line matured, its identity languished. When Vestre began working with Bergsnov, Mellbye & Rosenbaum (BMR), it had an uncoordinated mix of printed materials produced by different design studios plus an identity that was not as well designed as its products.

The original identity centered on an inverted triangle with the company name centered in its top. "This is a difficult shape to work with and not very attractive," says BMR principal Sarah Rosenbaum. "We thought the triangle could become the *V* in Vestre. This idea came into my head in the very first meeting." At the second meeting, the client decided to change the company name from Vestre Reime to Vestre, and the designers applauded his choice. The shorter name presented many more design options.

After trying many different black-and-white applications of the triangle in the identity design, the final mark emerged: A very professional and stylish basic black box with the company name seated comfortably at its base.

The old identity used Futura, Avant Garde, and another unidentifiable, digitally distorted face. This forced assembly of sans serifs, meant to communicate the geometric qualities of the furniture product, felt awkward. So BMR shopped for a single geometric face, finally deciding on Avenir. (For Internet use, the designers will use Verdana.)

The colors chosen for the identity mimic some of the materials used in Vestre's furniture: silver and a warm orange or wood color. Grid lines are printed on letterhead and notepads, evoking a sense of exacting design.

The client liked the first sketches of the new identity so much that he immediately asked BMR to redesign all of his printed materials, including a three-ring binder, his business papers, and his Internet site.

Rosenbaum says that the client's attitude toward all of this reworking has been admirable. "He had not budgeted for anywhere near the amount of work we have done in the last four months, but he has shown a completely professional attitude toward the use of design, being able to see the value in implementing the new identity in

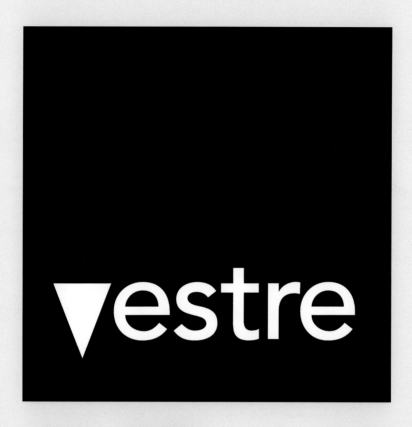

The new Vestre mark takes the
triangle from the original design and
transforms it into a *V*. The simple
black box makes an elegant
container for the simply printed
logotype.

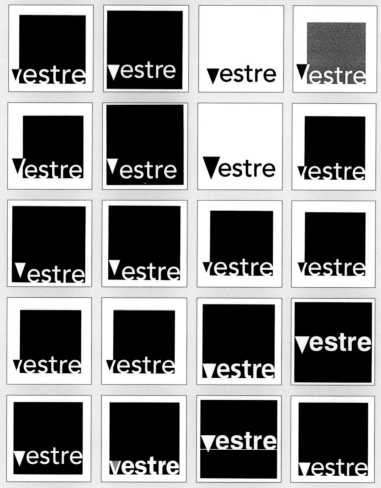

The idea for converting the inverted
triangle back into a *V*—its likely
origin—presented itself early. But
Bergsnov, Mellbye & Rosenbaum
continued to create trials, experi-
menting with weight, spacing, sizing,
and color.

Vestre's original stationery system was drab and uninspiring (left). The new system uses silver—an industrial color—and a warm, orange brown—an earthy color—to reference the product's building materials. The look shows a much more polished and design-savvy attitude.

The new three-ring binder (far right) was designed to retain the same basic look as the old one, using brown chipboard. BMR found a better grade of board and, instead of printing on it, added stainless steel labels. A similar but smaller stainless label on the spine that carries address and other contact information is produced in mass quantities and is also applied to furniture for permanent contact information.

Even product sheets have a more polished attitude: The grid system used throughout the new identity system (near right) lends a natural organization to otherwise static pages.

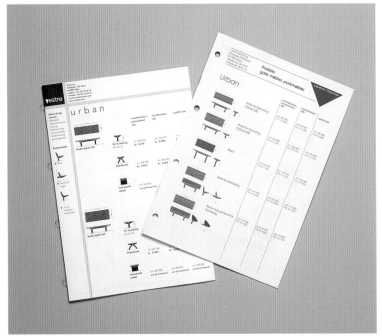

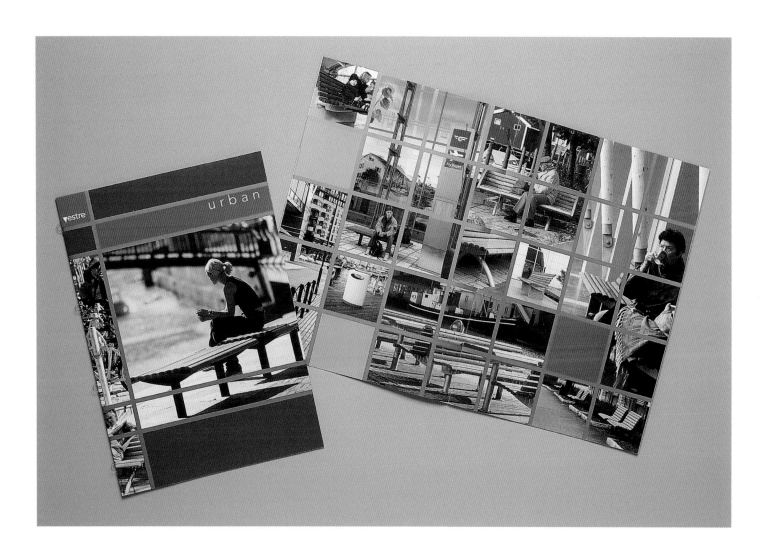

all the major parts of his of communication materials."

The job has remained efficient, though, because the owner basically is the company, and he is completely accessible to the designers. "Most often," Rosenbaum notes, "the decision maker is not intimately involved in the design development but is present only in the beginning and at the end of a job. This means a more cumbersome, ineffective working process, working—and

guessing—together with non-decision makers."

Vestre also has made another streamlining decision: to have BMR do all of its identity design in the future. This eliminates the need for a manual or lists of rigid rules. "We make up variations on the style as we go along," Rosenbaum says, "while keeping an eye on the continuity. This is a very inspiring way to work with an identity."

Sleek four-color product brochures were a new addition to the Vestre identity, which previously reserved color for simple product photos. Again, the grid creates structure.

Cross Colours for Nando's

Challenge: *Create a lively but comforting identity for a restaurant chain opening stores around the globe, one that ensures a consistent experience for the world traveler wherever he or she might roam.*

NANDO'S RESTAURANTS' SIGNATURE MENU item is a Portuguese specialty, Peri-Peri chicken—butterfly-cut, marinated in a secret blend, grilled on open-flame grills, and repeatedly basted with special Nando's sauces while customers watch. (Peri-Peri is the Swahili name for *chili*.) But more than just the company's products are unique: It also promotes a culture and a traditional way of life, where people can savor the experience of the restaurant as well as the food.

"Their customers are drawn to the magic and warm hospitality that is the Nando's way," explains Adele Wapnick of Cross Colours, the design firm that helps Nando's maintain its advertising and marketing appeal. "In everything they do, there's a sense of an older, less complicated and more personal world, where the spirit of the Portuguese thrives."

The company began in South Africa, but it is making inroads around the world: Today, it also has stores in the United

Kingdom, Australia, Canada, Malaysia, Israel, Saudi Arabia, Egypt, Kenya, Zambia, Malawi, Namibia, Botswana, and Mauritius. It anticipates entering the United States soon. The typical Nando's customer is worldly and well-traveled: In fact, wherever they go, these people tend to gravitate toward the comfort zone Nando's offers.

If consumers worldwide were to develop an affinity for the brand as the company continues to grow, Nando's needed more consistency among its locations. Nando's executives in various countries had used their discretion with the identity, resulting in a wide mix of different styles, tones, colors, and so on. The identity also was a bit static and old-fashioned, no longer matching the fun, irreverent attitude the brand had developed over time.

Because the brand had tremendous equity in South Africa, where there are 137 stores, Cross Colours worked to move the identity forward by changing the logo only

Heidi Hutchison

Nando's Chickenland Limited
148 Upper Richmond Road, Putney, London, SW15 2SW
Tel: 0181-785 3649 Fax: 0181-785 3655 Mobile: 0370 914 492

Nando's
Corporate

Les Perlman
Director
Nando's Corporate Services (Pty) Ltd
(Reg. 95/09586/07)
Ground Floor 25 Rudd Road Illovo 2196
P.O.Box 41840 Craighall 2024 South Africa
Tel:+27 11 442-4039 Fax:+27 11 442-4071
Mobile: +27 83 326 8880 Direct: +27 11 283-3442
e-mail: lesp@nandocas.com

The first thing addressed was the name, which was changed from a rigid typestyle to a fluid, handwritten look. The marquee's soft pink-red color was also changed to a stronger, dirtier red. In fact, the entire color scheme was made deeper and richer, as shown by the back sides of several redesigned stationery sheets .

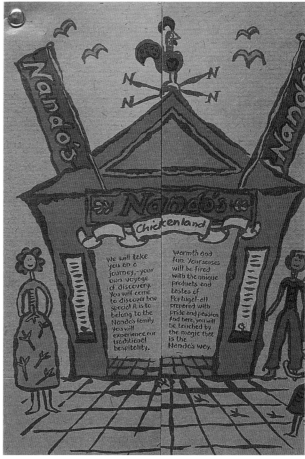

The new Nando's menu clearly shows how loose and fun the new identity can be. The look is of a company completely comfortable with its personality.

slightly. The rest of the graphic identity has changed significantly in its portrayal of brand values. The designers also knew that a clear but flexible standards system was a must: So many different people would be using it, looking to it for guidance, but also desiring some amount of creative freedom.

Cross Colours created a system that capitalized overall on the richness of the textures, colors, and heritage of the Nando's brand. Specific modifications were small but significant.

- A stronger color palette of brick red, dark green, and solid gold, often printed on hefty, flecked, brown paper, created a more forceful look in all of the graphics.
- A hand-drawn face with a more fluid nature for some text and headlines spoke to the fun of Nando's spirit.
- The leaves, which illustrate the gentle Portuguese culture, were made more in proportion with the logo.
- A background scroll element was made shorter, neater, and more efficient.
- The cockerel was redrawn in a looser style. He is more solid and cohesive, "yet he hangs loose!" says Wapnick. Still, he remains largely unchanged, in keeping with Cross Colours' original plan.

The new identity is currently being rolled out, and stores in every country have welcomed the changes and the standards kit that provides a means for them to control the identity at their location. Customers have reacted positively as well. But Adele Wapnick doubts that many will notice the specific changes to the logotype and cockerel mark, "[w]hich I believe is the responsible route in redefining a logo or symbol identity," she says.

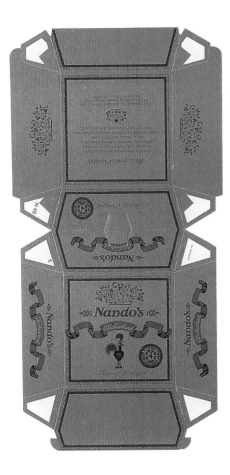

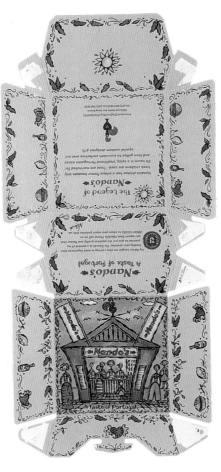

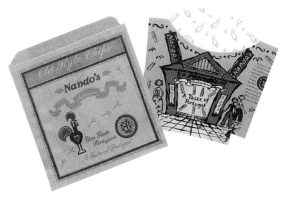

Food packaging carries through with the brighter color scheme and more confident, welcoming design.

Nando's also sells its special sauces. Its old labeling system (left) was so similar across the board in color and type that it was difficult to tell one variety from another. The brightened, enlivened redesign (right) distinguishes each type easily.

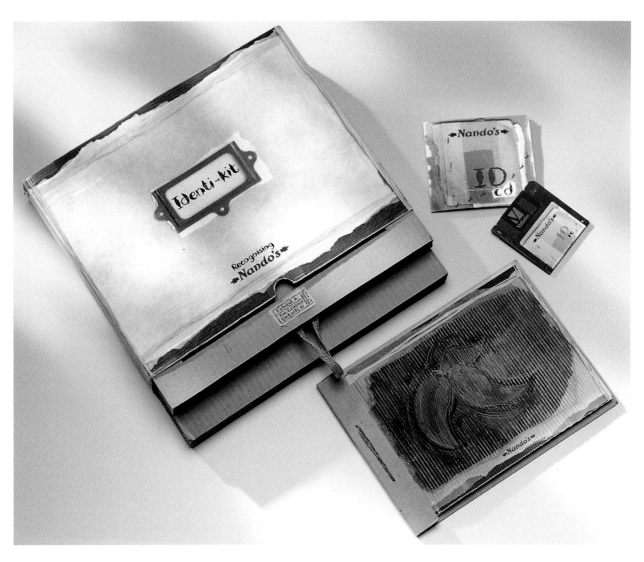

Even the new Nando's Identi-Kit, distributed to stores around the world, has the texture and color of the new identity. Several inside pages also appear here.

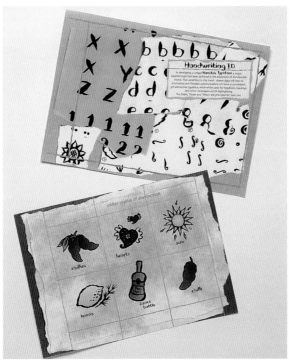

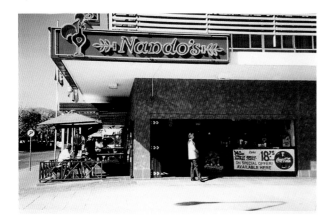

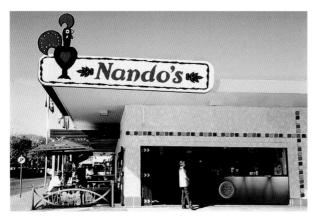

Phase two of the Nando's identity makeover will include new storefronts, interiors, menu boards, and signage. Several comps of proposed designs appear here.

Nando's advertising also received a facelift. The general approach is the same, but the presentation has much more life and texture.

Before

After

Before

Morgan Shorey originally conducted
business as an artists' and photo-
graphers' rep under her own name.
But she wanted something that said
more about what she did.

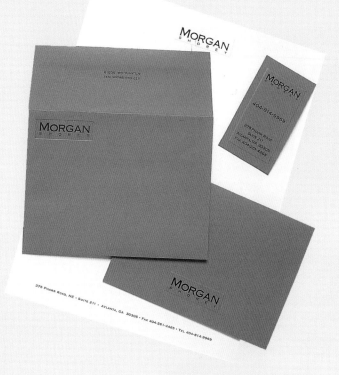

Dogstar for Heavy Talent

Challenge: A sole proprietor wants to recast her company's identity so that it sells her work, not her name.

LIKE MANY SMALL-BUSINESS OWNERS, Morgan Shorey used her own name for her artists' and photographers' rep business: Morgan Shorey, Inc. But as her business as an artists' and photographers' representative grew, she wanted a new name, one that focused on what she did, not on who she was.

"We're not a style-based creative office. We don't have a food guy and an architecture guy and all that. You call here if you really want the heavy talent," says Shorey, who contacted Rodney Davidson at Dogstar for help to find her new identity.

The phrase "heavy talent" was an ideal name for her firm. Shorey and Davidson agreed. Aside from its literal meaning and being on the whimsical side, she and the photographers she worked with at the time all have achieved large stature. Shorey liked the idea, and Davidson knew the double entendre would lend itself to plenty of conceptual, illustrative solutions.

The artist began by quickly sketching page after page of tiny thumbnails. His first trials portrayed superheroes and other larger-than-life characters. The tiny figures lifted or pulled or in other demonstrative ways struggled with heavy portfolios. Some solutions were all illustration, while others pulled in type as well.

One direction emerged as a favorite: the lifting figures. It graphically represented the name, was memorable, and had the humor the client wanted. But Davidson felt he had not found the right solution yet, and he went back to the drawing table.

This time he came up with the idea of a crane lifting a large portfolio. The skew in scale emphasized heavy even more than in his earlier designs. Yellow and black were appropriate colors for heavy equipment, but Davidson also liked their bright, energetic qualities. The idea for the type portion of the identity was resurrected from some of his first sketches.

DESIGN FIRM:
Dogstar

DESIGNER:
Rodney Davidson

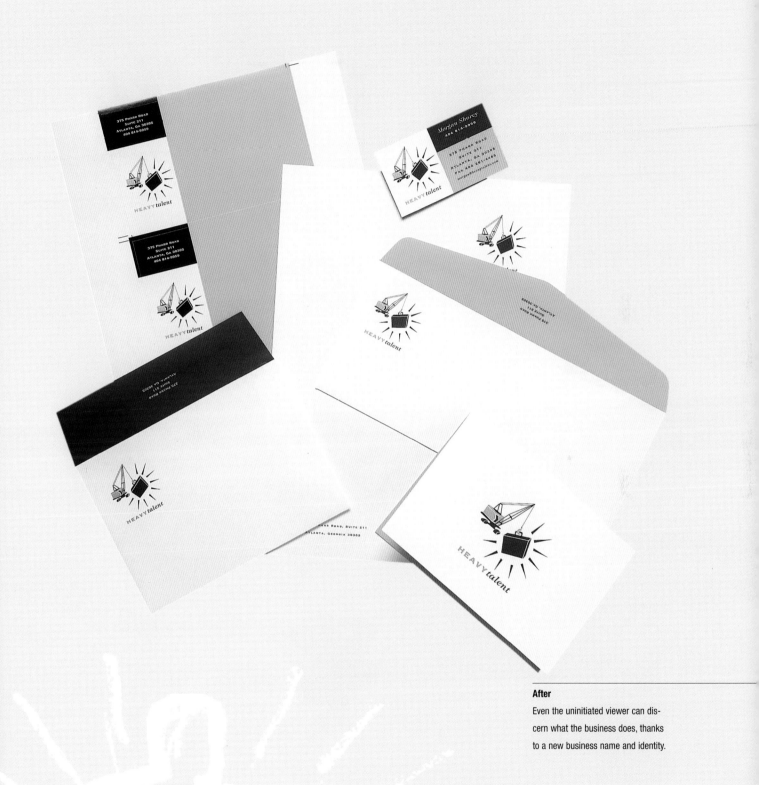

After

Even the uninitiated viewer can discern what the business does, thanks to a new business name and identity.

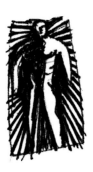

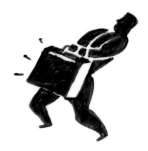

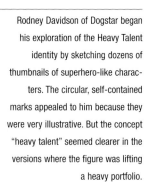

Rodney Davidson of Dogstar began his exploration of the Heavy Talent identity by sketching dozens of thumbnails of superhero-like characters. The circular, self-contained marks appealed to him because they were very illustrative. But the concept "heavy talent" seemed clearer in the versions where the figure was lifting a heavy portfolio.

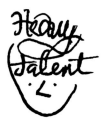

Typographic solutions were also
explored, but these didn't have the
same whimsical appeal of Davidson's
earlier sketches.

Davidson and Shorey were trying to
decide between these two figures
when the designer decided that a
better solution had yet to be found.

"It was exactly what I was looking for. The focus is totally on the large portfolio as it dwarfs the crane, swinging toward the viewer," Davidson says. "I believe this concept is superior to all the rest because it is unexpected, unique, has a concept played out in a visual pun, and is not gender-based."

Implemented in early 1998, the new mark has noticeably affected Shorey's business. In particular, it distinguishes her office from other artists' reps in the area. "When people see it on a box or package, they know that this is something very different."

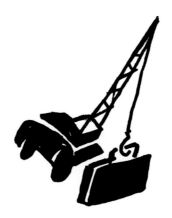

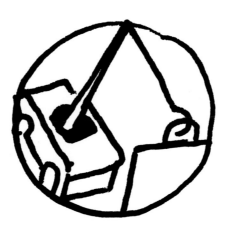

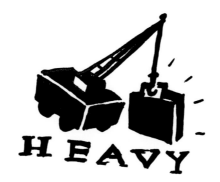

Back at his drawing table, Davidson happened upon the concept of a crane lifting the portfolio that made the concept of "heavy" much more memorable.

Before
China Youth Press's original identity
was built on the calligraphy of Lu
Xun, a Chinese literary giant in the
1930s. Although the mark was very
identifiable within China, it was
utterly confounding in foreign
markets where the press was
expanding its presence.

中国青年出版社

Wang Xu for China Youth Press

Challenge: As a publishing company begins to expand its operations outside of mainland China, it needs a more recognizable presence in non-Chinese-speaking countries.

In mainland China, many enterprises—especially publishing houses—like to use calligraphy of well-known people for their logotypes. One such company, China Youth Press, was founded in 1949 and is the same age as new China. It is one of the largest publishing houses on the mainland, publishing literature, art, and intellectual books. Since its inception, its identity has been formed around the calligraphy of Lu Xun, the Chinese literary giant of the 1930s.

But in the last twenty years, with the more open economic policy that has been developed in China, communication between the press and the outside world has increased. Comparing its identity with stronger identities of foreign publishing houses, the company realized the necessity of forging a new, more competitive presence.

China Youth Press has been trying to recreate its identity for almost ten years. But since all efforts were handled piecemeal, the results lacked continuity and caused confusion. In late 1998, China Youth Press asked graphic designer Wang Xu to redesign its corporate identity program.

Wang Xu began by exploring imagery that would resonate with Chinese youth. Perhaps the most significant event is the May 4 movement of 1919, an anti-imperialist, anti-feudal, political, and cultural movement influenced by the October Revolution and led by intellectuals. The youth at that time usually were pictured wearing scarves, generally atop blue clothing. This imagery gave the designer a starting point: Initial explorations included realistic and abstract versions of a young man with a scarf around his neck and a book in his hand.

From there, Wang Xu made the concept even more abstract. A simple twig and a leaf were positioned so that they either resembled a human figure with an uplifted arm or an extended human hand. Both designs formed the letter *Y* for *youth* and expressed vigor and vitality. Another exploration turned a young man's head and scarf into a book, but the designer was not happy with this direction.

Finally, the designer began considering the letter *C*, for *China*. The circular form of the character, combined with an abstracted, extended hand, formed an interesting sun image. But turning the hand downward created an even more engaging mark: The fingers now looked like pages of a book or a stack of books.

The designer knew he was on the right track when he discovered that the English pronunciation of *youth* is similar to the Chinese pronunciation of *young lion*, which the new mark also resembled. It was a happy coincidence: The lion's image stood for a rousing, strong competitiveness that China Youth Press wanted. The client accepted the mark at once.

"Compared with other publishing houses in mainland China, China Youth Press now has a stronger consciousness about having an international visual identity. As the new corporate identity needed to be international, it was better to use a lion image than a people image," says Wang Xu, adding that he felt that the trust and confidence his client gave him truly helped make the project a success. "China Youth Press is one of our best clients," he says.

DESIGN FIRM:
Wang Xu & Associates Ltd.

ART DIRECTOR:
Wang Xu

DESIGNER:
Wang Xu

After

The publishing company's new identity centers on this lion-like mark. It has the feeling of its home country, but the addition of English type turns it into a worldwide symbol.

Graphic designer Wang Xu began his redesign by considering concepts that said *youth* and *China*. He explored imagery attached to the May 4 movement of 1919, an anti-imperialist, anti-feudal, political, and cultural movement influenced by the October Revolution, during which young people were usually seen wearing scarves. He developed literal and abstracted ideas.

Also in an effort to express youth, these studies used abstracted twigs and leaves that eventually turned into a reaching hand.

Here, the image of a young man's head with the suggestion of a scarf turns into the shape of a book. However, Wang Xu wasn't happy with this approach.

To work in the concept of *China* more concretely, Wang Xu began exploring the letter *C*. Reintroducing the extended hand created an intriguing sunburst image, but turning the fingers/rays downward had an even more remarkable effect: The letterform was transformed into a lion, the perfect image to express vitality and competitiveness.

The 50th Anniversary of China Youth Press

To celebrate the fiftieth anniversary of China Youth Press in 1999, Wang Xu created this commemorative logo. On the threshold of a new millennium, the company's new mark gives it a more significant worldwide image.

STARTING OVER

—Ron Miriello on starting again, and
again—

"Earlier in my career, I felt that when
clients wanted to change one of my designs,
they were interfering, weakening the work.
But there were as many, if not more, times
when they made the work better, too. So
when their legal department says 'no, we
can't use this' and I've got two weeks to come
up with something entirely new, I try to
remember those times. Clients are not dumb.
They're partners.

"A good branding identity must cross
over all of a company's divisions—public
relations, advertising, legal, whatever. That's
why it's so electrified—an identity has to rep-
resent a lot of values. But a company can be
kind of schizophrenic about what it wants to
communicate because of this.

We have to become a journalist for the
client. We report on what they represent, ask
tough questions and then create a dialogue
that can become memorialized in the identi-
ty's content. The content might be latent, not
really obvious to anyone. But the brand
comes to symbolize those qualities.

"Think of creating a new identity as if
you are planning an experience for someone,
just as a director might plan out a movie.
What do you want them to experience? After
you agree on that, you can start the writing
and the casting."

Before

While the posters designed
by Massimo Dolcini in the
1980s are undeniably eye-
catching and well-com-
posed, the designer's style
was so recognizable at the
time that the identity
referred more to him than it
did his client, the
Municipality of Pesaro, Italy.

After

This poster forcefully depicts the Pesaro cultural department's new identity. Letterforms are used as objects and as art, and bold rules always frame event information. The spare, bold posters and invitations can be recognized easily. This image represents the title of a novel telling the story of a worker in a dump (*La discarica*). Both the can and the letters are depicted as rubbish.

Dolcini Associati for Municipality of Pesaro

Challenge: A city develops an accidental identity, then strives to refine it into something more useful.

THE MUNICIPALITY OF PESARO, ITALY, did not originally set out to develop an identity. But after Massimo Dolcini, founder of Dolcini Associati, created all of the posters and collateral materials need by the municipality's various governmental divisions throughout the 1980s, it slowly grew a very distinct identity. Unfortunately, because Dolcini's work was so recognizable, the public perception was that the design work was communications from the design studio, not the municipality.

For the next seven years, Pesaro's graphics became less coordinated, so the old identity began to fade. But in 1998, the Pesaro cultural office decided to resurrect the idea of a real identity and hired Leonardo Sonnoli, now art director of Dolcini Associati, to recreate its image.

"Mainly they wanted all of their communications to be easily recognizable, a sort of signature for all printed matter," Sonnoli says. "I wanted to create a new language for them, a sort of visual alphabet [that said], 'This is the voice or language of the public institution producing cultural events for the town.'"

Sonnoli interpreted his alphabet analogy literally: Influenced by the type-photo theories of Lazzlo Moholy-Nagy as well as the "letters as things" theories of Eric Gill, Jan Tschichold, and others, he developed a number of sketches that transformed letters into art. In some cases, the letterforms displaced or replaced other objects; in other instances, the letters themselves were the image.

Because he was producing posters and invitations, Sonnoli says that visibility was more important that readability. "People have to recognize immediately the subject, then [they can] read the information about the event," he explains.

Once he had his alphabetic approach nailed down, Sonnoli concentrated on the

Leonardo Sonnoli's sketches played with ways to treat letters as objects. He says that treating letters—usually used to convey written information—as art creates a visual/verbal hybrid, very different from other forms of visual communication.

layout for the pieces. To keep the printed matter recognizable no matter what art was used, he always used Foundry Sans for his type plus the same grid. A bold line is always place near the even information, which maintains the same tone on every piece.

The new identity has been a success: The events announcements have a very recognizable feel across the board. Citizens know immediately that a new occasion has been planned every time they see a new poster displayed.

The poster at right was made for a photographic exhibition on the Bosnian War. A bullet-pierced *B* is mixed with an exhibit photo.

Omnia mutantur, a Latin phrase meaning *all is changing,* was the title of an art exhibition of young artists. The egg is one of the most recurrent symbols in paintings during the Renaissance, the most influential art period in the Pesaro area.

Il lavoro delle donne (the women's work) was an exhibition on the folk needlework made by Pesaro-area women. The safety pin brings together the *d* of donne and a pink piece of cardboard carrying the opening date and hours. Usually, such a piece of cardboard is pinned on fabric to identify it.

This poster announced a lecture series on children's literature. The image is of a simple game—shadow puppets—combined with the first letters we learn: *a, b, c.*

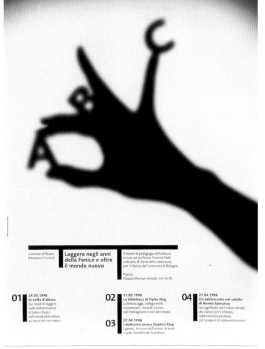

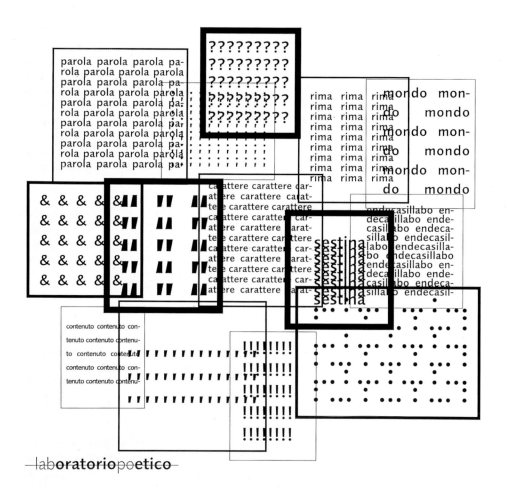

This imagery represented a poetry lecture series. Sonnoli's inspiration was the visual poetry of the 1950s and 1960s. The subtitle, poetry *laboratory,* helped the designer find his solution. "It represents many boxes where the elements of the poem are: rhyme, different letters, words, punctuation, and so on.

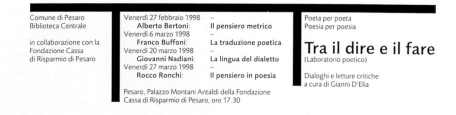

Comune di Pesaro Biblioteca Centrale	Venerdì 27 febbraio 1998 –		Poeta per poeta Poesia per poesia
	Alberto Bertoni:	Il pensiero metrico	
in collaborazione con la Fondazione Cassa di Risparmio di Pesaro	Venerdì 6 marzo 1998		
	Franco Buffoni:	La traduzione poetica	**Tra il dire e il fare**
	Venerdì 20 marzo 1998 –		(Laboratorio poetico)
	Giovanni Nadiani:	La lingua del dialetto	
	Venerdì 27 marzo 1998 –		Dialoghi e letture critiche a cura di Gianni D'Elia
	Rocco Ronchi:	Il pensiero in poesia	
	Pesaro, Palazzo Montani Antaldi della Fondazione Cassa di Risparmio di Pesaro, ore 17.30		

PESARO BIBLIOTECHE

DESIGN FIRM:
Dolcini Associati

ART DIRECTOR, DESIGNER:
Leonardo Sonnoli

Before

The original Eastpak identity was very popular in Europe, but it was considered somewhat tame in the United States.

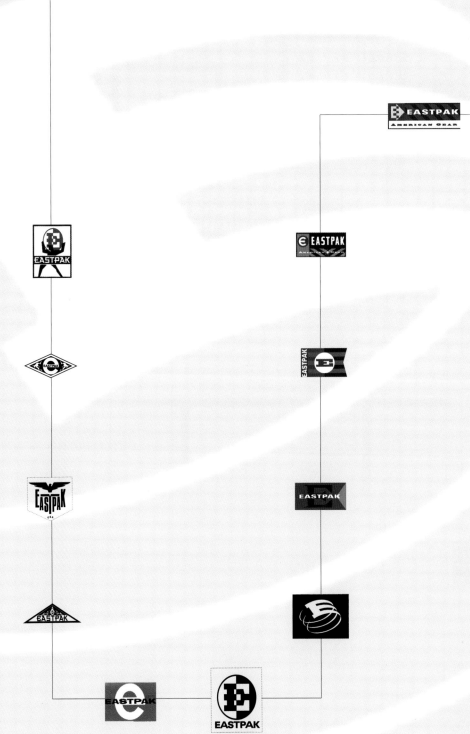

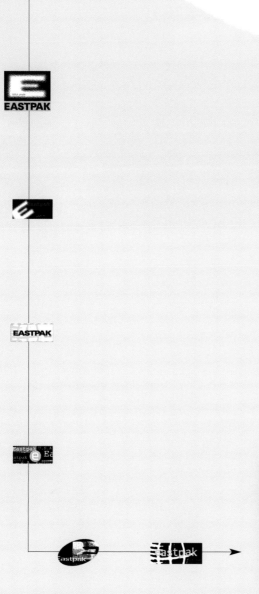

Miriello Grafico for Eastpak

Challenge: *A brand with wonderful prestige and name recognition in Europe, but not as much acclaim in the U.S., needs an identity redesign that preserves the former and improves the latter.*

AFTER COLEMAN PURCHASED THE EASTPAK BRAND name, it found itself with a quality line of backpacks with a split personality. Extremely popular in Europe, the Eastpak name in the United States was regarded as the poor relation of its main competition, Jansport. Eastpak was the brand your mom might buy for you because it was well-made and sensible. But most U.S. kids, teens, and young adults were more attracted to the competition's more colorful, graphic look.

Coleman asked Miriello Grafico to energize Eastpak's image and give it a bit more attitude. "The sky's the limit," Eastpak representatives told Principal Ron Miriello early on in the project, a guideline that his designers immediately embraced. The design team completed many studies of Eastpak's target audience, formal and informal—Miriello often would approach young people, ask them what they liked and disliked about their backpacks, and how they felt about the top

After a long and somewhat circuitous route, the new Eastpak identity was created. In addition to its more powerful look, it also was designed to be part of the product more, rather than just a label.

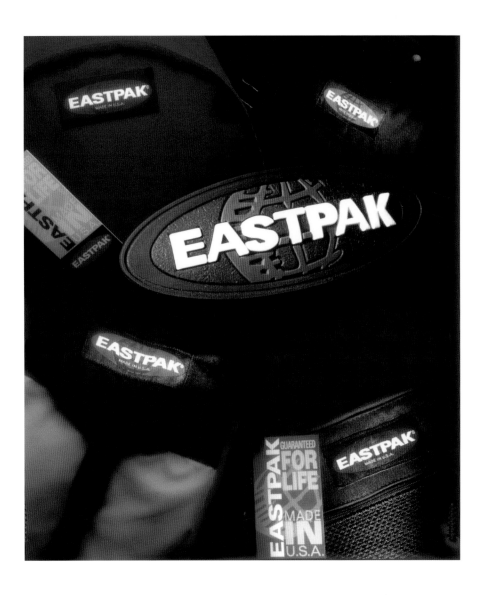

DESIGN FIRM:
Miriello Grafico

ART DIRECTOR:
Ron Miriello

DESIGNERS:
Ron Miriello, Monica Riu,
Michelle Aranda, Troy Viss,
Randy Klamm

PRODUCTION, APPLICATION:
Monica Riu

brands and why. Then the design team began to think about how to turn the backpacks into walking billboards.

A globe was part of Eastpak's original design: Miriello designers began by looking for ways to incorporate it, but they explored many other directions as well. The firm even dipped into product design: "[U]unlike a corporate identity where the identity represents a service, this was for an old-fashioned, kick-the-tires product," explains Miriello. Suggested redesigns included a skateboard bag, a bag with bungee wrap cords on the outside, and less boxy and more organically shaped bags. Designers eventually presented to Coleman approximately one hundred logo options, and Miriello felt sure that many of the marks had hit the mark. But the client's European representatives began to assert themselves: Their audience identified per-

fectly with the existing logo, and all of the proposed designs strayed too far from that identity.

Then Miriello realized that instead of a complete makeover, the assignment had turned into a facelift. "This project involved a lot of soul-searching on the part of the client," Miriello says; "trying to get a grip on what Eastpak was all about, its strengths, weaknesses, and goals. Normally, I don't want a client to use the design process to organize their thinking. But in this case, it became clear that a refreshed design would be better than a whole new look."

Phase two referenced the original design much more directly, with an added jolt of life and attitude. The name became more readable, the globe returned in some designs, and the original burgundy red was brought back and revised as an element that identified

 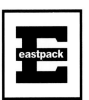

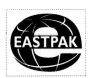 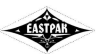 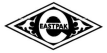

Nearly one hundred logo options were presented to Coleman in phase 1 of the project, but none appealed to the European sales force.

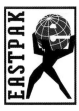 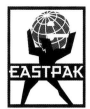

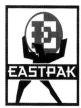 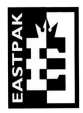

In phase 2 of the redesign, the product name became much more readable, and more attitude was injected through visuals and color.

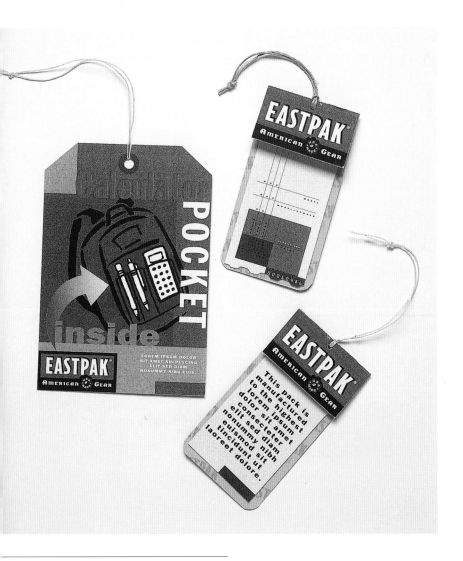

solidly with the original.

Ultimately, designers decided to be more inventive in how they used the logo on the product. They suggested rubber extension labels and molded details that integrated the brand into the product, rather than just being stuck on it. Hang tags could change while the brand remained constant, and secondary color schemes could change. Miriello Grafico recommended that the client also change its image in other ways: Be a presence at youth-oriented trade shows, for instance sponsor events like skateboarding competitions, and ratchet up the volume of retail advertising.

The redesign process took more than ten months, due to the many changes in direction. Still, Miriello was pleased with the results. "I'm glad we didn't settle too soon. If this is what they really want, then this was the best way," he says. "I'm glad we stayed with the project when the frustration with changing strategies mounted. In the end, it was about continuing to listen to what the business needed to succeed. That meant building on the strengths they didn't know they had."

Hang tags with changeable color schemes were designed to point out the functionality and fun of the product.

Opposite: Also part of phase 2, these designs focused on the *E* element, turning it into a branding symbol.

Before

When two design studios, Shankweiler Nestor Partners and Stermole Studio, decided to disband and reorganize under the flag of Nestor Stermole Visual Communications, its new principals were faced with having to recreate their combined identity.

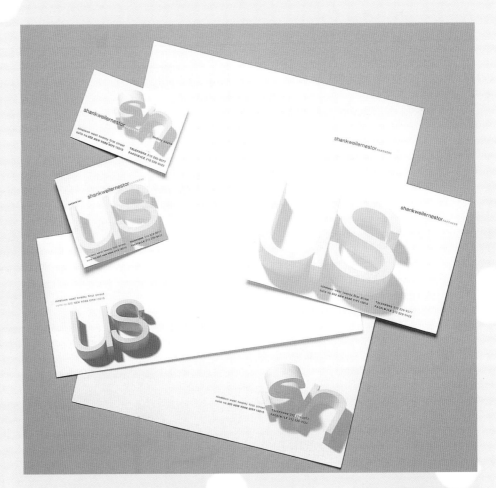

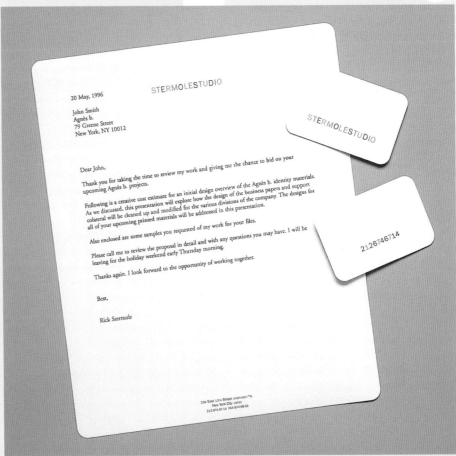

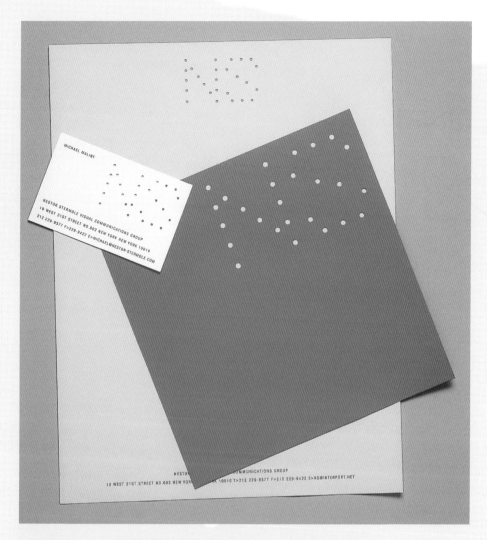

After

The new identity began around the
concept of drilled holes, but it quickly
evolved into something much larger.
The addition of a brilliant palette of
papers allows color to play against
color, speaking of the company's cre-
ativity and multilayer capabilities. The
result is an identity with visceral and
conceptual appeal.

Nestor Stermole for Nestor Stermole Visual Communications

Challenge: *When two creatives decide to combine their individual offices, settling on a single identity can be difficult.*

Rick Stermole and Okey Nestor each ran their own graphic design studios for a number of years. But when they decided to join forces, deciding on a single identity was tricky. It wasn't really necessary to retain any particular elements from their old studios—except perhaps for their own names—but they certainly didn't want to abandon their reputations as creative, in-demand professionals. Okey Nestor's original business was called Shankweiler Nestor, in which he partnered with Linda Shankweiler. Their logo was actually conceived and photographed by Rick Stermole: Its three-dimensional letters

announced the principals' names, but it said nothing about what they did. Stermole, on the other hand, relied on three bright colors and subtly dotted paper stock for his stationery system. The two identities were not similar in any way. "It's so difficult, trying to establish a business and bring in income," Nestor says of the process for thinking up the new design. "And now we're doing our own ID as well." He and Stermole brainstormed for vision words, terms that would describe what the new organization was all about. To test their favorite ideas, they faxed their lists out to key clients who were sympathetic to

DESIGN FIRM:
Nestor Stermole

ART DIRECTORS:
Okey Nestor, Rick Stermole

DESIGNER:
Robert Wirth

PRINTING:
Dickson's, SoHo Services, Continental Anchor

LASER DIE-CUTTING:
Laser Craft

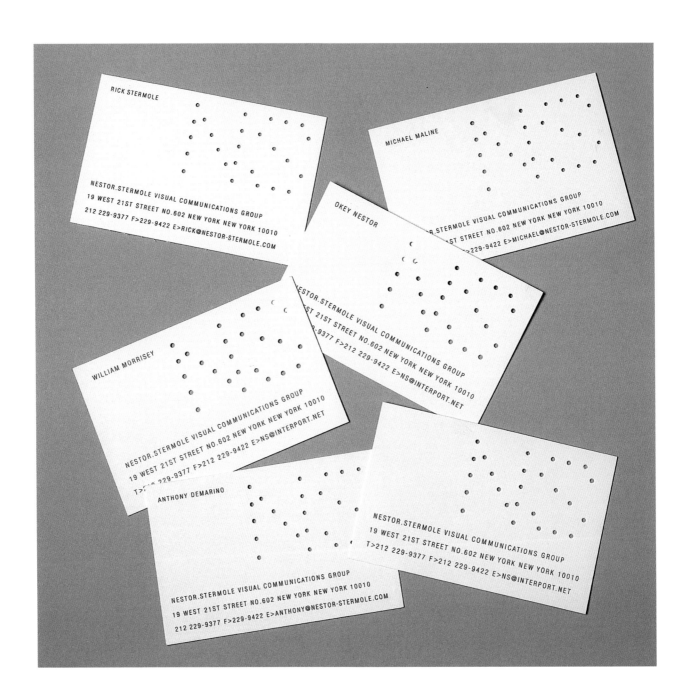

The first thing the new office needed was business cards. At this point, the hole pattern was punched with a die, but this caused production headaches. The designers later switched to laser cutting. The color on the laser-cut cards is very subtle but varied.

the new firm's plight. "It was horrible: Nobody liked any of the names." In the end, they decided on using their own names— Nestor Stermole Visual Communications. People knew who they were: Some new, esoteric, conceptual name had absolutely no equity. Still, says Nestor, such a defined name will make it difficult for them to add any additional partners in the future. The next step was to develop the graphical representation. "You grow as a designer and think about yourself differently from year to year.

We wanted to be very simple and tasteful, but to have an identity that would allow us to grow and make more of a statement if we want to," Nestor explains. The business name was so long that it would have been very difficult to work it into a single, memorable mark, so the designers shortened it to NS. Simply printing the letters on white or cream paper was clean and straightforward, but it seemed overly obvious. So the designers explored other ideas, among them die-cutting. In order for the design not to cut to

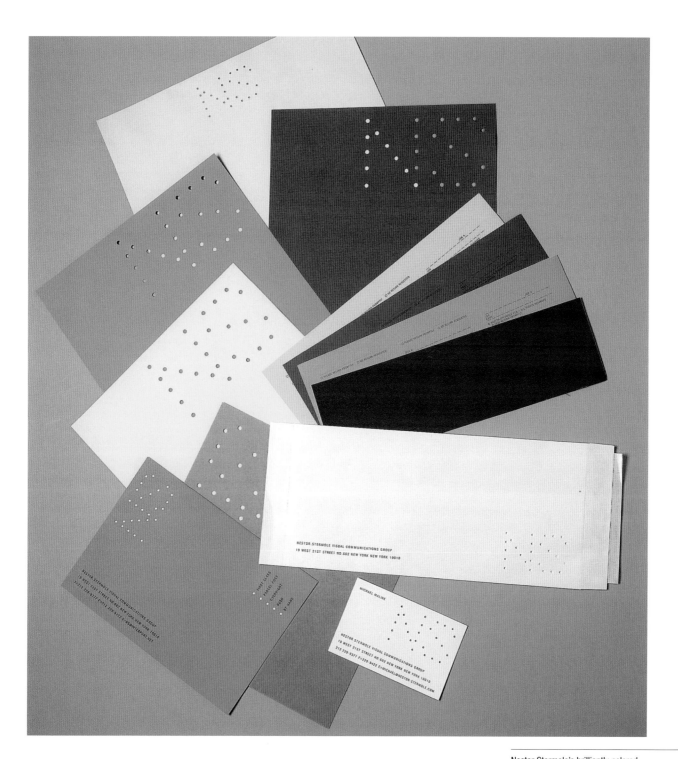

Nestor Stermole's brilliantly colored stationery system is highly recognizable and would no doubt stand out on a recipient's desk, already overpopulated with white and cream papers. The drilled-hole pattern allows additional colors to show through from behind. On components that must be on white paper, such as memos and fax sheets, the hole pattern is represented by a series of circles.

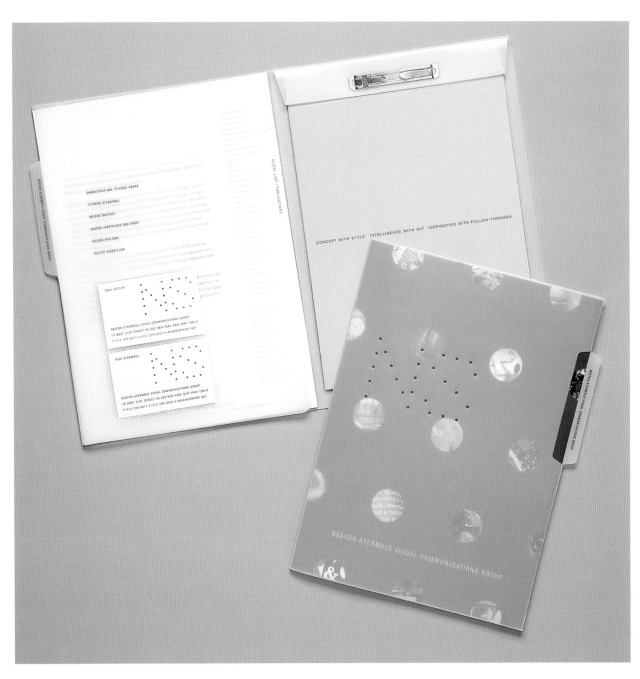

Nestor Stermole's presentation folder demonstrates the flexibility and growth potential of the punching motif and color system. Its plastic cover does not have to be printed because it carries the simple punch; inside, a hint of the color used on the stationery appears.

pieces the paper on which it die-cut, a series of punched holes was devised. But the printer's die was so small that it had to be cleaned out between every punch. "They gave us our business cards and told us not to come back," laughs Nestor. It was then that the die-cut holes concept really blossomed: Switching to laser-cutting, the designers decided to let the holes do more. Instead of just breaking the surface of the paper, now they would let more and more color show through. A paper palette of brilliant green, blue, red, yellow, red, orange, and yellow cre-

ated a new color story with each new piece of the stationery system. The laser-drilled holes allow additional colors to present themselves from behind. "You get a color surprise in every envelope. It's tough to know how to perceive yourself and to know how you want to be perceived," Nestor adds, noting that some design firms try to encompass their entire philosophy or style of work in their letterhead. "But it shouldn't jump out and accost you in a way that you don't want. Our identity is far more subtle than that."

Because any material can be drilled, the punches can be used in various ways, as shown by Nestor Stermole's exterior, wooden office sign.

NO.602

Reverb for Avalon Hotel

Challenge: When a hotel ages in a less-than-graceful manner, it needs plenty of sound design advice to revive its sense of style and comfort.

DESIGN FIRM:
Reverb

CREATIVE DIRECTOR:
Susan Parr

SENIOR CREATIVE:
James W. Moore

SIGNAGE CONSULTANT:
Bob Loza, Cyrano, Los Angeles

SIGN FABRICATOR:
Mark Nelson, Carlson & Co., Los Angeles

THE NEW OWNER OF THE RECENTLY OPENED Avalon Hotel bought a legend *and* a building complex when he purchased an aging residential hotel south of Beverly Hills. In its heyday, the hotel—then named the Beverly Carlton—housed Hollywood Stars like Lucille and Desi Arnez and Marilyn Monroe looking for a quiet hideaway. When Brad Kornson took possession of the hotel, it looked more like a shabby apartment building. But he had a vision of bringing the legend back to life, and he brought in a team of talented interior designers, architects, and the design office of Reverb to help.

Reverb is known not only for its identity work, but also for creating complete images that go beyond the graphic design work. "We guide the message through advertising, promotion, public relations, magazine articles, and even investor groups," explains Susan Parr, one of three Reverb principals with Somi Kim and Lisa Nugent.

The hotel's new owner wanted to attract an "art director-style person," not tourists, but young working professionals who would appreciate a clean, modernist environment. Another attraction of the hotel was that it was a bit apart from the craziness of Beverly Hills. "Part of the image had to be about serenity and hospitality. We coined a phrase for it—enlivened serenity," says Parr.

She and senior creative James Moore met early and often with interior designers and architects involved with the Avalon project. They spent plenty of time on research the original hotel, unearthing a 1948 *Forum* magazine article about the design of the original building complex.

They were excited to learn that the structure's original interior design and identity were created by the celebrated designer Alvin Lustig. Beneath an old façade on the front of the building was a wall of tile, each square carrying a unique jack symbol designed by Lustig. It was from this visual that the new identity grew.

Before

Beneath a façade on the front of the old Beverly Carlton Hotel, installed in an earlier remodel, creatives at Reverb found these wonderful tiles, created by the famed designer Alvin Lustig when he designed the hotel's interior and identity in 1948. From this jack pattern the entire identity system for the revitalized hotel grew.

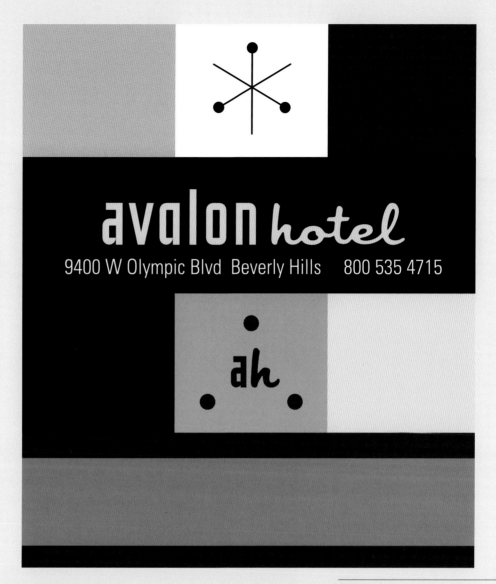

After

A number of elements in the new
identity system can be seen on this
book of matches. From the old tile
pattern, Reverb designers split out a
jack symbol and a three-dot mono-
gram. Not shown here is another
flexible element, a flower. But the ini-
tials of the hotel—*ah*—make a
descriptive tagline for the hotel.

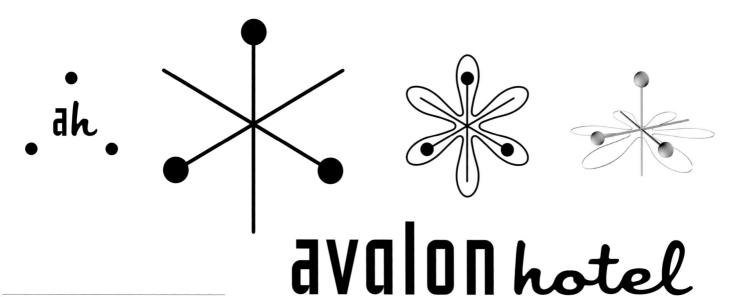

avalon *hotel*

Reverb likes to create flexible, multi-faceted identities that have depth, not single, stamp-like marks. This figure shows just a few of the ways the different components of the Avalon identity can be used.

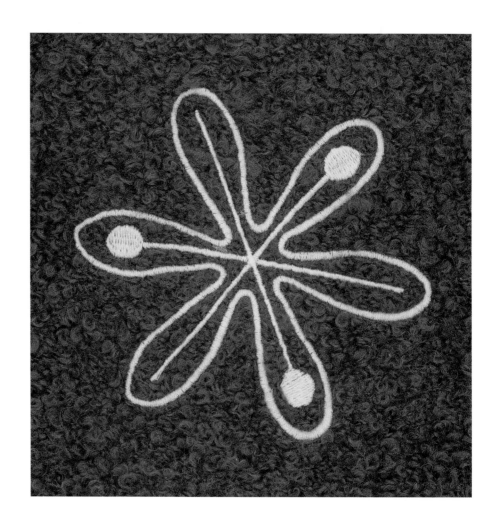

The symbols translate nicely to embroidery as well as to printing. Even in these one-dimensional applications, they have a distinct three-dimensional quality.

Avalon

Avalon

Avalon

Avalon

AVALON

avalon

Avalon

Avalon

avalon hotel
avalon hotel

a a a a

The designers played out the hotel name in a number of different typefaces, each with a very distinct personality.

avalon hotel
avalon hotel

a a a a

A squared-off face borrowed from an old typebook had the right feel, and mixing styles of lowercase *a*'s added even more flair. But the designers modified the bowled *a* slightly, shortening its top stroke and elongating its square counter. This created a more balanced, calmer character.

"Any design we do has to have variety and a richness. We didn't want to take the 'glam' hotel approach of creating a single logo and sticking it on everything," Moore explains. "We picked up on the Lustig design and moved it and broke it apart."

From the original symbol, the designers split out the jack symbol, a flower and a three-dot monogram. Those pieces can be used alone or together on printed, stitched, and fabricated hotel paraphernalia. Another, less prominent, mark emerged from the initial letters of the Avalon Hotel—*ah*—by fortunate coincidence exactly the phrase the hotel proprietors want guests to utter.

To match the flavor of this uniquely midcentury design, the designers selected two faces: a script type for the hotel's name, a face that would have been found in hotels in the 1940s, and a squared-off face borrowed from a type book and modified. It was chosen for its friendly, welcoming feel; setting one *a* in uppercase and the other in lowercase adds to its informal charm and creates a nice sight line.

The interior of the hotel follows the modern, minimal feel of the identity: Earth tones, surrounded by tile, woods, and metals, create the sense of a calming oasis in busy Los Angeles. "This is a place for people to go and not be bombarded with celebrity attractions," says Parr. "It is a quiet place, but a lively place."

The hotel's lighted sign, still under fabrication, has a soft, welcoming shape. Like its typography, it has the flavor of an icon from the 1940s.

The interior design of the hotel, created by Kelly Wearstler Interior Design, projects a peaceful but stylish demeanor for this enclosed area.

Photography: Grey Crawford

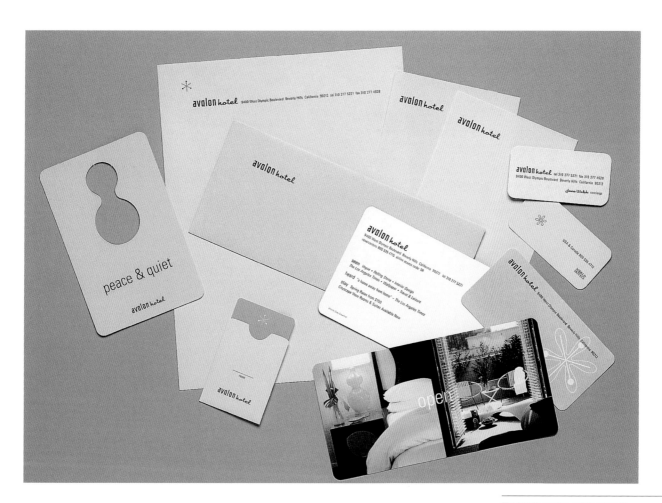

The hotel's printed collateral has the same peaceful feeling. Shapes are soft, while the colors are modern and appealing.

Photography: Grey Crawford

By fortunate coincidence, the initials of the Avalon Hotel spell out the exact sentiment the establishment's owner wants guests to feel. This piece of the identity is reserved for more intimate items, such as robes.

Addis
2515 Ninth Street
Berkeley, CA 94710
510.704.7500
fax: 510.704.7501
www.addis.com

Alexander Isley Inc.
4 Old Mill Road
Redding, CT 06896
203.544.9692
fax: 203.544.7189
www.alexanderisley.com

Atelier Works
The Old Piano Factory
5 Charlton Kings Road
London NW5 2SB
United Kingdom
atelier@atlierworks.co.uk

Bergsnov, Mellby & Rosenbaum
Sagvn, 23C, inng. 2, 0459
Oslo, Norway
www.bmr.no

BrandEquity International
2330 Washington Street
Newton, MA 02462
617.969.3150
fax: 617.969.1944
www.brandequity.com

BrownKSDP
Sarphatikade 10
1017 WV Amsterdam
The Netherlands
31 20 530 8000
fax: 31 20 530 8035
www.brownksdp.com

Carbone Smolan Agency
22 West 19th Street, 10th Floor
New York, NY 10011
212.807.0011
fax: 212.807.0870
www.carbonesmolan.com

Concrete
633 South Plymouth Court, Suite 208
Chicago, IL 60605

Cross Colours
P.O. Box 412109
Craighall 2024
Johannesburg, Gautney
South Africa
cross@iafrica.com

Desgrippes Gobé & Associates
411 Lafayette Street
New York, NY 10003
www.dga.com

Design Park
DongSung Art Center
1-5, Dongsung-Dong
Chongro-Gu
Seoul, South Korea
kh@designpark.co.kr

Dogstar
626 54th Street South
Birmingham, AL 35212
pavarodney@aol.com

Dolcini Associati
Via Meniana, 3 47900
Rimini, Italy

Félix Beltrán & Asociados
Pisco 680
Colonia Lindavisla
Mexico City, Mexico 07300

Girvin
1601 Second Avenue, 5th Floor
Seattle, WA 98101
206.674.7808
fax: 206.674.7909
www.girvin.com

Interbrand
200 E. Randolph Street, Suite 3500
Chicago, IL 60601
312.240.9700
fax: 312.240.9701
www.interbrand.com

Kan & Lau
28/F., 230 Wanchai Road
Hong Kong
www.kanandlau.com

Karo (Toronto) Inc.
10 Price Street
Toronto, Ontario
Canada M4W 1Z4
416.927.7094
fax: 416.928.6713
www.karoinc.com

Kiku Obata & Company
6161 Delmar Boulevard
St. Louis, MO 63112
314.361.3110
fax: 314.361.4716
www.kikuobata.com

Landor Associates
Klamath House
1001 Front Street
San Francisco, CA 94111
415.365.3190
fax: 415.365.1700
www.landor.com

The Leonhardt Group
1218 Third Avenue, Suite 620
Seattle, WA 98101
206.624.0551
fax: 206.624.0875
www.tlg.com

Lippincott & Margulies
499 Park Avenue
New York, NY 10022
212.521.0000
fax: 212.308.8952
www.lippincott-margulies.com

The McCulley Group
415 South Cedros Avenue, Suite 200
Solana Beach, CA 92075
858.259.5222
fax: 858.259.1877
www.mcculleygroup.com

Miriello Grafico
414 West G Street
San Diego, CA 92101
pronto@miriellografico.com

MLR & Associates (Murrie Lienhart Rysner)
325 W. Huron Street
Chicago, IL 60610
www.mlrdesign.com

Nestor Stermole Visual Communications
19 West 21st Street, No. 602
New York, NY 10010

The Partners
Albion Courtyard
Greenhill Rents
London ECI M6BN
United Kingdom
info@partnersdesign.co.uk

Pentagram
1508 West 5th Street
Austin, TX 78703
www.pentagram.com

Pentagram Design Inc.
387 Tehama Street
San Francisco, CA 94103
415.896.0499
fax: 415.538.1930
www.pentagram.com

Pinkhaus/Design
2424 South Dixie Highway, Suite 201
Miami, FL 33133
www.pinkhaus.com

Reverb
5514 Wilshire Boulevard, No. 900
Los Angeles, CA 90036
www.reverbstudio.com

Rigsby Design
2309 University Boulevard
Houston, TX 77005
www.rigsbydesign.com

Tharp Did It
50 University Avenue, Suite 23
Los Gatos, CA 95030
408.354.6726
fax: 408.354.1450
www.tharpdidit.com

Turner Ducksworth
164 Townsend Street, #8
San Francisco, CA 94107
www.turnerducksworth.com

Wang Xu
3/F, No. 29 Tian Sheng Cun
Huan Shi Dong Road
Guangzhou, China
gzxuwang@public1.huangzhou.gd.cn

Wolff Olins
10 Regents Wharf
All Saints Street
London NI 9RL
United Kingdom
44 (0) 20 7713 7733
fax: 44 (0) 20 7713 0217
www.wolff-olins.com

About the Authors

Clay Andres, self-proclaimed Web architect, is the author of numerous best-selling and award-winning computer books, including *Great Web Architecture*. He has been a freelance computer journalist since the dawn of personal computing and he is a Web columnist for CreativePro.com. In addition to writing about Web design, Andres has written technical marketing materials for corporate clients, including IBM, Apple, Xerox, and Adobe. Andres is also a Web designer and consultant with expertise in website architecture and branding. He lives in northwestern Connecticut.

Catharine Fishel has written about and worked with designers and illustrators for more than 20 years. She is the editor of LogoLounge.com, writes for leading design magazines such as *PRINT, ID,* and *STEPinside Design*, and is the author of many books on design-related topics, including *Paper Graphics, Minimal Graphics, Designing for Children, The Power of Paper in Graphic Design, Redesigning Identity, The Perfect Package, LogoLounge* (all Rockport Publishers), and *Inside the Business of Graphic Design* (Allworth Press).

Pat Matson Knapp is a Cincinnati-based writer and editor whose work focuses on design and its effects on business. A former newspaper journalist, she was editor of *IDENTITY,* a magazine devoted to corporate identity and environmental graphics, and was managing editor of *VM+SD* (Visual Merchandising and Store Design) magazine. She has contributed to a wide range of design publications.